114

REPRESENTATIONS OF REVOLUTION
(1789–1820)

REPRESENTATIONS OF REVOLUTION (1789–1820)

RONALD PAULSON

YALE UNIVERSITY PRESS
NEW HAVEN AND LONDON

Publication of this volume was assisted by a grant from the Publications Pro-
gram of the National Endowment for the Humanities, an independent federal
agency.

Designed by Nancy Ovedovitz and set in VIP Bembo type.
Printed in the United States of America by The Murray Printing Co., Westford,
Mass.

Library of Congress Cataloging in Publication Data

Paulson, Ronald.
 Representations of revolution, 1789–1820.

 Includes bibliographical references and index.
 1. Revolutions in art. 2. France—History—Revolution, 1789–1799—Art. 3.
Arts and Revolutions. 4. Neoclassicism (Art). 5. Romanticism in art. I. Title.
NX452.5.N4P3 1983 700'.94 82–13458
ISBN 0–300–02864–4

10 9 8 7 6 5 4 3 2 1

For Colin

Men make their own history, but they do not make it just as they please; they do not make it under circumstances chosen by themselves, but under circumstances directly encountered, given and transmitted from the past. The tradition of all the dead generations weighs like a nightmare on the brain of the living. And just when they seem engaged in revolutionizing themselves and things, in creating something that has never yet existed, precisely in such periods of revolutionary crisis they anxiously conjure up the spirits of the past to their service and borrow from them names, battle cries and costumes in order to present the new scene of world history in this time-honoured disguise and this borrowed language. Thus Luther donned the mask of the Apostle Paul, the Revolution of 1789 to 1814 draped itself alternately as the Roman republic and the Roman empire, and the Revolution of 1848 knew nothing better to do than to parody, now 1789, now the revolutionary tradition of 1793 to 1795. (Karl Marx, *The 18th Brumaire of Louis Bonaparte* [1852])

If a symbol is a concentrated image, then a revolution is the master-builder of symbols, for it presents all phenomena and all relations in concentrated form. The trouble is that the symbolism of a revolution is too grandiose; it fits in badly with the creative work of individuals. For this reason artistic reproductions of the greatest mass dramas of humanity are so poor. (Leon Trotsky, *History of the Russian Revolution* [1932])

CONTENTS ❧

ILLUSTRATIONS

ACKNOWLEDG-MENTS ·

To the Clark Library for support for my first trial flight on Burke, a lecture in June 1976 (chap. 3 of the present study), which was delivered in a number of other places thereafter and published as "Burke's Sublime and the Representation of Revolution" in *Culture and Politics from Puritanism to the Enlightenment*, ed. Perez Zagorin (University of California Press, 1980), pp. 249–70.

To Yale University and the National Endowment for the Humanities for support for a sabbatical year of work, 1977–78, and to the Trustees of the Rockefeller Foundation for allowing me a month's concentration at the Villa Serbelloni at the end of the same year.

To the University of Toronto for the invitation to deliver the Alexander Lectures in March 1979, which were called "The Representation of Revolution," and to the University of Zurich for inviting me to deliver the final version of the material in October 1981.

To the *Georgia Review* for permitting me to reprint parts of an essay on Rowlandson and to *ELH* for the chapter on the gothic novel. Parts of the chapters on Blake and Gillray appeared in a different form in a festschrift for Jean Hagstrum and in a collection of eighteenth-century essays edited by John Browning.

And to Peter Hughes and Harry Sieber for their expert opinions.

A very large proportion of the material that went into this work in progress does not appear in the final product. *Popular and Polite Art in the Age of Hogarth and Fielding* (University of Notre Dame, the Ward-Phillips Lectures, 1979), the first spin-off, filled in political background in England,

the art of prerevolutionary consciousness raising, and the aesthetics of sub-culture forms. Parts of *Book and Painting: Shakespeare, Milton, and the Bible* (University of Tennessee Press, the Hodges Lectures, 1982) and *Literary Landscape: Turner and Constable* (Yale University Press, 1982) grew out of either the assumptions of the revolutionary endeavor or actual chapters that seemed more relevant in other, nonrevolutionary contexts. Some parts have simply been published separately as essays (in particular "John Trumbull and the Representation of the American Revolution," in a festschrift for David Erdman). I have found it more convenient for me and I am sure also for the reader to print these elsewhere and refer to them here in footnotes.

In retrospect, I see that I wrote *Literary Landscape* as a pendant to *Representations of Revolution* rather as Richard Wilson painted one close-up landscape and balanced it with a panorama in which it finds its place. Both books can be subsumed under the general category of the representation of revolution in one or another of its forms. One of the first things to notice about a revolution is its reliance on natural metaphors of storms, earthquakes, and erupting volcanoes. Burke's sublime, of course, points toward landscape as well as the French Revolution; and in this sense *Representations of Revolution* leads logically and naturally into landscape painting as *the* artistic equivalent of the political upheaval—and in particular as an area in which the representation of revolution and the activity of the revolutionary artist can be discussed together.

New Haven
November 1981

CHAPTER 1 ❧
INTRODUCTION: THE FRENCH REVOLUTION AND THE NEOCLASSICAL STYLE

Jan. 21 [1793]. Thrush sings, the song-thrush: the missle-thrush has not been heard. On this day Louis 16th late king of France was beheaded at Paris, & his body flung into a deep grave without any coffin, or funeral service performed.

Jan. 28. Bees come out, & gather on the snowdrops.

Feb. 1. The Republic of France declares war against England & Holland.

Feb. 3. A strong gust in the night blew down the rain-gage, which, by the appearance in the tubs, must have contained a considerable quantity of water.[1]

In this passage from his journal the English naturalist Gilbert White relates with supreme detachment the violent revolution of a nation's government to "a strong gust in the night" and to the usual process of the seasons. Though the king of France is beheaded, the thrush, bees, and springtime return as usual, reflecting the cycle of the seasons and the old (but not forgotten) sense of the word *revolution* itself as a 360, not a 180, degree rotation. Among other things, White is attempting to assimilate the revolution to what he knows and understands. He is relating to natural cycles a "revolution" that had brought about irreversible change.

The problem to be explored is: How does a writer or artist represent something he believes to be unprecedented—hitherto unknown and unexperienced? I have chosen the French Revolution because it was a phenomenon many believed to be outside their experience and accustomed vocabulary—as Burke put it, "all circumstances taken together, the most

1. *Journals*, ed. Walter Johnson (London, 1931), p. 422.

1

astonishing [thing] that has hitherto happened in the world."[2] The French Revolution was the first, the paradigmatic "great" revolution (as opposed to uprisings, mutinies, and coups d'états) in which "the people" employed violence in order to change virtually every substructure of the social system.[3] The French Revolution "created the awareness of revolution," after which "we find a conscious development of revolutionary doctrines in anticipation of revolutions to come."[4] If the French example made revolution possible—even desirable—it also, from the events of 1788 onward and at each new stage, served to convince many people that *anything* was now possible. As Tocqueville said, looking back: "It created the politics of the *impossible*, turned madness into a theory, and blind audacity into a cult."[5]

Hannah Arendt's definition of revolution written in 1965 was still based on the French model:

> only where *change* occurs in the sense of a *new beginning*, where *violence* is used to constitute an *altogether different* form of government, to bring about the formation of a *new* body politic, where the *liberation* from oppression aims at least at the constitution of *freedom* we can speak of revolution.[6]

I have emphasized the important descriptive words: *change* and a *new beginning*, *violence* and an *altogether different* form of government, and the idea of *liberation* leading to *freedom* (breaking away from, among other things, oppression). Another contemporary definition bears even more closely upon the French Revolution:

> The political essence of revolution is the rapid expansion of political consciousness and the rapid mobilization of new groups into politics at a speed which makes it impossible for existing political institutions to assimilate them. Revo-

2. Burke, *Reflections on the Revolution in France* (1790), ed. William B. Todd (New York, 1959), p. 9.

3. See Chalmers Johnson, *Revolution and the Social System* (Stanford, 1964), pp. 45–46: "The people employ violence to change the systems of landholding, taxation, choice of occupation, integrative myth, education, prestige symbols, military organization, and virtually every other substructure of the social system." For "great revolution" as a type, see George S. Pettee, *The Process of Revolution* (New York, 1938), p. xi.

4. Samuel P. Huntington, "Modernization by Revolution," in *Revolution and Political Change*, ed. Claude E. Welch, Jr., and Mavis Bunker Taintor (North Scituate, Mass., and Belmont, Calif., 1972), p. 23; Pettee, *Process of Revolution*, p. 96.

5. Alexis de Tocqueville, a fragment of MS from the 1850s, in J. P. Mayer, ed., *Oeuvres complètes* (Paris, 1951–), 2, pt. 2, 255; trans. R. R. Palmer, *The Age of Democratic Revolution* (Princeton, 1959, 1964), 2, 130.

6. Hannah Arendt, *On Revolution* (New York, 1965), p. 28 (italics added). Cf. Crane Brinton's definition of revolution as "drastic, sudden substitution of one group in charge of the running of a territorial political entity by another group hitherto not running that government"—which must not be by election or general consent but by some form of violence, and by a small elite (*The Anatomy of Revolution* [New York, 1965 ed.], p. 4).

lution is the extreme case of the explosion of political participation. Without this explosion there is no revolution.[7]

In these terms, the French Revolution was the crucial historical event that led Western civilization, we are told, "to reorient itself from the 'higher' to the 'lower' classes and faculties of man"—that is, from the polite precepts of the upper classes to the instincts of the sub- and countercultures, from "reasoned assessment of an objective world toward spontaneous expression of the subjective."[8]

Here we touch on one of the paradoxes of the Revolution. It can be seen, as James H. Billington sees it, as a deeply irrational phenomenon.[9] And yet the revolutionaries saw themselves as directed by reason and the a priori assumptions that alone permit men to formulate a change for the better in a society based, as Burke believed, on irrational and unapproachable foundations of custom and sensibility.[10] Thinkers, philosophes, and in particular Voltaire and Rousseau were assigned much of the responsibility for the eruption of revolution. But this villainy itself was one of the literary fictions developed by Burke the artist (later by the Abbé Barruel, and later still by Billington), who produced an early representation of the Revolution that, as Joel Barlow argued, "paints ideal murders, that they may be avenged by the reality of a wide extended slaughter," until at length "the war of Mr. Burke was let loose, with all the horrors he intended to incite."[11] Burke would have denied this, but he wrote in an undeniably prophetic strain, and one thing he and many other writers and artists discovered, along with "the feasibility of altering the human condition by political action," was the feasibility now of altering political action by the action of art. Barlow, who knew about both American and French revolutions, referred (speaking, as it happens, about his fellow countryman, the painter Benjamin West) to "the revolution that has been brought about in the whole of the art [of painting] within the last thirty years by his having broke thro' the ancient

7. Huntington, "Modernization by Revolution," p. 23.

8. Conrad L. Donakowski, *A Muse for the Masses: Ritual and Music in an Age of Democratic Revolution, 1770–1870* (Chicago, 1977), p. 2.

9. *Fire in the Minds of Men: Origins of the Revolutionary Faith* (New York, 1980).

10. See Paul A. Robinson, *The Sexual Radicals: Wilhelm Reich, Geza Roheim, Herbert Marcuse* (London, 1970), pp. 138–39: "Conservatism depends for its survival on the denial of abstraction, just as radicalism relies heavily on the legitimacy of categorical statement. This is as true of Edmund Burke's critique of the universalism of the *philosophes* as it is of the historicist's opposition to the universal history of the Hegelians. The established order can be defined only if it is exempted from the structures of abstract rationality and from comparison with normative conceptions of human health or the good society."

11. Barlow, *The Conspiracy* (1793), quoted in Isaac Kramnick, ed. *Edmund Burke* (Englewood Cliffs, N.J., 1974), p. 126. See Peter Hughes, "Originality and Allusion in the Writings of Edmund Burke," *Centrum*, 4 (1976), 33.

shackles and modernized the art." [12] By this time artists were being given credit for their own metaphorical revolutions that drew strength from the political, but with West at least (or with Jacques Louis David in France) the style was rational in the extreme, described by a very different sort of "revolutionary" artist, the politically conservative John Constable, as "stern and heartless petrifactions of men and women—with trees, rocks, tables, and chairs, all equally bound to the ground by a relentless outline. . . ." [13]

My subject, artistic representation, is not the same as the reaction or response of individuals to the French Revolution, a subject thoroughly examined by R. R. Palmer in his indispensable volumes *The Age of Democratic Revolution*. [14] Rather I am exploring the problem of representing the phenomenon in words and images (the "figuration" of revolution could as well have been my title) by some major writers and artists whose responses were pro, con, or ambivalent.

Because of its apparent uniqueness, the French Revolution is an example of representation that to an unusual degree privileges the historical referent. Something happened in France in the 1790s that was called a "revolution," a word (in its new sense) denoting an overturning or overthrowing of an established government. The word (or metaphor) *revolution* then took on the associations of this particular historical series of events. The fall of the Bastille, the Terror, 9 Thermidor, and 18 Brumaire all became stages in a scenario which for Lenin and Trotsky as well as Hannah Arendt was called "revolution." We cannot say that the French Revolution was either a figment of imagination or a conventional symbol; to a large extent it *created* the paradigm of revolution. And so it tests our basic assumption that an unprecedented phenomenon can be defined only in terms of the known, in terms of models already at hand. An experience hitherto unknown is inevitably assimilated by analogy to areas of experience felt to be already understood, but the movement toward the familiar is contested by a less predictable movement from the familiar to the unfamiliar in which the figurative elements are modified by confrontation with the historical referent as well as with each other.

The referent, the actual French Revolution, was a situation in which historical actions were reported and known and had their effect on the emergent models and metaphors. But we are also dealing with poetic language and images that are self-generating in that they make little or no claim on

12. Yvon Bizardel, *American Painters in Paris* (New York, 1960), p. 77. See also Friedrich Heer, *Europe, Mother of Revolutions*, trans. Charles Kessler and Jennetta Adcock (New York, 1964), p. 36. Referring to "the greatness of all politically engaged writers," he also argues that "Revolution and the arts have always been closely connected, and in particular, revolution and literature" (p. 6).

13. *John Constable's Discourses*, ed. R. B. Beckett (Ipswich, 1970), p. 60.

14. See above, n. 5.

the real world of what actually happened in the phenomenon called the French Revolution. For example, the referent *French Revolution* might have a signified of *liberation* or of *violence* or of *terror*, and for each of these then various signifiers were automatically supplied: perhaps from nature—sunrise or hurricane; or from myth—Pandora's box or Saturn devouring his children. Once Edmund Burke's "French Revolution" itself had become a referent, for which the revolutionaries and counterrevolutionaries found their own signifiers and signifieds, we reach a point where literature and the process of "making" have taken over, only to be "matched" (to use E. H. Gombrich's terms) from time to time against historical events.[15] For of their very nature poetic language and images are complex, indefinite, and alogical, in contrast to the scientific language of the modern historian, which tries to be simple, definite, and logical and thereby becomes as "poetic" as the language of the contemporary historians of the Revolution, Chateaubriand, Dolphus, and Smyth. And so referentially what has to be taken into consideration is not (except for purposes of difference) what actually happened but what was thought to have happened, as reported in available sources—what served as referent and as analogue for the writer or painter, and the concepts and abstractions to which he had access and for which he sought equivalents.

There is obviously a sense in which images as well as words do not *represent* anything but serve only as counters for their users. As Wittgenstein's maxim "Don't ask for the meaning, ask for the Use" suggests, writers and artists do not use words and images to name a thing so much as to persuade to some end. What they *do* with their words and images is more important than what they represent with them.

But the scholar also attempts when possible to supply the writer's own latent content to the manifest one of his image—as we discern what (for example) Burke says as a public man, what he says at a deeper level of personality and intention, and what, seen through a Freudian or Marxist grid, he did not *mean* to say. For it is quite possible that the represented matter of the Revolution was only the particular "bricolage"—whatever was at hand at the moment—for the author or writer who wanted to talk about *something else*. Burke may have used the French Revolution to talk about matters much more private (Conor Cruise O'Brien thinks he was talking about Ireland, Isaac Kramnick about himself).[16]

This study is not, I repeat, about politics or even history but about art

15. See *Art and Illusion* (New York, 1960).

16. O'Brien, introduction, Burke, *Reflections on the Revolution in France* (Penguin ed., 1968); Kramnick, *The Rage of Edmund Burke* (New York, 1977). See Edward Wasiolek, "Wanted: A New Contextualism," *Critical Enquiry*, 1 (1975), 634; also pp. 628–29.

and representation.[17] It is, however, about human beings in a human situa-
tion. Incidentally revealed is what people thought the French Revolution
was, said it was, and above all made it out to mean; that is, how people
came to understand, assimilate, or make bearable (or usable) so astonishing
and agonizing an experience in which exhilaration turned to "Terror" and
terror to its chronic form of dread.

The special focus of this study, however, is the relationship of style to
subject matter. The question, as I meditated on it over the last several years,
was which category, the aesthetic or the political-historical, oversimplifies
the material less. Which is the more historically viable term for dealing with
the art, for example, of Blake or Goya? The whole subject of the represen-
tation of revolution, or even of the French Revolution in particular, is im-
possibly large. There are aspects, as well as whole geographical areas such
as Germany or Italy, that I have not approached and am probably incapable
of describing adequately. It has seemed best to subsume revolution under
the styles used to imitate it and to limit the area of coverage to a handful of
major works of art that can be said to reflect the revolutionary experience.

My assumption is that various new styles emerged in conjunction with
the Revolution. These styles all predated the Revolution but were adapted
by writers and artists as ways of expressing or responding to it. The French
themselves adapted a neoclassical style, seeing themselves as heroic Romans
of the Republic, but the style had already been fully developed before the
fall of the Bastille. The young Brissot and Robespierre saw themselves as
Romans and Greeks, and Jacques-Louis David's painting *The Oath of the
Horatii* was exhibited in 1785, his *Death of Socrates* in 1787, and his *Lictors
returning to Brutus the Bodies of his Sons* was already finished when the events
of July 1789 imbued it with a revolutionary significance at the Salon in
August.

Foreigners saw the Revolution as inexplicable. In attempting to find an
equivalent for the unexampled phenomenon across the channel they re-
sorted to aesthetic categories: beautiful, sublime, and grotesque. The beau-

17. I do not mean to involve myself in the philosophical, technical senses of *representation*
explored by Richard Wollheim, Nelson Goodman, and others. Further, my scope is not any-
thing like that of Howard Mumford Jones in *Revolution and Romanticism* (Cambridge, Mass.,
1974), which surveys in a very general way all aspects of the period and all countries, for
example connecting the meditations on death we know as the Graveyard School with the
Reign of Terror (p. 97). The single essay that most completely covers the literary subject is
M. H. Abrams's "English Romanticism: The Spirit of the Age," in *Romanticism Reconsidered*,
ed. Northrop Frye (English Institute Essays: New York, 1963), pp. 26–72; this material was
later reworked and diffused in *Natural Supernaturalism* (New York, 1971). Another study I have
found valuable is Herbert Lindenberger's *Historical Drama: The Relation of Literature and Reality*
(Chicago, 1975). Lindenberger deals with the question of how a playwright represents a his-
torical action: through conventions and stereotypes such as conspiracy, tyrant, and martyr
plots.

tiful, an equivalent that was also encouraged by the French, inevitably suggested a return to a former, pastoral time, a Golden Age or an Eden. The other two conveyed the complexities and ambivalences of the experience—whether seen at the moment (as by Burke) or in retrospect (as by Wordsworth). In both cases there were technical contemporary meanings of these terms: the sublime from Burke's *Philosophical Enquiry into the Origins of our Ideas of the Sublime and Beautiful* of 1757 and the grotesque from the growing interest in various forms of grotesque art (drole, caricature, and kermesse) and from the standard discussions of grotesque design in the art treatises that labeled it either unnatural or liberating, but certainly appropriate to represent the sort of *lusus naturae* that was the French Revolution.

Most important, perhaps, these aesthetic categories resolved themselves into various types of progression, and the French Revolution was, above all else (after its initial burst of light and heat), a questionable sequence of events. It was the sequence from the fall of the Bastille to the Terror and then to the Directory and Napoleon, the Empire, and Waterloo that characterized the puzzle of the Revolution. It was also the sequence from a sense of *liberty* as freedom from oppression to freedom to do whatever you want, and from *liberty* to Equality to Fraternity, and so on.

The sublime and the beautiful, as argued out by Burke and Paine, were not just opposing categories; they became in Wordsworth's *Prelude* and Keats's *Hyperion* (not to mention Shelley's *Revolt of Islam* and Mary Shelley's *Frankenstein*) a sequence: not just the great natural upheaval versus the quiet sunlit meadow or the island in a stormy sea but the progression to be desired or demanded or regretted from one of these to the other. In which direction the progression moved demonstrated the politics and personal interpretation of the spectator.

From the picturesque (a third aesthetic category introduced toward the end of the century in England to bridge the gap between sublime and beautiful) to the grotesque was a similar progression—or, for that matter, from the sublime to the grotesque. The picturesque was an aesthetic of surprising juxtapositions; the grotesque an aesthetic of eliding difference. The latter, we shall see, was a perfect revolutionary paradigm in that, based on the decorative patterns of metamorphosing plant–human forms, it showed either the human emerging triumphantly from nature or the human subsiding or regressing into nature—or ambiguously doing both. Similar transitions or sequences involve the movement from dark to light, but as the grotesque is all in all the dominant aesthetic mode of the period the movement tends to be cyclic and repetitive, toward undifferentiation. It is cyclic when Blake's Orc overthrows and then becomes Urizen, but in various ways the two are indistinguishable from the start. The cartoonist Gillray's George III, John Bull, and Louis XVI all merge into the same figure.

This book is therefore about revolution as something that subsumed—or

adapted—certain aesthetic categories and types of progression. But it is also about the relationship between these aesthetic categories and the psychological categories to which they may refer. For if we can clear away all the detail, all the ambivalences of the witnesses, we see—I believe—two basic interpretations of the phenomenon of revolution in this period, or perhaps in any period. One is oedipal and the other is oral–anal. In one the son kills, devours, and internalizes the father, becoming himself the authority figure, producing a rational sequence of events, although a sequence that might be regarded unsympathetically as prerational. In the other the revolution is seen—in practice, in the very midst of it—as merely a regression to earlier stages of being, an ingestion that produces narcissism rather than an internalized paternal authority. In one the effect is sublime or a progression (as in Wordsworth's *Prelude* or Keats's *Hyperion*) from sublime to beautiful, in the other grotesque, moving toward the undifferentiation of tyrant and oppressed.

If we add to the various meanings of representation Freud's sense, we have a process that is of its very nature regressive, returning to the memory of primal scenes. Both oedipal and oral–anal representations are in Freud's terms stages of regression, the latter being only an earlier, more primitive stage. A fundamental question then is whether revolution always summons up one or the other of these situations. Does it appear to be oedipal because it *is* always an oedipal conflict or because we tend to "represent" it in the Freudian sense of regressing to such scenes for equivalents?

If I introduce Freud's "representation," then with it comes the other process of recreation, which he called "symbolization." If representation is "the regression beyond memory images to the hallucinatory revival of perception," a primal scene of seduction, which may or may not be an actual, historical scene, then symbolization is a substitute for this traumatic scene the memory of which has been repressed.[18] It consists of cultural stereotypes—for "revolution," the images of natural change (hurricanes, volcanic eruptions, or conflagrations) or of myth (Pandora's box or Prometheus's theft).

In other words, if representation is accomplished through regression, symbolization requires no such explanation because "the work has already been done elsewhere." That is to say, in Paul Ricoeur's words, the dreamer "has merely utilized, as in the use of a common expression, symbolic fragments that have fallen to the sphere of the trodden commonplace, phantoms that he has momentarily brought to life."[19] This is simply the distinction

18. See Paul Ricoeur, *Freud & Philosophy: An Essay on Interpretation*, trans. Denis Savage (New Haven, 1970), pp. 95, 97, and Freud, *The Complete Psychological Works: Standard Edition*, trans. and ed. James Strachey (London, 1966–74), 5, 349, 543.

19. Ricoeur, *Freud & Philosophy*, p. 101.

between the ordinary use of symbols-at-hand such as volcanic eruption or Prometheus's theft, and the more complex process (parallel but perhaps also resorting for means of expression to "commonplace" materials) of "regression" or displacement of the actual revolutionary perception onto something else, more or less important to the person—either a real perception or a fantasy. The search (necessarily speculative) for the basis of representation will be the primary aim of this study, though obviously it is impossible to separate representation and symbolization in any clear way.

While I doubt that one needs any longer to justify the use of Freudian categories in eighteenth–century Europe, let me note that not I but Burke, Paine, not to mention Goya, are the ones who employ the categories of experience which Freud later named. There is no inconsistency in arguing that a scientifically valid theory of modern behavior might (even should) be applied historically as a hypothesis to respect the otherness of historical events and works created in the past. But we might strengthen the double status of the psychohistorical method by a glance at contemporary commentators on the French Revolution.

I am thinking in particular of Novalis, whose description of Burke's *Reflections on the Revolution in France* as "ein revolutionäres Buch gegen die Revolution" is followed in the very next of his *Vermischte Bemerkungen* (of 1797–98) by a psychoerotic interpretation of the phenomenon. He notes that run-of-the-mill opponents of the French Revolution symbolize their opposition in the traditional metaphors of medical pathology applied to politics, speaking of it as a fatal and contagious disease or, less desperately, as a minor or local infection. Novalis is quite right: the polemics of the time bristle with distinctions between the "sana" and the "insana" members or parts of the body politic. It was the opponents of genius, Novalis tells us (clearly recalling Burke), who went much further with the image. They "urged castration—they well saw that this alleged illness was nothing other than the crisis of the onset of puberty."[20] A more measured parallel can be found in Kant's *Was ist Aufklärung?* (1783), in which Enlightenment is not represented through the traditional figure of light dispelling darkness but rather of the emancipation achieved by a minor on coming of age.[21]

This kind of evidence is cited because it may serve at the outset to strengthen my argument and stave off the charge of anachronism that Freudian interpretations have been known to provoke. Indeed, since the tendency of my

20. " . . . die genievollsten Gegner drangen auf Kastration—sie merkten wohl—dass diese angebliche Krankheit nichts, als die Krise der eintretenden Pubertät sei" (see *Novalis Werke*, ed. Gerhard Schulz [Munich, n.d.], 2, 350). This is no. 116. See also the "Politische Aphorismen" (1798), nos. 58 and 59, in ibid., 2, 370.

21. "Aufklärung ist der Ausgang des Menschen aus seiner selbst verschuldeten Unmündigkeit. Unmündigkeit ist das Unvermögen, sich seines Verstandes ohne Leitung eines anderen zu bedienen" (*Was ist Aufklärung* [Göttingen, 1967], p. 55).

argument is to historicize, to graft onto a cultural and political context the representation and symbolization that Freudians tend to treat as mythological or private (e.g., Goya's Saturn or Blake's Tiger), I might recall that Freud's original theory accepted as true the accusations of incestuous rape or seduction in childhood made against parents, guardians, and nurses by patients he was treating for hysteria. Freud concluded that these events had actually occurred, that they were part of the order of historical events rather than of fantasy. He later shifted his account from history to fantasy, but the evidence of my study of revolution may suggest that Freud's first theory was closer to the truth.

THE SELF-PORTRAIT OF REVOLUTION

It is necessary to distinguish in general terms between the Revolution as it was to the French and as it was to the outside world, that is, between (in R. R. Palmer's words) the "relatively practical terms of rational politics and the needs of war" and "the ballooning up of the Revolution into a vast, fearsome, perpetual, gigantic and all-consuming force"—an image that was "the work in part of counter-revolutionaries who wished to discredit the real aims of the French Revolution, in part of romantic philosophers, and in part of rebellious spirits in those countries, like Germany, where real revolution had had the least effect."[22]

I do not intend more than a glance at the art produced *by* the French Revolution, from David's *Brutus* onward. I am interested primarily in the representation of the fact or phenomenon of revolution as seen from a little distance, from a counterrevolutionary situation. In France David, the actual revolutionary, was too close to the phenomenon, immersed in day-to-day problems of selling it, emphasizing its roots and continuity, to represent it with the degree of admiring or horrified detachment of a Burke or a Blake. But even here we have to distinguish the great festivals David planned, in which he presented the stereotyped, quite eclectic imagery of the Revolution (some of which derived from the iconography of his own paintings), from the history paintings executed just prior to the outbreak of the Revolution and from time to time thereafter. It was David who authoritatively fixed the analogy of republican Rome in his paintings of the 1780s, and above all in his *Brutus*, shown at the Salon in August 1789 alongside reportorial representations of the demolition of the Bastille and portraits of the historical protagonists. Karl Marx's words at the beginning of *The 18th Brumaire of Louis Bonaparte* (1852) remain the classic summation of how the French revolutionaries represented, officially at least, their revolution: They "performed the task of their times in Roman costume and with Roman

22. *Age of Democratic Revolution*, 1, 12.

phrases" to conceal their bourgeois motives—to conceal the reality of class
and economic forces that underlay this "make-believe world of paper slo-
gans and ideological foam." [23]

David was simply the artist who produced the definitive version of the
neoclassical style, fusing, as Diane M. Kelder has said, "the moralistic and
antiquarian into a powerful political broadside." [24] Simplicity was an impor-
tant element of David's style, but he also joined the aesthetic doctrines of
Winckelmann, Caylus, la Font de Saint-Yenne, and the Abbé Batteaux with
the contemporary views of the philosophes. In many cases they were iden-
tical from the start. Caylus, for example, was advocate of both a neoclassi-
cal style and political and social reform. He believed in the simple outline,
clear and descriptive drapery, and relief-like solidity of forms at the same
time that he believed in the principles of the *Encyclopédie*. On the other
hand, as Kelder concludes from her study of art in the French Revolution,
neoclassicism "was so involved with principles borrowed from contempo-
rary philosophy that the collapse of these principles in the social and polit-
ical realm [in the 1790s] robbed the style of that which had constituted its
religious content." Or, in Anita Brookner's words, "Only David, after a
very long struggle, managed a single moment of coalition between classical
form and analogous appropriate subject-matter," and these were "neoclass-
ical forms, which were soon to distintegrate under the weight of their con-
tent," that is, of historical fact. [25]

And yet David could paint in 1788, at the same time as the *Socrates* and
Brutus, a *Paris and Helen* in the same style for the king's brother the Comte
d'Artois. Reason and order were equally applied to the story of Brutus and
to the love of Paris and Helen. The fit seemed only more perfect, as well as
more expedient, when the reason and order were applied to the creation of
a new (or recreation of an old) society. It is true that partly and some of the
time the "Roman shape" contributed to the official portrait of revolution.
Many of the leaders had been brought up on Cicero's orations, Sallust's
Conspiracy of Catiline, Livy's first three books, Tacitus's *Agricola*, *Histories*,
and *Annals*, and Plutarch's *Lives*. [26] But each story could be used in contrary

23. *18th Brumaire of Louis Bonaparte* (ed. New York, 1963), p. 16. As Lindenberger says,
such poses are to be expected "because in revolutions, as in other tense political situations,
persons do not communicate their most intimate selves but resort to theatrical gestures and the
more ostentatious forms of rhetoric to achieve their ends. The writer who desires to face his
materials honestly is forced to note the discrepancies between a character's political and au-
thentic self, or between an 'official' and a 'real' view of a political event" (*Historical Drama*, p.
27).

24. *Aspects of 'Official' Painting and Philosophic Art 1789–1799* (Ph.D. diss., Bryn Mawr,
publ. Garland Press facsimile, 1976), p. 62.

25. Kelder, introduction, unpaginated; Brookner, *Jacques-Louis David* (New York, 1980),
pp. 29, 82.

26. Harold T. Parker, *The Cult of Antiquity and the French Revolutionaries: A Study in the
Development of the Revolutionary Spirit* (Chicago, 1937); and also Stanley Loomis, *Paris in the*

ways, by monarchists as well as subversives, by Girondins as well as Jacob-
ins, and while the revolutionaries were trying to valorize their day-to-day
actions, the emigrés were identifying them with the vices, licentiousness,
anarchy, and despotism on the other side of the Greco-Roman coin.

Moreover, it had been argued long before the Revolution's outbreak that
the situation of ancient Greece and Rome could *not* apply to so gigantic and
complex a country as France. It was essential that, among other things, the
Greco-Roman model be augmented by the modern model of the historical
revolution in America, which had already taken on the costume of the an-
cient Republicans and whose heroes had assumed the mantles of Cincinna-
tus and Cato.[27] The French of 1789 knew Patrick Henry's "Give me liberty
or give me death," which echoed the cry of Cato in Joseph Addison's play,
"Gods, can a Roman senate long debate / Which of the two to choose,
slavery or death!" They knew Nathan Hale's dying words, "I only regret
that I have but one life to give for my country," as a far more immediate
and poignant cry than Cato's "What pity is it / That we can die but once to
serve our country."[28]

The classical model was modified as well as justified by the success of the
American Revolution and the American experiment in government. By the
mid-1780s Brissot, the future leader of the Girondins, was writing: "You
believe you honor the Americans greatly by having them resemble the Ro-
mans and the Greeks; but I think them greatly *superior* to these ancients."
Then he adds of the French, that "the men of today, far from being degen-
erate, will be capable of surpassing their ancestors when the circumstances
are favorable. . . ."[29] At the outset, the ancient model was set in a tension
with the uniquely particular powers and circumstances of contemporary
France.

Terror (London, 1970), p. 47. I am indebted to Parker for the remarks on the Roman shape that
follow. Before the Revolution Robespierre read in Plutarch how in republican antiquity "the
careers leading to glory and to office were always open to talent," and Brissot wrote in 1781:
"The political constitution of Rome was very different from ours, and it was much better" for
it was a state where, "in order to be first, it was necessary only to be first in merit" (Robes-
pierre, *Oeuvres complètes*, ed. E. Keseur [Paris, 1913], 1, 24; Brissot, *Un independent à l'ordre des
avocats* [Paris, 1781], pp. 47, 48). Men as different as Robespierre, Marat, and Brissot all felt
blocked in a France in which many careers were closed to talent, and they read of precedents
for their rise in Plutarch's Greece long before the Revolution broke.

27. For the representation of the American Revolution, see Paulson, "John Trumbull and
the Representation of the American Revolution," *Studies in Romanticism*, 21 (1982); for the
French use of the American Revolution, see Palmer, *Age of Revolution*, 1, 260–63, 270–71.

28. *Cato* (1710), 2. i, 4. iv. See Kenneth Silverman, *A Cultural History of the American Revo-
lution* (New York, 1976), pp. 83, 643n.

29. Brissot, *Examen de Chatellux* (London, 1786), pp. 106–08. For example, the "natural
and sacred equality of the Americans," he says, was unknown to the Romans. The actual
American Revolution took the classical ideal out of the past and gave it a contemporary rele-
vance and chance of fulfillment.

What men saw in the Greco-Roman model changed with events—with time, place, and men—from Roman republican law to Athenian liberty to Spartan egalitarianism, asceticism, and courage. By 1793 the question fought out in speeches of the National Convention and in pamphlets was whether the proper, the appropriate model was, or should be, Athens, Solon, and the ideal of liberty but marred by disorder or Sparta, Lycurgus, and equality but accompanied by tyranny. The arguments included allusions to the fickle Athenian crowd on one side and to the regimented army of the Spartans on the other.

The historical referent itself, far more suggestive as an image but less controllable, consisted of the specific events of the fall of the Bastille, the flight of the royal family to Varennes, the Brunswick Proclamation, and the invasion of foreign troops. In this context we hear Robespierre's words: "The theory of revolutionary government is as new as the revolution that has produced it. It cannot be found in the books of political writers, by whom this revolution was not foreseen. . . ."[30] He was speaking in 1793 in the radical phase, when it was no longer possible to assimilate the Revolution to the past (e.g., to restore the old order that had been impaired by the abuses of recent monarchs). His images now are of the storming of the Tuilleries Palace, the trial and beheading of the king, and the trial and beheading of fellow revolutionaries.

Saint-Just's words "Liberty that prevails must become corrupt: I have said all"[31] sum up a great deal of what was learned from the experience of the Revolution: that, in Hannah Arendt's terms, liberation may not lead to freedom; men are only virtuous at the moment of their revolt and thereafter to be virtuous they must be governed by laws as rigorous as the ones they overthrew. This hard concept projected by Saint-Just could be dealt with only by being cloaked in images of Athens and Sparta. Long before the Terror the losers had begun to come to terms with their personal fates by creating their own mythologies. As they waited for the guillotine or fled into exile, they saw themselves as Socrates with his hemlock—or Phocion, or, slipping into nonclassical models, the English Republicans Sidney and Russell, martyrs to their political faith who could look forward to a vindication by history.

Day-to-day actions were therefore understood in terms of analogues or fictions which related to the shifting policies (foreign and domestic) of the government of the moment, or of different factions, as (in Jacques Ellul's

30. Robespierre, "Rapport sur les principes du gouvernement révolutionnaire, 5—nivôse An II, 25 décembre 1793," in C. Vellay, *Discours et rapports de Robespierre* (Paris, 1908), p. 311.

31. I have not appended references for the proverbial tags of the Revolution except in the case of words that were to have repercussions of particular interest for this study (see below n. 54).

sense) propaganda of agitation or of integration.[32] During the phase of integration the connections with the past were emphasized as an urge to conformity, to stabilize, unify, and reinforce the new order (or, in Saint-Just's terms, law), and to put a good face on the new government for the outside world. The Roman costumes were largely used in this phase, although the bloodier stories of Lucretia and the Horatii and Brutus and his sons supported the subversive phase, when the utmost "liberty" was required, and made a virtue, at the moment of overthrow. Propaganda as agitation, however, was used not only to subvert and overthrow but also to pursue a revolutionary course of action once the revolution was installed in power. It aimed at counteracting the resistance of a segment or class within the society, or it aimed at urging the populace simultaneously to physical action and a radical change in their behavior.

The imagery resorted to in the phase of continuing agitation was eclectic. In David's *Triomphe du peuple français*, designed in 1793 for the curtain of the Opera, the Roman matron Cornelia and her children (her "jewels") are shown alongside Brutus holding the edict that results in the death of his sons, but also present are William Tell and his son, who carries the arrow and split apple, and the revolutionary "martyrs" Marat, Lepeletier, and the rest, each carrying the attribute of his martyrdom—the wound of an assassin's dagger, the suicide's rope, the vial of poison, and even the blade of the guillotine.[33] The most brilliant case of the assimilation of Christian symbolism to the classical cult of great men was David's rendering of Marat, murdered in his bath, to resemble Christ in a pietà.[34] For if the Roman model supported the secularizing process of the Revolution, the pietà served David not only as a moribund form to express (and be enlivened by) a real contemporary event but also as an image which could draw upon feelings unavailable in the most intense Roman allusion. Christian symbolism was the only available form known to large numbers of the poor and illiterate. By using it David was stressing the continuity with old forms, however outmoded, and with the past itself, while at the same time inventing a totally new significance to replace the old, the *ancien* one: a Marat, a *true*

32. See Ellul, *Propaganda: The Formation of Men's Attitudes*, trans. Konrad Kellen and Jean Lerner (New York, 1972).

33. See James A. Leith, *The Idea of Art as Propaganda in France* (Toronto, 1965), and *Media and Revolution: Moulding a New Citizenry in France during the Terror* (Toronto, 1968), esp. pp. 43–52. For the mood in Paris in 1789 expressed in popular songs, see Cornwell Rogers, *The Spirit of Revolution in 1789* (Princeton, 1949), and also Ernest F. Henderson, *Symbol and Satire in the French Revolution* (New York and London, 1912). See also E. H. Gombrich, "The Dream of Reason: Symbolism of the French Revolution," *British Journal for Eighteenth-Century Studies*, 2 (1979), 187–205.

34. Robert Rosenblum, *Transformations in Late Eighteenth-Century Art* (Princeton, 1967), p. 83.

national martyr (a martyr of the 1790s), to replace the fictitious and remote ones of the saints' calendar.

In terms of art the process involved two stages: destroy the old image and replace it with a new. As the journal *Révolutions de Paris* said in September 1789: "We should speak to the people of their glory by means of a public monument, for we must never forget in this revolution the powerful language of symbols." But if it "is objected that such a statue is too costly," the *Révolutions de Paris* recommends that the people take the bronze from statues of kings or religious images and "from the debris . . . we may raise one to the defenders of the fatherland."[35] The process was even more clearly stated at a Jacobin Club meeting:

> Destroy these signs of slavery and idolatry [in Christian and royal art] which only serve to perpetuate ignorance and superstition. Replace them with images of Rousseau, Franklin and all the other great men, ancient and modern, which will fill the people with a noble enthusiasm for liberty.[36]

As in Russia after the October Revolution, the cult of kings and saints was replaced by the cult of merely "great men." But the form art takes is the row of icons: Lenin becomes a secular Christ and the Politburo his apostles. Of course, the great action of the great man had been the subject of the Greco-Roman paintings of the 1790s. But the obvious collapse of neoclassical order and the ambiguous deaths of revolutionaries in the 1790s (by assassination, by execution, by suicide) changed the emphasis to a less rational neo-Christian iconography. Not only was Marat a Christ but the Committee of Public Safety was a revolutionary apostolate of twelve.[37]

In terms of language, revolution makes words mean something else. "So revolutions broke out in city after city," Thucydides wrote in a famous passage. " . . . To fit in with the change of events, words, too, had to change their usual meanings." As Burke wrote: "Things are never called by their common names. Massacre is sometimes *agitation*, sometimes *effervescence*, sometimes *excess*; sometimes too continued an exercise of a *revolutionary power*."[38] At the simplest this was a process of substitution. The revolutionary Convention began the attempt on 5 October 1793 by establishing a new calendar with Year One, from the creation of the Republic (followed by the execution of the king), beginning 22 September 1792. The old cal-

35. S. J. Idzerda, "Iconoclasm during the French Revolution," *American Historical Review*, 60 (1954), p. 14.

36. From a diary of Jacobin meetings, quoted in Albert Mathiez, *Les origines des cultes révolutionarires* (Paris, 1904), p. 112.

37. On representing the Mexican and Russian revolutions, see Paulson, "Representations of Revolution," *Bennington Review*, no. 2 (1978), 62–74.

38. Thucydides, *Peloponnesian War*, trans. Rex Warner (London, 1954), pt. III, ch. vi; Burke, "Preface to the Address of M. Brissot" (1794), in *Works*, 3, 521.

endar had imprisoned the public consciousness within the confines of the Christian tradition, in which Sunday meant going to church and Friday fasting, and the innumerable saints' days served as models of piety. Time itself was trapped in the religious cycle of Lent and Easter, Advent and Christmas, and the whole calendar of years began arbitrarily with the birth of Christ. The calendar (of saints and martyrs) was recreated from a secular point of origin, a rebirth or redemption or some other term that repudiated its religious connotations.

The principle of substitution was to be "Nature" and not the imposed assumptions of a religion or a tradition-enshrined social structure. The republican year was divided into four parts to correspond no longer to religious times but to the four seasons, and divided into months named after the characteristics of nature. Whereas the Roman republican "costumes" Marx refers to were always regarded as mere figures of speech or decoration (though such decoration sometimes became real, as in the arguments-to-the-death between Athenians and Spartans in the final speeches of a neo-Socrates or Phocion), the calendar constructed on "natural" divisions was an essential structure of the new state. Sundays and saints' days were replaced by feasts consecrating trees, fruits, and domestic animals.

This was of course a literary "nature," closer to Virgil's pastorals than to anything recognizable as the French countryside. And with the actual course of history the new month names of natural association took on quite different ones: Thermidor became forever the date of Robespierre's fall and the waning of the active revolution; Brumaire the Napoleonic coup d'état which put an end to the revolution and simply moved the time up to the Empire, which historically followed the Republic. "Nature" in the change of street and city names, and in personal names (the nom de guerre), meant a Roman name (Gracchus Babeuf) or the name of a contemporary hero. There were proposals for the "natural," that is, allegorical logic of the new Parisian street names: "Is it not natural that from the Place of the Revolution one should follow the Street of the Constitution to that of Happiness?"[39]

On the visual level, Notre Dame was transformed into the "Temple of Reason" with a pageant in which an actress plays the Goddess of Reason and girls with tricolor sashes play Liberty and the Torch of Truth. In the same way, the dictionary of Ripa's *Iconologia* was replaced with a new vocabulary which included the bonnet (liberty), the cockade (the nation), the pike (weapon of freemen), the club (the popular will), and the fasces (revolutionary solidarity). Venus, the goddess associated with the corrupt aristocracy, was replaced by a Trinity—not of Father, Son, and Holy Ghost but of three women, Liberty (carrying a pike capped with a red bonnet), Equality (carrying a level), and Fraternity (carrying the fasces). These were ac-

39. Billington, *Fire in the Minds*, p. 48 n.152.

companied by other females named Reason, Nature, Truth, Virtue, Probity, Force, and Victory, carrying their own Ripan equivalents or attributes.[40]

Take the example of the flag. You wipe out the fleurs de lis, the armorial bearings, and replace them with simple color relationships, with three equal areas of red, white, and blue: symbolically the colors of Paris enclosing the white of the Bourbons without their symbol (also the same resonant colors of the American flag). Thus emblematic iconography was replaced, its aristocratic associations were eliminated (as Venus was replaced by Reason or Virtue), by pure colors with their own symbolic-emblematic meaning newly assigned.[41]

The most famous case of this kind of transvaluation was the red flag. In the early days of the Revolution a red flag had been used as a sign of martial law, which the gendarmerie displayed as a warning to the assembled civilians that if they did not disperse they would be fired upon. It was employed in this way in 1791 when a republican demonstration was broken up in the "Massacre of the Champs de Mars." Then in July 1792 the Jacobin journalist Carra reversed its meaning by printing on the flag in black letters, "Martial Law of the Sovereign People against Rebellion by the Executive Power," thus making it the flag of revolution.[42]

The favorite areas—nature and abstract virtues—from which the French took their imagery can be seen in the transvaluation of playing cards. In March 1791 the duty on cards was abolished and card makers eradicated all emblems of royalty. The crowns disappeared and the royal fleurs de lis were modified into meaningless ornaments. A pack of 1793 by Jaume and Duguourc of Paris had printed on its wrapper: "Plus de Rois, de Dames, de Valets. Le Génie, La Liberté, L'Égalité les remplacent. La Loi au-dessus d'eux" (No more Kings, Queens, Knaves. Genius, Liberty, Equality take their place. Law is above them). Kings were turned into "Sages" or "Geniuses" or "Elements." The Sages (of Hearts, Spades, Diamonds, and Clubs, respectively) were Solon, Brutus, Cato, and Plato; the Geniuses were War, Commerce/Arts, Navy/Commerce, and Agriculture/Peace; and the elements were Fire, Water, Earth, and Air. The Queens became Virtues (Justice, Force, Prudence, and Union), Liberties (Arts, Press, Commerce, and Religion), and Seasons (sometimes with their classical labels, Ares, Flora, Vesta, and Pomona). The Knaves were Égalités (each marked Égalité, with

40. Leith, *Idea of Art*, p. 108.

41. The tricolor first appeared in July 1789. Other tricolors followed: the Italian (red–green–white) in May 1795, Dutch (red–white–blue in horizontal stripes) in September 1795, the Swiss (red–black–yellow) in 1798—and so on to the present tricolor flags of Ireland, Yugoslavia, Romania, Syria, South Africa, Mexico, and other Latin American countries that maintain a spiritual bond to the French Revolution.

42. Palmer, *Age of Democratic Revolution*, 2, 39, citing A. Mathiez, *Le Dix-août* (Paris, 1931), p. 61.

no additional name), *Graves* (Hannibal, Scaevola, Horatius, and Decius), or *Cultivateurs* (Jardinier, *Vendangeur, Moissonneur, Bûcheron*). In some decks Rousseau appeared as "Sage" of Clubs.[43]

The point is that the French annexed to the unprecedented phenomenon in which they found themselves other phenomena which may or may not have been revolutionary—a kind of *bricolage* based on a few elementary categories. But if the outbreak of the Revolution convinced revolutionaries such as Camille Desmoulins that the French were the equal of the ancient Greeks and Romans and had the right to imitate them, by the end of 1790 many were convinced that they were superior to the ancients, were their own model, creating their own precedents. The Oath of the Horatii, for example, may have created the Oath of the Tennis Court but also was superseded by it. Though images of other oaths continued to appear in the representations of artists (the Oath on the Rütli), the historical fact held its own if it did not overwhelm the model. Its oath was that the National Assembly, when it met again, would not dissolve until it had written a constitution for France. Its own peculiar features transcended any model and created a new one based not on a single patriot or sibling swearing an oath but on a disparate mass of men meeting in a royal tennis court to proclaim their independence of royal authority. David stretches the neoclassical style to cover a huge conversation picture along the lines of Copley's *Death of Chatham*, based on the transformation of a royal tennis court into a legislative chamber. The open window and the blowing curtains visualize the metaphor of letting new air into this games room.

These "legislators" were, in fact, "what the king and the other estates feared they were: a mob, unreasonable, a mere aggregate of grouped incoherence. . . . But their oath of allegiance, their agreement to stand together despite the fact that they *were* a mob, is a sign of their faith in a total and more radical harmony than that held by the more conservative estates."[44] This very incoherence vitiated David's painting of the scene. So many of the figures were so soon discredited and executed (so rapidly did change operate in the Revolution) that the painting never reached completion. This was a new kind of order which could be understood only in its own terms, and to trace its actual effect we would have to look beyond the neoclassical forms of the official propaganda of David.

The *Fête révolutionnaire*, the gathering in the Champs de Mars or another

43. See W. Gurney Benham, *Playing Cards: History of the Pack and Explanations of its many Secrets* (London, 1931), p. 139, figs. 199–206.

44. I am quoting from Jerome McGann's interpretation of John Ashbery's poem "The Oath of the Tennis Court," a series of apparently random and unrelated lines. "Each line is, as it were, one of those debarred commoners, removed from a larger coherence but standing together" ("Formalism, Savagery, and Care, or the Function of Criticism Once Again," *Critical Inquiry*, 2 [1976], 620–21, 624).

huge open field, was one of the symbolic acts of the Revolution. Openness in space was a quality that followed from the antitype of the Bastille: "National feasts can have no enclosure except the vault of the sky, because the sovereign, that is to say the people, can never be shut into a circumscribed place." [45]

This crowd, the agent not only of the festivals but of the spectacular street scenes—the *sans-culottes* and the *bras-nus* (shirt-sleeved crowd), the "stocking-knitters," the members of the revolutionary sections—was exalted to *le peuple* or domesticated by allusions to the fickle Athenian multitude. Alternatively it was called by outsiders (but also upon occasion, during periods of agitation, by its heroes and leaders) *buveurs de sang*. Ultimately it created its own image with the national citizen army, the *levée en masse*, and the "40,000 ragged republicans" who engaged in the battle of Jemappes (1792): "spontaneous and undisciplined, a truly revolutionary horde, spurning all military proprieties, who advanced singing the *Marsellaise* and swept away the Austrian army." [46] The idea of the sovereignty of the people, and its force, which did (or seemed to) appear at decisive moments such as August 1792 to revolutionize the French government itself, and then to win battles against disciplined and well-equipped professional armies and take over foreign governments, created the myth that Trotsky placed at the heart of the revolution: "The most indubitable feature of a revolution is the direct interference of the masses in historic events." [47]

The relocation of sovereignty was the greatest of the renamings that took place in France. First, the decree of the Section de Manconseil on 31 July 1792 claimed the autonomy of the sections. But the consequence, the dissolution of the body politic itself, was apparent to the Legislative Assembly, which annulled the decree on 4 August declaring that sovereignty belonged to the people as a whole, not to a "section" of the people. As Albert Soboul writes: "The people had a concrete concept of sovereignty vested in the general assemblies of the Section: the bourgeoisie advanced a more abstract interpretation which was more in keeping with their particular interest." [48] At every turning point of the Revolution opposing conceptions of sovereignty clashed, and the people's interpretation—of a concrete group, a mass

45. See M. Ozouf, *La Fête révolutionnaire 1789–99* (Paris, 1976), p. 152, and Billington, p. 48. Rousseau's *Lettre a d'Alembert sur les spectacles* (1758) established the idea of the revolutionary festival: "It is in the open air, it is beneath the sky that you must assemble to give yourself up to the sweet sentiments of your happiness" (*Oeuvres complete*, ed. Musset-Pathay [Paris, 1824], 2, 175–76).

46. I am quoting phrases from Palmer's stirring summary of Jemappes in *Age of Democratic Revolution*, 2, 58. Cf. below, p. 27.

47. Trotsky, *History of the Russian Revolution* (1931–33; trans. 1932; ed. London, 1965), 1, 17.

48. *The Parisian Sans-Culottes and the French Revolution, 1793–94* (Oxford, 1964), p. 108 (also pp. 106–07).

of the un-elite, the low, simple, and uneducated—intervened, manifesting the idea that insurrection is the final resort of the sovereign people. The result, however, was only another series of substitutions. After 10 August popular sovereignty was invested in the Convention, and then later in its governmental committees, in the Committee of Public Safety—then in the Directory, the Consulate, and ultimately in Napoleon, the great man who embodies the Popular Will. But at every crucial stage when sovereignty was in question, the "people" arose. And starting with the massacres of September 1792 the popular exercise of justice or vengeance also became an essential attribute of sovereignty. As the sans-culottes themselves put it: "When the people is in a state of insurrection [*en insurrection*] and when it finds that it has unfaithful mandatories, we must arrest them, judge and punish them on the spot."[49]

One scenario of the Revolution can be written around the different concepts and locations of sovereignty. In this scenario the sans-culottes provided the striking force, but a segment of the bourgeoisie (i.e., the Jacobin Club) planned and organized the *journées*, exploiting the popular force for its own ends. The importance of this alliance of a "club" with the people became apparent when the insurrections organized by the sans-culottes alone (in Ventôse Year II and Germinal and Prairial Year III) failed. The popular protest had required the organization from above. In the final failure of the crowd ended the possibility of a full recognition of popular rights, or total popular sovereignty. For a counterrevolutionary like the Abbé Barruel, this proved that the Revolution had been conceived and engineered from the start by a freemason elite. For the revolutionaries what remained, however, were two principles: of violence as a last resort for large masses of people, and the conducting of affairs in public where private intrigue was apparently impossible. The need for violence and for making affairs public were both images and facts of their Revolution.

The crowd and the violence were the facts or fictions that transcended Roman costumes in France and abroad. They were indigenous images that were not repudiated or censored but assigned different identities with the changing historical circumstances. Violence was interpreted by the French leaders as *exaltation terroriste*, as democratic action, or as a necessary response to the use or threat of force by the counterrevolutionaries. (At every stage the crucial catalyst to more extreme action, generated by and in the

49. Quoted in ibid., pp. 133–34 (see also pp. 130–31, 136–39). As Soboul puts it: "Insurrection to the sans-culottes, therefore, signified the resistance of the people who rise, refuse to obey unacceptable laws, recover possession of their sovereign rights, demand a reckoning from their mandatories, and, finally, dictate to the latter their wishes. At this stage, insurrection is a mass demonstration which reflects both the unanimity and the majesty of the popular movement" (p. 171).

crowd, was an aristocratic conspiracy.) "Popular action" from the fall of the Bastille onward defined itself as a type of extrajudiciary activity, or lynching, but it did so in terms of what has come to be called "crowd ritual," as common in London as in Paris (though in London only mimed).

The originality of these symbolic actions should not be exaggerated. Where they seemed most sui generis, they often adapted past experience and traditions. Group violence in which the people assumed the roles of magistrate and executioner found its model in the religious wars ("crowds taking on the role of priest, pastor, or magistrate to defend doctrine or purify the religious community"). These symbolic gestures took place, Natalie Z. Davis has shown, "when it [was] believed that religious and/or political authorities [were] failing in their duties or need[ed] help in fulfilling them"—that is, in a "revolutionary" situation. Similarly, the revolutionary ringing of the tocsin to assemble the section or the people had its origin in religious assemblages. Davis argues that violent crowds need "a sense that what they are doing is legitimate." The crowd's destructive acts themselves were based on official, ruling class forms. As the French imitated the royal army by forming a mob of nonsoldiers and defeating the enemy, they also cut the heads from corpses and displayed them on pikes because "governments themselves commonly exposed the heads of defunct malefactors to public view."[50] The mob action was a parody, a reconstruction, and a correction—a distinctive new creation—of the old government's actions.

Thus side by side coexisted conventional representations in terms of the old dead iconography of the ancien régime (whether storming the Bastille is portrayed as the slaying of the Hydra or as Roman republican revenge on the order of the Horatii) and the thing itself, the "Storming of the Bastille," the "Oath of the Tennis Court," or the revolutionary "people"—a term which already dominated Wollstonecraft's answer to Burke in 1790 and which distinguished the crowds that appear (like flowing masses of lava) as part of the sublime landscapes of John Martin and J. M. W. Turner. The imagery of the phenomenon of the Revolution itself merged the powerful natural force (Robespierre's "tempête révolutionnaire," Desmoulins's "torrent révolutionnaire") with the indistinguishable, vague, indeterminate shape of the sovereign people.

Still the crowd was a historical image, relatively undistanced from actual events of the Revolution. Lynn Hunt has argued that by the founding of the Republic in 1792 "the collective violence of seizing liberty and overthrowing the monarchy were effaced behind the tranquil visage and statu-

50. Davis, *Society and Culture in Early Modern France* (Stanford, Calif., 1975), p. 169 and, in general, pp. 164–69 and 171. On adolescent youth as participants in crowd violence, going back to the role of apprentices and looking forward to youths such as fiery Orc, see Davis, pp. 182–84. The last quotation is from Palmer, *Age of Democratic Revolution*, 1, 483.

esque pose of an aloof goddess,"[51] the female figure of Liberty. This substitution rendered safe and respectable the disorder and uncertainty of the crowd (disturbing even when naturalized in a "tempête révolutionnaire").

The femaleness of all the allegorical figures (Equality and Fraternity as well as Reason, Nature, and Truth) was summed up in the goddess Liberty, a young woman draped in a Roman tunic. This female also replaced the single paternal figure of the king. In the basic family metaphor on which the state based itself, she was a sister of Reason and Nature or of Equality and Fraternity, or of the Davidian sisters of the Horatii, freed by her brothers from the paternal tryanny or the threat of royal rape. (The philosophes called themselves *frères*, referred to their relationship as *fraternel*, a kind of brotherhood, and in the later stages of the Revolution Robespierre and Saint-Just were trying to appear a fraternal group.)

She also replaced the ancien régime Venus, evoking instead the Virgin Mary or sometimes a Caritas figure (and to the counterrevolutionary propagandists recalling a Magdalen, a prostitute, a low woman of the sort who marched on Versailles). But something of Venus remained, even when after 1793 Liberty was shown as a more quiet, and subsequently matronly, figure. Even ancien régime love, associated with royal mistresses and rococo nymphets, was both demystified and remystified by the Revolution, degraded, and then transvalued. The act of love, the quintessential act of rebellion in a patriarchal society, was perhaps more significant than the Roman shape of the woman Liberty, which replaced the symbol of the unruly crowd but embodied the underlying symbolism of sexual release and fulfillment beyond the bounds of primogeniture and hierarchy. Liberty became for the male revolutionary (especially for Englishmen) a sentimental love object, sometimes to be saved from the paternal authority but also to be courted. This image of woman, which Mary Wollstonecraft would have regarded as a continuation of ancien régime male chauvinism, is never an active force, that role being reserved for the male. But she is the other half of the revolutionary paradigm of the act of illicit love and regeneration (for the Marquis de Sade, incest between brother and sister), and the Caritas associations lead finally to the birth of a child, the embodiment of the new order.

The mixture of old and new, of conventional and historical fact, was

51. Hunt, "Engraving the Republic," *History Today*, 30 (1980), 11–17. See also Maurice Agulhon, "Esquisse pour une archéologie de la République: l'allégorie civique féminine," *Annales: Economies, Sociétés, Civilisations*, 28 (1973), 5–34, and *Marianne au combat: L'imagerie et la symbolique républicaines de 1789 à 1880* (Paris, 1979). In a forthcoming essay, Hunt argues that the feminine Girondin image of Liberty was replaced by David (and the radicals) with the virile Hercules, symbolizing the people who go beyond the early stage of mere liberty, taking the power of the royal image of Hercules into their own hands ("Hercules and the Radical Image in the French Revolution").

reflected abroad in the way the London Corresponding Society closed its letters: "Farewell, hoping that the hydra of tyranny and imposition shall soon fall under the guillotine of truth and reason."[52] In France the guillotine, that unique symbol, was called both "the popular ax" and "scythe of equality," and as the metaphor of Death the grim reaper flourished in speeches, broadsides, and newspapers, it was suggested that this scything led to a harvest which promoted the supply of bread and the feeding of the people. Mme. Guillotine was merely another of the female figures (like Liberty, Reason, and Nature) who attempted to naturalize a more powerful symbol, that of the two upright posts and the diagonal of the blade poised to drop with sure, instantaneous, and absolutely unstoppable effect: a symbol of revolutionary action, its headless progeny became symbols of revolutionary effect.

The machine itself, although originating as an Enlightenment device of rational and painless punishment, was closely associated with the crowd. It rose out of a mass of people as judges and audience; it participated in the myth that the "people" brought about the revolution and each execution was *its* justice, a manifestation of its voice (as the cry rose with the elevation of each severed head). Of the metaphors generated by the leaders of the Revolution none was more powerful—or predictive—than Billard-Varenne's in his *Last Blow against Pride and Superstition* (1789): "However painful an amputation may be, when a member is gangrened it must be sacrificed if we wish to save the body."[53]

Finally, and equally irreducible to Roman costume, were the great verbal tags, the great paradigmatic cries—usually uttered in public, sometimes at the guillotine: Madame Roland's "Oh Liberty, what crimes are committed in your name!" and even the Comte d'Artois's ancien régime aside, "You can't make an omelet without breaking some eggs." With Saint-Just's "Liberty that prevails must become corrupted," these sum up one large aspect of feeling about the Revolution: It is a complex mixture of good and evil, but the end justifies the means. It is a process of two phases: the revolt, preoccupied with liberty, followed by the reconstruction of law, which inevitably restrains, redirects, and suppresses the unleashed liberty necessary for the first phase.

52. Letters to Thomas Hardy, quoted in Melvin J. Lasky, *Utopia & Revolution* (London, 1976), p. 690, n. 20. The print *La véritable guillotine ordinaere ha le bon soutien pour la liberté* merely represents the machine, but many prints deal with the idea of headlessness and beheading. Villeneuve produced many guillotine cartoons, with the machine dripping blood. One has a caption that reads "A warning to plotters. Traitors look and tremble: it will not cease its activity until you have lost your life." Another has the royal family, a line of St. Denis's carrying their severed heads and presenting themselves at the gates of Hell. See Leith, *Media and Revolution*, p. 49, who cites J. M. Boyer-Brun's counterrevolutionary *Histoire des caricatures de la révolte des Français* (1792).

53. Quoted in Palmer, *Twelve who Ruled* (Princeton, 1941), p. 12.

Bertrand Barère's words in the National Assembly of 1792, "The tree of liberty grows only when watered by the blood of tyrants," soon were changed to "watered by the blood of the sons of liberty." The idea that the revolutionary gives his life in order to water the tree of liberty became the idea that *his* death was as much a part of the breaking of eggs as the tyrant's. The Roman republican sacrifice of one's self—a Curtius who leaps into the crevasse to found Rome and ensure its greatness, or the Brutus who sacrifices his own sons for the state—begins, stimulated by the actual train of events in Paris, to become the blind destructive force (the "tempête révolutionnaire") that carries away both revolutionary and tyrant.

Vergniaud's "The revolution devours its own children" (spoken in 1793, to which Saint-Just replied that the Revolution will not devour itself but only its enemies) were the words that reverberated abroad in England and in Spain. Vergniaud's actual words were:

> Alors, citoyens, il a été permis de craindre que la révolution, comme Saturne dévorant successivement tous ses enfants, n'engendrât enfin le despotisme avec les calamités qui l'accompagnent.[54]

Vergniaud's words are the most terrible of all those spoken—a reflection of the imagery of cannibalism, often with humorous emphasis, found in the popular press of the *Père Duchesne*, who described with black humor how many aristocrats he had devoured that day. The cannibalistic devouring of the father by his jealous sons, who thereby absorb the father's strength and wisdom but then internalize him, becomes the primal horde (ironic fraternity). At least in retrospect Vergniaud's words bring down our emphasis hard upon the relation of the generations, not only referring back to the king killed and supplanted but to the generations of the revolution that succeed each other with frightening rapidity, producing an ironic and cyclic structure for the fiction of revolution.

I think we can see in France a three-way conflict, relating the figures (or images) imposed from above, those from below, and the historical reality or referent. The Revolution itself can be seen as an order imposed from the top, by well-bred Girondins in their cultivated salons, and a revolution rising from below, from the bottom up, the great ground swell of the "revolutionary masses." The Jacobins tried to mediate between these opposite

54. This remark appears toward the beginning of a fairly long oration delivered to the assembly on 13 March 1793. The speech was answered by Marat, who began by heaping scorn on the prepared, rhetorical character of the address, contrasting his own spontaneity with Vergniaud's conscious oratory. This eventually led to scuffling over whether or not the speech should be printed in the records. The entire speech and debate appear in *Le Moniteur Universel*, no. 75, 16 March 1793 (15, 702). The episode (speech and context but not date) was given currency in Lamartine's *Histoire des Girondins* (1847–48), bk. 38, ch. 20. But earlier (in 1835) Büchner quotes Vergniaud's phrase in *Danton's Death*. I go into so much detail because of the importance of Vergniaud's words to Goya (see below, p. 367).

forces (or fictions), using the sans-culottes to unseat the Girondins. But the struggle can also be seen as an agon of imageries: from the top, the imagery of republican Rome imposed by lawyers and poets and artists who were an educated, intellectual elite, essentially part of the establishment.

Lord Byron found it easy to sympathize with a Mirabeau or Lafayette but not with a Robespierre or Marat. "Why, our classical education," he wrote to John Cam Hobhouse, "should teach us to trample on such unredeemed dirt as the *dis*-honest bluntness, the ignorant brutality, the unblushing baseness of these two miscreants, and all who believe in them." He refers to them as "awkward butchers" and concludes that he knows (echoing Danton's phrase) "that revolutions are not to be made with rose water, but though some blood may & must be shed on such occasions, there is no reason it should be clotted. . . ."[55] This was how the division looked from London. Historically Byron's "classical" model won when the Directory wiped out the sans-culottes and Napoleon replaced the Roman Republic with the Empire, reconstituted after the Concordat as a Holy Roman Empire.

I need to explain what I mean by imagery from below, for I doubt the Trotskyite fiction of "revolutionary masses." I mean rather a set of images, produced by professional writers and revolutionaries, but taken from the subculture, and so distinct from, often quite at odds with, the ruling culture (which included Robespierre and Saint-Just as well as Brissot and Condorcet). I mean the sort of effect one finds in a New York subway in the spray-paint graffiti that covers the walls, posters, and official signs. This is the graphic expression of a subculture that has felt itself to be repressed.

In France there was nothing of the plebeian sort to draw upon, and it did not occur to anyone to do so. The official art of the Salon held sway. The subculture was, as in New York, graffiti on the border of the official, which sometimes was allowed to well up in the form of crowds that destroyed prisons or overturned provisional governments but always under the supervision of an elite. It was used at each stage, as in Saint-Just's sense of "liberty," as a prelude, a way into the period of "law." It just happens to have succeeded in the mythology of revolutions, emerging in Trotsky's formulation as its very essence.

In the French Revolution Catholic forms functioned, even after the secular direction taken by 1790, much as they did in the Russian Revolution. In both countries the religious forms were essentially subculture, or at least popular forms, and were used by being transvalued. Catechisms or saints' lives, while maintaining the aura of the sacred, served as an armature for new meanings, and when David painted his *Marat* he was using this feeling and a form that could be seen in any church, as opposed to in the salons and

55. *Lord Byron's Correspondence* . . . , ed. John Murray (London, 1922), 2, 143.

great houses where the paintings of Roman subjects were hung. Religious faith was, however, a content as well as a form, as Robespierre made clear in his speech to the Jacobin Club at the beginning of the Terror:

> Atheism is aristocratic. The idea of a great being who watches over oppressed innocence and punishes . . . wickedness is altogether popular. If God did not exist it would be necessary to invent him.[56]

At the heart of Robespierre's "great being" was the Biblical paradigm of a "Last Judgment on the way to Paradise," an earthly one. But the emphasis was on "judgment." "It expressed justice that was both transcendent and imminent . . . ," as Jacques Ellul has said. "Tyranny would be abolished and the guilty punished and eliminated. The purging process, aimed at removing the bad from the good, would allow humanity to be regenerated, and society's original sin would not recur."[57]

The crowd itself, though its actions were in some ways as formal as their ruling class equivalents, was in a far more profound sense something *other*—because this "regression" when once unleashed did not stop short of the primal horde and its cannibal feast. The art of David and the official speeches cannot prevent the instinctual forces from arising to the surface and mingling with the official/academic but faintly ludicrous ones of the upper middle class who want to remain aloof from the mob and deny its part in the proceedings. These forces are of course emergent under the smooth surface and geometric order of David's *Brutus* in the image of a father killing his own sons for their treason to the state and to himself as proconsul. He suppressed only the image of the son's heads, carried aloft on pikes, from the exhibited picture of August 1789.

It is here that we find the central and most important aspect of the self-representation inside Paris: a tension of the stereotypic and the unique, of the symbolic and the representational, which is to say the regressive, which urges a return to the primal scene which Père Duchesne and others (in England Burke) knew as the real heart of the matter, a scene more primal than republican Rome or Lycurgan Sparta.

A final word about the "historical reality," the third aspect of the three-way conflict I have described. The sheer novelty of the French Revolution required new forms of representation and even more basically raised the central aesthetic challenge: how to represent the unprecedented. The French Revolution was and *was perceived to be* unprecedented, and there is something obtuse in the discovery of supposed forerunners such as the English Civil War of the seventeenth century. After such an event as the French Revolution (in our own time we might think of Hiroshima or the Holo-

56. 20 November 1793; quoted in W. Henley Jarvis, *The Gallican Church and the Revolution* (London, 1882), p. 247.
57. Ellul, *Propaganda*, p. 90.

caust), the human condition is altered: not everywhere or in every respect, but certainly in any attempt to represent the possibilities of the human condition. Because both the French Revolution and the Romantic movements were concerned with surprising possibilities, with sublime extremes, this alteration became almost at once a given, an inescapable part of both politics and aesthetics.

There had nonetheless been a double preparation for a new state of affairs and of the arts, a double anticipation of a new age of revolutionary republicanism in politics and of contorted sublimity in aesthetics. The Marquis d'Argenson was convinced that revolution was imminent in the mid-1740s, and the republican ideal was far more than a Roman tragedy (or American triumph) to eighteenth-century Europe.[58] As we shall see in the next chapter, the aesthetic revolution had begun at least as early as Burke's *Philosophical Inquiry into the Origin of our Ideas of the Sublime and Beautiful* (1757), and the grotesque was a mode waiting in the wings with an already appropriate history. The new esteem for the sublime and the grotesque entailed also a loss of interest in the beautiful. This was the age in which aesthetics had dropped—or was about to drop—beauty overboard, or rather into the sublime abyss.[59] The aesthetic and political paradox seems to be that we can perceive as unprecedented only that for which we have already been prepared.

What we call the "history" of the French Revolution consists already of artistic representations framed and shaped by aesthetics, ideology, and historical narrative. I have referred to "the image of the battle of Jamappes" (p. 19), but the "ragged republicans, . . . spontaneous and undisciplined, a truly revolutionary horde, spurning all military proprieties, who advanced singing the *Marseillaise* and swept away the Austrian army," is an artful representation of the event. The French army did sing the "Marseillaise" (and "Ça ira") and it did win a decisive victory. But its backbone remained the regular regiments of the royal army, it actually outnumbered the Austrian force, and it was commanded by Dumouriez, a shrewd tactician, royalist, and source of the later prophecy that "Democracy would devour Europe, and end by devouring itself." Even Michelet, who calls Jemappes a miracle, admits and grapples with this kind of evidence in his account of the battle.[60] We have before us a new view of events as unstable, at once shaped and falsified by their representations—a view summed up when Wa-

58. See Franco Venturi, *Utopia and Reform in the Enlightenment* (Cambridge, 1971), especially "Kings and Republics in the Seventeenth and Eighteenth Centuries," pp. 18–46.

59. See Herbert Dieckmann, "Das Abscheuliche und Schreckliche in der Kunsttheorie des 18.Jahrhunderts," in *Die Nicht Mehr Schönen Künste: Grenzphänomene des Asthetischen,* ed. Hans Robert Jauss (*Poetik und Hermeneutik,* III, Munich, 1968), pp. 271–317.

60. Michelet, *History of the French Revolution* (1847–1853), trans. Keith Botsford (Wynnewood, Pa., 1972), 4, 317–33. For Dumouriez, see below, p. 367, n. 66.

terloo, the mythic battle, is experienced by Fabrice in Stendhal's *La Chartreuse de Parme* as meaningless confusion. To what extent is the battle of Jemappes or of Waterloo an artistic representation and to what extent a historical event?

DAVID

Beneath the official culture of the Roman shape was also another sort of subculture—the sub- or preconscious expression, or the personal vision, of the individual artist. The case of David, for example, makes us distinguish between the representation of the French Revolution, which had not begun until after he completed his *Brutus*, and the prerevolutionary painting that stimulates to revolutionary consciousness or that only represents a particular state of mind that will later find *another* correlative in the events of the French Revolution.

As art historians have shown, there were respectable traditions behind the two motifs David employed in his Salon paintings before and after the advent of Revolution: the oath of allegiance to some higher principle and the "heroic corpse" who is either a consequence of that oath or a cause of its being enunciated.[61] But David does peculiar things with these traditions, combining them and conflating the Roman stories from which they derive.

The Oath of the Horatii (1785, fig. 1) depicts the family sending out its sons as Roman champions to battle the opposing Alban champions, their cousins the Curatii. As a consequence of the Horatii's victory the surviving Horatius brother is cursed by his sister, whose lover he has killed in the duel, and he kills her for her lack of *pietas*. Instead of telling this story, however, David goes back before the battle to the oath taking, which is not part of the story in his sources. The picture has usually been read—from the time of the Revolution—as an oath (like Fuseli's Oath on the Rütli) to seek liberty from royal tyranny. But the picture is more ambivalent than that. If read simply as the oath of the Horatii, as its title indicates, it represents an oath *to the father* that is going to lead not to liberty but to the death of one of the daughters—precisely parallel to the later duty–love theme of David's *Brutus*. The father is both the fulcrum of the heroic oath and the authority that will confirm the fears of the quaking women.

David complicates the oath itself by taking his graphic image from representations of the oath of Lucius Junius Brutus over the corpse of his sister Lucretia, who was raped by the son of King Tarquin, an example of droit du seigneur (Beaumarchais's Count Almaviva much intensified), "an act of Imperial lawlessness."[62] The rape was followed by her suicide and a heroic

61. See Rosenblum, *Transformations*, ch. 2.
62. Brookner, *Jacques-Louis David*, p. 78.

oath of a different sort, parallel to that of the Horatii but this one sworn to
the brother, Brutus, *against* the authority figure, Tarquin. The visual image
allows David to conflate the story of the Horatii not only with that of Lu-
cius Junius Brutus, the overthrower of royalty and founder of republican
Rome, but with that of Marcus Brutus, whose oath was to assassinate an-
other tyrant, Julius Caesar.

Thomas Crow has shown that David probably exploited a factional ref-
erence in his painting, thus aligning himself with the political group that
supported the banker Guillaume Kornmann, whose young wife had run
away with a young aristocrat.[63] Kornmann patronized Brissot, Gorsas, and
Carra, who in the pamphlet war that followed called this a seduction, even
a rape; the enemy was the king's minister Calonne and the court, who de-
fended the young aristocrat. Both groups were "liberal" if not in some
sense (for the time) "revolutionary." David's painting could have been read
as a kind of revolutionary statement by one liberal faction, opposed as it
happened to the other liberal faction for which Beaumarchais wrote his
Marriage of Figaro. Beaumarchais and his play were attacked as reactionary
by these future Girondins, who would themselves later be beheaded by the
party David allied himself with once the Revolution of 1789 got under way.

I do not want to suggest that David was proffering a subversive, antigov-
ernment message in the guise of an acceptable story. Anita Brookner con-
vincingly shows him to have been an intuitive artist who painted (in the
years before the Revolution) from personal rather than public motives. He
was not above exploiting a public or factional motive, but it is more im-
portant to see that he produces a painting that has both a manifest and a
latent content. If the manifest content is the oath against the neighboring
country, the latent (within the graphic image and its tradition) is the oath
to avenge a sexual violation by the tyrant—and to the woman, not to her
husband—and so the death of a feminine figure which brings about this
oath, followed by rebellion and the founding of a republic.

Critics have seen this as basically a male–female polarity informing all
David's Salon paintings:[64] the stoic oath-taking male is juxtaposed with the
weak pleading female. (David also considered paintings of Regulus going
to certain death in Carthage, taking leave of his wife and children, and of
Coriolanus with his mother pleading for his native Rome.) Latent in the
scene, however, is the death of the woman, whether as a result of the sexual

63. Crow, "*The Oath of the Horatii* in 1785: Painting and Pre-Revolutionary Radicalism in
France," *Art History*, 1 (1978), 424–71.

64. For the tradition of paintings showing the "polarity between masculine strength and
feminine weakness," see René Huyghe, introduction to the exhibition catalogue, *David* (Paris,
1948); Rosenblum, *Transformations*, pp. 70–71; and Brookner, *Jacques-Louis David*, p. 83. For
the tradition of paintings of a female sacrificed to Honor or Duty, see Rosenblum, p. 65; for
"the emotional cleavage of families" see p. 66.

violation of the king or (which is the fact in both cases) by the binding oath to a father. Even *Paris and Helen* (1788, Louvre), the mythological subject that interrupted David's images of historical virtue, projects the story of the voluntary "rape" by the young man, who takes Helen away from her husband Menelaus (or Kornmann), and the consequence—latent, unstated in this image of lush decadence—of the Trojan War.[65]

In both of these images the latent content is powerfully proleptic. One projects death and victory (in one reading victory is followed by death, in the other death is followed by the victorious removal of Tarquin and the founding of the Republic); the other projects death and destruction out of an illicit love affair.[66]

The Death of Socrates (1787, Metropolitan Museum, New York) introduces another conflating of stories like that of *The Oath of the Horatii*. This time beneath the ostensible iconography of the story of Socrates' death David employs the image of the Last Supper. The graphic precedent for the composition is Poussin's first set of *The Sacraments*, and Socrates, about to take up the cup, is shown with twelve other figures, some around him and others sadly departing. The situation is, as Brookner has seen, "decidedly eucharistic in flavour."[67] David has combined the oath and the death in a single act that is proleptic in the manner of Benjamin West's *Death of General Wolfe*: West showed Wolfe dying at the moment of victory, a death that projected the conquest of Canada and the birth of the British Empire.[68]

Now we come to the *Brutus* (fig. 2), which was painted before the events of the summer of 1789 and exhibited at the end of the summer. The story of Lucius Junius Brutus has been carried one stage further: from being the avenging brother he has become the consul and father, the revolutionary who now must govern. His sons have joined a conspiracy to return the monarchy, and he has obeyed his oath as consul by condemning them and witnessing their execution. In August 1789 Brutus was read as a representative of revolutionary virtue, the heroic Roman who beheads his own sons to preserve the state. And yet we should notice that David portrays not the act but its consequence. The sons' bodies are being returned to his house; he sits in the shadow beneath the statue of Roma, and on the other side of the picture, in the light, are the grieving women. Notice not only the way David has cut Brutus off from his wife and daughters, but has placed him

65. On Paris's decadence—Helen's "Spartan conditioning and his Phrygian decadence" ("a most significant reversal of roles")—see Brookner, *Jacques-Louis David*, p. 88.

66. In the case of David's *Oath of the Horatii* (which though completed in 1784, was first exhibited at the Salon of 1785), the consequence was materialized by his pupil Girodet in *The Death of Camilla*. This happened to be the Prix de Rome subject of the year.

67. Brookner, *Jacques-Louis David*, p. 85.

68. See Paulson, *Emblem and Expression: Meaning in English Art of the Eighteenth Century* (Cambridge, Mass., 1975), pp. 199–203, and "The Aesthetic of Mourning," forthcoming.

in shadow, his family in the light.[69] The painting is less concerned with the taking of sides than with the exploration of the private consequences of a public virtue.

The image anticipates the Revolution as it in fact developed. We might think that the revolutionary Brutus is a version of Vergniaud's Saturn; he is rather an example of an image that became associated with the Revolution and influenced people's reading of revolutionary events—from Burke's reference to the Revolution as one in which "sons . . . called for the execution of their parents" and "wretches calling themselves father . . . demand the murder of their sons, boasting that Rome had but one Brutus, but they could show five hundred"[70]—to Vergniaud's resounding words. This is an image that helped to bring about the seeing of events in a certain way, if not the events themselves, as Burke was said to have brought about the horrors he had prophesied. (The interpretation of the image was also, of course, first determined and then supported by Voltaire's tragedy *Brutus*, popular before the Revolution and performed thrice weekly during its height.)

David's politics before 1789 seem to have been those of an artist politician rather than a political activist. His concern was with the Académie, his own coming to terms with academic assumptions and practice, and his studio (those "sons" with whom he carried on a love–hate rivalry to the very end of his life, when Gros was beseeching him to return from exile and he followed each entreaty with a sterner rebuff). It just happened that the imagery of fathers and sons was the same with which political writers wrote of the three estates in France and had written of the revolution in America. David was both full academician and—he felt—an outsider from its ruling party; he was metaphorically both son to the inscrutable Académie and father to his own students. Insofar as the shock of his Salon paintings derived from the fact that the French were (Brookner's words, p. 79) "unaccustomed to seeing Antique symbols invested with such violent emotion," it was due not so much to his feelings about French society as to his obsession with the "corruption" of the Académie.

The "unfocused exasperation, not to say hostility," David brought to his

69. Rosenblum describes how David employs a compositional "void that emphasizes . . . the unbridgeable gulf between masculine stoicism and feminine abandonment to the passions . . . Brutus in shadow, the women in glaringly clear light—underlines the rupture" (*Transformations*, p. 77). See also Robert L. Herbert, *David, Voltaire, Brutus and the French Revolution: an Essay in Art and Politics* (London, 1972). The basic sources for the Brutus story were Livy 2. 5; Valerius Maximus 5.viii. 1; and Plutarch, "Publicola," 7.

Besides other versions of Brutus in the act of condemning his sons or choosing between love and duty, there was Jean-Simon Barthélemy's *Manlius Torquatus condemning his Son to Death* (Salon, 1785, Tours, Musée), which was reexhibited at the Salon of 1791 as "Exemple de discipline militaire" (no. 241).

70. Burke, *Letters on a Regicide Peace*, *Works* (London, Bohn ed., 1893), 5, 209.

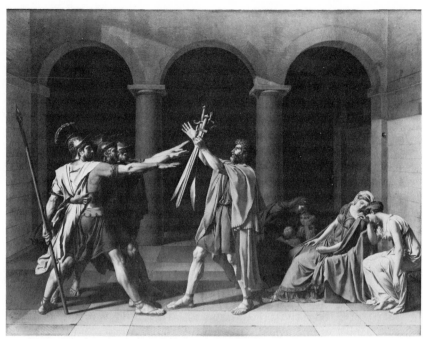

1. Jacques-Louis David, *The Oath of the Horatii*. Painting, 1784–85.

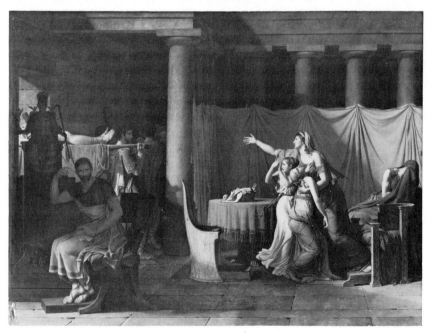

2. Jacques-Louis David, *Lictors returning to Brutus the Bodies of his Sons*. Painting, 1789.

Brutus[71] was in fact against the Académie for its refusal to honor his dead pupil Jean-Germain Drouais, which put him in a state of mind that was a microcosm of France's at the verge of the Revolution. The artist in whom a personal matter comes to stand for or charge the revolution with meaning was a situation we shall see most clearly in Wordsworth and Goya but in one sense or another in most of its observers. Once into the political revolution, David's revolution was largely a campaign to overthrow the Académie.

The painting is not, however, a systematic, an allegorical attack on the Académie, and this is why I have spoken in terms of manifest and latent contents. The power of the picture lies in its being on a secondary level a psychomachia, an image of divided loyalties (the truly Corneillian situation) deriving from the conflicting emotions of the father *and* the mother, which materialize the mixed emotions of the father himself.[72] The painting is about Brutus. In the larger terms of what is happening in France and will happen, it deals with a situation of duty carried out despite human feelings. In terms of David's own situation it expresses his mixed feelings of duty and loss—for a "son"—in relation to the absolute demand of Roma and the absent but implicit *others* out there who represent this absolute, explicitly the stony-faced lictors who carry in the bodies.

The elements are (1) the Académie (closely related to the status quo of the French government), which would have been much the same as the system that excluded lawyers of talent such as Robespierre from its highest reaches; (2) David's studio, his "sons," one of them cut short in his prime but refused acknowledgment by the Académie because he had not lived long enough for full membership. Finally there is (3) David himself, who though regarding himself as outside the Académie was of course a full member, sharing (whether or not he wished to acknowledge the fact) its most basic assumptions, even its laws—an artist both of and not of the establishment, divided in very much the way he conflates and juxtaposes his different plots of Socrates and Christ or of the Oaths of the Horatii and

71. Brookner's phrase (*Jacques-Louis David*, p. 91). We also know of David's strong feelings about the French Academy in Rome (for example, mildly attempting suicide after one of his rejections when he applied for the Prix de Rome) and its directorship.

72. The evidence, if it is needed, is in David's written description of the painting of Brutus. He says he has returned to France ("this poor country") "like a dog thrown into the water against his will, and who has to reach the bank in order not to lose his life." The painting he is undertaking, he writes, is about "Brutus, man and father, who has deprived himself of his children and who has returned to his home [i.e., parallel to this return to "this poor country"], where are brought to him the bodies of his two sons for burial." He sits in "distress at the foot of the statue of Roma," as the bodies are brought in, and first learns this fact by the "cries of his wife, the fear and fainting of his eldest daughter" (to Wicar, 14 June 1789, quoted by J. L. J. David, *Le peintre Louis David, 1748–1825* (Paris, 1880); trans. Herbert, *David, Voltaire, Brutus*, pp. 123–24).

of Brutus. This scenario might explain something of the cathectic power we feel in the figure of Brutus. He is the father who loves the son but has no power against the law, his oath, the system, the government, or whatever is embodied in that primitive statue of Roma. What is expressed is hardly revolution—but rather total frustration.

In the later paintings of the Revolution (in contrast to the conglomeration of conventional imagery in the festivals) David isolates one element of the earlier Salon paintings: the oath in *The Tennis Court Oath*, even finally in *The Coronation of Napolean* and *The Distribution of the Eagle Standards* ("this time an Imperial and autocratic" version),[73] and the dead raped–murdered body, the "heroic corpse" of Drouais, idealized and classicized (increasingly, as with Lepeletier and Bara, feminized) into a Christ that retains vestiges of the sexuality of Lucretia but also inevitably recalls the bodies of the sons of Brutus.

The oath remains in the background: Lepeletier was murdered because he voted for the king's death, Marat because of his dedication to revolutionary virtue. Also in the background of Marat's corpse (offstage) is the woman who speaks for human feelings. In some strange way Charlotte Corday merges the chorus-for-mercy with the raped, violated figure for whom it mourns. Women become the major factor only in *The Intervention of the Sabine Women* (1794–98) to bring an end to the factional strife of the revolution; here they emerge from passive obedience to the center, as again finally in *Mars disarmed by Venus*, David's last history painting.

As the case of David shows, we cannot say that the imagery-from-above is simply repressing the reality-from-below, because both are formalizations or symbolizations of experience—formalizations perhaps of different experiences, of perhaps the reality principle as opposed to the pleasure principle (the more profound regression being that of the subculture or the subconscious). Both are in conflict with the *other*, which is the curb of reality itself, of events. But David's example also asks whether events are really separable from the models that enunciate them. The models not only cover, costume, and conceal reality as event but also determine it. Without the Roman ethos there could be no Brutus as simultaneously tyrannicide and tyrant, as there could be no Curtius who kills himself to perfect the state, and without the Greek ethos there could be no Socrates with his hemlock.

There is no independent event; there are only conflicting models of action jostling against eighteenth-century French citizens with their own complex cultural heritages that are non- or more-than-Roman or Greek. The jostling is perhaps less of model and event than of model and character—a conflict of ethoi in which the subculture ethos, and perhaps the sub*conscious* ethos,

73. Brookner, *Jacques-Louis David*, p. 160.

is simply closer to the local reality—and so seems less costumed, less fancy dress.

David's example suggests that paintings, even the official ones for a successful revolution, if made by a sufficiently complex artist will have a latent as well as manifest content, or will be about his "revolution" as well as the political one, or about something other than revolution. It also suggests that a "revolutionary" painting may contain an implicit prolepsis which can have as much influence on events as events have on the representation. It even suggests that a style can be dealt with not only in terms of its efforts to retain a relationship to its (official) content but also in terms of the different significances it holds for its employer, its local observers, and its foreign critics.

Crow is right to document the outrage among the Académie's conservative factions to David's painting, and it is plain that the outrage (as well as the fervent defense) was along political as well as aesthetic lines. The first, I have suggested, tells us that David was not above exploiting the support of a faction and that the painting's content and a party line were the chief considerations for reception. His *Horatii* had political overtones for one liberal faction but equally (if the alignments had been different) for another more or less liberal. The aesthetic, however, is the more important reaction. The aesthetic opposition was outraged by the unusual looseness, attenuation, and dislocation of David's forms. They discerned the beginning of a tendency to disunification that we shall see carried to an extreme in the works of Goya. To them, and conceivably to David himself, this development of the neoclassical style can be thought of as revolutionary. It denotes an extreme tension that, together with its ambiguous subject matter, might point toward some kind of dissolution—of values that are political as well as aesthetic—in anticipation of a new order.

But John Constable's reference (in 1836) to David's "stern and heartless petrifications of men and women" and the "relentless outline" with which he bound them "all equally on to the ground" may, on some level, tell us as much about the style's employer and its local observers as about its foreign critic.[74] By the end of the century it might have appeared that David at the outset of the Revolution had already perfected an official style—a style of order not dissolution—that would have served either side, for Louis XVI, the reformers, or revolutionaries, certainly for the Girondins or the Jacobins, as at the end it served for Napoleon.

The style after 1789 was, of course, not intended to correspond to "revolution." The philosophes and artists who desired a change of the sort that became the Revolution in politics and the School of David in art obviously sought equivalents to the stability of alternative values, and these—the re-

74. *John Constable's Discourses*, ed. R. B. Beckett (Ipswich, 1970), p. 60.

action against frivolity and insecurity felt to be embodied in the rococo style—were thought to be expressed in a style of clarity, order, and certainty. This neoclassical style presupposed a particular image of the political act as reaction to a flighty present and return to secure and solid ideals of the past. The style itself was revolutionary only in the sense that at a date earlier than the political revolution it had overthrown a dominant style, and when the political revolution arrived it utilized this successful precursor.

David's own style retained the dislocations that were criticized in the 1780s, and his greatest works of the 1790s expressed such revolutionary dislocations of consciousness as assassination, narrowing the whole historical machine to a dead man in a bath, joining the classical context with the Christian, and preparing the way for the intense fragments Goya exposed in his *Caprichos*. A study of David's neoclassical style would deal with equivalence, tension, and then transformation to suit the increasingly irrational, unpredictable, disillusioning referent. The next stage would be to examine the attempts of his epigones, the "sons" Gros and Girodet, to adjust new styles to the changing circumstances of the Revolution, Empire, and Restoration.

The example of France makes immediately clear the basic alternatives, which were to regard revolution as a unique phenomenon for which a new vocabulary had to be invented or to assimilate it, consider it a common occurrence, not something new and strange (as Talleyrand said, it was all simply the result of human vanity). Even among the revolutionaries themselves there were those who wanted it to seem unique and unprecedented and those who wanted it to seem part of the past, a recovery of a lost ideal or a return to an earlier state in one form or another. This is in a very general way summed up in David's assimilation of his own experience to the French Revolution.

CHAPTER 2 ❧
THE VIEW
FROM ENGLAND:
STEREOTYPES

If the French representation of the Revolution involved a tension between the consciously fictive (the recovery of a Roman ethos) and the pressure of events, the English stood at another remove. They lived within the tension of their own English fictions (Marx reminds us that in *their* revolution of the 1640s it was not the Roman costume but the "speech, passions and illusions from the Old Testament" that they borrowed "for their bourgeois revolution"[1]) and a secondary French reality— history at second hand in written reports. And this was modified by a primary English reality of a recently successful American "revolution," the Gordon Riots of 1780, certain local reform movements, and from 1793 a Pittite "repression," which among other things meant that the revolutionary sympathizers were writing at the prerevolutionary stage (some felt in a counterrevolutionary situation) of subversion and agitation. They were writing about England; the French Revolution was only one foreign ingredient in a pie of their own making.

A contemporary who wrote about the French Revolution, his own situation in England, or about almost any subject in the 1790s had no choice but to take into consideration the phases of the Revolution as they evolved and developed in time. From the English point of view the first phase, from 1788 to 1792, was in general one of approval celebrating the fall of a despotism and the rise of a constitutional monarchy. The beginning was the familiar "Fronde" of the nobility: the Parle-

1. Karl Marx, *18th Brumaire of Louis Bonaparte* (New York, 1963), p. 17.

ments and other interest groups, with which Burke, for example, could sympathize as equivalents of his own Whig aristocracy, whom he had defended against the encroachments of George III. Moreover, the initial English response was one of pleasure at seeing the French monarch embarrassed and weakened as a rival to England. At this stage the English, especially of the Whiggish persuasion, liked to see events in France against their own Glorious Rebellion of 1688.

The scenario was transformed, however, by the meeting of the States General in May 1789 and the entry of the people—the mob—on the scene: the declaration of one "National Assembly," the capture and destruction of the Bastille, the peasant risings (the "Great Fear") of the summer, and the crown's inability to dismiss the new assembly. The historical precedent of the Glorious Rebellion was now interpreted in antithetical ways: by the Reverend Richard Price in his speech celebrating the anniversary of 4 November 1689 as an act of revolution, of state overthrow; and by Burke—fitting it into the Whiggish interpretation of the revolution of 1688—as a nonrevolution, an extraordinary measure which strengthened the aristocracy against a tyrant king, but no precedent, no model for events of a hundred years later.

The second phase can be illustrated by Sir Samuel Romilly, an enthusiast of the first phase (though even then allowing some ambivalence to creep in concerning the outrages committed in the storming of the Bastille). In September 1792 he was writing, in the light of recent events, a lament for the French people who

> employ whole days in murdering women, and priests, and prisoners! Others, who can deliberately load whole waggons full of victims, and bring them like beasts to be butchered in the metropolis; and then (who are worse even than these) the cold instigators of these murders, who, while blood is streaming round them on every side, permit this carnage to go on, and reason about it, and defend it, nay, even applaud it, and talk about the example they are setting to all nations. One might as well think of establishing a republic of tigers in some forest in Africa, as of maintaining a free government among such monsters. . . .[2]

Here are the images, including the tigerishness, automatically turned to for the second stage of reaction, following the royal family's flight to Varennes, their capture, the overthrow of the monarchy, the bloodshed surrounding the coup, and the September Massacres. This phase only came to its logical end in January 1793 with the execution of the king—a totally new turn (though Burke would have said inevitable).

From a more sympathetic point of view—the one held by the "new Whig"

2. Romilly, letter to M. Dumont, 10 September 1792, from *Memoirs of the Life of Sir Samuel Romilly, Written by Himself; with a Selection from his Correspondence, Edited by his Sons* (2d ed., London, 1840), pp. 2, 4–5.

leaders Fox and Sheridan—the second phase was summed up in the plotting of Louis XVI and Marie Antoinette and the threat of foreign intervention on their behalf, which led to the crisis of the summer of 1792, when the royal couple was imprisoned, a National Convention was called, a republic was declared, and all nations were urged to overthrow their kings.

With the execution of the king, the threat to England by France's economic policies, and the declaration of war, England was felt by its governing ministry to be in a state of emergency. The result was the appearance of an English tyranny with censorship and suspension of habeas corpus, culminating in the treason trials of 1795. In this phase England seemed to many a reprise of the French ancien régime.

Meanwhile, the Revolution had gone into its third phase, the dog-eat-dog period of 1793–94, when it seemed to be "devouring its own children." The Great Terror was the symbol of this period, and also the idea of purges followed by further purges, until finally with 9 Thermidor the purger was purged and Robespierre fell. In the next phase the "Thermidor reaction" settled down into the Directory: a time less bloody (punishment was now the "dry Guillotine" of Devil's Island), more cynical, run by bourgeois profiteers, which ended with the rise of Napoleon and his coup of 18 Brumaire 1799.

The confusion of response from 1793 onward was the result of well-wishers either suffering disillusionment or speaking out with a new desperation; of Burke feeling vindicated while at the same time growing more fearful of the prospect; and of response intensified as a consequence of the French policy of extending the Revolution. The "eager and indiscriminate idealistic crusading" of the Girondins changed to the active military proselytizing of the Jacobins, the cynical "manipulation of satellite republics" by the Directory, and the outright conquests of Napoleon.[3] Unlike the English revolution (of 1642–49 or 1688), which was thought of by the English as "peculiar and local" and was never made for export out of England, the French Revolution embodied a universal threat. "The Revolution in France is certainly a forerunner to other Revolutions in Europe," Paine wrote to Burke as early as 1790,[4] and Burke believed him, relating the threat to the French (or philosophe or Enlightenment) need to generalize, universalize, and rationalize. Above all there were the French military victories from 1793 onward:

> Where her armies went, revolutionary institutions and revolutionary ideas had followed them, whether the governments of France wanted it or not. A new element of ideology had entered international life. Since 1792, when the Republic

3. R. R. Palmer, *The Age of Democratic Revolution* (Princeton, 1959, 1964), 2, 123.
4. 17 January 1790, in Burke, *Correspondence*, ed. Alfred Cobban and Robert A. Smith (Chicago, 1967), 6, 71.

announced in a famous decree that it offered friendship to oppressed peoples everywhere, the discontented of all lands had been able to look to an avenging and protecting power. From 1793 onward, that power was exporting revolution.[5]

As the sympathetic Thomas Emmet (brother of Robert) wrote from Ireland:

> Nor did such events [from which the Irish dissidents could take their cue] seem distant, for now the French arms were again emblazoning their cause with success and hiding in the splendour of their victories the atrocities of their government.[6]

The age has been called the Age of Revolution. For our purposes this means that there was a great hope and fear of revolution in one's own country, with many abortive revolutions and uncovered plots to prove it—and the need to explain the phenomenon. Burke, at his death in 1797, was so terrified of the possibility of invasion and revolution in England that he made plans for a secret burial to prevent the triumphant Jacobins from digging up his remains as Cromwell's had been in 1660.

In this phase plots and scenarios emerged, seeking to explain and understand the phenomenon. What was needed was some causality to account for the unprecedented events of 1789 to 1800: "simple explanations in terms of single causes [which] are easy to grasp." The most popular of these was the myth of the secret societies, embodied in the voluminous works of Abbé Barruel. "The scale and violence of the changes that men were called upon to account for soon seemed to exhaust all conventional and familiar categories of explanation."[7] And so the cause was found in the formation of secret societies such as the illuminati and the freemasons.

The story of the French Revolution ends only with the fall of Napoleon, by which time "the Revolution had become a subject of historical enquiry"[8] as well as of myth. This was the phase in which the subject was not the revolution proper but the question of Napoleon as hero or monster, as executor or executioner of the Revolution. The ambivalence was only deepened by the conservative reaction that followed his fall, summed up in the transition from Waterloo to Peterloo, which turned many of the English back into nostalgic sympathy for the Revolution.

5. J. M. Roberts, *Mythology of the Secret Societies* (London, 1972), p. 147.

6. W. J. MacNeven and T. A. Emmet, *Pieces of Irish History* (New York, 1807), p. 67.

7. Roberts, *Myth*, pp. 148–49; cf. Palmer, *Age of Revolution*, 2, 5. See also Jacques Godechot, *The Counter-Revolution Doctrine and Action 1789–1804*, trans. Salvator Attanasio (Princeton, 1981).

8. Hedva Ben-Israel, *English Historians and the French Revolution* (Cambridge, 1968), p. 72.

THE STORMING OF THE BASTILLE

The initial, and probably most influential, image picked up from Paris was the storming of the Bastille. As Burke noted, practically speaking the destruction of this old prison "was a thing in itself of no consequence whatever. . . . It could not contain any garrison sufficient to awe such a city as Paris. As a prison, it was of as little importance."[9] The actual attack had been to secure arms to protect the people of Paris against a suspected aristocratic repression, but once the building was taken and its handful of prisoners released, the symbolic import was recognized. The Bastille was razed, "creating in the heart of Paris a field of nature where the towers of tradition once stood."[10] Small images of the prison were made from the dismantled stones and disseminated to every department of France "to perpetuate there the horror of despotism,"[11] and in the empty space left by the prison was erected (in 1793) an enormous statue of Nature in the shape of a sphynx, out of whose "fertile breasts" spurted "an abundance of pure and healthful water."[12]

What one notices, however, is that as a historical referent the Bastille was hardly adventitious. The act of tearing it down and releasing "prisoners" was itself a literary fiction before as well as after the actual assault on the structure. The building may have been sought out more for a priori literary than for practical reasons, and certainly once it was taken literature called for its symbolic demolition and dissemination.

As a child in England in that July of 1789 the radical William Hone was told, "There's a revolution in France" and when he asked "What's a revolution?" the reply was: "Why, the French people in Paris have taken the Bastille, and hung the Governor, and let loose all the prisoners, and pulled the Bastille down to the ground."[13] That was a revolution.

The response was sometimes more personal. "I congratulate you on the demolition of the Bastille," Horace Walpole wrote the radical Hannah More in September 1789:

> I mean as you do, of its function. For the poor soul itself, I had no ill will to it: on the contrary, it was a curious sample of ancient castellar dungeons, which the good folks the founders took for palaces: yet I always hated to drive by it, knowing the miseries it contained. Of itself it did not gobble up prisoners to glut its

9. Letter to unknown correspondent, January 1790, in *Correspondence*, 6, 80.

10. Billington, *Fire in the Minds of Men: Origins of the Revolutionary Faith* (New York, 1980), p. 45.

11. J. Hillairet, *Connaissance du vieux Paris* (Paris, 1956), p. 12.

12. *Chronique de Paris*, 18 July 1793, in Ernest F. Henderson, *Symbol and Satire in the French Revolution* (New York and London, 1912), pp. 357–58, illus. 356.

13. Hone's memoir of his early life, quoted in Edgell Rickword, *Radical Squibs & Loyal Ripostes: Satirical of the Regency, 1819–21* (New York, 1971), p. 4.

maw, but received them by command. The destruction of it was silly, and agreeable to the ideas of a mob, who do not know stones and bars and bolts from a *lettre de cachet*. If the country remains free, the Bastille would be as tame as a duckingstool, now that there is no such thing as a scold. If despotism recovers, the Bastile will rise from its ashes—recover, I fear, it will. The *Etats* cannot remain a mob of kings, and will prefer a single one to a larger mob of kings and greater tyrants.[14]

One may smile at Walpole, the antiquarian whose ambivalence toward the fall of the Bastille is based on distinctions of function and form. But he represents the point of view of the conservative who could not deny the beauty of the act as well as of the building it destroyed. He already foresaw its consequences—the role of the "mob" and the predictive cycle from one tyranny to another even greater.

For an anonymous writer of the London *Times* in July 1789 the first sense of *revolution* was simply a release of some repressed natural force. There was the city of Paris, the center of the civilized world, out of which suddenly erupted a crowd of the unnumbered, unclassified poor. What an Englishman saw, with the model of the Gordon Riots of 1780 still in his mind, was an eruption, a lid blown off, an explosive gesture that liberates subconscious drives.[15]

The sequence, outlined in the 20 July issue of the *Times*, began with the mob breaking down tollgates, destroying the barriers and the books of the excise officers, "by which very large entries of goods passed without paying the revenue." Then they attacked the Bastille and released all the state prisoners. They took the governor and the commandant of the garrison to a place of public execution, "where they beheaded them, stuck their heads on tent poles, and carried them in triumph to the Palais Royal, and through the streets of Paris." Next they attacked the "Hotel de Ville, or Mansion-house," and took the Prévot de Marchand, or Lord Mayor" (the *Times* insists on the English parallels), who were beheaded and their heads exhibited.

The images that first came out of France then are of the destruction of prisons and state buildings, the beheading and exhibiting of officials' heads on tent poles, followed by the report that offers are being made for the queen's head and by the even worse imaginings of the *Times* correspondents: "one man tearing from the mangled body of another pieces of flesh,

14. Walpole to Hannah More, September 1789, *Correspondence*, ed. Paget Toynbee (London, 1903–05), 14, 208. Cf. William Cowper, *The Task*, bk. V, ll. 379–92 (1784), and Coleridge, "Destruction of the Bastille" (1789).

15. London *Times*, 20 July 1789: " . . . we have all seen and felt the sad effects of an unlicensed populace in our own country, at the time of that dreadful conflagration in London during the riots of 1780." See *The Times Reports the French Revolution* (London, 1975).

and dipping the same into a cup, which was eagerly drained by the executioners. . . ."

The crucial donnée is the fact that France was the most advanced center of European civilization, still leading the way in the arts and sciences. The most populous state in Western Europe and in many ways the most powerful and dangerous, it was both model and bête noire of the English. Above all, it was the most imitated of all European countries; and so, by implication, anything France did, soon England—and Italy and the Netherlands—would also do.

Sympathizers, even after suffering disillusionment and reaction, could look back with awe on those early days. Robert Southey recalled that "few persons but those who have lived" through the 1790s "can conceive or comprehend . . . what a visionary world seemed to open upon those who were just entering it. Old things seemed passing away and nothing was dreamt of but the regeneration of the human race."[16] The most famous such expression was Wordsworth's "Bliss was it in that dawn to be alive, / But to be young was very heaven," with "young" an operative word. These were *young* people who were experiencing with special delight the emergence of other young people recreating their destiny in France.

In 1790 Sir Samuel Romilly recorded his immediate response:

> Who, indeed, that deserves the name of an Englishman, can have preserved a cold and deadly indifference, when he found a nation, which had been for ages enslaved, *rousing on a sudden from their ignominious lethargy, breaking asunder their bonds*, and, with an unanimity which has no example in history, demanding a free constitution: when he viewed all the *fortresses of tyranny destroyed*; when he saw the *dungeons of state thrown open*, and the *prisons of superstition unlocked*; when he beheld the Asiatic despotism of the king, and the feudal tyranny of his nobles at once abolished. . . .[17]

As my added emphasis suggests, the passage is full of the obvious equivalents of revolution—the metaphors that at first spring to mind but that also follow naturally from the specific historic event of the storming of the Bastille—"such a scene," as Romilly called it (anticipating both Burke and his answerers). France was, he continued, "a kingdom, which the *darkest superstition* had long overspread, and which had been the theatre of the most bloody persecutions," and against this now "the bright prospect of universal freedom and universal peace was just *bursting on their sight.*"

Joseph Priestley in 1791 saw both American and French revolutions as moving the world "from darkness to light, from superstition to sound

16. *The Correspondence of Robert Southey with Caroline Bowles*, ed. Edward Dowden (Dublin, 1881), p. 52.

17. Romilly, *Thoughts on the Probable Influence of the French Revolution on Great-Britain* (London, 1790), pp. 2–3.

knowledge and from a most debasing servitude to a state of the most ex-alted freedom."[18] It was this sense of light which Laetitia Barbauld em-ployed in her address of 1790 to her conservative countrymen:

> We appeal to the certain, sure operation of increasing light and knowledge, which it is no more in your power to stop, than to repel the tide with your naked hand, or to wither with your breath the genial influence of vegetation. . . . The spread of that light is in general gradual and imperceptible; but there are periods when its progress is accelerated, when it seems with a sudden flash to open the firma-ment, and pour in day at once.[19]

Barbauld combines the light of knowledge with the irresistible forces of nature, using light to express again the irreversible moment of change.

If the sunburst was an automatic equivalent, still however not dissociated from diurnal routine, other images implied a total break in the natural cycle. Mary Wollstonecraft's writings are a mine of such images. She refers to the "violent convulsions" of 1789 in France "which, like *hurricanes* whirling over the face of nature, *strip off* all it's blooming graces." Such measures are taken that "at once root out those deleterious plants, which poison the bet-ter half of human happiness." She also refers to "the rumblings of the ap-proaching *tempest*" and "the gathering *storm*." She is of course writing in her *Historical and Moral View of the Origin and Progress of the French Revolution* (1794) with the vocabulary of Burke and Paine (strip off, root out, "pity the plumage and forget the dying bird"), already a kind of lexicon upon which to draw. But her most basic and automatic images need no such conven-tional authority, as when she writes, finding the image of Pandora's box no longer adequate, of the "people": "unable to endure the increasing weight of oppression, they rose like" —searching for an analogy—"a vast elephant, terrible in his anger, treading down with blind fury friends as well as foes."[20]

18. *Letters to the Right Honourable Edmund Burke* (1791), letter 14.

19. *Works of Anna Laetitia Barbauld*, ed. Lucy Aiken (1825), 2, 355–77. There was even a historical event of relevance—the eclipse of the sun which took place near noon on 5 Septem-ber 1793 as the Paris crowds were preparing to march on the Convention. They merely laughed and joked at the phenomenon. "It is significant that the Parisians laughed," writes R. R. Pal-mer. "The grandfathers of these same men would probably have been struck with fear. They would perhaps have seen in the darkness a sign of God's disapproval, abandoned their purpose, and either crept back into their homes or rushed headlong into the churches. The men of 1793 simply stood, stared, exchanged a few witticisms and proceeded with their business. After fifty years of the Age of Enlightenment even men in the street, uneducated though they might be, saw in the eclipse a mere phenomenon of nature." There is the further irony that this day was also the first day of the so-called Reign of Terror, which was intended (as Palmer says) as "an attempt to force a new enlightenment upon the country." (See Palmer, *Twelve who Ruled* [Princeton, 1941], pp. 44–45.) For Goya's response to the symbolism of light, see below, pp. 343–57.

20. *Historical and Moral View of the Origin and Progress of the French Revolution* (1794), pp. 70–71, 84, 87, 32.

Of the images that follow from the storming of the Bastille, I will mention at this time only that of the crowd and the burst of light out of darkness. Conservatives as well as supporters of the Revolution saw a precedent for what was happening in Paris in the organized (or unorganized) mob of the 1780 Gordon Riots, which carried out roughly the same schedule of destroying a prison and the property of the ruling class, employing violence, and administering summary justice to officials of the state. The rioters systematically burned the Fleet, Newgate, and King's Bench prisons, freeing 2,000 prisoners onto the streets of London, and went after other symbolic state buildings. Thirty-six separate fires were visible in one night. This was the context in which many English people naturally saw the events of 14 July 1789.

The crowd became a distinct force and threat with the reformers' "associations" of the 1770s. The associations, inspired by the Irish associations, were primarily the work of Christopher Wyvil in Yorkshire, and they qualify as a quasi-revolutionary organization because they held large meetings (a kind of secular Methodism) and because their message to the ruling class was that assemblies of private individuals, forming spontaneously throughout the land, were more representative than Parliament. These meetings pretended to be truer spokesmen of the people's wishes than Parliament and to have the power to take binding action. They introduced the issue of sovereignty, or representation of the people, which continued to be the chief one until the Reform Act of 1832. These extraparliamentary associations being formed in 1779 were self-created assemblies aimed at overruling the official legislature, or at least at overthrowing Parliament. In this sense they were an extension of the old English crowd of the Skimmingtons and Charivaris and "bread riots" by way of the greater organization of the Wilkite crowds of the same decade. Indeed the threat of the Wilkite crowd seemed about to come true when Wyvil and his friends threatened to produce a "General Association"—a "national convention" or "second Runnymeade." All these plans came to ruin by the violence of that ultimate "association" called the Gordon Riots, but the whole specter arose again in 1789.

Light struggling against the dark is the import of many of Mary Wollstonecraft's characteristic passages in her *Vindication of the Rights of Men* (1790). She refers to

> the dark days of ignorance, when the minds of men were shackled by the grossest prejudices and most immoral superstition. And do you, Sir [addressing herself to Burke], a sagacious philosopher, recommend night as the fittest time to analyze a ray of light? . . .
>
> Sacred be the feelings of the heart! concentred in a glowing flame, they become the sun of life: and, without his invigorating impregnation, reason would prob-

ably lie in helpless inactivity, and never bring forth her only legitimate off-
spring—virtue.[21]

Later, in her *Historical and Moral View*, she notes that the writings of Voltaire
and Rousseau, the policies of Turgot, the teachings of the philosophes and
Physiocrats, and all

> the irresistible energy of the moral and political sentiments of half a century, at
> last kindled into a blaze the illuminating rays of truth, which, throwing new light
> on the mental powers of man, and giving a fresh spring to his reasoning faculties,
> completely undermined the strong holds of priestcraft and hypocrisy. . . .[22]

These passages contain the complex imagery often encountered in the years
following 1789, energy-fire-illumination of dark areas combined with the
suggestion of returning spring and fruition. As she goes on, "when men
once see, clear as the light of heaven," all will be well.

She draws on the basic transvaluation of the French of light/dark that
followed from the sun's being the source of light, warmth, and power, as
God and therefore as his vice-regent the king. At the outset of the eigh-
teenth century Louis XIV surrounded himself with the imagery of Apollo
and called himself the Sun King. Around the middle of the century, by the
kind of transvaluation we associate with revolutions, the sense of light was
shifted by the philosophes to individual human reason, to the "Enlighten-
ment," and the king and church became the darkness (and so ignorance)
which the light attempts to penetrate and dispel. Or perhaps we should say
that the philosophes, *les lumières*, grafted onto the sun as God the icono-
graphical tradition of the sun as Truth chasing away the shadows of the
mind (out of Ripa's *Iconologia*).

But the Bible also offered passages that were a direct alternative to the
royal metaphor, from the prophets who were opposing the kings of Israel
to the fulfillment of their prophecies in the First Coming (there was a ten-
dency to skip the tradition of Jehovah as sunlight, divine wrath, and sheer
power): "The people which sat in darkness saw great light; and to them
which sat in the region and shadow of death light is sprung up" (Matt.
4.16), and the great light is of course Christ, the "light of the world" (5.14–
16) come to redeem fallen, self-imprisoned man. "But if thine eye be evil,
thy whole body shall be full of darkness. If therefore the light that is in thee
be darkness, how great is that darkness" (6.23). And that "light" of the Sun
King was of course recognized and reinterpreted as "darkness," and the
most commonplace set of associations during the Revolution revolved around
this contrast of light-enlightenment-reason-freedom versus darkness-ig-

21. Wollstonecraft, *Vindication of the Rights of Men* (1790), facsimile ed. Eleanor Louise Ni-
choles (Gainesville, Fla., 1960), pp. 19, 70.
22. *Historical and Moral View*, p. 12.

norance-imprisonment, which were at least in England strongly associated with New Testament redemption opposed to Old Testament cruelty, oppression, and darkness.

Thomas Paine always wants to place his views "in a clearer light," wants us "to possess ourselves of a clear idea of what government is, or ought to be," as opposed to the obscurity and rhetoric of Burke; Wollstonecraft argues that "True morality shuns not the day"; and in James Mackintosh's words, "we cannot suppose, that England is the only spot that has not been reached by this flood of light that has burst in on the human race." And when the Revolution inevitably disappointed these sanguine expectations, we hear Hazlitt referring to the hopes for kind feelings and generous actions which "rose and set with the French Revolution. The light seems to have been extinguished for ever in this respect." [23]

SERIES, SEQUENCES, AND PLOTS

Revolution, to begin with, is change, but unlike any other form of change. It is, as George S. Pettee has said, "the most wasteful, the most expensive, the last to be chosen; but also the most powerful, and therefore always appealed to in what men feel to be a last resort." [24] Whether as the consequence of a human action or as something beyond human control, the natural, the conventional order of events is in danger of being altered. Pandora opens her box, Prometheus steals fire; the darkness turns to light, or the still volcano erupts. Then Pandora slips away (hope remaining in the bottom), Prometheus is punished, light turns again to darkness and the volcano subsides, or the sun never sets and the light and fire merely intensify.

At the end of the Revolution in 1798 Thomas Malthus cited the men who believed it "a period big with the most important changes, changes that would in some measure be decisive of the future of mankind." But "the great question," he adds, is

> whether man shall henceforth start forward with accelerated velocity towards illimitable, and hitherto unconceived improvement; or be condemned to a perpetual oscillation between happiness and misery, and after every effort remain still at an immeasurable distance from the wished-for goal. [25]

From the position of the man with the hard sad facts of population growth, sexual desire, and food supply, Malthus looks down on the drama of the

23. Paine, *Complete Writings* (New York, 1900), 1, 277, 278; Wollstonecraft, *Vindication of the Rights of Men*, p. 131; Mackintosh, *Vindiciae Gallicae* (1791), p. 345; Hazlitt, from *The Memoirs of Thomas Holcroft*, in *Collected Works*, 2, 155.

24. *The Process of Revolution*, p. 96.

25. *Essay on the Principles of Population* (1798), ed. James Bonar (New York, 1965), pp. 2–3.

Revolution and the claims of its proponents that it contributed to the grow-
ing perfectibility of man.

Progress is the most sanguine metaphor used by the French themselves,
and most notably by Condorcet. The idea of progress had widened from
accumulation of human knowledge to "include governments, economies,
social institutions of all types, even morality and human happiness," and
therefore certain sorts of freedom.[26] From the battle of the Ancients and
Moderns and Bacon's *Advancement of Learning* onward, one line of thought
argued that progress is the normal process of nature. A corollary was there-
fore the Physiocrat model, which announced that the task of the statesman
was merely to remove obstructions to this natural progress. The encrusta-
tions of convention have to be removed for nature to carry on its normal
growth. Whether for a plant or a human body, the process of healthy de-
velopment involves cropping, removing swaddling bands or corsets, and
allowing an organic fulfillment.[27] Listing the nine stages of development
from past to future, Condorcet repeatedly underlines the barriers, stop-
pages, and hurdles that impede progress. It becomes clear that the only way
to regain nature's "free and uninterrupted flow" is "the obliteration of ob-
structing institutions" and "artificial circumstances" that are diverting its
natural movement—"the way of revolution, of total destruction of the ex-
isting social order."[28] The French Revolution was the only solution, and the
first evidence that mankind at long last was freeing itself from these ob-
structions, opening up a near future of liberty, equality of opportunity,
democracy, and universal education. At the time, however, this model
was remarkably optimistic and ill-fitting to the actual circumstances of the
Terror.

But progress was also a revolutionary metaphor in the sense of its new-
ness and strangeness. The most ancient metaphors of change were based on
the cycle of the plants and the human cycle, on the myths of Persephone's
contract with Pluto and Demeter's yearly changes from mourning to re-
joicing—and even further back on the rituals of the old king, the new, and
the wife-mother. The basic mythos of tragedy or comedy, with the dichot-
omies of youth and age, birth–death, and rise–decline, has always been used
by man to keep mutability under control. Progress was one deviation from
this basic metaphor, and for that reason ominous.

26. See Robert A. Nisbet, *Social Change and History: Aspects of the Western Theory of Devel-
opment* (New York, 1969), pp. 139–58.

27. See Adam Smith, *Wealth of Nations* (1776), and looking back to Fielding, Paulson, *Pop-
ular and Polite Art in the Age of Hogarth and Fielding* (Notre Dame, 1979), pp. 172–74.

28. Nisbet's words, pp. 117, 143. Referring to the Enlightenment-Physiocrat model: "And
it was this aspect [the need to remove obstructions], of course, that in the eighteenth century
was to make the theory of progress such a marvellous ally for those concerned with revolu-
tionary overthrow of existing institutions" (p. 113).

As Northrop Frye has noted, there were two great intellectual crises before the twentieth century.[29] The Newtonian separated mythological from natural space, but far more revolutionary, in both special and political senses, was the crisis he calls the Darwinian, which separated mythological from natural time. This was under way long before Darwin and in fact followed naturally in the general secularization process which was the decline of religious belief. First there was a secularization of man-centered space into one of natural laws to which human creation was subordinated; and second a secularization of time, which questioned the whole sense of man's development in time and his relationship to his rulers. The first involved a spatial representation, a picture, while the second involved a progression in time—a series, a sequence, or a plot. The first could remain metaphysical and might shake religion to its foundation, but the second, more dangerous was full of political overtones as well.

We see emerging from the events of the French Revolution a new sense of the way one action or event follows another—a new sense of plot or sequence and new examples of serial structure. As we have already seen, one sequence involved the relationship between word and action. Much of the significance of the French Revolution to the English was verbal, hinging on the meaning of the word *revolution* and other words of the sort to which Thucydides referred that are reinterpreted or made new in times of revolutionary stress. Words may always have different meanings, but in a time of revolution everyone becomes aware of a peculiar phenomenon of a piece with the larger one of political and social change. The strategy of the Fifth Monarchy Men in the mid-seventeenth century was to go to a market town and make a proclamation—to utter words, as they said, "and so to dispose and disperse the Declarations among the country people, who will carry and spread them abroad, so that it will leave a seed sowne."[30] In the same way, the pronunciamiento became the standard way of carrying out a revolution in nineteenth-century Spain. Action was necessarily preceded by words. The actions fulfilled the words—as one school of thought argued that the French Revolution fulfilled the words of the philosophes, of Voltaire and Rousseau, and another that the more horrific stages of the Revolution were produced by the prophecies of Burke's *Reflections*.

The word *revolution* now projected certain abrupt, broken, and unpredictable sequences of events. It was not always so. The original naming of the word was astronomical, referring in both Latin and the vernacular to the rotation of bodies (as in Copernicus's *De revolutionibus orbium coelestium*

29. Frye, "Expanding Eyes," *Critical Inquiry*, 2 (1975), 207.
30. Champlin Burrage, "The Fifth Monarchy Insurrections," *English Historical Review* (Oct. 1910), p. 723; cited in Lasky, p. 283.

of 1543): a circular motion returning to its point of origin.[31] Thus the "Glorious" Revolution of 1688 was a *revolution*, indeed *the* English revolution, because it removed a usurping tyrant in order to restore ancient liberties, expelling James II in order to return a "constitutional" monarch William III. The *revolution* of 1660 removed the usurping Cromwell in order to restore the rightful monarch Charles II. The upheaval of 1649, on the other hand, was the great *rebellion*. In his *Dictionary* (1755) Samuel Johnson was still defining *revolution* in its astronomical sense, and when he turned to its political sense, "Change in the state of a government or country," he connected it to the regularity of all his other senses ("Rotation; circular motion," or even "Motion backward") and with the Glorious Revolution of 1688, "the change produced by the admission of king William and queen Mary."

Revolution then was only an astronomical confirmation of human and plant cycles, but its regularity allowed for variant interpretations. One was the repetition of events and acts, or general types of them, over the centuries; another was a large pattern of movement from genesis to decay and back, from a primitive simplicity to increasing complexity, which leads to its own "dissolution in some great catastrophe," and then begins the process all over again.[32] For example, the metaphysical cycles of Vico or the satiric ones of Dryden (in *The Medal*) move from gods or kings to aristocratic leaders and thence to the people, but at that point the cycle is renewed by a necessary return to the king. There was no precedent for a permanently successful democracy; it seemed apparent that the people could never recover the authority they had projected (or God had bestowed) on others than the monarch.

The basic struggle over the word *revolution* came in the seventeenth century with its trial revolutions/rebellions, each in its way a rehearsal for the great one a century later. The conflict lay between the strictly astronomical sense of repetition, a full circle, and the sense of a single *revolution* as an overthrow, a half-circle, a disruption, and so an irreversible change. Already in Swift's *Tale of a Tub* (1704), a book about forms of mental, political, religious, and social subversion, the word *revolution* is used to refer to an enthusiast's overturning of his brain or of the state (which may build upon such uses as James Howell's to mean "a change of Masters.")[33]

31. On the word *revolution*, see Karl Griewank, "Emergence of the Concept of Revolution," trans. and ed. Heinz Lubasz, in his *Revolutions in Modern European History* (New York, 1966), pp. 55–61; Peter Calvert, *Revolution* (London, 1970), pp. 69–73; Raymond Williams, *Keywords: A Vocabulary of Culture and Society* (New York, 1976), pp. 226–30; Melvin J. Lasky, "The Birth of a Metaphor," in *Utopia & Revolution* (London, 1976), pp. 219–59. Also useful is Perez Zagorin, *The Court and the Country: The Beginning of the English Revolution* (New York, 1969), pp. 13–16.

32. Nisbet, p. 38; see pp. 33–41.

33. *Epistolae HO-ELianae: the Familiar Letters*, ed. Joseph Jacobs (1892), 2, 687.

Henry More, whose *Enthusiasmus Triumphatus* (1656) was one of Swift's models in the *Tale*, wrote about the relationship of religious, poetical, and political enthusiasm to such equivalents as inebriation and *revolution* itself, which he said was one of those new words whose reinvention or perversion by the enthusiasts was to be deplored. Along with other words (revolt, rebellion, overturn, tumult, sedition, civil war) it was being used to describe a sudden and radical political change, which might therefore be materialized in action. This sense of governmental overthrow was used by John Wilkes in 1763 when he wrote from Paris: "The distress in the provinces is risen to a great height, though Paris is as gay as usual. The most sensible men here think that this country is on the eve of a great revolution." [34]

Even then the word, though designating upheaval and political insurrection, for Wilkes retained its sense of circularity. "It is perhaps a sign of the genius of the English language and character," Melvin J. Lasky concludes, making a central point of his *Utopia & Revolution*, "that revolution, even at a time of violence and rebellion, should have gone by the name of reform"—for it retained essentially that sense among most English people, basically empirical folk unaffected by the rationalist French genius. [35] It took a Napoleon to rail (on his death bed) against those with "their English notions" who saw in revolution "a mere reform of abuses," while refusing to admit that "it constituted, all in itself, a complete social rebirth." [36]

Burke was the first English writer to use the sense of the word accepted by Napoleon. Unlike his fellow Englishmen, who used the older and more favorable sense of *revolution* at least until the September Massacres and the regicide in 1792–93, Burke makes clear that in his *Reflections on the Revolution in France* (1790) the word carries the new sense of a large violent upheaval from below that brings about a restructuring of society. Blake then, when he wrote his poem *The French Revolution* (1790), retained Burke's transvalued word in order to preserve the old meaning: France was returning to its ancient liberties, turning its absolute monarchy into a constitutional monarchy, as even Louis XVI realizes when he remarks that "the ancient dawn calls us / To awake from slumbers of five thousand years" (ll. 7–8).

Burke carried the day with his redefinition. Whereas few English writers thought of more than reform at home, they were very aware of *revolution* abroad. Napoleon's jibe reflects the attempts of writers in France, even when during the Empire it was as delusive a word as *reform* in England, to turn

34. *The Correspondence of John Wilkes and Charles Churchill*, ed. Edward H. Weatherby (New York, 1954), p. 64.

35. Lasky, pp. 514–15.

36. *The Mind of Napoleon*, ed. J. Christopher Herold (New York, 1955), pp. 251–56.

revolution from its sense of circular into a linear or an irregular progress but one carrying with it the idea of irreversibility. If Napoleon meant "a complete social rebirth," which included the royal family of Bonapartes, another form the irreversibility took was derived from the fact that revolutionaries of the 1790s had called at every stage of rest for a further extension of the revolution—for "a truer and deeper fulfillment," for a "grand climax" to follow what was so far only prelude."[37]

Some ideas of circularity were never lost. One was a return to the time before men were dispossessed of their rights and freedoms—in Babeuf's words, "the aim of revolution is to take us back to the aim of society, of which we have lost sight." Another was the seeming return in the empire of Napoleon to the reign of a Louis XIV—or in the Committee of Public Safety and the Terror to a repression hardly dreamed of during the ancien régime, and with Thermidor and the Directory to a conservatism and cynical opportunism easily related back to the period before 1789. This motion appeared to be a simple overthrow of 180 degrees which inevitably (as the cynics would say) goes on to a full circle and a return to tyranny. *La plus ça change la plus c'est la même chose.*

We could list other categories of metaphor based on forms of natural (and unnatural) change, but I will only make the general point that these stereotypic images derive from no single source. Lasky and other writers note that to describe revolution one naturally turns "to the elemental forces of nature," but these tempests, hurricanes, eruptions, let alone the appearance of the sun from behind clouds, are all literary references, mostly from the Bible, which conditioned the way people looked at nature.[38] We have already seen them mediated through the vocabularies of the French Physiocrats and the English laissez-faire economists, and we shall see them evoking aesthetic categories of the time, primarily the sublime and beautiful.

The juxtaposition of Gilbert White's natural and political observations was also probably determined by passages like the one in Ecclesiastes that begins "To every thing there is a season": "A time to be born, and a time to die; a time to kill, and a time to heal; a time to break down, and a time to build up. . . ." Even Burke's famous phrase for the French people, "swinish multitude," presumably referred to the Gadarene swine who were possessed by devils (e.g., Matt. 8.30–32). The earthquakes of Lima, Lisbon, Calabria, and Sicily were existential facts, but they were seen as presages in relation to what was happening in France because of the prophecies in the Books of Daniel and Revelation, the great analogues used by pro- and antirevolutionists in England and certainly felt in every prophetic page of Burke's

37. Quoted by Lasky, *Utopia & Revolution*, p. 275.
38. Lasky, *Utopia & Revolution*, p. 70.

attacks.[39] If the "speech, passions and illusions" of the Civil War were adopted from the Old Testament (as Marx said), so also in the 1790s, except that it was now the Old Testament prophets who pointed toward the Gospels, the First Coming, which promised them an imminent Second Coming, and so above all toward the Book of Revelation.

The one traditional view of history that implied both circularity and forward motion was the Biblical, which was, however, a single cycle moving upward to a resurrection: from Adam's sin to Christ's redemption and a paradise of *new* creatures. Revelation's "And I saw a new heaven and a new earth. . . . And he that sat upon the throne said, Behold I make all things new" (Rev. 21.1, 5) is the paradigm of much revolutionary writing in England. As thus reinterpreted, the Christian myth was a model that included sin and death but also resurrection, reincarnation, and redemption, both another chance for faltering mankind and for a new world. It also, as both the case of France and the case of Ireland from the eighteenth century to the present show, saw action as deriving from martyrdom, the Tree of Liberty watered with the blood of martyrs.

The sentiment of Pierre Gaspard Chaumette in the National Convention, September 1793, "Let [the forming of an army] be followed by a terrible and incorruptible tribunal and by the fatal instrument which cuts off at one blow both the plots and the days of their authors," echoed both the Physiocrat sense of removing an obstruction and the guillotine's of beheading.[40] But it was in the King James Bible that the English read that not only does David run "and cut off Goliath's head" but the Lord "hath cut off the enemies of David from the face of the earth"; Israel is to be "cut off" for its sins, every male in Edom is to be "cut off" (literally circumcized and/or beheaded), and Jeraboam's house is to be "cut off."[41] "Cut off" carried a more powerful sense in England than in France, where beheading was the normal mode of execution (the last beheading in England had been in 1746).

It was in the light of the Old Testament prophecies and the New Testament fulfillments that many English men and women looked at the actions and the sequence of events across the channel. What was an automatic response for many, however, was a vocabulary of revolution for others. What Christopher Hill has called the heretical subculture represented a repressed vocabulary, an underground set of words and ideas, with their own partic-

39. For these earthquakes seen as the result of man's sins, see the *Gentleman's Magazine*, 66 (1789), 933–94. In Gilbert White's passage, see also his memory of the lines: "For lo, the winter is past, the rain is over and gone; the flowers appear on the earth; the time of the singing of birds is come, and the voice of the turtle is heard in our land" (Song of Songs 2.11–12).

40. Quoted in Wilfred B. Kerr, *The Reign of Terror, 1793–94* (Toronto, 1923), p. 84.

41. The Biblical passages are from 1 Samuel 17.51, 24.21; also 1 Kings 9.7, 11.16, 13.34, 14.14; "Him that pisseth against the wall" will be "cut off," 14.10, 21.21; "The wicked shall be cut off from the earth, and the transgressors shall be rooted out of it" (Prov. 2.22).

ular meanings, which were ready to hand for revolutionary movements in 1789.[42]

Even the metaphor of 180-degree turning carried the force of the words the Fifth Monarchy Men quoted from Ezekiel (21.27): "Overturn, overturn, overturn," from the passage that begins: "Thus saith the Lord God; Remove the diadem, and take off the crown: this shall not be the same: exalt him that is low, and abase him that is high" (v. 26). The metaphor that had been established in the seventeenth century for the English was the overthrow of the Beast and the coming of the fifth and final monarch predicted by Daniel. They drew on the Bible (not the Physiocrats) for their imagery of overturning rotten structures and floods and fires to destroy the old and bring about the new.

On the other hand, the revelation projected by Christ in the twenty-fourth chapter of Matthew could be read by counterrevolutionaries as the coming of Anti-Christ, a Robespierre or Napoleon: "For many shall come in my name, saying, I am Christ; and shall deceive many." The extension of revolution into war follows: "And ye shall hear of wars and rumors of wars: see that yet ye be not troubled: for all these things must come to pass, but the end is not yet. For nation shall rise against nation, and kingdom against kingdom: and there shall be famines, and pestilences, and earthquakes, in divers places." At length there will be darkness and the "great sound of a trumpet," and the angels "shall gather together his elect from the four winds, from one end of heaven to the other." But whatever the interpretation, the concept of a division of sheep from goats and the survival of an elect remains, and both revelation and revolution imply both destruction and renewal. The Bible made people see nature and natural or social phenomena according to its metaphors, and revelation was one metaphor, in England at least, for the process of the French Revolution.

In many ways, of course, the English reformers who thought about the Revolution preferred to see it as not a continuation but a disruption of Biblical categories. Mary Wollstonecraft operated in much the same way as Blake, seeing the Revolution as summed up in the overthrow of old mythologies, which in effect she repudiates and then transvalues. In her *Historical and Moral View . . . of the French Revolution* she writes:

> We must get entirely clear of all the notions drawn from the old traditions of original sin: the eating of the apple, the theft of Prometheus, the opening of Pandora's box, and the other fables, too tedious to enumerate, on which priests have erected their tremendous structures of imposition, to persuade us, that we are naturally inclined to evil . . . [p. 17]

42. See Hill, *The World turned Upside Down: Radical Ideas during the English Revolution* (New York, 1972); also Clark Garrett, *Respectable Folly: Millenarians and the French Revolution in France and England* (Baltimore, 1975).

In the *Vindication of the Rights of Woman* she introduces all these basic myths of how evil was introduced into the world: from "the box of mischief thus opened in society" to man "as a lawless planet darting from its orbit to steal the celestial fire of reason; and the vengeance of heaven, lurking in the subtile flame, sufficiently punished his temerity, by introducing evil into the world" (pp. xi, 30).

These were the stereotypes, the conventional symbolization resorted to by the antirevolutionists: the explosion, the release of the repressed, the volcanic eruption from the perspective of Pandora's box or Prometheus's theft of fire. If the emphasis was on Prometheus rather than his noble theft, the result was a tyrant-hero like Robespierre who suffers for his presumption, leading to the ultimate Promethean figure, Napoleon. The supporter of the Revolution placed the emphasis on the noble theft, but Wollstonecraft went even further and, no longer seeking a transvaluation of the old myths, sought a "historical" account which was *un*mythical. She tried to put her emphasis on the natural phenomenon, the unique historical reality, for example, the "people," although not without resort to similes that were a confusion of the new and old. Even the "vast elephant, terrible in his anger, treading down with blind fury friends as well as foes," which is the best she can come up with to describe the "people," is probably a translation of the Biblical Behemoth (Job 40.15).

Wollstonecraft is merely attempting to draw our attention to the fact that the historical events themselves produced a particular story or plot, falsified by metaphors of original sin and redemption, seasonal change, or Pandora's box. A contemporary had no choice but to take into consideration the actual phases of the Revolution, its development as a process in time. Plot was never quite the same again. The events and actions of the Revolution made possible certain kinds of literary (and indeed existential) schemes. Initially, the most striking and original elements focused on beginnings that broke bounds and exploded forms, effecting an open-ended plot. But some observers, following the Revolution to the bitter end, saw sequences broken and unpredictable, without beginning, middle, or end. For others the plot had now assumed a form that was asked to be regarded in conventional literary terms of tragic, comic, or tragicomic denouement, of full circle or anticlimax.

Analogies between the events of the Revolution and tragic or indeed tragicomic drama as well as Biblical stories sought to convert the distasteful mutations of the Revolution into natural causes. The analogy with nature indicates most clearly what displacement was sought. The fiction of light or natural energy replaced the actual human violence of subject against subject against king. Images of tempest, eruption, and fire stood for, or screened, a human violence less easy to face. But as the Revolution progressed and the violence in Paris escalated, the images of Revolution appeared as reiter-

ations of the very violence they sought to replace. Those natural conflagrations served as analogues to more monstrous acts on the human level.

History books were the final repositories of these human formulations. The chief retrospective fiction developed in England by the Tory historians (and by reformed enthusiasts of the Revolution's early phase) was that revolutionary violence inevitably leads to military despotism; revolutions are started by the elite itself, by the nobility, and then are taken over by the middling sort and finally fall into the hands of those "awkward butchers" (Byron's words) the masses—slipping increasingly out of human control into instincts that can hardly be distinguished from natural forces. The early leaders are good men such as Lafayette or Roland, but the early leaders are also the revolution's first victims, and leadership is usurped by a Marat and a Robespierre. Initial and moderate revolutionary success opens the door to all sorts of excesses by the factions and turbulent elements of society that it unleashes.[43]

43. See Ben-Israel, *English Historians and the French Revolution.*

CHAPTER 3 ❦
BURKE, PAINE, AND WOLLSTONE-CRAFT: THE SUBLIME AND THE BEAUTIFUL

Burke's first response to the Revolution, written on 9 August 1789, adopts the metaphor of art. He expresses his "astonishment at the wonderful Spectacle": "what Spectators, and what actors! England gazing with astonishment at a French struggle for Liberty and not knowing whether to blame or to applaud!" At once, however, he detects "something in it paradoxical and Mysterious" because, in the act of destroying the Bastille with a "spirit it is impossible not to admire," he sees that "the old Parisian ferocity has broken out in a shocking manner."[1] This passage was echoed near the beginning of his mature thoughts on the subject, *Reflections on the Revolution in France* (1790):

> In viewing this monstrous tragic-comic scene, the most opposite passions necessarily succeed, and sometimes mix with each other in the mind; alternate contempt and indignation; alternate laughter and tears; alternate scorn and horror.[2]

By this time Burke's ambivalence had settled on the matter of whether the Revolution was a continuation of old revolutions—the English Civil War, not of course the Glorious Rebellion of 1688, which some of his colleagues liked to see as its analogue—or something absolutely and appallingly new. He starts off his *Reflections* with the metaphors of English radical dissent seen through the eyes of his literary mediator, Swift's *Tale of a Tub*. The

1. To Lord Charlemont, *Correspondence*, ed. Alfred Cobban and Robert A. Smith (Chicago, 1967), 6, 10.
2. *Reflections on the Revolution in France* (1790), ed. William B. Todd (New York, 1959), p. 9. Cf. both Gilbert White's passage in his journal (above, p. 1) and Ecclesiastes 3.4.

"spirit of liberty" is a "wild gas," and once "the fixed air is plainly broke loose," Burke writes, "we ought to suspend our judgment until the first effervescence is a little suspended, till the liquor is cleared, and until we see something deeper than the agitation of a troubled and frothy surface."[3]

Burke's argument is determined less by logic than by a Swiftean chain of association that links Richard Price's Revolutionary Society speech (which set him off) with the dissenters, their incendiary sermons, illumination and zeal, divine afflatus, the regicide Reverend Hugh Peters, memories of the Civil War, and the "leading in triumph" of King Charles I. The last becomes the type of (or analogue for) the conveyance of Louis XVI to Paris by the crowd, with (to complete the parallel with Charles I) the element of predictability or prophecy in the inevitable execution that lies ahead, and also the Augustan (Popean as well as Swiftean) evocation of the *Via Dolorosa* of Christ in the description of how the king and his queen "had been made to taste, drop by drop, more than the bitterness of death, in the slow torture of a journey of twelve miles, protracted to six hours. . . ."[4]

But this is the climax of various interlocking series of images. The Swiftean metaphor of body-clothing is energized on the third page with French society now revealing itself "stripped of every relation, in all the nakedness and solitude of metaphysical abstraction." The Enlightenment metaphor of bright and undeflected light intertwines with Burke's own distinctive metaphor of organic growth. The imagery of light and dark of course plays a large part in Swift's *Tale*, and like Swift Burke begins with the words of the enemy, the source of his own transvaluation of the image. For he is reacting against the metaphor formulated by Richard Price shortly after the fall of the Bastille, addressed to the "friends of the Great and Glorious Revolution of 1688":

> I see the ardor for Liberty catching and spreading. . . . Behold, the light you have struck out, after setting America free, reflected to France, and there kindled into a blaze that lays despotism in ashes, and warms and illuminates all Europe! Tremble all ye oppressors of the world! . . . You cannot now hold the world in darkness. Struggle no longer against increasing light and liberality.[5]

3. Cf. Swift, *Tale of a Tub* (1704), ed. A. C. Guthkelch and D. Nichol Smith (Oxford, 1958), pp. 215–16. Burke recalls the well-known passage in the *Tale* where the Grub Street Hack posts the works of modern writers and shortly after returns to find them all gone: "Who, born within the last forty years, has read one word of Collins, and Toland, and Tindal, and Chubb, and Morgan, and that whole race who called themselves Freethinkers? Who now reads Bolinbroke? Who ever read him through? Ask the booksellers of London what is become of all these lights of the world" (p. 108). Cf. "Dedication to Prince Posterity," *Tale*, pp. 34–35.

4. *Reflections*, pp. 11–12, 78–81, 86. The Christ parallel has been pointed out by Peter Hughes, "Originality and Allusion in the Writings of Edmund Burke," *Centrum*, 4 (1976), 38–39.

5. Sermon, 4 November 1789, to the Society for the Commemoration of the Glorious Revolution, published as *A Discourse on the Love of our Country* (1789). Before the Revolution

Price has raised the imagery of Enlightenment into one of conflagration, and Burke revises it into the false usurping sun of the human reason as "not the light of heaven, but the light of rotten wood and stinking fish—the gloomy sparkling of collected filth, corruption, and putrefaction."[6] This is the false light cast by Swift's enthusiasts and Pope's dunces, the light of the "new philosophy" which only its *adherents* perceive as a "glorious blaze."[7]

But Burke is also—and I think much more importantly—approaching the subject of light through the aesthetic context of his own *Philosophical Enquiry into the Origin of our Ideas of the Sublime and Beautiful* (which he published in 1757, thirty years before), where he argued that darkness is sublime, light is not: "But," he qualified his generalization, "such a light as that of the sun, immediately exerted on the eye, as it overpowers the sense, is a very great idea. . . . Extreme light, by overcoming the organs of sight, obliterates all objects, so as in its effects exactly to resemble darkness."[8] This same fierce glare, this power or uncontrolled energy seen as sublime in his *Philosophical Enquiry*, becomes thirty years later in his *Reflections* the model for the Enlightenment rays that have been intensified by the revolutionaries into "this new conquering empire of light and reason" which dissolves all "the sentiments which beautify and soften private society." The true sun, as he sees it, enters

> into common life, like rays of light which pierce into a dense medium, [and] are, by the laws of nature, refracted from their straight line. Indeed in the gross and complicated mass of human passions and concerns, the primitive rights of men undergo such a variety of refractions and reflections, that it becomes absurd to talk of them as if they continued in the simplicity of their original direction.[9]

His image of man's intricate and complex nature as the essential reality that must be preserved in society is the exact contrary of the revolutionary's view of man as an obstruction to the beneficent sunburst of human liberty.

proper began, Price was prophesying "a progressive improvement in human affairs which will terminate in greater degrees of light and virtue and happiness than have yet been known, and a time when "the shades of night are departing, the day dawns" (*Evidence for a Future Period of Improvement in the State of Mankind with Means and Duty of Promoting it* [1787], pp. 5, 53).

6. House of Commons, 18 February 1793; in *Speeches of the Right Honourable Edmund Burke* (1816), 4, 120.

7. Wollstonecraft responded to Burke that "Dr. Price's sermon . . . [has] lighted some sparks very like envy in your bosom" (*Vindication of the Rights of Men*, p. 110).

8. *Philosophical Enquiry*, ed. J. T. Boulton (London, 1958), p. 80.

9. *Reflections*, p. 73. Cf. Mary Wollstonecraft's agreement that when the Revolution quiets down "the proud distinctions of sophisticated fools will be eclipsed by the mild rays of philosophy" (*Historical and Moral View*, p. 72). Again in *Rights of Woman*: ". . . the darkness which hides our God from us, only respects speculative truths—it never obscures moral ones, they shine clearly, for God is light, and never, by the constitution of our nature, requires the discharge of a duty, the reasonableness of which does not beam on us when we open our eyes" (p. 270).

By implication, Burke posits two suns: the royal or natural sun, which is, in England at least, refracted through the prism of human nature or human possibility, and the false usurping sun of human reason, which he describes alternately in terms of the blinding sun of sublimity or the phosphorescence of rotten wood and stinking fish.

Burke's argument has been proceeding by a process of analogy like the one he recommends as the essential of government itself. He moves from the organic growth of the plant (the great British oak)[10] to the countryside, the country house and the georgic ideal of retirement, the estate, the aristocratic family and its generations, the inviolability of inheritance. The house becomes a castle and the concept of patrilineal succession merges with the argument for "chivalry." "We wished," he says at the heart of his argument, ". . . to derive all we possess as an inheritance from our forefathers. Upon that body and stock of inheritance we have taken care not to inoculate any cyon alien to the nature of the original plant."[11]

All of these image patterns, in themselves conventional, build and merge until they erupt in the double scene of the king being led in triumph by his rebellious subjects and the queen attacked in her bedroom as the mob cuts down her guard:

> A band of cruel ruffians and assassins, reeking with his blood, rushed into the chamber of the queen, and pierced with an hundred strokes of bayonets and poniards the bed, from whence this persecuted woman had but just time to fly almost naked, and through ways unknown to the murderers had escaped to seek refuge at the feet of a king and husband, not secure of his own life for a moment. [pp. 85–86]

There is, it needs to be said first, no evidence of Marie Antoinette's fleeing "almost naked."[12] The imagery of clothing, activated earlier, reemerges with

10. The metaphor runs throughout Burke's works, surfacing as the "British Oak" in *The Reflections* (p. 103). Cf. his letter to the Duke of Richmond, 15 November 1772: "You, if you are what you ought to be, are in my eye the great oaks that shade a country, and perpetuate your benefits from generation to generation" (*Correspondence*, 2, ed. Lucy S. Sutherland [Cambridge, 1960], 377). Notice that he identifies the great oaks with noblemen like Richmond. He saw the Revolution not so much as a threat to monarchy as to the aristocracy and gentry—not as "the destruction of all absolute Monarchies, but totally to root out that thing called the *Aristocrate* or Nobleman and Gentleman" (to Earl Fitzwilliam, 21 Nov. 1791, *Correspondence*, 6, 457). For a good discussion of the changing senses of the organic metaphor in the seventeenth century, see Michael Walzer, *The Revolution of the Saints: A Study in the Origins of Radical Politics* (Cambridge, Mass., 1965), 171–77, and for a general essay on Burke's metaphors, see Philip E. Ray, "The Metaphors of Edmund Burke: Figurative Patterns and Meanings in his Political Prose" (Diss., Yale University 1973).

11. *Reflections*, p. 35; for the sequence, see pp. 26–27, 35–42, 78–81, 85–89.

12. Cf. the account of the *Gazette Nationale ou Le Moniteur Universel*, 12 October 1789, 293–95, and *Memoirs of Madame de la Tour du Pin*, ed. Felice Harcourt (London, 1970), pp. 131–37. See also the account in the diary of Nicholas Ruault (of the *Moniteur*) in scatological detail of how the crowd treated Marie Antoinette's bedchamber (*Gazette d'un Parisien sous la Révolution* [Paris, 1977]).

the cruelly penetrating power of the sunlight, and when Burke tells how "All the decent drapery of life is to be rudely torn off," all those religious customs and illusions of the past stripped away, revealing "our naked shivering nature," he is thinking of the queen: "On this scheme of things, a king is but a man; a queen is but a woman; a woman is but an animal; and an animal not of the highest order" (pp. 92–93). In this scene at the very heart of the *Reflections* the metaphoric stripping of society has become the literal stripping of the queen.

When you strip the queen, you expose the principle of equality, but you also prove your masculinity in relation to the king (the "father" of his people, the center of his universe, descendant of the "roi soleil").[13] You pierce the queen's bed "with an hundred strokes of bayonets and poniards" as a surrogate for the queen herself, and, as Burke intimates, were she captured she would best play "the Roman matron" and "save herself from the last disgrace by taking her own life" (p. 91). Burke is recalling the imagery of republican Rome adapted by the French themselves, focused on stories such as the Horatii, the rape of Lucrece, and all the deadly conflicts between love of family and loyalty to the state (see above, p. 31). But Burke sees much deeper, beneath the Roman costume to the most primal situations which only the sans-culottes revealed upon occasion, sometimes printed in the popular Paris papers.

The brutal sensuality of the ragged mob derives, of course, from memories of the sexual license traditionally detected under the idealistic claims as the real motivating force of the radical Protestant sects. The attack on the queen, her nakedness, and the capture of the king lead to "fervent prayer and enthusiastic ejaculation" (pp. 86–87) as the marriage of religion, sex, and politics did in Swift's *Tale of a Tub*. But Burke's own particular concatenation of the natural, genetic, and inherited with the revolutionary's sexual

13. For the king as father, see, e.g., James I's statement, "I am the husband, and all the whole island is my lawful wife," which, as Michael Walzer says, "is building on medieval arguments whose source is the mystical marriage of Christ and the Church. But he is also referring his listeners to their own experience of family life in a patriarchal society" (Walzer, *Regicide and Revolution: Speeches at the Trial of Louis XVI* [Cambridge, 1974], p. 22). We could also go back to Filmer's *Patriarcha* (1680) or Bossuet on the king of France: "The love that he has for his kingdom is confounded with his love for his family" (Walzer, p. 25); and so Walzer, p. 25: "If the king were husband to his realm (in which the qualities of wife, body, and property were, like the king's love, confounded), then he might also be called the father of his subjects." (See also Walzer, *Revolution of the Saints*, p. 196–98.)

The imagery of clothes derives in one sense from Rousseau's famous assertion: "I demolished the petty lies of mankind; I dared to strip man's nature naked," in *The Confessions* (London 1953), bk. 8, p. 362; also in *Discourse on the Arts and Sciences* (Everyman ed., New York, 1950, pp. 147–48). Both before and after the events of 6 October 1789, Burke refers in the same terms to the stripping of Indian women of the highest rank for examples (see Isaac Kramnick, *The Rage of Edmund Burke: Portrait of an Ambivalent Conservative* [New York, 1977], pp. 137–38, 152–53; on Rousseau, pp. 154–55).

license focuses on the traditional imagery of the king as father, his subjects as his family. He makes striking use of the topic in his allusion (pp. 116–17) to Medea, who like the French, cuts up her father and boils him in order to "regenerate the paternal constitution."[14]

As he refines the image of the queen's rape, however, in his later attacks on the revolutionaries what emerges is rather an insinuating seduction, for which his model (and, he believes, the revolutionaries') is Rousseau's *Confessions* with its young parvenus, "dancing-masters, fiddlers, pattern-drawers, friseurs, and valets de chambre," who enter the sacred family circle, seduce the wife or daughter, and undermine the authority, indeed take the place of the father-husband. Burke develops the model in the sequel to his *Reflections*, *A Letter to a Member of the National Assembly* (1791), where he argues that Rousseau has become for the revolutionaries a figure "next in sanctity to that of a father," and following his example, they encourage tutors "who betray the most awful family trusts and vitiate their female pupils" and they "teach the people that the debauchers of virgins, almost in the arms of their parents, may be safe inmates in their house. . . ." The National Assembly, he believes, hope that "the females of the first families of France may become an easy prey" to these dancing masters and valets, "and other active citizens of that description, who have the entry into your houses, and being half domesticated by their situation, may be blended with you by regular and irregular relations."[15] For it is precisely the object of the revolutionaries "to destroy the gentlemen of France," and so, Burke concludes,

> by the false sympathies of this *Nouvelle Éloise* they endeavor to subvert those principles of domestic trust and fidelity which form the discipline of social life. They propagate principles by which every servant may think it, if not his duty, at least his privilege, to betray his master. By these principles, every considerable father of a family loses the sanctuary of his house.[16]

If we place these passages back in the context of Burke's *Reflections* and the well-known passages idealizing Marie Antoinette, we see Burke opposing a vigorous ("active"), unprincipled, rootless masculine sexuality, unleashed and irrepressible, against a gentle aristocratic family, patriarchal and based on bonds of love. His point of departure, I should suppose, was Rousseau's well-known assertion in the *Confessions* that "seamstresses,

14. Cf. Ovid, *Metamorphoses*, bk. 7, and Hobbes's reference, which Burke is recalling in *Leviathan*, ch. 30. See Walzer, *Revolution of the Saints*, pp. 183–98.

15. *A Letter from Mr. Burke to a Member of the National Assembly in Answer to some Objections to his Book on French Affairs* (1791), in *Works*, 2, 539–40.

16. Ibid., p. 541. Burke further develops the idea of the Jacobin assault on the family in *Letters on a Regicide Peace*, where predictions from the earlier works are shown as carried out (*Works*, 5, 208–13).

chambermaids, and shop girls hardly tempted me; I needed young ladies. Everyone has his fancies, and that has always been mine. . . ."[17] Rousseau is much concerned with the "servant's intimacy with his mistress" (p. 172), to which end in fact he used his own musical and pedagogical talents, and he refers to cases of servants who enter a household and seduce the wife or daughter under the father-husband's nose. Burke is probably recalling Rousseau's account of M. de Tavel, Mme. de Warens's philosopher-teacher, who slipped into her affections and first drew her away from "her husband and her duties" by inculcating her with philosophical sophistries ("He succeeded in persuading her that adultery was nothing" [p. 190]).

But the most striking facts about Rousseau's own affairs with ladies at first seem at odds with Burke's model. (These are facts, incidentally, which do not apply to his long affair with the working-class Thérèse.) One fact is his passivity and the other is that they are husbandless women. What Burke may have seen, or sensed, however, was the way Rousseau insinuated himself into this passive role to become an irresistible combination of both son and lover to the widow. For a third striking aspect of Rousseau's affairs beginning with Mme. de Warens is the oedipal dimension. She is "Maman": "By calling her Mamma and treating her with the familiarity of a son," says Rousseau, ". . . I felt as if I had committed incest . . . " (p. 189). He tends to choose his ladies from among widows and otherwise husbandless women, after the rival has already been disposed of (and they are, of course, older women—after Mme. de Warens, Mme. de Larnage is forty-four and the mother of ten). But in Mme de Warens's case the servant Anet fills the role of husband, and (although Burke cannot have known this) his death may well have been suicide in response to Rousseau's superseding him in his mistress's affections. Anet "died in our arms," Rousseau, unruffled by the bizarre scene, tells us, "with no other spiritual exhortations than my own; and these I lavished on him amidst transports of such heartfelt grief that if he had been in the state to understand me, he should have received some consolation." And this is followed by Rousseau's "vile and unworthy thought . . . that I should inherit his clothes, and particularly a fine black coat which had caught my fancy" (p. 197), which he promptly puts into action. The pattern is completed by his taking over Anet's duties in Mme. de Warens's household, and finally by his being superseded himself by another young servant (a journeyman wigmaker who "succeeded in making himself all important in the house," he says): "In short I found my place filled" (pp. 250–51). Rousseau does, in perhaps ways that Burke sensed, all too well fit his model.

17. *Confessions*, trans. J. M. Cohen (London, 1953), p. 132. For our knowledge of Burke's reading of the *Confessions* and other works by Rousseau, see Peter J. Stanlis, "Burke and the Sensibility of Rousseau," *Thought*, 36 (1961), 246–76.

There remains throughout Rousseau's relations with Mme. de Warens and other ladies a distinct ambivalence. He can say, in a personal context (a sentence that would have been significant to Burke), "that it is not only in the case of husbands and lovers that the owner and the possessor are so often two very different persons" (p. 215). Then in *La Nouvelle Héloise*, his novel about such a triangle, there is his praise of the young woman who has an affair before marriage but can regain her virtue as a wife, and in the second part of the *Confessions* there is his scathing opinion of the unfaithful wife: ". . . morality and marital fidelity . . . are at the root of all social order" (p. 405). And yet, as he tells us, the success of *La Nouvelle Héloise* made possible for him the conquest of any woman, "even of the highest rank" (p. 504).[18] And finally, as was all too evident in the *Confessions*, an actual seduction and affair were not required for Rousseau to bring about the disruption of a family (recall the effect of his friendship with Mme. d'Houdetot on the d'Epinay household).

In psychological terms, then, Burke offers a rationale for repression: Avarice, ambition, and sexuality are passions in men which must be controlled and restrained by the state, but Rousseau and his followers, in both private life and public, would outlaw all repression.[19] The two qualities he emphasizes are youth and energy. The revolutionaries are "bold, presuming young persons." "*One* thing, and *one* thing only" explains their success: "they have *energy*," "this dreadful and portentous energy." Sheer energy, the energy of ability without property, Burke believes to be the most dangerous threat to ordered society; for "ability is a vigorous and active principle, and . . . property is sluggish, inert and timid. . . ."[20] The *Letter to a Member of the National Assembly* ends with a peroration about the energy of the revolutionaries: "You are naturally more intense in your application," he says, than relaxed and detached Englishmen. "This continued, unremitted effort of the members of your Assembly I take to be one of the causes of the mischief they have done."[21] What Burke finds appalling is that this energy or unchecked instinct can be directed with such fearful intensity toward finding ways to possess the master's wife or daughter and to overthrow the king (and lead him in triumph).

18. For a confirmatory interpretation of *La Nouvelle Héloise*, see Tony Tanner, "Julie and 'La Maison Paternelle': Another Look at Rousseau's *La Nouvelle Héloise*," *Daedalus*, 105 (1976), 23–46.

19. As Burke puts it, "Men are qualified for civil liberty in proportion to their disposition to put moral chains upon their own appetites. . . . Society cannot exist unless a controlling power upon will and appetite be placed somewhere, and the less of it there is within, the more there must be without" (*Letter to a Member*, in *Works*, 4, 51–52).

20. *Thoughts on French Affairs*, *Works*, 3, 353; *Remarks on the Policy of the Allies* (1793), 3, 437; *Reflections*, p. 140.

21. *Works*, 2, 557–58.

All this makes a fairly complicated model, with ramifications less corresponding to Rousseau's *Confessions* than suggesting that Burke fitted Rousseau into a prior model of his own. The peculiar obsession with sexuality in Burke's attacks on the revolutionaries can be explained, for example, as it has been by Isaac Kramnick, in terms of Burke's psyche, especially his childhood experiences.[22] He himself was, after all, a parvenu, like Rousseau the music-master or philosopher who used his talents to insinuate himself into the lives of the great, toward whom his feelings were ambivalent. Long before reaching Burke's psyche, however, we have to acknowledge the extremely conventional literary elements of his attack which derive from the polemics of the English Civil War and its aftermath, in which religious enthusiasm leads to the unleashing of sexual drives and/or the overthrowing of government. In Swift's terms, we recall, the errant vapor (the "gas" Burke refers to) rises from semen adust to seek an outlet in orgasm or, when this is impracticable, it rises to the brain, overturns it, and causes the individual to overturn society as well. There is, in short, a high degree of the conventional in Burke's vocabulary and imagery.

Kramnick tends to go straight to the archetype or the biography, over the head, so to speak, of the literary text. He draws proper attention to Burke's excremental imagery: "the principle of evil himself, incorporeal, pure, unmixed, dephlegmated, defecated evil," Burke writes, referring to the Jacobins as Phineas's birds, who (in the *Aeneid*) "flutter over our heads, and souse down upon our tables, and leave nothing unrent, unrifled, unravaged, or unpolluted with the slime of their filthy offal."[23] However, the scatology goes off into imagery of mere darkness ("black and savage atrocity of mind," "all black with the smoke and soot of the forge of confiscation and robbery").[24] Kramnick associates, quite correctly, the scatology, the anality, the darkness, and dirt of the Jacobins with Satan, a black, sulfurous figure whose anus is saluted in the ceremony of the Sabbath. But the basis of such imagery is to be found in Swift's Grub Street hacks and Pope's

22. I refer to a lecture delivered by Kramnick at Yale University, December 1975, which has been incorporated into Kramnick's *The Rage of Edmund Burke: Portrait of an Ambivalent Conservative*. Kramnick sees the parallel as one between Burke's life and his writings. "The confrontation was always," he writes, "between bold and adventurous newcomers, who sought power or status, and those in power who were naturally entitled to such privileges. . . . The very terms of its formulation here—upstart newcomers replacing the naturally privileged— evoke oedipal themes" (p. 109). In other words, in one sense the Jacobins are merely fitted into the formulation Burke had employed often before, deriving from childhood trauma, which long predates the writing of the *Philosophical Enquiry*. Another important study that has appeared since I wrote this essay is Peter Hughes's "Originality and Allusion in the Writings of Edmund Burke" (see above, n. 4), a serious attempt to get at the peculiar literary quality of Burke's writings.

23. *Letter to a Noble Lord, Works*, 5, 141, 120–21.

24. *Correspondence*, 2, 526.

dunces, and, insofar as it involves Satan, in the central paradigm of *Paradise Lost*, upon which Burke as well as Dryden, Swift, and Pope built their satiric fictions. For Burke Paris is Milton's hell (everywhere "rankness" and "refuse and rejected offal")[25] and the story is of the troops of God opposing the Jacobin fallen angels, with all the old associations of pride, impiety, and overthrown order.

The best clue to what Burke makes of Satan appears in a speech he delivered in Commons on 11 April 1794 in which he describes the Jacobin hell:

> The condition of France at this moment was so frightful and horrible, that if a painter wished to portray a description of hell, he could not find so terrible a model, or a subject so pregnant with horror, and fit for his purpose. Milton, with all that genius which enabled him to excel in descriptions of this nature, would have been ashamed to have presented to his readers such a hell as France now has, or such a devil as a modern Jacobin; he would have thought his design revolting to the most unlimited imagination, and his colouring overcharged beyond all allowance for the license even of poetical painting.[26]

This passage, with its reference to the "terrible" and to painting, recalls Burke's own *Philosophical Enquiry into the Sublime and Beautiful*, in terms of which he is now saying that the true sublime in government is a mixture of fear and awe or admiration, whereas the false sublime, a perversion of this (like the false *light* versus the true), generates only fear and a grotesque energy. It is not surprising that Burke's formulation in the *Philosophical Enquiry* is couched in terms of a family:

> The authority of a father, so useful to our well-being, and so justly venerable upon all accounts [i.e., the sublime], hinders us from having that entire love for him that we have for our mothers, where the parental authority is almost melted down into the mother's fondness and indulgence [i.e., the beautiful].[27]

More interesting, however, is Burke's allusion to Milton's hell, seen in the light of the examples he offers in the *Philosophical Enquiry* of the terrible as the defining feature of sublimity. As in the *Reflections*, I believe the illustrations and metaphorical decoration take us closest to Burke's true intention, often saying more than he may have meant to say. One of the prime qualities that evoke the terrible (which certainly anticipates the imagery of the *Reflections*) is obscurity, and Burke illustrates this with Milton's descrip-

25. *Works*, 5, 211–13.

26. *Speeches*, 4, 164–65; *Parliamentary History*, 31 (1794–95), 379.

27. *Philosophical Enquiry*, ed. Boulton, p. 111. Neal Wood's essay, "The Aesthetic Dimension of Burke's Political Thought," *Journal of British Studies*, 4 (1964), 41–64, connects this passage, and Burke's categories of sublime and beautiful, with Burke's general theory of government. My reading of Burke's pamphlets of the 1790s is at a deeper level of consciousness, revealed by his excesses of rhetoric, his metaphors, and his half-articulated examples (such as the Medea reference in the *Reflections* and the Miltonic ones in the *Philosophical Enquiry*).

tion of Satan, who amid his fallen angels, "above the rest / In shape and gesture proudly eminent / Stood like a tower. . . ." About the passage Burke says:

> Here is a very noble picture; and in what does this poetical picture consist? In images of a tower, an archangel, the sun rising through mists, or in an eclipse, the ruin of monarchs, and the revolutions of kingdoms. [p. 62]

I think we can begin to see where Burke's imagery of revolution in fact came from and what it meant to him. It was the terrible of his sublime, with precisely the aesthetic distancing implied in his formulation that pain and danger "are simply painful when their causes immediately affect us [i.e., if we were in France]; they are delightful when we have an idea of pain and danger, without being actually in such circumstances" (p. 51). In his first *Letter on a Regicide Peace* (1796) Burke wrote of the Revolution:

> I can contemplate, without dread, a royal or a national tiger on the borders of PEGU. I can look at him, with an easy curiosity, as prisoner within bars in the menagerie of the tower. But if, by habeas corpus or otherwise, he was to come into the lobby of the House of Commons while your door was open, any of you would be more stout than wise, who would not gladly make your escape out of the back windows. I certainly should dread more from a wild cat in my bed-chamber, than from all the lions that roar in the deserts behind Algiers. But in this parallel it is the cat that is at a distance, and the lions and tigers that are in our ante-chambers and our lobbies.[28]

It is well to remember that Burke was originally galvanized into active opposition to the Revolution by the threat in Price's speech of a tiger closer to home than "distance" might suggest, and on 25 October 1790 he wrote to Calonne that in the *Reflections* "in reality, my object was not France, in the first instance, but this Country."[29] Burke could come to terms with the Revolution by distancing it as a sublime experience, even while denying its sublimity and realizing that it might not keep its "distance."

But the description he quotes of Satan (from *Paradise Lost*, book 1) is preceded, two pages earlier in the *Philosophical Enquiry* (illustrating the same concept of "obscurity"), by the description of Death in book 2, confronting Satan at the Gate of Hell and shaking at him "a deadly dart," *as seen by* Satan.[30] There is no portrayal of Satan in the passage describing his con-

28. *Works*, 5, 225.

29. *Correspondence*, 6, 141.

30. Among many other examples of Burke's references to the French revolutionaries and their Foxite followers in England as an "infernal faction . . . sprung from night and hell," and so on, I would single out Burke's Commons speech of 11 May 1791, where he quotes the Satan–Sin–Death passage to characterize the "anarchy in government" of France; i.e., describing Death the challenger as he appears to Satan (*Speeches*, 4, 31–32). Near the end of his life he wrote that "we hate Jacobins as we hate the Gates of Hell" (to Rev. Thomas Hussey, 9 Dec.

frontation with Death, and so for the equivalent view of Satan Burke went back to the passage in book 1. Satan addresses Death as a rebel son (ll. 681–87), and Death replies in kind to Satan: "Traitor Angel, art thou hee, / Who first broke peace in Heav'n and Faith, till then / Unbrok'n, and in proud rebellious Arms / Drew after him . . . "; and he refers to himself as king (the one unobscure part of him is his "Kingly Crown") and to this realm "Where I reign King, and to enrage thee more, [am] / Thy King and Lord." Burke himself refers to Death as the "king of terrors" (p. 59), the ultimate sublime, the real father.

Our sensation in reading Burke's passage derives from viewing not a static figure, however powerful, but an aggressive action: not just Satan or Death but the two challenging each other, and not just a confrontation but consecutively Burke himself seen as facing Death and then facing Satan confronting Death, so that we see him assuming the role of each challenger in turn. Between Satan and Death in this scene (though not mentioned by Burke) is the figure of Sin, the daughter-lover of Satan, the mother-lover of Death, suggesting a single powerful image of the son who challenges his father for the person of his mother. The deep ambivalence of the emotion is patent in the fact that it is Satan, the arch rebel, who himself has become the father figure, and each insists on *his* being a king and father, the other a son and rebel.

Burke's solution to the confrontation with this unthinkable phenomenon, the French Revolution (one already adopted to some degree in his attacks on Hastings' Indian depredations),[31] was to fit it into the framework of aesthetic categories he had worked out himself thirty years before. He is not unaware of that other category, the beautiful, associated by him with

1796, *Correspondence*, 9, 170). In Commons in 1791 he called Jacobinism "a shapeless monster, born of hell and chaos," and now was the time "for crushing this diabolical spirit" (*Parliamentary History*, 29 [1791–92], 419, 386).

31. The Hastings situation may have been another model for the French situation when it arose. In the Hastings speeches too Burke refers to "the desperate boldness of a few obscure young men" and accuses Hastings of having "undone women of the first rank" and of having raised dancing girls to positions of power like Rousseau's hairdressers and dancing masters (*Works*, 2, 146; 4, 267; see Kramnick, *Rage of Edmund Burke*, pp. 134–42). At the end, in 1794, he was equating Hastings with the Jacobins as the same threat to "property, rank, and dignity," the same danger of murder and chaos ("Speech in General Reply," 7 June 1794, *Works* [London 1887], 12, 10, 11; ibid., 16 June 1794, 395–96; Kramnick, p. 133). The organic imagery is also present, as in Burke's reference to Hastings' and the India Company's tampering with the age-old social structure and traditions of India, which "stood firm on their ancient base; they have cast their roots deep in their native soil" ("Speeches in the Impeachment of Warren Hastings—First Day Saturday, February 16, 1788," *Works*, 9, 383). He opposes the traditional ruling class of India to "obscure young men" like Hastings, of no rank who "tossed about, subverted, and tore to pieces . . . the most established rights, and the most ancient and most revered institutions of ages and nations" ("Speech on Mr. Fox's East-India Bill," *Works*, 2, 22). See also P. J. Marshall, *The Impeachment of Warren Hastings* (Oxford, 1965), pp. 84, 92, 183.

sentimental comfort and soft curving lines. But beauty, "that quality or those qualities in bodies in which they cause love, or some passion similar to it," he associates with the mother, the queen, the chivalry that surrounds her, while it is desire or lust to which "we must attribute those violent and tempestuous passions" of the sublime. "We admire what is large and submit to it; we love what is small enough to submit to us" (pp. 91, 113). For if Burke sees revolution as sublime, Rousseau presumably sees it as beautiful, emotions centering around the mother's breast (and a future pastoral state with gently rolling hills and blooming flowers).

The accepted definition of the sublime experience before Burke wrote and redefined it was transfiguration in the presence of some great and unknowable power such as tempest, hurricane, or vast mountain scenery. In *Spectator* 411 and 421 Addison defined it as a sense of immensity or abundance that cannot be contained; as a desire or need to go beyond confines and controls; and as the reaching for what is "too big for its capacity," implying the wish to extend oneself beyond what is rational, possible, or prescribed. Addison, however, sees the sublime as liberating and exhilarating, a kind of happy aggrandizement, whereas Burke sees it as alienating and diminishing. Beauty for both is repose, a comfortable, perhaps enervating status quo, but the sublime projects the mind forward to ultimates, positing a confrontation with power and change that for Burke at any rate is the essence of terror. To turn, as his examples imply, from the beautiful to the sublime is to turn from the comfort of the mother to the threat and incomprehensibility of the father, but more to be part of a confrontation with this father over the beautiful, mediating, desired mother.

The sexual dimension of the scene is plain in both the *Philosophical Enquiry* and the *Reflections*. He in fact tends to use the imagery of tumescence to describe the sublime experience, which begins with "an unnatural tension and certain violent emotions of the nerves" (p. 134). He writes of those confronting the sublime, that "their minds are erect with expectation"; and ambition, another aspect of the situation, is what "tends to raise a man in his own opinion, produces a sort of swelling or triumph, that is extremely grateful to the human mind" (p. 50). It is easy enough to relate this to Swift's analysis of enthusiasm in *A Tale of a Tub* and to Burke's own use of the imagery in his description of the rebels' "fervent prayer and enthusiastic ejaculation" in the *Reflections* (p. 86).

On the next page of the *Philosophical Enquiry* after the account of Satan, Sin, and Death, Burke brings together Job and God, another son and father.[32]

32. Thomas Weiskel, in his brilliant Freudian analysis of the sublime, has drawn attention to the example Burke adduces, earlier in the *Enquiry*, of the "delight" of the sublime, which is in "escaping some imminent danger, or on being released from the severity of some cruel pain" (p. 34). Burke's example is the simile Homer gives Achilles when he stands before Priam, who, in order to persuade Achilles to return the body of his son Hector, reminds Achilles of

The animals cited—the horse, wild ass, tiger, unicorn, leviathan—are examples of the power of God, the voice out of the whirlwind, over a presumptuous, weakly challenging man.[33] And this congeries of allusions is followed a page later (p. 68) by the contemplation of God Himself, from which "we shrink into the minuteness of our own nature, and are, in a manner, annihilated before him." Job capitulates; he does not curse God and die but internalizes Him. If we look back at the famous passage about the public execution (to see which Burke believes we would abandon a tragedy being performed in a theater), we notice that he is referring to "a state criminal of high rank" (presumably Simon Lord Lovat), a traitor to the king; this is followed by the example of an earthquake—another Job-like confrontation of God and man (pp. 47–48).

It is the experience of the son's revolt, with its implications of sexual release, followed by his feelings of guilt, and the accommodation by which he comes to terms with the father, internalizes him as superego, and himself becomes a father. It is first the feeling of the son as he challenges Death, and then of the "son" Death facing his towering father Satan, as they confront each other, held apart by the mother-lover. The ambivalence of the rebel toward the act of revolt is both because it is an aggressive act and because the object remains beyond comprehension.[34] It is also because Burke can imagine himself in one or both positions.[35]

his own father Peleus. The passage Burke quotes from Homer stops with the simile; he omits: "Thus Achilles gaz'd [i.e., on Priam]: / Thus stood th' Attendants stupid with surprize." Priam's response is to make Achilles "think of thy Father's Age, and pity mine! / In me, that Father's rev'rend Image trace, / Those silver Hairs, that venerable Face. . . ." The mixed terror and surprise (and, of course, acquiescence on Achilles' part) are the result of a confrontation between a person who has wronged a second person, who is playing to him the role of his father (when, interestingly, the wrong itself was the killing of a son). "Priam," writes Weiskel, "has cleverly assumed the role of the father in Achilles' mind—thereby engaging in his interest powerful prohibitions against anger and parricide" (*The Romantic Sublime* [Baltimore, 1976], pp. 87–92). A later example cited is Helen, her lover Paris, and her husband Menelaus (p. 171).

33. He contrasts the wild ass with work animals who serve the will of a master: the wild ass "is worked up into no small sublimity," he says, "merely by insisting on his freedom, and his setting mankind at defiance" (p. 66, referring to Job 39.5b–8a).

34. This was a different sublime from the phenomenon Burke saw in earlier political situations, and so he thought of it as a false sublime. For example, in his *Thoughts on the Present Discontents* (1768), as Kramnick notes, Burke asked that "the beautiful virtues" of party government "replace the sublime virtues of Pitt's leadership, or of George III's for that matter" (p. 114). In other words the sublime of the strong single minister or king presented as a simple father–son conflict, resoved here in the solution of "party," becomes in the French Revolution a real oedipal confrontation with the implied third, the mother/wife/lover.

35. See, for example, Conor Cruise O'Brien's interesting introduction to the Penguin edition of the *Reflections* (London, 1968), where he argues that Burke, "in his counter-revolutionary writings, is partially liberating—in a permissible way—a suppressed revolutionary part of his own personality"—i.e., the Irish Burke (pp. 34–35). This is an idea that goes back to Burke's contemporaries, with Wollstonecraft writing to Burke in her *Vindication of the Rights of Men*:

The oedipal formation is superimposed upon an original ambivalence (to authority—or to the idea of freedom) and so there is a rapid alternation of attraction and repulsion, evident in Burke's explanation of the initial effect the Revolution had on him, of "gazing with astonishment . . . and not knowing whether to blame or to applaud." [36] But the pattern Burke at once detected in the Revolution—or assigned to it, prophesied, perhaps even in some sense brought about by his prophecy—was obtained by spreading out this ambivalence into the consecutive stages of a plot. As he says, these opposite passions "necessarily succeed, and sometimes mix with each other." In the scenario of the Revolution one first destroys the father and then of necessity internalizes him and becomes more repressive, more the tyrant than he was. [37]

I must distinguish the sublime in which Burke himself is participating from the sublime as a rhetorician's tool. I have been speaking of the first, but a few words must be added about the second. While regarding the Revolution as a false sublime, Burke sees the terrors of something like the sublime experience as a warning to Englishmen who might see the Revolution as beautiful. He remembers his earlier words in the *Philosophical Enquiry* that "terror is a passion which always produces delight when it does not press too close," and now he wants it to press close (p. 46). He does not want the Revolution to produce "delighted horror" because he intends for its "pain and terror to be so modified [by contact with reality] as to be actually noxious." He does not *want* his reader to feel safe: the tiger is not in Pegu but in London. In terms of Longinus's definition of the sublime, Burke has failed if he "carries his hearer . . . not to persuasion but to ecstasy," since he seeks to convince him that the Revolution is a clear and present danger.

Man's response to an ongoing process cannot be analyzed in the same way as his reaction to a discrete event like a scene in a play or in *Paradise Lost* (or a public execution) or to a static object like a tower. Accordingly Burke treats the Revolution in his *Reflections* as a series of isolated outrages, notably "the atrocious spectacle of the sixth of October 1789." But he projects not only a series of sublime scenes but a sublime plot of the sort I have

"Reading your Reflections warily over, it has continually and forcibly struck me, that had you been a Frenchman, you would have been, in spite of your respect for rank and antiquity, a violent revolutionist . . . " (p. 109). And Novalis wrote, "Es sind viele antirevolutionäre Bücher für die Revolution geschrieben worden. Burke hat aber ein revolutionäres Buch gegen die Revolution geschrieben" (*Novalis Werke*, 2, 349).

36. To Lord Charlemont, *Correspondence*, 6, 9–12; *Reflections*, p. 9.

37. For a discussion of the development of this revolutionary paradigm in anthropological terms, see Eleanor Wilner, *Gathering the Winds: Visionary Imagination and Radical Transformation of Self and Society* (Baltimore, 1976), p. 20, and especially the introduction and the chapter on Blake.

outlined, only attempting to remove the "security" he insisted on as requi-
site to the sublime. This removal, which is an attempt by every rhetorical
means to create immediacy, is the chief persuasive strategy of the *Reflections*
and the works that followed.

Burke is also aware that this security was the safety-catch that functioned
to protect the individual himself from becoming a revolutionary—from fol-
lowing a continuous process of psychic liberation and experimentation, like
the Jacobins among whom "every counsel, in proportion as it is daring, and
violent, and perfidious, is taken for the mark of superior genius" (p. 160).
The momentary liberation and exultation, the purgation, which man ex-
periences in his secure encounter with the terrible, the unconstrained, or the
rebellious, cannot be allowed permanent sway without a disastrous break-
down of those habitual inhibitions which constitute civilization. In Burke's
terms, a regression is taking place to earlier, less mediated stages of devel-
opment.

Thus underneath the aesthetic and moral vocabulary (the grounding, for
example, of social attitudes in a traditional Christian vocabulary), Burke
allows us to sense the profound psychic forces of the Revolution that seemed
to offer a permanent release from the necessary discontents of civilization.
These were precisely the forces that had been given a sanctioned, carefully
distanced airing in his aesthetic of the sublime but that in his final summa-
tion of the French Revolution in *Letters on a Regicide Peace* of 1796 showed
the Jacobins regressing from oedipal to anal–oral manifestations, from de-
monic to bestial and from eucharistic to cannibalistic behavior. He opens
the first "Letter" with another version of Milton's Death:

> . . . out of the tomb of the murdered monarchy in France has arisen a vast, tre-
> mendous, unformed spectre, in a far more terrific guise than any which ever yet
> have overpowered the imagination, and subdued the fortitude of man. Going
> straight forward to its end, unappalled by peril, unchecked by remorse, despising
> all common maxims and all common means, that hideous phantom overpowered
> those who could not believe it was possible she could at all exist. . . .[5, 155]

Death is now a Gothic fantasy confronting the writer directly, without me-
diation, like the tiger of Pegu who appears later in the "Letter," and it is a
"she"—now not merely the son who rises from the tomb of his murdered
father but, presumably, a fantasy based on those women Burke described
in the *Reflections* who marched on Versailles and brought back the king and
queen in triumph to Paris:

> . . . the royal captives who followed in the train were slowly moved along, amidst
> the horrid yells, the shrilling screams, and frantic dances, and infamous contume-
> lies, and all the unutterable abominations of the furies of hell, in the abused shape
> of the vilest of women. [p. 95]

It was, he writes, "a spectacle more resembling a procession of American savages," leading their captives "into hovels hung round with scalps, . . . overpowered with the scoffs and buffets of women as ferocious as themselves" (p. 80).

If the first image sets the stage for Revolutionary monsters that will eventuate in Victor Frankenstein's creature, and the second in Blake's "Tyger," other images carry us back to the cannibalism that will be evoked in the graphic work of Gillray in England and Goya in Spain: "By cannibalism, I mean their devouring as a nutriment of their ferocity, some part of the bodies of those they have murdered; their drinking the blood of their victims, and forcing the victims themselves to drink the blood of their kindred slaughtered before their faces" (5, 212). It is not difficult to see how Burke's imagination takes him from the threatening specter that rises from the tomb of the murdered king to the primal horde that devours "as a nutriment of their ferocity" the body of the king. But the emergence of the specter as "she" draws attention to the whole movement of the *Letters on a Regicide Peace*, which is downward and backward into undifferentiation of the sexes as well as of the ruler and ruled, the hunter and hunted, and the eater and eaten.

PAINE

The most famous metaphor in Thomas Paine's *Rights of Man* (1791–92) appears at the conclusion of the second part (1792):

> It is now towards the middle of February. Were I to take a turn in the country, the trees would present a leafless winterly appearance. As people are apt to pluck twigs as they walk along, I perhaps might do the same, and by chance might observe, that a *single bud* on that twig had begun to swell. I should reason very unnaturally, or rather not reason at all, to suppose *this* was the only bud in England which had this appearance. Instead of deciding thus, I should instantly conclude, that the same appearance was beginning, or about to begin, everywhere; and though the vegetable sleep will continue longer on some trees and plants than on *others*, and though some of them may not *blossom* for two or three years, all will be in leaf in the summer, except those which are *rotten*. What pace the political summer may keep with the natural, no human foresight can determine. It is, however, not difficult to perceive that the spring is begun.[38]

Paine's metaphor of natural process is, among other things, a response to Burke's organic metaphor of the state and his plea for sexual repression. Paine refers to "the vegetable sleep" out of which man is just emerging, and even notes, thinking of Burke's British oak, that some trees may *not* blossom—"those which are *rotten*." The natural, and so irresistible, process of

38. *Rights of Man*, ed. Henry Collins (London, 1971), p. 294.

nature is his point: the first of the old connotations of the word *revolution* to be developed as its meaning changed from the rotation of celestial bodies to the fundamental transformation of society. There is no sense of a winter returning, only of the progress from winter to spring and its irreversibility.

But also present are the connotations of spring, warmth, love, rebirth, youth, and happiness—in short, the beautiful, the green world we still encounter in the images of Russian revolutionary films in which the crowds of workers converging on the prison or factory or palace are related by montage to the bursting buds of spring, the melting ice, the opening of the water-flow, which becomes a raging torrent sweeping away all the locked, cold, and dead barriers.

To see how Paine arrives at his version of the Revolution we have to look back to Matthew 24.32–33, in a chapter devoted to a rehearsal of the Second Coming:

> Now learn a parable of the fig tree; When his branch is yet tender, and putteth forth leaves, yet know that summer is nigh: So likewise, ye, when ye shall see all these things, know that it is near, even at the doors.

The context includes Bunyan's phrase describing the millenarian future when it will be "always summer, always sunshine, always pleasant, green, fruitful, and beautiful," and, looking ahead, Burke's counterversion in which precisely such a pastoral scene is destroyed by the Revolution: "All the little quiet rivulets, that watered an humble, a contracted, but not an unfruitful field, are to be lost in the waste expanse, and boundless, barren ocean of the homicide philanthropy of France." [39] The immediate precursor of Paine's passage, however, was Richard Price's sermon which ignited Burke's *Reflections*. The seeds of ideas, says Price, had been planted by philosophers since Milton and are now growing to be a "glorious harvest" in France, and this becomes his climactic metaphor of fire ("I see the ardor for liberty catching and spreading . . . "; see above, pp. 58–59 and n. 5), which Paine develops some sixty pages earlier than the passage about the budding trees at the opening of his notorious chapter 5 (part II):

> From a small spark, kindled in America, a flame has arisen, not to be extinguished. Without consuming, like the *Ultima Ratio Regum*, it winds its progress from nation to nation, and conquers by a silent operation. (p. 232)

And that silent operation is the opening up of the buds that brings part II to an end, in a kind of sublimation of consuming fire in fructifying warmth and spring.

The image of the Revolution as beauty, peace, and a pastoral *locus amoenus* was made much of in France itself, especially in the graphic form of its great

39. Quoted in Lasky, *Utopia & Revolution* (London, 1976), p. 281; Burke, *Third Letter on a Regicide Peace* (1797), in *Works*, 5, 268.

festivals marking the stages in the progress of the Revolution. The most symbolic gesture of these festivals was the transformation of the Champs de Mars into a pastoral setting for parades in which "animals of warfare were excluded, with only peaceful cows and doves permitted."[40] The re-naming of days to replace saint's days with trees, fruit, and domestic animals was a similar transvaluation. But in the depths of the Terror the dream was held by Girondin and Jacobin alike of a peaceful island in the midst of the stormy sea, and the festivals represented "in the navigation of life what islands are in the midst of the sea: places for refreshment and rest."[41] In the background were memories of the island on which Rousseau was buried, but, as Paine's conjoint imagery of fire and spring sunlight suggests, the conflict lay between the initial impetus (the spark or fire) and the peaceful end of the conflagration, the good that must come out of necessary evil. Paine tried to elide the difference in his concluding passage, but the French more realistically joined the image (again graphically in their spectacles) of a tranquil island utopia with an erupting volcano, made of badly needed explosives held back from the front in the autumn of 1793 after the execution of Marie Antoinette. At the Feast of the Supreme Being a year later a volcano appeared again, this time transformed into "a peaceful mountain of floral beauty," but the fragility of the relationship between volcano and flowers became clear within the month when Robespierre, the author of the Feast, was himself beheaded.[42]

For Paine also uses the burgeoning of plants in springtime as a final metaphorical statement of the individual French citizens rising as "the people," as a great crowd—a "vast mixed multitude of all ages, and all degrees" (as opposed to Burke's "swinish multitude")—leading to the central historical fact, whose symbolism did not escape Paine, the destruction of the Bastille. Paine brings the crowd as disorder, fire, and energy into conjunction with the Bastille, "the high altar and castle of despotism" (p. 78). He uses the destruction of the Bastille as the focus of *Rights of Man*, a materializing of those metaphors used by Adam Smith and the Physiocrats for the blockage of a laissez-faire economy and therefore of social, moral progress. But he is also responding immediately to Burke's "custom," which blocks the way, the "succession of barriers, or sort of turnpike gates . . . set up between man and his Maker," i.e., kings, parliaments, magistrates, priests, and nobility (p. 89). If his primary images are of the release of the repressed, of natural rebirth and the irresistible force of a crowd breaking down a prison, behind the contrast of energy and constraint is a larger one between youth and age, between circumstances and what Paine calls contracts (and Blake

40. Billington, *Fire in the Minds of Men*, p. 50.
41. Cited in Mona Ozouf, *La Fête révolutionnaire, 1789–1799* (Paris, 1977), p. 205 n.1.
42. Billington, p. 69.

calls "charters"). The words "control" and "bind" are repeated again and again, connected with those men of the past, "who existed a hundred years ago" and made "laws" that now resist the "continually changing" circumstances of the living (p. 65). The past are the "dead," embodied in "musty records and mouldy parchments" and now in Burke's writings, and in his sources ("How dry, barren, and obscure," p. 68). Paine even notes, as he approaches the storming of the Bastille, that the Archbishop of Vienne, at the time president of the Assembly, was "a person too old to undergo the scene" that was about to unfold, while the actor called for by the circumstances was "a man of more activity, and greater fortitude," the young Lafayette (p. 75). Indeed the "living" are embodied in Lafayette, "a young man scarcely then twenty years of age" when he assisted in the American Revolution, which itself was part of the larger opposition between the old moribund governments of Europe and the young one in America.

As Burke's plot (his "Jacobean tragedy") centered on the Via Dolorosa of the king and the attack on the queen, so Paine's centers on the taking of the prison, the march on Versailles, and his own version of the triumphal return with the royal family to Paris. What Burke treats in terms of the topos of the world turned upside down Paine treats in terms of a return to the natural and proper. His context is his own *Common Sense* (1776), which must in its way have influenced Burke's formulation as much as Burke's influenced Paine's in *Rights of Man*. What Burke would have seen in *Common Sense* was its insistent connection of family (bastardy versus heredity and primogeniture), the sundering of the family, the parting or "separation" of the colonies from the father country in American "independence."

In Paine's travesty of Burke's beloved law of primogeniture a bastard is the origin of the English monarchy: "A French bastard landing with an armed banditti, and establishing himself king of England against the consent of the natives, is in plain terms a very paltry rascally original.—It certainly hath no divinity in it."[43] Paine's questioning of authority in *Common Sense* by no means stopped with the relationship of colonies to fatherland, as Burke must have seen. But starting with the case of the Americans, he calls for "a final separation" rather than leaving the next generation "to be cutting throats, under the violated unmeaning names of parent and child" (p. 87). And confronted with what was for him and the Americans the crucial day of 19 April 1775—the American version of 14 July, which was the massacre at Lexington—Paine brings together all his strands (including the bastardy), saying he will reject

the hardened, sullen tempered Pharaoh of England for ever; and disdain the wretch, that with the pretended title of FATHER OF HIS PEOPLE can unfeelingly hear

43. *Common Sense*, ed. Thomas Wendel (Woodbury, N.Y., 1975), p. 68.

of their slaughter, and composedly sleep with their blood upon his soul. [*Common Sense*, p. 90]

From the image of the false father, the Saturn-figure who can approve the slaughter of his own children, he moves (a few pages later) to the demand for something very like Freud's primal horde, which figuratively breaks up and ingests the royal symbols of the father, urging: "let the crown at the conclusion of the ceremony ['a day . . . solemnly set apart for proclaiming the charter'], be demolished, and scattered among the people whose right it is" (p. 99). Paine's wishes were carried out a few months later when the equestrian statue of George III in New York City was pulled down by the "Sons of Liberty," broken into pieces, and laid "prostrate in the dirt."[44]

Indeed, Paine could draw upon the American Loyalists' (the Tories') references to England in their propaganda as the "parent trunk," independence as "forbidden fruit," and the revolution as the attempt to lop off "every excrescence from the body politic. Happy if they can stop at the true point, and in order to obtain the fruit . . . do not cut down the tree." He also had the transvaluation of this imagery in the Sons of Liberty's ceremony of setting up some "young oak" as a "Tree of Liberty." Winthrop Jordan has explored the mythic dimension of this American imagery, from which emerges a remarkable parallel to the Satan–Sin–Death situation at the heart of Burke's paradigm for both the sublime and the Revolution.[45] Primitive man worships his father as a tree, or as Christ on a cross; Genesis tells of man's guilt at having eaten his father/god in the story of the "forbidden fruit"; and man sets up a maypole at Merrymount or a Liberty Tree in the town square. From Milton's regicide pamphlets onward, the equation of king and father was pretty clearly part of the republican tradition of polemics. Even the "youth" connected with the American Revolution was present for Paine to develop. He refers in *Common Sense* to the "infant state" of the Colonies: "Youth is the seed time of good habits, as well in nations as in individuals" (pp. 111–12). Many of the leaders themselves were young, as

44. See Winthrop D. Jordan, "Familiar Politics: Thomas Paine and the Killing of the King, 1776," *Journal of American History*, 60 (1973), 294–308; esp. p. 298, where he refers to "a political eucharist" and to the Primal Horde who "ate him in order magically to acquire his power."

45. See ibid., p. 303. For a suggestive but considerably less reliable account along the same lines, see Lloyd de Mause, "The Formation of the American Personality through Psychospeciation," *Journal of Psychohistory*, 4 (1976), 1–30. It should probably also be remarked that Paine in *Common Sense* employs the Puritan typology of self which Burke seeks to discredit in his *Reflections* (see Paine's references to "wilderness" and "emigrants," the experiences of God's chosen people; "Monarchy is ranked in scripture as one of the sins of the Jews," Jordan notes, p. 297). But for Paine everything was symbolic that was made by man. His own cast iron single-arch bridge was prefabricated in thirteen sections, symbolizing the thirteen states; the bridge would physically create, by connecting the distant riverbanks, a perfect union, preserved from the ordinary ice-damage to the piers.

were most of those who guided the fate of the French Revolution (from Danton and Robespierre to the very young Saint-Just and Napoleon).

The parental situation in England was the reverse of the one Paine had advocated at the end of *Common Sense*. Recalling perhaps Burke's metaphor of Medea, like the French, cutting up her father and boiling him to "regenerate the paternal constitution" (*Reflections*, pp. 116–17), Paine turns the metaphor around in *Rights of Man* and comes up with the father Saturn cannibalizing his sons (all except the firstborn):

> By the aristocratical law of primogenitureship, in a family of six children, five are exposed. Aristocracy has never more than *one* child. The rest are begotten to be devoured. They are thrown to the cannibal for prey, and the natural parent prepares the unnatural repast. [*Rights of Man*, p. 104]

This is by no means the last we shall hear of Saturn in relation to the French Revolution. In the midst of the accusation of the Girondins (including Vergniaud) Paine told Danton that Vergniaud had been right about the Revolution devouring its young.[46]

Paine brings together youth-age, father-son, primogeniture, and organic growth in a single powerful condensation some pages earlier, connecting the towering oak with "the despotic principles of the government" which are centuries old and "too deeply rooted to be removed . . . by anything short of a complete and universal revolution" (p. 69). "Lay then the axe to the root," he says (p. 80), quoting Matthew 3.10 ("And now also the axe is laid unto the root of the trees: therefore every tree which bringeth not forth good fruit is hewn down, and cast into the fire"), completing the phallic dimension of the metaphor and projecting another version of what Burke saw the "cruel ruffians and assassins" doing to their king, the Rousseauist valets de chambre doing to their master.

From both the "Lay then the axe to the root" passage and the climactic passage about the burgeoning buds of spring, Paine moves to *The Age of Reason* (1793), where he turns to the greatest of "musty" texts, the Bible:

> I have . . . gone through the Bible, as a man would go through a wood with an axe on his shoulders, and fell trees. Here they lie; and the priests, if they can, may replant them. They may, perhaps, stick them in the ground, but they will never make them grow.[47]

46. Quoted in David Freeman Hawke, *Paine* (New York, 1974), p. 287.

47. The Bible is, of course, the source for most of Paine's own metaphors, starting with the one alluded to in "Lay then the axe to the root." Burke picked up "root out" too in relation to the great British oaks in his letter to Fitzwilliam of 21 November 1791 (see above, n. 10). The sympathetic Anna Laetetia Barbauld passes on all of Paine's metaphors: "It is equally vain to expect to perceive a tree whose roots are cut away. It may look as green and flourishing as before for a short time; but its essence is passed, its principle of life is gone, and death is already within it." Again: "Whatever is loose must be shaken, whatever is corrupted must be lopt away; whatever is not built on the broad basis of public utility, must be thrown to the ground. . . . Obscure murmurs gather, and swell into a tempest" (*Works*, 2, 355–77).

And this sums up *Rights of Man* also, in which Paine goes back to origins—to the time before the Normans ("we must trace it to its origin" he says of the English government, p. 93), long before the artificial barrier of primogeniture was put between us and our heritage of freedom.

"Titles," he says, "are like circles drawn by the magician's wand, to contract the sphere of man's felicity. He lives immured within the Bastille of a word, and surveys at a distance the envied life of man" (p. 102). The "Bastille of a word" shows that Paine shares with many other predecessors (in literature Swift, Fielding, and even more, Sterne) the old topos of life versus (and being constricted by) the written or printed word of the past, with its "power of binding and controlling posterity to the 'end of time'" (pp. 62–63). His own rhetoric includes the idea of clearing away these fetters and barriers, of freeing argument from Burkean art and artifice, leaving it plain, open, and unhindered. Although he parodies Burke's own images (most obviously the idea of chivalry becoming Don Quixote in search of windmills to tilt with), and so produces his own myth of bastardy, his true view expressed in the myth is that "The past was a tale told by an idiot" (p. 14).[48] Plot, story, and history for him are only discontinuity and a total rejection of precedent of every kind. In *Rights of Man* he stopped with an upbeat ending, a myth of a pastoral future. Later, locked up awaiting possible execution at the hands of the Jacobins, he chose to write in *The Age of Reason* his ultimate demystification of the Christian "Book" or of any "Book," which included the French Revolution also.

WOLLSTONECRAFT

Paine was quick to see that for Burke revolution is a theatrical performance, just as his hell derives from Milton's poem and painted representations of it, and the whole is a strange aesthetic experience, one important element of which is the inevitable distance of the Englishman from the immediate danger but with the undeniable potential for a reprise on his own soil. In a passage as brilliantly sustained as any in the *Reflections*, Paine ties together "the tragic paintings by which Mr. Burke has outraged his own imagination, and seeks to work upon that of his reader" (paintings "very well calculated for theatrical representation"—indeed "a composite of art," "a dramatic performance" which produces "a stage effect") with Burke's persistent

48. Near the beginning of the *Reflections* Burke compares France to "the scene of the criminals condemned to the galleys, and their heroic deliverer, the metaphysical knight of the sorrowful countenance" (p. 7). He is referring to the revolutionaries, but as his critics saw and as he sensed himself in his passages defending Marie Antoinette, Burke was Don Quixote and the queen his Dulcinea. For Paine's treatment of Burke's theatricality, see James T. Boulton, in *The Language of Politics in the Age of Wilkes and Burke* (London, 1963), and Peter H. Melvin, "Burke on Theatricality and Revolution," *Journal of the History of Ideas*, 36 (1975), 449.

clothing imagery, leading up to: "He pities the plumage, but forgets the dying bird." Burke himself, of course, may have been thinking of the passage in *Common Sense* where Paine had written: "Government, like dress, is the badge of lost innocence; the palaces of kings are built on the ruins of the bowers of paradise"—which neatly reversed in advance Burke's pastoral setting ravaged by revolution.[49]

But Paine could also have been building on an even earlier response to Burke's *Reflections*, which emphasized the aesthetic dimension. A pamphlet called *A Vindication of the Rights of Men* was published by the end of the same month that saw the *Reflections*. Within a few weeks the second edition carried the name of its author, Mary Wollstonecraft. The addition of a woman's name was significant, for Wollstonecraft substitutes for the model of tyranny shared by Burke and Price—the religious plight of dissenters— one of her own: the plight of women in a male society. It was part of her answer to Burke's "letter" but also part of the female persona to choose the woman's literary form par excellence as the perfect vehicle for the "effusions of the moment" (as she describes them in her preface) and for "the spontaneity and vigor" of her attack.[50]

In many ways Wollstonecraft's response is the closest in spirit to Burke's own book. It is an impassioned letter addressed directly, and much of the time intimately, to Burke. It shares Burke's rhapsodic structure and even more than the *Reflections* functions as a poem rather than an argument. But what makes the *Vindication* especially interesting is the fact that running counter to the general, somewhat vague and repetitious dithyramb (which turns our attention from the French Revolution to the plight of the English poor; which polarizes the images of the property-oriented Burke and the champion of liberty Price) is Wollstonecraft's powerfully original insight into the relationship between English liberty and the servitude of women.

It is very clear that Wollstonecraft, while consciously inspired by Burke's attack on her friend and mentor Richard Price, was far more deeply stirred by his two central images of the French queen as beautiful, sexually threatened, passive, and vulnerable in an age when chivalry is dead; and of the procession that carried her to Paris, to the accompaniment of "horrid yells, and shrilling screams, and frantic dances, and infamous contumelies, and all the unutterable abominations of the furies of hell, in the abused shape of the vilest of women." Wollstonecraft quotes these lines and replies: "Probably you mean women who gained a livelihood by selling vegetables or fish, who never had had any advantages of education" (pp. 67–68). She is

49. *Rights of Man*, pp. 71–73; *Common Sense*, p. 50.

50. See Mitzi Myers, "Politics from the Outside: Mary Wollstonecraft's First Vindication," *Studies in Eighteenth-Century Culture*, 6 (1977), 116; see also 113–32; also R. R. Fennessy, *Burke, Paine and the Rights of Man: A Difference of Political Opinion* (The Hague, 1963).

expressing exactly Burke's fear when she connects the Revolution and its "assembly of unlettered clowns" (and the crisis they have produced) with "the active exertions that were not relaxed by a fastidious respect for the beauty of rank, or a dread of the deformity produced by any *void* in the social structure" (p. 117). This "void" (versus "the beauty of rank") is also the "abused shape of the vilest of women," and elsewhere "the poor wretch, whose *inelegant* distress extorted from a mixed feeling of disgust and animal sympathy present relief" (p. 12). Wollstonecraft probes downward to Burke's fear that the beautiful will be overthrown by the sheer vagueness, size, and force of "sublime" energy.[51]

These are the horrible, ugly, violent, aggressive *women* (versus Burke's more usual Rousseauistic men) of the Parisian mob who march to the royal palace and bring back the king and queen—women who in effect *are* the Revolution. Burke's contrast between the two kinds of women drew Wollstonecraft's attention to her own position as the female outsider in a male society and led to the tone of irate detachment which distinguishes her pamphlet (and to the identification of the author's sex in the second edition). But the contrast between the queen and the wretched women of the mob also allowed her to see to a level of Burke's argument only dimly sensed by other writers in their comments on his theatricality and the pleasure he seemed to take in the Revolution as a spectacle. Wollstonecraft's insight was far deeper: she saw that his categories were essentially his own aesthetic ones of the *Enquiry*. She bluntly asserts that "if we really wish to render men more virtuous, we must endeavour to banish all enervating modifications of beauty from civil society" (p. 115). Her contempt and indignation, she says, should not be taken as merely "a flight of fancy; for truth, in morals, has ever appeared to me the essence of the sublime; and, in taste, simplicity the only criterion of the beautiful" (p. 2).

She joins the images of the two kinds of women in passages she directly addresses to Burke:

51. Natalie Z. Davis notes that "Among the market women who marched to Versailles in October 1789, it is very likely there were men in female garb." She shows that "the donning of female clothes by men and the adopting of female titles for riots were surprisingly frequent" from the seventeenth century onward in both France and England. Female dress was "a practical concealment, and readily at hand in households," but, more important, "the female persona authorized resistance": "On the one hand, the disguise freed men from full responsibility for their deeds. . . . After all, it was mere women who were acting in this disorderly way. On the other hand, the males drew upon the sexual power and energy of the unruly woman and on her license (which they had long assumed at carnival and games)—to promote fertility, to defend the community's interests and standards, and to tell the truth about unjust rule." It is possible that this employment of the feminine image by men also helps to explain the figure of Liberty. See Davis, *Society and Culture in Early Modern France* (Stanford, Calif., 1975), pp. 147–48, 149–50.

A *gentleman* of lively imagination must borrow some drapery from fancy before he can love or pity a *man*.—Misery, to reach your heart, I perceive, must have its cap and bells; your tears are reserved, very *naturally* considering your character, for the declamation of the theatre, or for the downfall of queens, whose rank alters the nature of folly, and throws a graceful veil over vices that degrade humanity; whilst the distress of many industrious mothers, whose *helpmates* have been torn from them [e.g., by press gangs], and the hungry cry of helpless babes, were vulgar sorrows that could not move your commiseration, though they might extort an alms. [pp. 26–27]

The queen is recalled by the clothing imagery (drapery/fancy) and the "graceful veil" that makes vice charming; the women of the mob are represented by the "many industrious mothers," who eventually respond to the impressing of their husbands by marching to Versailles to get the queen. From passive observers, they have become an active force, filling the vacuum left by the pusilanimous males. The queen herself remains only a passive image of beauty, threatened by the irrational force of *other* women that is now unleashed.[52]

Women readers of Burke's *Enquiry* "have laboured to be pretty, by counterfeiting weakness" (p. 111). They are the Marie Antoinettes of the greater world, convinced by Burke's aesthetic that "*littleness* and *weakness* are the very essence of beauty" (p. 112) and that "Nature, by making women *little, smooth, delicate, fair* creatures, never designed that they should exercise their reason to acquire the virtues that produce opposite, if not contradictory, feelings" (p. 114). In Burke she sees the civilization that uses the search for beauty to replace the correction of crimes against the people, that sees experience in aesthetic rather than moral categories—that, in short, "refines the manners at the expense of morals" or makes them "a painted substitute for morals" (pp. 11, 157).

Burke's beautiful, she makes clear, is only a prettifying, as when reason

52. Wollstonecraft's description of Marie Antoinette in *An Historical and Moral View of the Origin and Progress of the French Revolution* (1794) is as loving and detailed as Burke's (pp. 131–35). She sees in the queen precisely a woman "with all those complacent graces which dance round flattered beauty, whose every charm is drawn forth by the consciousness of pleasing," who has sold herself to beauty (p. 131). Opposed to her are the women who marched to Versailles, "the lowest refuse of the streets, women who had thrown off the virtues of one sex without having power to assume more than the vices of the other." And this mob she contrasts with "the honest multitude, who took the Bastille" (p. 426). These same people, when Marie Antoinette arrived "young and beautiful" as Dauphine, loved her "and in their eagerness to pay homage, or gratify affectionate curiosity, an immense number were killed." Wollstonecraft adds: "In such a voluptuous atmosphere, how could she escape contagion?"—and, by implication, how could the mob not be turned into the raging grotesque women who are "the lowest refuse"? (p. 33). Wollstonecraft's *Historical and Moral View* was published in 1794, but (although awareness of the death of the king and queen is present, e.g., p. 134) it covers once again only the chief events of Burke's *Reflections* leading up to the removal of the king and queen to Paris in October 1789.

"is only employed to varnish over the faults which it ought to have corrected" (p. 4). It is the clothing—the veiling or covering over—that Burke argues for so fervently. The stripping of the woman (of Marie Antoinette), which Burke summons up as a horrible prospect, Wollstonecraft sees as the essential and necessary act. Echoing Burke on Marie Antoinette, she writes:

> Is hereditary weakness necessary to render religion lovely? and will her form have lost the smooth delicacy that inspires love, when stripped of its Gothic drapery? (p. 120)

Gothic is her favorite word for Burke's aesthetic: "These are gothic notions of beauty," she says, "—the ivy is beautiful, but, when it insidiously destroys the trunk from which it receives support, who would not grub it up?" (p. 10).[53] This grubbing up is the active, energetic, sublime part of the operation, and the part Burke fears. Again "Gothic gallantry" is opposed to a woman's "humanity," which "should have been better pleased to have heard that Lord George Gordon [inciter of the Gordon Riots] was confined on account of the calamities which he brought on his country, than for a *libel* on the queen of France" (p. 89). "Gothic" summons up ideas of chivalry and courtesy but also castles, cells, locked rooms, high walls, contracted marriages, and all the customs that make women fit into Burke's beautiful.

Marie Antoinette is the perfect focus because although queen she stands for the "weakness and indulgence" that "are the only incitements to love and confidence" in Burke's system (p. 124). Woman is at the center of this problem because Burke and English society in general believe that God gave women beauty so that they would not be inclined

> to cultivate the moral virtues that might chance to excite respect, and interfere with the pleasing sensations they were created to inspire. Thus confining truth, fortitude, and humanity, within the rigid pale of manly morals, they might justly argue, that to be loved, woman's high end and great distinction! they should 'learn to lisp, to totter in their walk, and nick-name God's creatures.' [p. 112]

Love or admiration of women is the "homage [which] vitiates them, prevents their endeavouring to obtain solid personal merit; and, in short, makes those beings vain inconsiderate dolls, who ought to be prudent mothers and useful members of society" (p. 54).[54]

53. This and other remarks ("You mourn for the idle tapestry that decorated a gothic pile" [p. 152]) anticipate Paine's more famous "You pity the plumage and ignore the dying bird."

54. Back in her novel *Mary* (1789), she wrote that in time of tribulation Mary "built a terrestrial paradise liable to be destroyed by the first serious thought: when she reasoned she became inexpressibly sad, to render life bearable she gave way to fancy—this was madness" (ed. Gary Kelly [London, 1976], p. 37). Wollstonecraft's view of the wife probably also draws upon Steele's *Tatler* no. 45 (23 July 1709), about the "unhappy Teraminta" whose life is luxurious but imprisoned, her only purpose being to satisfy her keeper. The contrast between Mary

This is Wollstonecraft's central insight: that beauty and seductiveness are
men's fiction imposed on women to keep them weak and submissive, Marie
Antoinette-like, so that such men as Burke can use them as his image of the
ideal chivalric society; rather than the messy, gross, vigorous (to Burke
grotesque) women who take the law into their own hands. These are mas-
culine women who, utterly outside Burke's aesthetic categories, are implic-
itly contrasted with the men who are ordinarily "unmanly" or "effeminate."
Wollstonecraft reveals the underlying experience of a woman: perhaps the
most basic, personal revolutionary experience in England, since there were
few black slaves (see below, pp. 93–94), and since women could be upper
class as well as eloquent without sharing the rights of their men—could
experience in an aristocratic body the agonies of the poor and oppressed.

By *primogeniture*, which "enables the elder son to overpower talents and
depress virtue" (p. 50), which is at the center of most revolutionary litera-
ture of the time, Wollstonecraft refers not to the brother but to the husband
or father who overpowers his wife and daughter. The gross and obvious
effect of her civilization on a female is the sacrifice "to family convenience,"
and the more subtle and insidious one is the inculcation of the "desire of
shining," of being beautiful, witty, and vain.

So it becomes clear that Wollstonecraft was inspired by the passages about
the queen who stood for everything beautiful and seductive, which to Burke
meant the goodness, and to Wollstonecraft meant the tyranny, of society—
and about the women of the "swinish multitude" that led the king and
queen to Paris: the two aspects of women which she saw as the heart of the
problem raised by the French Revolution. And from this insight she went
straight into her sequel, *A Vindication of the Rights of Woman* (1792), where
she attributes the social oppression of women to the assumptions that make
them submissive and delicate objects of beauty. Here she carries her argu-
ment one step further:

> Women are, in fact, so much degraded by mistaken notions of female excellence,
> that I do not mean to add a paradox when I assert, that this artificial weakness
> produces a propensity to tyrannize . . . (p. 25).

They "become either abject slaves or capricious tyrants" (p. 83). Although
still talking of society in general, she is already thinking of women when
she writes of "the freedom which has been bartered for splendid slavery"
(p. 29)—a phrase which applies only to women. Her view can be contrasted
with Burke's Swiftean thesis that idle and restless minds (imagining minds)
are the causes of "revolutions" in philosophy, religion, and government.
Taking women as her example, she sees their idle, restless, and imaginative

and poor Ann, her lovesick friend, runs through the novel: "In every thing it was not the great
[which draws Mary], but the beautiful, or the pretty, that caught her attention" (p. 13).

minds as creating illusions that keep them happy—fools among knaves—or make them tyrants but prevent them from carrying out a revolution. She makes her revolutionary thesis explicit: "It is time to effect a revolution in female manners—time to restore to them their lost dignity—and make them, as a part of the human species, labour by reforming themselves to reform the world" (p. 83). In *Rights of Woman*, which is as directly aimed at Rousseau as *Rights of Men* was aimed at Burke, Wollstonecraft argues that women must not submit physically and mentally to the male-oriented world but must train both mind and body. "To preserve personal beauty, woman's glory! the limbs and faculties are cramped with worse than Chinese bands, and the sedentary life which they are condemned to live, whilst boys frolic in the open air, weakens the muscles and relaxes the nerves" (p. 77). Her favorite terms are *exercise* and *exert*. Because women have been brought up to feel "contempt of the understanding," they have failed to develop "that persevering ardor necessary to give vigor to the faculties, and clearness to the judgment" (p. 46).[55]

The underlying image is of the female spirit struggling, through the energy of body and mind, to break out of social institutions, cultural assumptions, constricting dress, and her own body and sex, as well as from the prison of a specific marriage. She still contrasts Burke's categories, opposing "a pretty woman, as an object of desire" to "a fine woman, who inspires more sublime emotions by displaying intellectual beauty" (p. 86). In *Historical and Moral View* (1794) she refers to the "energetic character—A supple force, that, exciting love, commands esteem" (p. 23)—who *excites* rather than *exudes* love. Her figure is not the Burkean (or Blakean) revolutionary rapist but the female who attracts love but is energetic in other ways. She does not waste revolutionary energy on lovemaking.[56]

"I do not wish [women] to have power over men," she writes in *Rights of Woman* (p. 112); "but over themselves." Her image of the ideal situation for a woman (at least in society as presently constituted) is widowhood. Only the widow, she remarks in a passage on arranged marriages in the *Vindication of the Rights of Men*, shows that women can occasionally fall in love (p. 48). In the ideal family Wollstonecraft virtually removes the male (as husband and father) altogether. Her longest and most central discussion of the family in *Rights of Woman* assumes the absence, indeed the death, of the husband-father. Widowhood offers the real test of womanhood: Now "she subdues every wayward passion to fulfill the double duty of being the father as well as the mother of her children" (p. 91). The absence of the

55. See p. 49 for the sort of passage in Rousseau that outrages her—and is very like the Marie Antoinette passage in Burke.

56. She is closer to the Puritanic revolutionaries Eric Hobsbaum talks about in his essay on sex and revolution (*Revolutionaries: Contemporary Essays* [New York, 1973], pp. 216–19).

husband-father also gives rise to beneficial suffering and struggle ("experi-ence") for both wife and daughter. Earlier she has remarked that "An un-happy marriage is often very advantageous to a family, and . . . the ne-glected wife is, in general, the best mother" (p. 49). The woman should prefer struggle to the "present enjoyment" (p. 31) of sexual passion. Woll-stonecraft's fear of transient love and sexual passion, and her consequent advocacy of enduring friendship, is less important than her thirst for some variety of struggle or adversity in the relationship between man and woman.

At one point Wollstonecraft remarks that "the contemplation of the noble struggles of suffering merit has raised admiration" (p. 50), and this naturally recalls Milton's Satan and his sense of "injured merit." She adds a footnote at the bottom of the page to "Milton's pleasing picture of paradisiacal hap-piness" of Adam and Eve:

> yet, instead of envying the lovely pair, I have, with conscious dignity, or Satanic
> pride, turned to hell for sublimer objects. In the same style, when viewing some
> noble monument of human art, I have traced the emanation of the Deity in the
> order I admired, till, descending from that giddy height, I have caught myself
> contemplating the grandest of all human sights;—for fancy quickly placed, in
> some solitary recess, an outcast of fortune, rising superior to passion and discon-
> tent.

This is a passage of some import for the whole drift of Wollstonecraft's writing. Like Blake, she has "turned to hell for sublimer objects," and within her purview is still Burke's "grandest of all human sights," not the deity but "an outcast of fortune, rising superior to passion and discontent"—a wronged woman, who in relation to men is a Satan to whom active evil is to be preferred to passive good. As widow—as mother in relation to her chil-dren—woman is a self-sufficient Satan who has no need for man at all.

She has distinguished two categories: the sublime of the strong-willed, educated, struggling woman, and the beautiful of the faint-hearted passive "bird in a gilded cage." The underlying insight of Wollstonecraft's writings on the French Revolution is that the beautiful is no longer a viable aesthetic category. Poets and historians can no longer write about Burke's sad chi-valric fantasy based on female beauty: "it becomes necessary to observe, that, whilst despotism and superstition exist, the convulsions, which the regeneration of man occasions, will always bring forward the vices they have engendered, to devour their parents" (*Historical and Moral View*, p. 259). The eye of the poet and historian must inevitably move back toward the cannibalism and undifferentiation of the primal horde, indeed to the undifferentiation of aesthetic categories once the beautiful has been left be-hind. For a third category that remains unforgettable is the grotesque rout of women who march to Versailles, who could become sublime (she im-plies) were they to be educated. The force of her imagery (as opposed to

her argument) lies in the grotesque shapes and energies of that mob. The second stage, she would insist, is the harnessing of this energy into a sublimity that rises above both weak negative beauty and the positive grotesque. But her contribution to the imagery of revolution lies in her vivid portrayal of the existential woman.

CHAPTER 4 ❧
BLAKE'S
LAMB-TIGER

In the "Preludium" to Blake's *America* (dated 1793) a chained youth is being fed by the daughter of his captor; he snaps the chain and takes her—rapes her (or rather she allows him):

> The hairy shoulders rend the links. free are the wrists of fire;
> Round the terrific loins he seizd the panting struggling womb;
> It joy'd: she put aside her clouds & smiled her first-born smile.

In fact, "Soon as she saw the terrible boy then burst the virgin cry," and her joyous cry connects him with the spirit of freedom "who dwells in darkness of Africa" and has succeeded in a revolution "on my American plains."[1]

The illustration (fig. 4) shows this youth, "fiery Orc," helplessly chained to the ground, wept over by an Adam–Eve pair of parents. (Pity in the *Songs of Experience* was one of the chains binding Blake's downtrodden.) The youth is involved in a complicated system of lines that make him appear entangled in the roots of a great tree, which (as well as Burke's ancient oak) evokes the Tree of Knowledge. In the second illustration (fig. 5) he pushes his way up out of the earth and the root-tangle. "Blasphemous Demon, Antichrist, hater of Dignities, Lover of wild rebellion, and Transgressor of God's Law"—a little

1. See *The Poetry and Prose of William Blake*, ed. David V. Erdman (New York, 1965), pp. 50–51, and Erdman, *The Illuminated Blake* (New York, 1974), pp. 139–40. My discussion in the following pages should be read in the context of the basic books on the subject of Blake's visual-verbal art: Jean Hagstrum, *The Sister Arts* (Chicago, 1958), and *William Blake: Poet and Painter* (Chicago, 1964), and W. J. T. Mitchell, *Blake's Composite Art* (Princeton, 1978).

later "Devourer of thy Parent": these are the names Orc is called by Al-
bion's Angel, the spirit of English Toryism, whose name could as well be
Burke.[2]

Blake's etching *Albion Rose* (fig. 3) is dated 1780 to recall the American
Revolution and the Gordon Riots of that year (but was probably executed
closer to 1790). It shows a naked male youth as the center of a sunburst,
breaking the Vitruvian circle that circumscribes him, and his center of grav-
ity is his loins.[3] Light, youth, sexuality join in Blake's image of revolution,
and these are of course the images of revolt he develops with so light a
touch in *Songs of Innocence and Experience* (the combined work), where the
"innocence" of the Biblical lambs and children Christ suffers to come unto
Him is overdetermined by the growing sense of "innocence" in the new-
born, unfettered, unexperienced, and so (to his parents) dangerous child of
the newborn American and French revolutions.

Blake's plot resembles Burke's, seen of course from the other side. Blake
was no lover of Burke's theories; he was thinking of Burke when he anno-
tated Reynolds's *Discourses* with the remark, "Obscurity is Neither the Source
of the sublime nor any thing Else." He read the *Philosophical Enquiry*

2. Blake's inspiration for *America* and its sequels *The Song of Los* (with its divisions "Africa"
and "Asia") and *Europe* is the opening of Paine's second part of *Rights of Man*, which hails the
American Revolution as the model for revolutions to come:

> So deeply rooted were all the governments of the old world, and so effectually had the
> tyranny and the antiquity of habit established itself over the mind, that no beginning
> could be made in Asia, Africa, or Europe, to reform the political condition of man.
> Freedom had been hunted round the globe; reason was considered as rebellion; and the
> slavery of fear had made men afraid to think.
>
> But such is the irresistible nature of truth, that all it asks, and all it wants, is the liberty
> of appearing. The sun needs no inscription to distinguish him from darkness; and no
> sooner did the American governments display themselves to the world, than despotism
> felt a shock, and man began to contemplate redress.

This passage could serve as a précis for *America* and the prophecies that followed it; Paine's
pages abound with contrasts between the "old world" of Europe and the "new" or "infant"
world of America; the idea is that now that the Americans have revolted, so will the Europe-
ans. Blake changes the image of *Translatio Studii* into a *Translatio Libertatis* from America to
France and England. See *Rights of Man*, p. 181; cf. *Common Sense*, p. 101, which this passage
echoes: "Every spot of the old world is overrun with oppression. Freedom hath been hunted
round the globe. Asia and Africa have long expelled her. Europe regards her like a stranger,
and England hath given her warning to depart. O! receive the fugitive, and prepare in time an
asylum for mankind," he says, addressing America.

3. For counterinterpretations of *Albion Rose*, cf. Joseph Wittreich, *Angel of Apocalypse:
Blake's Idea of Milton* (Madison, 1975), pp. 52–57, 65; and Mitchell, *Blake's Composite Art*, pp.
54–55 n.23. Mitchell argues that "the center [of Blake's figure, as opposed to the sunburst] is
the loins rather than, as in the Renaissance figure, the navel. This is Blake's way of stressing
the use of the erotic image 'Naked Beauty Displayed' as a central means of 'Improving sensual
enjoyment' and disclosing 'the infinite which was hid'" (p. 53 n.25).

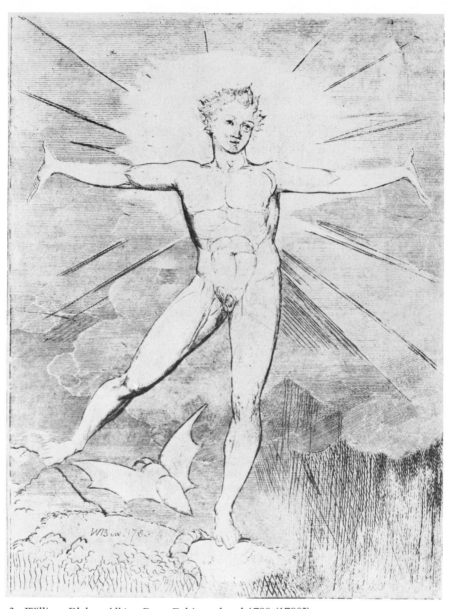

3. William Blake, *Albion Rose*. Eching, dated 1780 (1790?).

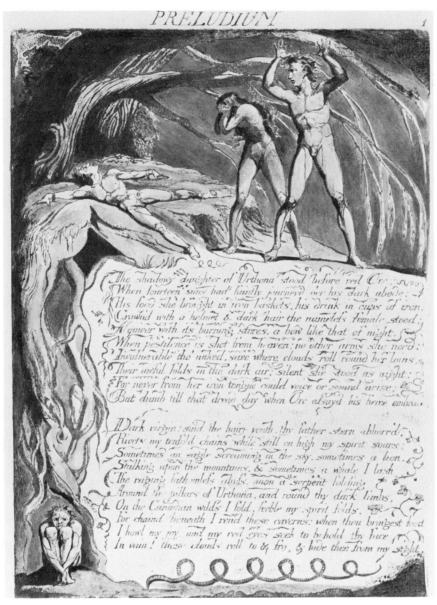

The shadowy daughter of Urthona stood before red Orc.
When fourteen suns had faintly journey'd o'er his dark abode;
His food she brought in iron baskets, his drink in cups of iron:
Crown'd with a helmet & dark hair the nameless female stood;
A quiver with its burning stores, a bow like that of night,
When pestilence is shot from heaven; no other arms she need:
Invulnerable tho' naked, save where clouds roll round her loins,
Their awful folds in the dark air; silent she stood as night;
For never from her iron tongue could voice or sound arise;
But dumb till that dread day when Orc assay'd his fierce embrace.

Dark virgin; said the hairy youth, thy father stern abhorr'd;
Rivets my tenfold chains while still on high my spirit soars;
Sometimes an eagle screaming in the sky, sometimes a lion,
Stalking upon the mountains, & sometimes a whale I lash
The raging fathomless abyss, anon a serpent folding
Around the pillars of Urthona, and round thy dark limbs,
On the Canadian wilds I fold, feeble my spirit folds,
For chaind beneath I rend these caverns; when thou bringest food
I howl my joy, and my red eyes seek to behold thy face
In vain! these clouds roll to & fro, & hide thee from my sight.

4. William Blake, *America* (1793), preludium 1.

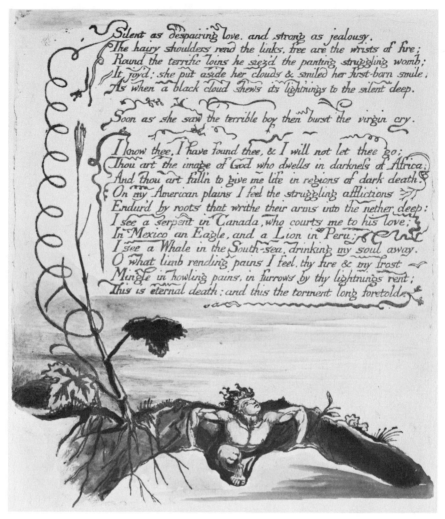

Silent as despairing love. and strong as jealousy.
The hairy shoulders rend the links. free are the wrists of fire;
Round the terrific loins he siez'd the panting struggling womb;
It joy'd: she put aside her clouds & smiled her first-born smile;
As when a black cloud shews its lightnings to the silent deep.

Soon as she saw the terrible boy then burst the virgin cry.

I know thee, I have found thee, & I will not let thee go;
Thou art the image of God who dwells in darkness of Africa
And thou art fall'n to give me life in regions of dark death.
On my American plains I feel the struggling afflictions
Endur'd by roots that writhe their arms into the nether deep:
I see a serpent in Canada, who courts me to his love;
In Mexico an Eagle, and a Lion in Peru;
I see a Whale in the South-sea, drinking my soul away.
O what limb rending pains I feel. thy fire & my frost
Mingle in howling pains, in furrows by thy lightnings rent;
This is eternal death; and this the torment long foretold.

5. William Blake, *America*, preludium 2.

"when very young" and hated it,[4] and when he drew his own *Satan, Sin, and Death* he made Satan the young challenger and Death the old, bearded Urizenic figure.[5] His contrary version of Burke is based on his personal reading of the Bible and Milton's *Paradise Lost*, together with the image of the young American Revolution with which he grew up, and his awareness (to which he also refers in the passage that opens *America*) of the "God who dwells in darkness of Africa." *The Visions of the Daughters of Albion* (1793) chronicles the attempt of the revolutionary principle to fly from America to Europe, where the soil is not so receptive. But David Erdman has also pointed out the connection between rape in the *Visions* and the atrocity stories in J. G. Stedman's *Narrative of a Five Years' Expedition against the Revolted Negroes of Surinam*, which Blake illustrated: The situation is the triangle of the female slave, her slave-lover, and the master who owns her and has her, which in this case leads not to the slave-lover's rebellion (as in *America*) but only to stasis, recriminations, and feelings of guilt.[6]

The extreme situation of the black slave and white master, as patently as Burke's submerged metaphor of the sublime, lies behind Blake's fiction. News of the summer of 1791 had focused on the flight to Varennes and capture of the French royal family *and* on the revolt of the slaves in Santo Domingo. But the agitation against slavery had arisen in England in the 1770s and 1780s; the Society for the Abolition of the Slave Trade was founded in 1787, and in the next year the question was first raised before Parliament. Supported by the oratory of Burke and Pitt as well as Fox, the slavery model was at hand before the French Revolution commenced. As Sheridan said in Commons (23 Apr. 1790), he was convinced "that the power pos-

4. David Erdman, *Blake: Prophet against Empire*, rev. ed. (New York, 1969), pp. 647, 650. Blake lumps together Burke's *Enquiry*, Bacon's *Advancement of Learning*, and Locke's *On Human Understanding* as empirical treatises and says he wrote comments on them similar to the ones on Reynolds's *Discourses*.

5. This is the version in the Huntington Library and Art Gallery, San Marino, California, in which Death, ordinarily a skeleton, is bearded. See Paulson, *Book and Painting: Shakespeare, Milton, and the Bible* (Knoxville, 1982), p. 112.

6. Erdman, *Blake*, pp. 230–42. Examples of oppression vividly presented by Wollstonecraft are the press-gangs, the game laws, and the slave trade. The *Analytic Review* was sufficiently impressed to quote from the first two passages in its review of *Rights of Men* (Dec. 1790). Her own metaphor for the common Englishman's oppression of women takes on urgency from these others that apply primarily to men. Her use of the slave analogy, for example, is the reverse of the more usual one (for example, Blake's), in which the slave master rapes the slave girl: "Where is the dignity, the infallibility of sensibility, in the fair ladies, whom, if the voice of rumor is to be credited, the captive negroes curse in all the agony of bodily pain, for the unheard of tortures they invent? It is probable that some of them, after the sight of a flagellation, compose their ruffled spirits and exercise their tender feelings by the perusal of the last imported novel" (p. 111). These ladies, she tells Burke, "may have read your *Enquiry* concerning the origin of our ideas of the Sublime and Beautiful, and, convinced by your arguments, may have laboured to be pretty, by counterfeiting weakness."

sessed by the West India merchant over the slave, was such a power as no man ought to have over another."[7] Very much in the air were the stories of the strong sexuality of male blacks. The punishment on the statute books of many Colonies for runaway male slaves was castration. This was not merely to render them docile but because of the male black's reputation for sexual prowess, and it implicitly highlights the rivalry between master and slave for both the slave's wife and the master's wife. Although supporting the abolition of the slave trade, Burke foresaw the danger of slaves planning rebellion against their masters with the object of "murders, rapes, and horrid enormities of every kind."[8]

Behind Blake's triangle of Orc–Urizen–Enitharmon is the rebellion which consists of the slave changing places with the master and taking his wife-daughter (roughly speaking, Caliban, Prospero, Miranda). Blake was also, of course, aware of the basic issue in the minds of most commentators on the French Revolution: the closed aristocratic family with its hereditary rights and principles of primogeniture, which (as Paine was arguing) had to be broken open. This situation was intensified by the slave triangle; Orc was one of those rebellious slaves, chained to a rock. And in this context the failure of Theotormon becomes even more striking and reprehensible. Paine in *Common Sense*, says: "As well can the lover forgive the ravisher of his mistress as the continent forgive the murders of Britain."[9]

But Blake's revolutionary plot is to some extent reflected in Theotormon's stasis, the point at which the historical referent is replaced or complemented once again by a literary signifier or model. Blake is parodying the situation of Macpherson's *Oothoon*, whose betrayal is revenged by an Orc who acts and kills the betrayer; his Theotormon only berates the innocent Oothoon. I think he was also recalling the black romance of Aphra Behn's *Oronooko* (1678), in which a white master wants Oronooko's beloved Imoinda, and Oronooko is another anti-Theotormon, whose rebellion takes place in Surinam. The closest parallel among black romances is the story of Yaricko and her white lover Thomas Inkle (a well-known version of which appeared in *Spectator* no. 11), which did have a strong female and a weak male. But his immediate model was Stedman's narrative *and* his personal knowledge of Stedman, which exceeds the limits of the narrative or at least powerfully reinforces the hints of the narrative: the weak white lover takes a black wife, fails to protect her against the rage of her white master, and returns to England leaving her to certain death.

7. *Parliamentary History*, 19 (1777–78), 698. See also Winthrop Jordan, *White over Black: American Attitudes toward the Negro, 1550–1812* (Chapel Hill, 1968). For the iconography of the black in the graphic works of Hogarth, see Paulson, *Book and Painting*, pp. 80–82.

8. Burke, *Works*, 3, 517; see also "A Letter to the Right Honourable Henry Dundas, . . . with the Sketch of a Negro Code," *Works*, 5, 521–44.

9. *Common Sense*, p. 100.

Finally, it is well to remember that during these same years, between 1790 and 1794, Blake was producing the lyric outbursts of the *Songs of Experience*, largely about children who either sink into repression or make futile attempts at Orc-like rebellion and are snuffed out. The children react against the figures of father, god, priest, and king: the baby who has just burst into the world ("piping loud") struggles against his "father's hands" and his "Swaddling bands" but subsides to sulk Theotormon-like upon his mother's breast; or the "little boy lost" rebels and is burned at the stake by a priest, with his parents (like the Adam and Eve of *America*) weeping but acquiescing spectators; or the "little girl lost" who has fallen in love with her Orc is met by "her father white" whose "loving look, / Like the holy book, / All her tender limbs with terror shook." The basic image is of the garden of love turned into a graveyard, sexual energy locked up in a church, desires bound up by briars, the Edenic apple poisoned or the rose cankered, and the warm public house replaced by the cold church. The referent is England in the mid-1790s under the Pittite repression, warming its hands at the fire across the channel, and the literary analogue is the Old Testament Genesis.

WORD VS. IMAGE

The text of the preludium to *America* deals with the revolution in America and the antislavery movement in England, in the story of the boy, "fiery Orc," chained down, rising, and breaking his chains. The illustrations (figs. 4 and 5), however, show something else. Helplessly chained to the ground, he is wept over by a pair of parental figures who resemble Adam and Eve. A few pages later the lines in which Albion's Angel addresses him as "Blasphemous Demon, Antichrist, hater of Dignities; / Lover of wild rebellion, and transgressor of God's Law" are accompanied by an illustration of children sleeping peacefully with a sheep (fig. 6). David Erdman interprets this as a projection backward in time: "an emblem of peace before the [American] war and prophesied to follow the [French] revolution,"[10] but clearly the main point is the violent juxtaposition of visual and verbal texts. It is a stronger version of the discrepancy we feel between the words about Orc, Urthona, and his daughter and the illustration of Orc, Adam, and Eve. A dialectic is at work in the words and image, setting against each other the equally extreme ways the French Revolution looked to Burke and to Paine: Burke's "transgressor of God's Law" and Paine's perception "that the spring is begun."

This kind of visual catachresis centers on the representation of the French Revolution. I shall begin by examining it as a transvaluation of accepted

10. *Illuminated Blake*, p. 145.

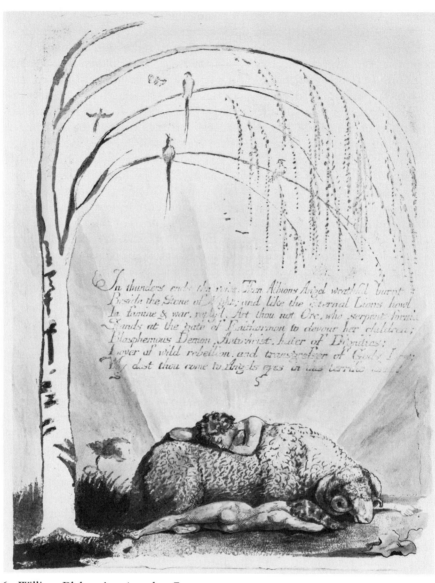

6. William Blake, *America*, plate 7.

images of the revolution and then go on to examine it as a representation of the revolutionary process itself.

Perhaps what we have associated more than anything else with the Revolution is renaming (see above, p. 15). This *recreation* of meaning characterizes the revolutionary spokesmen in France, but we should not be surprised to find it even more glaringly, because more desperately, employed in nonrevolutionary (counterrevolutionary) England by a sympathizer of revolution such as Blake. In England, however, Blake's response was conditioned by Burke's *Reflections*, which took the utopian rhetoric of spreading illumination/fire in Price's address to the Society for the Commemoration of the Glorious Revolution, and with the aid of common sense returned the renaming to its original signification of uncontrolled destruction. Paine then went about the same process of common sense analysis in his critique of Burke's "renaming" of the events in France. Essentially in the same spirit Blake demystifies the rhetoric of Burke and the counterrevolutionary polemicists—with the exception that his demystification is posited, as a revolutionary's vision, on a resting point that is a higher mystification, a mystery that *cannot* by solved by common sense.

My example is one of the *Songs of Experience,* "The Tyger," which in the annotation of college texts is usually explained as a poem dealing with the question of how we are to reconcile the wrath of God and punishment of sin (the tiger) with the forgiveness of sin (the lamb of *Songs of Innocence*).[11] This interpretation sees the tiger as another of the wrathful father figures in *Experience.* He is, however, more closely akin to the natural energy of the tigers in *Innocence* who may also, among other energetic acts, devour sheep or children. On a primary level of Blake's intention the tiger exists in relation to the word *tiger* in its 1790s' context.

The *London Times* of 7 January 1792 tells us that the French people are now "loose from all restraints, and, in many instances, more vicious than wolves and tigers." Of Marat the *Times* reports: "His eyes resembled those of the *tyger cat,* and there was a kind of ferociousness in his looks that corresponded with the savage fierceness of that animal" (26 July 1793).

John Wilkes, after his initial support of the Revolution, spoke of "this nation of monkeys and tigers," conflating the double caricature of French fashion and French savagery, and Sir Samuel Romilly referred (above, p. 38) to the French as "a republic of tigers in some forest in Africa." Even Mary Wollstonecraft admitted that the Paris "mob were barbarous beyond the tiger's cruelty." Burke described the Jacobins in 1795 as so violent that "even the wolves and tigers, when gorged with their prey, are safe and

11. See, e.g., Hazard Adams, "Reading Blake's Lyrics: 'The Tyger,'" and John E. Grant, "The Art and Argument of 'The Tyger,'" in *Discussions of William Blake,* ed. Grant (Boston, 1961), 50–63, 64–83.

gentle" by comparison, and the next year he compared them to a "tiger on the borders of PEGU" (where it may have been considered safe) that suddenly makes its appearance in the English House of Commons (above, p. 67). Years later Wordsworth looked back on the Paris of 1792 as

> . . . a place of fear
> Unfit for the repose which night requires,
> Defenceless as a wood where tigers roam. [12]

The image was very much in the air in the 1790s. On the one hand, the French themselves sang the words in their "Marseillaise" (1792): "Tous les tigres qui sans pitié / Déchirent le sein de leur mère!"; on the other the tiger was an image that naturally came to mind in the effort to describe the strange events across the channel. Had Burke recalled Ripa's *Iconologia* he would have had a learned authority for the signification of tigerish cruelty, but both Burke and Blake probably shared one common source: Milton's simile for Satan prowling around Paradise:

> Then as a Tiger, who by chance hath spi'd
> In some Purlieu two gentle Fawns at play,
> Straight couches close, then rising changes oft
> His couchant watch, as one who chose his ground
> Whence rushing he might surest seize them both
> Gript in each paw. . . .
>
> [*Paradise Lost* 4.11.403–08]

Burke must have remembered this passage, having just quoted the description of Satan and Sin, when he chose the tiger as well as Leviathan, the horse, the bull, and the wild ass as "sublime" animals in the *Philosophical Enquiry*. Blake, like Paine, saw through Burke's aesthetic/dramatic representation of the Revolution in which the "beautiful" passive queen is threatened sexually by the active, male, "sublime" force of the revolutionaries—a plot Blake reversed in the joyful reciprocation of Urthona's daughter.

In *The Marriage of Heaven and Hell* (1790?) he connects Leviathan and tigers in the vision of the French Revolution conjured by a Burkean angel (p. 18). The angel sees a storm with "Leviathan": "his forehead was divided into streaks of green & purple like those on a tygers forehead" (like the "fearful symmetry" of the tiger in *Experience*). As soon as the angel leaves, however, the vision dissolves into a pastoral scene with a harper singing a song about natural change: "a harper who sung to the harp, & his theme was, The man who never alters his opinion is like standing water, & breeds

12. Romilly, letter to M. Dumont, 10 September 1792, from *Memoirs of the Life of Sir Samuel Romilly* (London, 1840, 2d ed.), 2, 5; Wollstonecraft, *An Historical and Moral View of the French Revolution* (1794), p. 521; Burke, *Letter to a Noble Lord* (1795), *Works*, 5, 112; *First Letter on a Regicide Peace* (1796), *Works*, 5, 225; Wordsworth, *Prelude* (1805), ll. 80–82.

reptiles of the mind" (p. 19). In short, both Leviathan and the tiger are only in the mind of the angel.

Blake's "The Tyger" is that angelic formulation, spoken by a Burke who sees the French Revolution, politically and aesthetically, as a sublime spectacle/threat. The references in the poem to the creator (of the Revolution) and to the revolt of the fallen angels ("When the stars threw down their spears") tell the story. The tiger is a natural force, but *what* sort of force depends on the beholder. The Job passage that Burke evokes in his discussion of sublime animals is also (with "The Lamb" of *Innocence*) the syntactic model for "The Tyger": a series of questions addressed by God speaking from the whirlwind to Job, ending:

> Canst thou draw out leviathan with a hook? or his tongue with a cord which thou lettest down? Canst thou put a hook into his nose or bore his jaw through with a thorn? Will he make any supplications unto thee? Will he speak soft words unto thee?[13]

Burke's animals are sublime precisely when they will *not* answer with Job, No, I cannot; when they will not serve the wills of their masters. The wild ass, for example, "is worked up into no small sublimity, merely by insisting on his freedom, and his setting mankind at defiance."[14]

When in this context we look at the drawing that illustrates the verses (fig. 7), we see a tiger that looks like a lamb. Both in terms of its face and its stance—certainly not *couchant* (or even *regardant*)—the tiger does not threaten. In the text it is "burning bright" against the "forests of the night," but in the illustration it stands against the pink of a dawn and a single leafless tree. The tiger no longer burns bright: it has lost its fire and its nocturnal ferocity, its revolutionary figuration. We see before us on the page, in the Urizenic words and the Blakean image, the angel's vision and the reality.

Blake engenders the contrast with his visual image in much the same way he contrasts the words of Albion's Angel in *America*, excoriating Orc for

13. Job 41.1–3. Proposed by Morton Paley, *Energy and Imagination: A Study of the Development of Blake's Thought* (Oxford, 1970), pp. 45–46. Paley quotes from Edward Young and William Smith on the sublimity of such questions, especially in Job 37, "where we behold the Almighty Creator expostulating with his Creature. . . . There we see how vastly useful the Figure of Interrogation is, in giving us a lofty Idea of the deity, whilst every Question awes us into Silence, and inspires a Sense of our own Insufficiency" (trans. *Peri Hupsous*, p. 154, cited in Paley, p. 49). Paley sees the dichotomy as between the angels who call the Revolution evil and the poet who calls it sublime. Cf. also Harold Bloom's "strong" reading, which suggests that Cowper, as *the* sublime poet of the later eighteenth century, may be the imagined speaker (*Poetry and Repression: Revisionism from Blake to Stevens* [New Haven and London, 1976], p. 47; also p. 46: "The forerunners of Blake's Tyger are the Leviathan and Behemoth of Job, two horrible beasts who represent the God-ordained tyranny of nature over man, two beasts whose final name is human death, for to Blake nature *is* death").

14. Burke, *Philosophical Enquiry*, p. 66; Job 39.5.

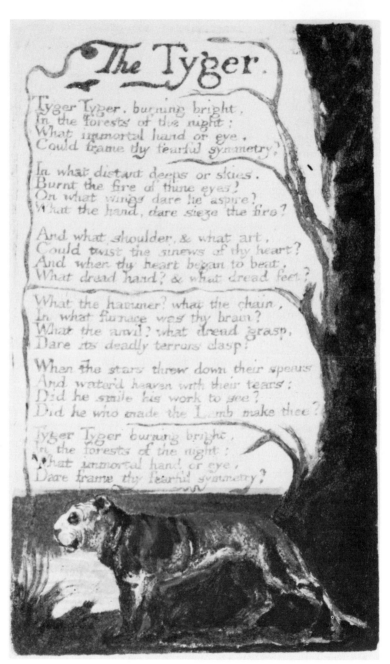

7. William Blake, "The Tyger," *Songs of Innocence* (1795).

his revolutionary proclivities, with the image of children lying down to sleep alongside a peaceful sheep. He is not denying the vigor of the tiger—one of those "tygers of wrath" in *The Marriage of Heaven and Hell* that "are wiser than the horses of instruction"—but only redefining a counterrevolutionary image of revolutionary cruelty. The catachresis indicates not only a contrast with the words of Albion's Angel but something positive about revolution. It is a kind of innocence confronting experience, best seen in the brief scenarios of the *Songs of Experience*. These *Songs* transform the gentle children of contemporary children's verses into the little rebels of Freud and Melanie Klein, who appear to their elders as devils (or, as in the case of the little boy who is burned at the stake in "A Little Boy Lost," possessed by devils).

It is significant that "The Tyger" starts out as a description of the tiger, but the description is immediately displaced onto an account of its maker and its making. The crucial final lines of the first and last stanzas ("What immortal hand or eye, / Could frame thy fearful symmetry?") apply equally to God, the fiction-maker of the French Revolution (Burke), and the poet himself, who is both creating and coming to terms with—"framing"—the tiger in the sense of both making and delimiting it. "Did he smile his work to see? / Did he who made the Lamb make thee?" could cover all these *makers*, with the first an especially ambiguous pivoting on Burke–God–Blake. The tiger is taken from description to making, from response to ever more distant contexts in space and time—from forest to "distant deeps or skies" and from *this* night to the night of creation.

On the other hand, as Steven Shaviro has argued, the tiger is in psychic terms an object of primal repression—whether on the part of the Englishman of the 1790s or of Blake himself; it is an example of "the instinct being denied entrance into the conscious,"[15] and so the speaker is defined, as by Freud, as motivated by anxiety: "It was anxiety which produced repression, and not, as I formally believed, repression which produced anxiety."[16] The poem is an expression of anxiety—anxiety transformed into terror and awe, which sums up Blake's analysis of Burke and/or of the Blakean view of the Revolution.

In more general terms, what "The Tyger" and all the *Songs of Experience* show us is how Blake demystifies the word. *The Marriage of Heaven and Hell*, contemporary with the poems of *Experience*, is a much larger, more

15. See Freud, "Repression," *Standard Edition*, 14 (1957), 148; Shaviro, "Differential Structure of Romantic Imagination: Blake, Shelley, Stevens" (Diss., Yale University 1981), pp. 58–61. The tiger is therefore "an empty signifier, a screen or mirror which reveals only the desires and fears of its interpreter. . . . As a figure of primal repression, the tyger cannot be tied down to any given and specified context, but rather draws to itself whatever secondary repressions, or repressed contents, the reader is able to supply" (pp. 63–64).

16. Freud, *Standard Edition*, 20 (1959), 108–09.

direct statement. When he writes that "the Eternal Hell revives," he means that the French Revolution is taking place. "Hell" here is the counterrevolutionaries' (and in particular Burke's) word for it. In the same way these people exalt "all Bibles or sacred codes" and detest energy, exalt the Messiah, and detest Satan the tiger. Blake collects his "proverbs of Hell" during his walk "among the fires of Hell . . . as the sayings used in a nation, mark its character": in other words, in France. But he is a visitor, an Aeneas in the underworld, a Dante in hell, and his writing is not about the Revolution in France but about the repression—the imaging of the Revolution as diabolic—that is being carried out at home in England. Satan is transvalued into Christ because this is the way Christ looked to the Pharisees and Levites, who noted that he healed on the Sabbath and kept company with wine-bibbers and harlots—just as the French Revolution looked to Burke and children looked to their parents in *Songs of Experience*.

Blake employs at least two other forms of the revolutionary metaphor of discrepancy or catachresis: to describe his own process as artist and to describe the actual process of the historical revolution in France. For in the process of transvaluation he moves from a representation of revolution (in the English misconceptions about the French Revolution) to what we might call a revolutionary art: an art of "hell," of the tiger, of (as he describes it in *The Marriage of Heaven and Hell*) acid burning and corroding, a radical return to Gothic forms and illumination; and so he raises the question of the relationship between political and artistic revolution.

In his initial image of the French Revolution (fig. 3), sunlight, youth, and sexuality join, but art is also involved. Rising out of enslavement is equated with youth bursting the Vitruvian textbook diagram of the proportions of the human body. The sun's energy, as opposed to the geometrical shape, is part of the meaning. The "Marseillaise" included the lines: "The rays of the sun have vanquished the night, / The powers of darkness have yielded to light." In his poem *The French Revolution* (1791) Blake still refers to the king of France as the sun, but he is now obscured by clouds, and a new sun is rising to replace him: a political *and* aesthetic sun.

As the works of Burke and Coleridge (among others) show, however, the sun was a radically ambiguous symbol: it burned and destroyed as well as illuminated. In plate 20 of *Urizen* Blake describes Orc in the verse as born in flames while he portrays him visually as Icarus falling in flames, from too close contact with the sun. Thus the fall of Orc, or revolutionary energy, is implicit in his birth, or at least in his rebellion. In plate 10 of *America* (fig. 9) Blake shows "fiery Orc" amidst flames, either—depending on the coloring of different copies of the book—emergent or being consumed. (In the black-and-white state, apparently the first, Orc is emerging from the

flames; the version in which he is engulfed in the flames is later, an after-thought in light of the turn taken by the Revolution.)

In this case, Blake makes his point even more striking by juxtaposing this image of Orc in plate 10 with Urizen in plate 8 (fig. 8): he shows them posed as mirror images. Moreover, he places a speech of Orc under the image of Urizen, and the Urizenic evocation of Albion's Angel and his convocation of angels under the image of revolutionary Orc, rendering them interchangeable.

Blake has now passed from the catachrestic image as transvaluation of counterrevolutionary terms to its representation of the ambiguous or para-doxical process of revolution itself. Epistemologically these double images are different ways the revolution is seen, or different aspects of it, but his-torically they are also temporal stages in its development. The interchange-able image of Orc and Urizen, or indeed of the lamb and the tiger, indicates a compressed relationship that in the books that followed *Urizen* Blake ex-foliates into a narrative structure.

Looking back at his "Bible of Hell," we can say that Blake arrives at his plot by transvaluing the conventional progression of Old Testament to New (or Law to Gospel, Fall to Redemption) by making the relationship one of liberation rather than typological fulfillment. Law is to Gospel as confine-ment is to freedom. But then, as Blake discovers by observing the events in France, freedom moves back to confinement again, as New becomes Old Testament, coexisting simultaneously as in the confrontation of Orc and Urizen.

However, the Biblical model of the single cycle of the Son who redeems fallen man (or in Blake's terms, his Father) proves unsatisfactory beside the classical one, already introduced by Paine (in *Common Sense*), of the vicious and continuing cycle of the son castrating his father, internalizing him, and oppressing his own son until that son becomes powerful or artful enough to kill him. Historically, a Robespierre votes to kill the king and then be-comes more powerful and cruel than any Bourbon. Blake mythologized him in *The Book of Ahania* (1795), and in the *Four Zoas* (1796–1807?) he made Napoleon the definitive protagonist of the Orc cycle.

Even before he was aware of history's irony that successful revolution will fail from internal flaws, Blake foresaw its failure from external re-straints. At the very beginning of *America* he placed a frontispiece that con-tradicted the progression of both "Preludium" and the narrative that fol-lowed it (fig. 10). The narrative leads to a happy ending: While Urizen has obscured the fires of the American Orc with clouds and mist, it is promised that after twelve years the French Revolution will spread throughout Eu-rope; meanwhile, however, the frontispiece shows the giant Orc now meekly serving to patch the very breach he has made in the tyrant's wall. The visual image tells us that the process has by this time led only back to the rebel

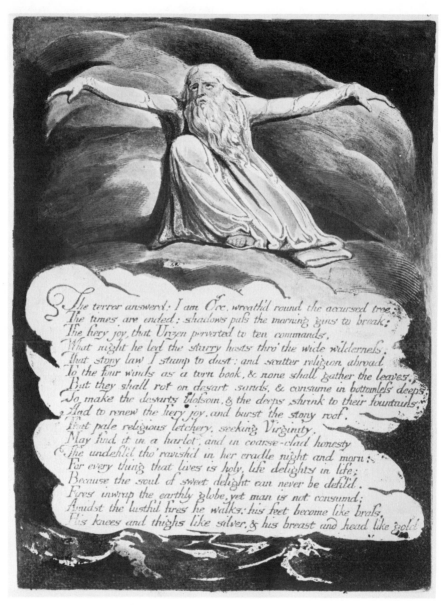

The terror answerd: I am Orc. wreath'd round the accursed tree:
The times are ended; shadows pass the morning gins to break;
The fiery joy, that Urizen perverted to ten commands,
What night he led the starry hosts thro' the wide wilderness:
That stony law I stamp to dust: and scatter religion abroad
To the four winds as a torn book, & none shall gather the leaves;
But they shall rot on desart sands, & consume in bottomless deeps;
To make the desarts blossom, & the deeps shrink to their fountains.
And to renew the fiery joy, and burst the stony roof.
That pale religious letchery, seeking Virginity,
May find it in a harlot, and in coarse-clad honesty
The undefil'd tho' ravish'd in her cradle night and morn:
For every thing that lives is holy, life delights in life;
Because the soul of sweet delight can never be defil'd.
Fires inwrap the earthly globe, yet man is not consumd;
Amidst the lustful fires he walks: his feet become like brass,
His knees and thighs like silver, & his breast and head like gold.

8. William Blake, *America*, plate 8.

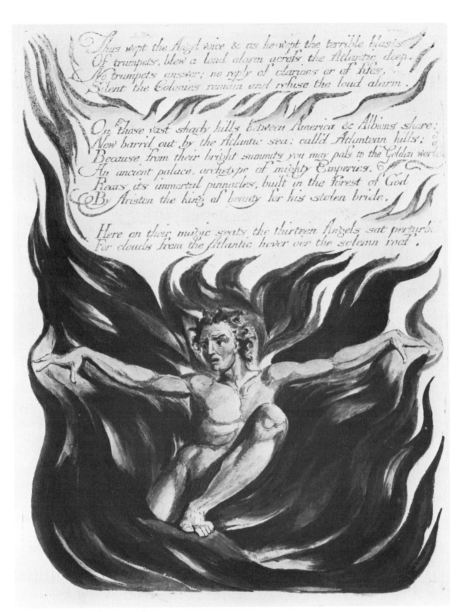

Thus wept the Angel voice & as he wept the terrible blasts
Of trumpets, blew a loud alarm across the Atlantic deep.
No trumpets answer; no reply of clarions or of fifes,
Silent the Colonies remain and refuse the loud alarm.

On those vast shady hills between America & Albions shore;
Now barrd out by the Atlantic sea: call'd Atlantean hills:
Because from their bright summits you may pass to the Golden world
An ancient palace, archetype of mighty Emperies.
Rears its immortal pinnacles, built in the forest of God
By Ariston the king of beauty for his stolen bride.

Here on their magic seats the thirteen Angels sat perturb'd
For clouds from the Atlantic hover oer the solemn roof.

9. William Blake, *America*, plate 10.

serving as his own counterrevolutionary, either as a huge, stupid Gulliver
(or a Theotormon in *Visions of the Daughters of Albion*) or as a tyrant in his
own right.

The Blake structure I have outlined finds an analogue in another work
that was written in 1794 to recount the events of 1789 only. Wollstonecraft
wrote her *Historical and Moral View* during the Terror, concluding her ret-
rospect at the end of II.ii with the fall of the Bastille: "Down fell the temple
of despotism; but—despotism has not been buried in its ruins!—Unhappy
country!—when will thy children cease to tear thy bosom?—. . ." (p. 163).
I am suggesting that this is the sort of sequence Blake gives us in *America,
Visions of the Daughters of Albion*, and other "visionary" works.

We may conclude that there was a turn in the historical revolution in
France which seemed to render conventional signifiers of revolution inad-
equate. If *America* celebrated the Pittite repression within England that greeted
the Revolution, the later illuminated books reflected the cyclic pattern of
revolutionary process that revealed itself in France from the autumn of 1792
on. The result is that the Revolution and Blake's poems have become mod-
els for each other. In this relationship the referent has begun to determine
the signifier, and the artist is moving beyond the conventional images of
sunrise, erupting volcanoes, hurricanes—even the sublime—to equivalents
that depend on the actual turn of events or that indicate the unrealiability of
any image as a guide to truthful representation of the revolutionary phe-
nomenon.

Blake's skepticism about the language of revolution may derive as much
from revolutionary as from counterrevolutionary rhetoric (vs. event).
Transvaluing both Biblical stories and the accepted meanings of words, he
shows that words regain power when freed from the formulations of Ten
Commandments or the charters or contracts he talks about in "London."
But he acknowledges that they are still words, ever ready to slip off into
antitheses of the Divine Logos, to conceal meaning—or to produce "mean-
ing" that conceals the reality of human desire, the Orc in us.

It is not surprising then that in the illuminated books of the 1790s the
word and image are in various ways at odds. One is not quite reliable with-
out the other; more needs to be conveyed than can (under the present Pittite
censorship or man's fallen state) be conveyed by either one or the other.
Blake is also demonstrating, however, that they certainly do not make a
unity; they are not simply "illustrative" of each other or constitutive of
some absent existent object such as "revolution."

Not only the cynical play with words in both France and England, but
all the concern with language systems following the upheavals of the Thirty
Years' War on the Continent and the Civil War in England fed into Blake's
central realization of the discrepancy between word and image. Whenever
civil upheaval is to be described mimesis fails, as do the other normative

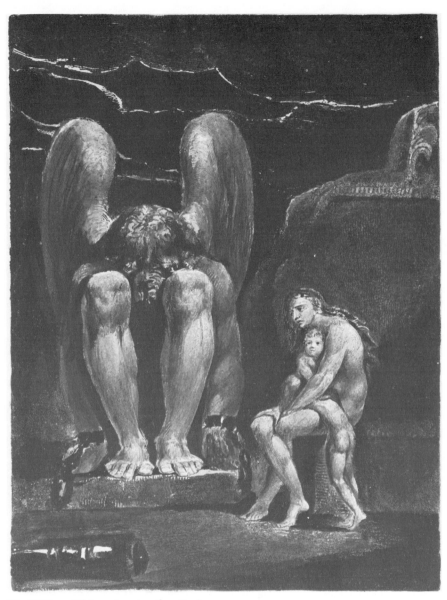

10. William Blake, *America*, frontispiece.

assumptions laid down by academies of literature and art, especially the
principle of *ut pictura poesis*, the notion that painting and poetry were "Sister
Arts." The artist's function is neither the portrait painter's making present
what *was* present but is now absent, nor the history painter's making pres-
ent what is yet only dimly present in the words of the poet, but the "revo-
lutionary's" making present what was not present before—what has been
only distorted by the words of Commandments or the rules of the acade-
mies. The words alone are ironic utterances; the images are direct and de-
scriptive. The words censor, the images naively expose, but the words also
reveal subtleties denied by the visual image.

In linguistic terms we might explain the "Orc Cycle" as Blake's initial
reversal of hierarchical oppositions, giving priority to the "oppressed"
member of the hierarchy, and then as his process of denying the "revolu-
tionary" member its newly privileged "sovereignty" by revealing that it
was in fact implicit within its antagonist master. This formulation applies
to the general relationship of the Sister Arts in the "Bible of Hell."

Perhaps I can suggest one more reason why a tiger is employed by Blake
to complement the lamb. It is an unexpected word because the lamb has
been presented in the context of Innocence *and* Experience, and so we an-
ticipate as its contrary a lion or a wolf. The prophetic source, once again,
tells us that "the wolf and the lamb shall feed together" (Isa. 65.25), which
came into common usage as "the lion and the lamb shall lie down to-
gether"—but never the tiger and the lamb. As Blake himself put it in *Amer-
ica*, there will be a time when "Empire is no more, and now the Lion and
Wolf shall cease." But "Tiger" *is* the correct word, and Blake's literary source
in Burke's *Philosophical Enquiry* and counterrevolutionary polemic was sup-
plemented, I propose, by the lines from the opening of Horace's *Ars poetica*,
the locus for the whole traditional understanding of the doctrine of ut pic-
tura poesis. That passage describes the painting of comically monstrous
creatures roughly resembling centaurs and mermaids.

Painters and poets, says Horace, have been free to try anything, "but *not*
to the extent / Of mating the mild and the wild, so that snakes are paired /
With birds, and tigers with lambs." [17] Most of the seventeenth- and eighteenth-

17. The translation is by Smith Palmer Bovie (*Satires and Epistles of Horace* [Chicago, 1959],
p. 271). The whole Latin passage reads:

> Humano capiti cervicem pictor equinam
> iungere si velit, et varias inducere plumas
> undique collatis membris, ut turpiter atrum
> desinat in piscem mulier formosa superne,
> spectatem admissi risum teneatis, amici?
> Credite, Pisones, iste tabulae fore librum
> persimilem, cuius, velut aegris somnia, vanae
> fingentur species, ut nec pes nec caput uni

century English translations remain faithful to the Latin "tigribus agni," and the prose renderings of Samuel Patrick, Samuel Dunster, and Christopher Smart transmitted that reading to the English common reader. The Earl of Roscommon's version ends:

> But nature, and the common laws of sense
> Forbid to reconcile antipathies,
> Or make a snake engender with a dove,
> And hungry tigers court the gentle lambs.

The lyric of Blake's "Tyger" superficially poses the question of how evil energy can coexist with meek goodness in God's universe. Blake is saying that they do coexist in his poetic universe of contraries, which is also that of the French Revolution. We must submit to the purpose of "The Tyger," as of the French Revolution, to raise and sustain the paradoxes of the world of experience.

The Sister Arts is a persistent metaphor in Blake's illuminated books. He uses it to demonstrate the bleak separation of visual and verbal meanings in the world of experience (revolution and counterrevolution), simultaneously a world of rebellion and repression. While in the *Songs of Innocence* there is no significant level of supraliteral meaning, in *Experience* Blake introduces an authorial voice, self-consciousness, and the literary Fall that—in irony, satire, punning—is ambiguity of meaning. The state of experience forces us into the position of the self-conscious reader, trapping us in the labyrinth of possible meanings. The unity of textual meaning and literary form in *Songs of Innocence* represents the unfallen word, a divine or prelapsarian logos before the advent, perhaps, of the written lyric; *Songs of Experience* is demonstrably the realm of the fallen word.

In terms of the history of the French Revolution, the poems express an education, a process that requires Experience, including the loss it entails. In terms of the poetic development from Innocence to Experience, as described in the introduction to *Innocence*, Blake traces the progression of the lyric (lyros = lyre) from a piped, spontaneous song to a literary form. The piper's pipe, which was once filled with the breath of life and art, now becomes the "hollow reed," the pen of the amanuensis; the piper becomes a poet and hence falls from innocence in the production of his art. In the world of experience, surrounded by tears and blackening churchs and palace walls running blood, the piper becomes a bard, recalling ultimately

reddatur formae. "Pictoribus atque poetis
quidlibet audendi semper fuit acqua potestas."
Scimus, et hanc veniam petrimusque damusque vicissim;
sed non ut placidis coenant immitia, non ut
serpentes avibus geninentur, tigribus agni.

Gray's last bard, who utters his curse on the murderous king and plunges
to his death.

One other thing that distinguishes experience from innocence is the loss
of the mutual dependence of text and design that is apparent in *Songs of
Innocence*. In *Experience* the lyric is noticeably separate from the design; their
potential disengagement seems apparent from the way the text floats in front
of the infinitely receding void of the pictorial framework—time works against
space in a strict dichotomy. In "London," for example, the illustration seems
to be an emblematic representation of what is *not* stated in the poem: The
old Urizen and the young Orc are a simplification or displacement of the
dense connotations of the words into a different world altogether.

In plate after plate Blake presents the natural antipathy between the Sister
Arts, as between the polar interpretations of the Revolution, but at the same
time he demonstrates that the apparently unresolvable antipathy can be
transcended. He places them in a new relationship to each other that is
metaphoric instead of illustrative or merely mimetic—which creates in a
"revolutionary" way rather than merely repeats or substantiates. He is in
fact reaffirming—or rather redefining—the unity of the Sister Arts of po-
etry and painting; he is seeking a continuity with that old tradition as a
model for the unity he sees in art (or in revolution as an artistic experience,
a making on his part) as opposed to the Burkean separation of the arts.
Burke, in the passage he illustrated with Milton's description of Death, tried
to demonstrate the superiority of the poet's words over the artist's visual
image. Blake uses the visual image to correct and complement the fallible
repressive word, but both have to stand if the transaction is to be complete.

For Blake paradox seems to be the characteristic feature of revolution
itself, as well as the interpretation of it. The French Revolution offered the
concrete case in which words have antithetical meanings ("tiger" or "devil,"
but also "General Will" or "traitor"), and in which the actors prove to be
both good and evil at the same time (a Lafayette, a Robespierre, or a Na-
poleon). These contradictions could be read either as a double bind in which
the revolutionary enthusiast (Romilly, Wordsworth, or Hazlitt) found him-
self or as a paradox where we accept the paradox as we repudiate the sepa-
ration of the Sister Arts. The Revolution, like his art, inhabits for Blake
that mythic area of ambiguity and doubleness where contraries can coexist.

CHAPTER 5 ᕤᕦ
ROWLANDSON, WILKES, FOX, SHERIDAN, & CO.:
THE COMIC/ PICTURESQUE

It would be hard to name two artists more antithetical than Thomas Rowlandson and William Blake: one frivolous, the other deadly serious; one all flesh, the other all spirit; one concerned with eating, drinking, copulating, and their most unpleasant physical consequences, the other concerned with pure spiritual energy. But however different their temperaments, their life spans were almost identical. They were born within a year of each other in 1756–57 and died within four months of each other in 1827. And however different their subject matter, both were masters of figurative art in line and watercolor. We might almost see them as Blakean contraries—Rowlandson representing what Blake called his "negative state." Rowlandson was a specter of Blake, or Blake an emanation of Rowlandson. Or, as Jeremy Potter has suggested in his comic novel about a Rowlandson collector, *Dance of Death*: "If Bacon was Shakespeare, might not Blake be Rowlandson? Blake, not wishing people to know about the earthy side of his supposedly otherworldly character, had expressed his villainous id under the pseudonym of Rowlandson." [1]

This bizarre notion may conceal a

1. Potter, *The Dance of Death* (London, 1968), p. 65. Rowlandson was born 28 November 1756 or 1757—there is some argument as to which it was; he died 12 August 1827. Blake was born 14 July 1757 and died 21 April 1827. Blake on Rowlandson: "I am sorry that a Man should be so enamour'd of Rowlandson's caricatures as to call them copies from life & manners, or fit Things for a Clergyman to write upon" (to George Cumberland, speaking of John Trusler, 26 Aug. 1799; *Letters*, ed. Geoffrey Keynes [Cambridge, Mass., 1970], p. 31). See Paulson, "The Spectres of Blake and Rowlandson," *Listener*, 2 August 1973, pp. 140–42.

deeper truth. Different as their conscious assumptions were, they focused intensely on the same problems, and both were artists who developed, throughout the body of their work, powerfully consistent personal myths. The two sides of the revolutionary experience cast up antithetical figures such as Blake and Rowlandson, or Goya and Domenico Tiepolo, Shelley and Byron (or Don Giovanni and Don Juan, Saturn and Punchinello).

The comic equivalent of Blake's romantic triangle appeared at about the same time in Rowlandson's drawings and prints. Of course Rowlandson was not putting together narrative series, as Blake was, but one subject he obsessively repeated from the 1780s onward shows a repressive father, an energetic young man, with a pretty young girl. (It is interesting that it should have been Rowlandson's engraving of Hogarth's *Satan, Sin, and Death* that survived into the 1780s.) Blake calls the old man Urizen, portraying him surrounded with books and tables of the Law, almost engulfed in a long white beard like the Old Testament Jehovah's. Rowlandson's old men are simply horribly ugly, decrepit, wealthy, powerful, and possessive. His concern is with what Blake calls "the fiery joy, that Urizen perverted to ten commands," and the authority figure is a clergyman, a schoolmaster, a father, a husband, a physician, a lawyer—but always old and trying to suppress youthful high spirits. These old men not only keep their wives and daughters away from the young men, they also impose dull moral lessons on them, teach them useless information, cheat them of their money, try to make them into connoisseurs, and even extract their teeth and saw off their legs. These old men persecute the handsome young man who is trying to live by spending, drinking, and wenching. Then (it is difficult to be precise about dates with Rowlandson, but it appears to begin in the 1790s)[2] the young man takes to subverting the old man, usually in terms of his young wife, daughter, niece, or servant-girl. The house is a prison to be broken into, its walls are to be scaled, doors unlocked, its windows penetrated; and the final result, for Rowlandson, is the exuberant pornographic drawings, in which the young lover is carrying out his Orc-like intentions over the discomfited, sleeping, or dead body of the old man.

2. The only reliably dated works are the prints, and they often add dates after the fact or change them in later states. But to judge by the dated prints, it appears that in the 1780s the young man is fairly consistently thwarted by the old man. There are a few exceptions: A young man is getting the girl while the old man drowses over the fire (dated 1785, signed Wigstead), and another hides under a bed waiting for the old man to leave his wife, called away on a false alarm (1786, *The Doctor called up or the False Alarm*). In the 1790s this sort of scene becomes more frequent: two drawings of 1792 are concerned with getting into or out of a young ladies' boarding school (*The Elopement* and *Smuggling In*, Mellon Collection, reproduced in John Hayes, *Rowlandson, Watercolors and Drawings*, London, 1972, pl. 92), and one of around 1795 shows the young blade being helped down from the high tower window of a "Bastille" by his colleagues (*A Military Escapade*, Mellon Collection, reproduced in Hayes, pl. 100). By 1800 the subject of the violent sexual triangle is obsessive for Rowlandson.

A drawing that is in most ways typical (fig. 11) shows an invalid spilling his tea on his gouty leg and ringing for help, but his maid is otherwise occupied. In the context of all Rowlandson's drawings, however, the configuration we see is an old man, a pretty young girl, and a young virile rival: The old man needs a pretty young girl (wife, daughter, or more probably servant-girl) but loses her to the young rival. Nature itself is erupting against the old man in the form of his boiling tea kettle, his violent cat, and the reflexes of his own gouty leg.

But in one way the drawing is atypical: The handsome young man is a black servant. This is perhaps the closest Rowlandson ever comes to duplicating both the Rousseau–Burke model of the young servant-seducer and Blake's slavery model, and it presents us with a radical difference. Ordinarily Rowlandson never gives much indication that his young man is anything but a younger son or at the least a gentleman. We have to distinguish between an English revolutionary like Blake, whose concern begins with human slavery, and one like Rowlandson, the common man who wants to throw bricks at a policeman, when both use the same situation.

Blake uses energy and youth specifically to express the French Revolution, borrowing from the rebellion of a young country in America, and he embodies revolution in sexual fulfillment. As Freud tells us, "Apart from the sexual instincts, there are no instincts that do not seek to restore an earlier state of things":[3] a truth readily available to Blake even if Burke had not already laid out the terms of the opposition. The radical dissenting tradition (the "heretical subculture"), with those Gnostic overtones that are attached to the "Everlasting Gospel," saw the Ten Commandments as the result of a curse of the tyrannous Old Testament God, who was probably an evil demiurge, and so believed the Law was no longer binding on God's people. The result could be the rebellion Paine projected, or it could be simply a return to an original prefallen sexuality. Thomas Edwards (in his attack on the Ranters, *Gangraena*, of 1646) described an antinomian preacher in London who "on a Fast Day said it was better for Christians to be drinking in a Ale-house, or to be in a whorehouse, than to be keeping fasts legally."[4] Aliezer Coppe, according to Anthony à Wood, was accustomed "to preach stark naked many blasphemies and unheard of villainies in the daytime, and in the night be drunk and lye with a wench that had also been his hearer stark naked."[5] We have to recall Blake and his wife naked in their garden ("Come in! it's only Adam and Eve you know") and his belief, reiterated in prose and poetry, that the naked human form was the supreme

3. *Standard Edition*, 18, 41.

4. See A. L. Morton, *The Everlasting Gospel* (London, 1958); Hill, *The World turned Upside Down: Radical Ideas during the English Revolution* (New York, 1972), p. 152.

5. *Athenae Oxoniensis* 2, (1692), 367.

11. Thomas Rowlandson, *The Disaster.* Drawing, ca. 1800.

symbol of the divine in man and the liberation of the spirit, and connect these with the imagery of clothing used by both Burke and Paine and with the Ranter doctrine that clothes represent a loss of innocence, the curse of the Fall (as Paine reminded Burke), and that a return to nakedness would lift the burden of the moral Law.

Eating and drinking and wenching are life-giving ways of breaking the dead Law. At his simplest, in the *Songs of Innocence and Experience*, Blake has a child sing, "Dear Mother, dear Mother, the Church is Cold, / But the Ale-house is healthy and friendly and warm," and at his most literally antinomian, as we have seen, he has fiery Orc break his chains and sexually assault the daughter of Urthona, his old father-keeper-tyrant. The point made by almost every *Song of Experience* is that political repression is related to (or equated with, or reducible to) sexual repression. The progression from *Innocence* to *Experience* is from little stories about guardians, shepherds, and mothers to much darker stories about the repressive force of fathers, gods, priests, and kings. Scattered through are those figures of children who either adjust, are martyred, go into hiding, or wait out the fourteen years (referred to in *Europe*) until Rousseau's *Social Contract* (1762), with its clarion call that man break his chains, has been fulfilled by the American Declaration of Independence (1776); until the child has reached the age of puberty, when it is time for Orc to become sexually active.[6]

Rowlandson, on the other hand, embodies what we might call the weak revolutionary imagery of Charles James Fox, Richard Brinsley Sheridan, the Prince of Wales, and their circle. He emerged just as Fox was creating his ethos by opposition—to the British role in the American Revolution, to the Marriage Act (which had been imposed on rakes like his father, Henry Fox, to keep them from marrying young heiresses), and to the proposal for a London police force.[7] The paradigm for the Fox circle was the conflict between the Prince of Wales (their patron) and that great father-figure of a king George III.[8] Every one of Rowlandson's drawings dealing with the

6. See Erdman, *Blake: Prophet against Empire*, rev. ed. (New York, 1969), pp. 258–59, 261.

7. There is no direct documentation to connect Fox with Rowlandson. The latter made political caricatures on both sides of issues but there is an unmistakable bias toward Fox and his friends.

8. The bias toward the Prince of Wales is even more apparent (with a few exceptions) than toward Fox. The prince's patronage of Rowlandson can be inferred from the fact that he bought the *English* and *French Reviews* prior to showing in the Royal Academy of 1786, as well as others (Hayes, *Rowlandson*, p. 11; A. P. Oppé, *English Drawings . . . at Windsor Castle*, London, 1950, under cat. nos. 517, 510, 511, 530, 541). There are surviving drawings by Rowlandson of the prince (reproduced in Bernard Falk, *Thomas Rowlandson: His Life and Art* [London, 1949] opp. p. 21; according to Hayes, the prince also appears in *Vauxhall Gardens* [Hayes, p. 80]). Rowlandson's *Excursion to Brighthelmestone* of 1790 was dedicated to the Prince of Wales— perhaps evidence of patronage, perhaps only an acknowledgment of the association between the prince and Brighton (Falk, p. 100). The most notorious evidence of patronage is the tra-

subject of the old authority figure being discomfited or outwitted by his son (preferably with a young woman) would have had some personal application for his circle.

Fox summed himself up for his mistress, Mrs. Armistead, when he remarked, in a letter about his reactions to the French Revolution: "You know I have a natural partiality to what some people call rebels."[9] His revolutionary stance meant primarily that by gifts and temperament he was better suited to opposition than to office. He never understood the French Revolution and hated Paine's *Rights of Man*. Defending the French Revolution was, first, "defending his own version of what it had meant in its early days, those distant summer days of humanitarian sentiment and expansive benevolence" when it resembled the American Revolution, and second, defining a viable Whig position against Pitt.[10] On hearing of the execution of Marie Antoinette, he felt an ambivalence for the Revolution that recalls Burke's: "What a pity that a people capable of such incredible energy should be guilty or rather be governed by those who are guilty of such unheard-of crimes and cruelties."[11] As with all the writers and artists we have discussed, *energy* is a key word.

The essential dynamic of both Blake and Rowlandson is energy, which is contained in and vitalizes the human form. In Blake this appears in the tension and release of thrusting and leaping figures. Energy is either constrained in contorted, agonized creatures, or it is released in flying or leaping forms;[12] its essence, associated with flames, flight, vortices, and ser-

dition of the erotic drawings executed for (or acquired by) the prince, which were supposed to have been part of the collection at Windsor Castle but which seem to have been destroyed by one of George IV's successors.

As to the Prince of Wales and the king his father, when the prince heard news of the execution of Louis XVI, he was filled with "a species of sentiment towards my father which surpasses all description"; he requested an audience "to express my gratitude to my good and gracious father" and broke with Fox by declaring his support for the king's ministers (John Brooke, *George III* [London, 1970], p. 345, referring to 24 Jan. 1793). But a short while after this he was again ridiculing his father. The Marriage Act and the London police force were also deeply rooted in the popular mind as bugbears and threats to English liberty (see E. P. Thompson, *The Making of the English Working Class* [New York, 1966, pp. 81–82]). My point here is to show the ethos of the elite around the Prince of Wales, but these were notions shared with the working class and the radical movement.

9. British Library, Add. MS. 47570, f. 191; quoted in John W. Derry, *Charles James Fox* (New York, 1972), p. 322.

10. Derry, p. 324. Fox liked to draw parallels between the American and French revolutions and to link both to the Glorious Rebellion of 1688. The French Revolution was a phenomenon "he constantly sought to confine within the limits of the American example," Derry writes (p. 321). In fact, he was, like the French revolutionaries themselves, caught within an immediate practical political situation and thus claimed to see himself as a conservative force, defending traditional English liberties and established constitutional values against Pitt and Burke.

11. British Library, Add. MS, 47571, f. 144; quoted in Derry, p. 326.

12. Both can be seen in *America*, plate 3.

pents, is both awesome and threatening, wonderful and sinister in potential. For both artists energy is irrepressible: Orc must burst his chains, and young lovers must copulate, young men must have women, and structures of order that are used by the old and moribund to contain them topple and crash. Energy is defined in opposition to an established order; but it expresses both destructive and creative impulses. The destruction of restrictive order fires the imagination to create. In *America* 10 (fig. 9) the ambiguity of human energy is embodied in the flames in which Orc (in a Urizenic pose) is either emergent or engulfed. He can be a transcendent expression of revolution, release, and creativity, or he can be an invitation to destruction.

The energy of Rowlandson's youths does not, like Blake's, transfigure the sexual encounter, and its most violent effect is on their elders. We might simply call the Rowlandsonian mode a parody sublime of overturning and collapse which reduces the eruption of volcanoes to the accidents of the aged as seen by youth. But I take Rowlandson's real emphasis to be on novelty, movement, and change, and it is my opinion that if Blake needs the rationale of the sublime, Rowlandson needs an intermediate state, the picturesque. For Uvedale Price writing in 1794 the picturesque is good because it depends on "variety" and "intricacy," "two of the most fruitful sources of human pleasure," and their consequences of "curiosity" and "irritation."[13] The beautiful *and* the sublime produce only stasis, either "insipidity and monotony" or the "iron bonds" of terror, while the picturesque fulfills man's basic need to overcome both of these. Rowlandson would have agreed with Price that the highest aesthetic pleasure is not familiarity but the perception of movement and that the basic characteristic of art is the portrayal and inducement of energy.

Rowlandson is perhaps only a context in which to understand Blake's genuine attempt to represent the experience of the French Revolution. But both were exploring a *kind* of revolution, and at times they occupy almost the same territory. In *Songs of Experience*, Blake's most sublimated representation of revolution, the fiery youths are children imprisoned in the houses of their parents, in the black coffins of chimneys, sometimes in their black bodies (of slaves), and in the cages of schools. A typical "Song of Experience" is "The School Boy," in which Blake opines, "How can the bird that is born for joy, / Sit in a cage and sing?"[14] At this point he is very close to

13. *An Essay on the Picturesque* (1794), pp. 17–18. The passages referred to run from pp. 73 to 87.

14. The schoolboy paradigm is really implicit in Paine's opening of *Common Sense*, fifteen years before the fall of the Bastille, where he contrasts society, which promotes happiness, with government, which restrains and punishes our vices. He sets up a convivial gathering (to build a house) against a repressive schoolmaster figure, the monarch whose evil force leads to "a degradation and lessening of ourselves" (p. 66)—precisely the enemy shared by Rowlandson and Blake.

Rowlandson and a drawing called *The Milk Sop* (fig. 12): a capped and gowned young man leans from a window to steal a kiss from a passing milkmaid, while his angry and horrified old tutor looks on aghast. The schoolboy is clearly "born for joy" and unlike the trapped bird above him is bursting out of the imprisoning cage of the window. The tutor is a mild form of all the repressive fathers and aged husbands in Rowlandson's triangles, but there is also a faint reminder that (as Blake's schoolboy knows) inevitably "the blasts of winter appear": the two infants in the milkmaid's pail, overweighed by the dog stealing her milk from the other pail, indicate the consequences and responsibilities that accompany the world of liberty. With joy comes potential grief and with love parenthood: "Joys impregnate. Sorrows bring forth." [15]

Rowlandson's young men remain at about the level of Blake's children. Looking back on all the cases we have dealt with, we can accept a pair of generalizations. First, any discussion of revolution must begin with Condorcet's assumption that "The word 'revolutionary' can be applied only to revolutions whose aim is freedom," in that this aim is paramount over either justice or greatness. [16] But then, in practice, as Hannah Arendt has insisted, the first stage, liberation, is not necessarily followed by freedom, a quality much more difficult of achievement: "The notion of liberty implied in liberation can only be negative, and hence, . . . even the intention of liberating is not identical with the desire for freedom." [17] Rowlandson's people never progress beyond liberation; like Casanova, his young Orc could as well represent survival in the ancien régime, and his plots could be interpreted as a symptom rather than a response. But insofar as they are parallel to the apocalypse of the 1790s they (along with the Fox circle) continue to represent the enlightenment liberation of the 1780s. [18]

Blake, however, is very aware that the liberation of a constricted individual has to be followed by the creation of a new order from the bottom up—a true revolution in every sense of the word. He admits the inevitability of a 9 Thermidor and an 18 Brumaire but proceeds to build his own New Jerusalem of the imagination over the facts of a smoky, chartered London. He abandons the political reality with the Napoleonic wars, seeing on this level only the cyclic return of Urizen.

The literary precedents out of which Blake put together his revolution allowed for the further stage beyond liberty to an attempt "to build a new

15. Erdman, *The Illuminated Blake* (New York, 1974), p. 106; *Marriage of Heaven and Hell*, in Erdman, *Poetical Works*, p. 109.

16. Condorcet, *Sur le sens du mot révolutionnaire* (1793), in *Oeuvres* (Paris, 1847–1849), 12, 615.

17. Arendt, *On Revolution* (New York, 1965), p. 22.

18. See Paul Zweig, *The Adventurer* (New York, 1975), pp. 142–45, and Jean Starobinski, *The Invention of Liberty, 1700–1789* (Cleveland, 1964).

12. Thomas Rowlandson, *The Milk Sop*. Drawing, 1811. Rowlandson published the etching (in Thomas Tegg's *Caricature Magazine*) 16 December 1811.

house where freedom can dwell." These were Milton's *Paradise Lost*, the
Book of Revelation, the texts of Boehme and Swedenborg, and other works
that explore the meaning of freedom in apocalypse. In Rowlandson's case
the literary and graphic precedents were memories of Restoration come-
dies, picaresque narratives such as those of Smollett, and images of sexual
libertinage out of Boucher and Fragonard.[19] But sources hardly matter. His
plot is simply that most elemental of all comic structures in which the old
society blocks the new, in the form of old fathers and masters keeping apart
young lovers, with the consequent explosion of energy in which the new
society overthrows—but then incorporates—the old. This is a comic or
grotesque equivalent of the sacrifice of the father by the son, who then,
having cannibalized him, *becomes* the father. Both, as Burke may have rec-
ognized, were elemental structures of literary and human experience by
which people could deal with such phenomena as the French Revolution.

Rowlandson's young man does not exactly age into his old one but the
artist's sympathy gradually shifts in that direction, or he sees the forces as
opposite and comically equal. He also portrays a middle-aged husband who
is more interested in hunting or drinking with his companions than in hav-
ing sex with his wife; who has become part of a growing family of chaotic
children and dogs, given over to eating and drinking. In this context an-
other, younger man—perhaps his apprentice—appears in the background
of the picture. The husband becomes jealous, discovers the boy in a bed-
room closet, and Rowlandson's emphasis in his drawings and prints shifts
away from the youth's stratagems to the husband's padlocks, his successful
discovery of the youth, and his attempts to recover the sexual energy of the
young lover, as he tries elaborate ways of making love, using the most
grotesque devices that dwindle (as he ages, more or less in step with Row-
landson himself) into voyeurism.

In a print called *The Anatomist* (fig. 13) the lover of the old surgeon's
young wife is trying to smuggle himself into the house (or she is trying to
smuggle him in) disguised as a subject for dissection. The surgeon, we see,
will take cadavers from whatever source offers itself, including resurrec-
tionists, to advance the cause of science—the obsession that keeps him from
his wife. In this confrontation it is not certain whether Orc or Urizen, the
life or the death force, will triumph. In the later work of both Rowlandson
and Blake the repression of age and the revolution of youth teeter back and
forth until they become virtually interchangeable: both unsatisfying re-
sponses to immediate experience, which remains sexual.

19. For Smollett and Fragonard, see Paulson, *Rowlandson: A New Interpretation* (New York,
1972), pp. 77–78, 22–23. The dramatic sources for Rowlandson's scenes are obvious, but to
reach them we have to leap back (with Rowlandson) to the Restoration, to Molière, and to
popular traditions that survived on the Continent.

13. Thomas Rowlandson, *The Anatomist*. Etching, n.d.

THE ARTIST, THE PRETTY GIRL, AND THE CROWD

Rowlandson's drawings raise another question related to the representation of revolution in life, and that is the representation of revolution in art. Both Rowlandson and Blake, in their drawings, obviously draw upon the subculture tradition that had developed imagery and vocabulary distinct from the classical reference of the academic establishment. The imagery of republican Rome had been the heritage of the so-called eighteenth-century Commonwealthmen, appropriated at one level by the victorious Whigs in 1714 and at another by the proscribed Tories who, like Swift, having seen themselves as Romans of the Empire in the reign of Queen Anne, began to see themselves now as Catos and Brutuses. Both versions survived into the 1780s accompanied by the style developed by Gavin Hamilton and Benjamin West of an austere neoclassicism that anticipated David's in France. There were, of course, Royal Academicians who had leftist sympathies but the extent of their rebellion was to paint in the neoclassical style, in a pale Roman rhetoric; at best in the frantic neoclassicism of Heinrich Füseli, who after a gesture toward the French (showing Thor, Odin, and the Midgard Serpent, his R.A. diploma piece of 1790) turned resolutely anti-Revolution.

On the other hand the popular tradition, founded on religious unorthodoxy, on a marriage of radical politics and religious myths of Apocalypse and Revelation, had no visual tradition to bank upon. Only Blake can be said to have produced a tension between the religious unorthodoxy and Greek classicism. In order to convey his transvaluation of the Bible graphically he had to use the familiar high-style forms of the "Raphael Bible" and the Bible of Michelangelo's Sistine ceiling. The tension continued, as we have seen, in the playing of his Michelangelesque visual images against his pseudo-Biblical texts with their intensely heretical retelling of the Biblical stories.[20]

Rowlandson, although he later employed neoclassical forms, stood for a very different sort of aesthetic reaction. In the spring of 1784 he had exhibited at the Royal Academy two of his most ambitious watercolor compositions of contemporary crowds at play, *Vauxhall Gardens* and *Skating on the Serpentine*. There was also an etched squib, *The Historian animating the Mind of a Young Painter* (fig. 14), which is signed and dated 1784. During the fifteen years preceding, Sir Joshua Reynolds P.R.A. had delivered eleven presidential discourses exalting history painting based on classical literary texts and the imitation of old masters as the ideal for serious young artists to follow, and in December 1784 he delivered his twelfth on "the Art of using Models."[21]

20. For a discussion of Blake's use of Michelangelo and Raphael, see Paulson, *Book and Painting: Shakespeare, Milton and the Bible*, pp. 116–20.

21. I do not know whether Rowlandson's print was published after Discourse 12 or at the

Rowlandson shows an old man, a historian, reading from a book to a young artist whose very lively young wife and child are on the other side of his easel. The historian is related to a great many men in Rowlandson's drawings whose faces are buried in books though surrounded by beautiful natural landscapes or women. He is old; the artist and his wife are young. Youth and age, the topos of living versus book-learning, are essential elements in Rowlandson's schema as they are later in Paine's. Separating the artist from his family is the canvas on which he has begun to paint a historicomythological subject, and he inclines toward the historian (as does the bust of Homer on the wall) in order to hear his every word. Between him and the historian is a wide window onto the outside world, through which, however, nothing is visible.

In discussing this print in my book on Rowlandson, I said that Rowlandson "opposes the historian and his book to the real world of the artist's family, which, Rowlandson is saying, should be the artist's subject." For "real world" I ought to have said "life" or "nature as life" or something like that. I was thinking of the representations Rowlandson was attempting in his R.A. pictures of 1784. A knowledgeable reviewer, however, pointed out that the mother and child are based on painted prototypes by Reynolds and Michelangelo.[22] The Reynolds (fig. 15; a Reynolds "imitation" of a Michelangelo group from the Sistine ceiling) was a portrait of the Duchess of Marlborough and her daughter, engraved in mezzotint by James Watson in 1768, readily accessible to Rowlandson and quite possibly recognized by purchasers of his print. I take this to be the most interesting fact about the

time of the R.A. exhibition, but the Discourse could have served as a text for his etching. About the "*art of seeing Nature*, or in other words, the Art of using Models," it argues that the artist should correct nature "by bringing the ideas of great Artists more distinctly before his mind, which will teach him to invent other figures in a similar style"; it takes issue with Francis Bacon's view that "a man shall find much in experience, but little in books"; and argues for the need "to consult with, to call in, as Counsellors, men the most distinguished for their knowledge and experience" before putting brush to canvas (presumably men like the historian in Rowlandson's print). Rowlandson could have read Reynolds's first seven Discourses in the edition of 1778; he could have heard the tenth through twelfth. The eleventh (1782) talked about the artist's need for "the Genius of a Poet . . . as of a Painter"; the artist's need to correct the form "of the model, which he then happened to have before him" (i.e., in the flesh); and his need to imitate not just the *Iliad* but Homer himself. Parts of this chapter originally appeared in a somewhat different form as "The Artist, the Beautiful Girl, and the Crowd: The Case of Thomas Rowlandson," in the *Georgia Review*, 31 (1977), 121–59.

22. See Paulson, *Rowlandson: A New Interpretation*, p. 23, and Peter Walch, *Philological Quarterly*, 52 (1973), 4–15. Walch does not, however, verify Rowlandson's access to the composition. He only draws attention to the borrowing, thinking it somehow invalidates the "real world" instead of interestingly testing it. I should add that there is a drawing for this print (unreversed, formerly Reitlinger coll.) with the inscription, probably not in Rowlandson's hand, "Thompson the Poet reading his 'Seasons' to Wilson the Painter."

etching, for whether or not Rowlandson wants his source recognized, he
acknowledges the impossibility of representing nature without art—and he
does this by imitating Reynolds himself, the great proponent of "imita-
tion." (He has, however, rendered the Reynolds version subculture: The
ornate chair is made an ordinary, kitchen chair, and the elaborate drapery
simplified into the furnishings of an artist's garret.)

The joke that Rowlandson has touched upon reaches up to the present in
cartoons showing the artist with a cubist image on his canvas and a cubist
woman sitting as his model. The position held by Rowlandson is that of
the empirical tradition sharpened by the insights of Locke and Hume but
most powerfully expressed in the later eighteenth century by Samuel John-
son: the belief that reality is a test of art; that reality and art are sadly incom-
patible, although the artist ought to seek reality, that is to say "nature," or
the wife and child rather than a Juno or Venus.

If we look for the graphic paradigm on which Rowlandson based his
picture—the equivalent of the Reynolds portrait for the wife/child group—
we must turn back in time to Hogarth's subscription ticket for *A Harlot's
Progress* called *Boys Peeping at Nature* (1731, fig. 16). This print deals with
the various ways in which nature can be imitated by an artist. One putto
idealizes, stylizing and reducing the number of Nature's obtrusive breasts
(an important consideration according to Lomazzo's *Trattato dell'Arte*); an-
other turns his back and draws her from his imagination; and the faun, who
does not even hold a pencil and paper, lifts Nature's veil, which conceals
the vulgar, animal, instinctual realism of the sexual component, in order to
show or to have a look. Nature is a "peeping," a gesture, a way of life,
rather than a fixed representation, but it is also an artistic beginning over
again, a looking at things afresh, a getting down to basics ("Antiquam ex-
quirite Matrem"), and iconographically it is a lifting of the allegorical veil
that conceals naked Truth.

With this example before us, we can see the point of departure for Row-
landson's designs of the 1780s as the problem of imitation and of how to
start over. There is a true or correct model present (a wife and child, the life
which he ought to represent) and a false model (either a book read by an
old man or a historicomythological representation on the canvas). These
are alternatives in the same sense as the different versions of Nature in *Boys
Peeping*. However, there is one additional element in the Hogarth: The faun
is being restrained by a putto who disapproves of his vulgar gesture; the
tension between the exposure and the restraint is Hogarth's statement of his
own balanced position, also implied by the academic style in which these
academic putti are represented. This style is quite different from Rowland-
son's explosive, personal though elegant line. But the imitation of Reyn-
olds, it might be argued, serves to *contain* the Rowlandsonian rebellion in
the same way that Hogarth's putto restrains the faun, although perhaps "serves

14. Thomas Rowlandson, *The Historian animating the Mind of a Young Painter*. Etching, 1784.

15. Sir Joshua Reynolds, *Caroline, Duchess of Marlborough with her Daughter*. Mezzotint by James Watson, 1768.

to contain" is less accurate than to say it creates a tension between rebellion and submission.

Rowlandson was drawing this design five years before the outbreak of the French Revolution, when Hogarth's faun lifting Nature's skirts (and no longer restrained by a modest putto) had become Rousseau wishing to strip Nature bare of any remaining artifice, and was to become the revolutionary for whom (according to Burke) "All the decent drapery of life is to be rudely torn off." Art as embodied in Rowlandson's old man becomes the trinity of father, king, and priest, and his young man becomes variously Blake's fiery Orc, Burke's oversexed Jacobin rapists, and Paine's bursting buds of spring. Indeed, I wonder whether we have couched the problem so far in the correct terms: Does the imitation of the Reynolds portrait group as a representation of the mother/child show Rowlandson's acknowledgment that nature cannot be represented without art, or rather that a repudiation of the father figure of the Royal Academy is necessarily combined with an attempt to find common cause with that father, which we might call the impossibility of constructing ab ovo, without *his* conceptualizations? In these terms the crucial element of *The Historian animating the Mind of a Young Artist* is the old man with his book versus the young man as rivals for the young girl. The superego (the old historian) displaced and internalized in the Reynolds imitation of the mother/child is, I suspect, a compact version of the typical Rowlandson drawing in which the young man gets the young girl away from the old man—only, in another drawing, to emerge as himself a jealous guardian.

I think we can divide Rowlandson's drawing into, first, the image of the artist within the picture, who inclines toward the historian and whose wife and child obediently assume the pose of a Reynolds portrait group, and, second, the actual artist outside the picture, who uses these elements to argue where an artist *should* find his subject (and where he himself, in his R.A. pictures of the time, does) while admitting the impossibility of copying nature without the mediation of art.

In a second artist satire Rowlandson published a year later,[23] *Intrusion on Study, or the Painter Disturbed* (1785, fig. 17), the artist unaided is transforming the girl, his nude model, into a heroic Venus on his canvas. The painter's brush has its phallic significance: To copy the female body on a canvas makes it safe by a fictive displacement. The model is alive and present but her recoil at the intrusion is at one with the artist's; the equivalent of the Reynolds imitation is her automatic assumption of a *Venus pudica* pose, simulta-

23. Based on P. A. Baudouin's *La Modèle honnête*, engraved by Moreau le jeune, 1770, which shows a chaperon or the model's mother trying to ease her embarrassment; the painter shows impatience.

neously covering her pubes and her eyes (doing the work of the modest putto). For "nature" or "life" has now become the intrusion of the street, tavern, and brothel into the artist's studio. The artist's male friends break in, disrupting his pretty illusion. The new elements are the sexual basis of instinct and the violence of the unstructured crowd, brought together and related, if not equated, as agents of disruption in relation to structures of art which now signify something like repression.

The graphic models for this print are Hogarth's artist satires, his *Distressed Poet* and *Enraged Musician* (1736, 1741). The Poet's imitation is his poem "On Riches," his models a map of "Gold Mines of Peru" and a rhyming dictionary. His isolation from nature, as the outside world of streets and people, is indicated by the cubicle in which he has shut himself off with his models, even from his wife and child (who reappear in Rowlandson's *Historian*). Intruding from the outside world are a milkmaid seeking payment for an unpaid bill and a hungry dog, who has entered with her and is devouring the family's last morsel of food. On the strength of Hogarth's *Distressed Poet*, I think the message of Rowlandson's intruders is that the artist *should* be in bed with his model, following his natural instincts, and not painting her as Venus. Or in some sense he should be representing the kind of intrusion they embody (as in paintings like *Vauxhall Gardens* and *Skating on the Serpentine*).

In the closed picture frame of his window raised above the level of the city street, the Musician (fig. 18) is even more cut off than the Poet. His model consists of the notes of a scale on a sheet of paper, and while we do not know what he is playing, it is clearly not from *The Beggar's Opera* or the street-singer's subculture collection. The intrusion takes the form of a crowd of noisemakers, plebeian and free of constricting scales and laws of counterpoint and harmony, and a pretty milkmaid, the equivalent compositionally of the Poet's wife, another alternative model to the written music and the poem on riches. She probably derives from the happy vendors of Dutch street scenes, but in Hogarth's terms she illustrates his belief, expressed in his *Analysis of Beauty* (1753): "who but a bigot, even on the antiques, will say that he has not seen faces and necks, hands and arms in living women, that even the Grecian Venus doth but coarsely imitate?"

The beautiful young girl, Hogarth's and Rowlandson's, is part of, yet separate from, the crowd. She is made of Lines of Beauty, the crowd is formed of grotesque expansions and contractions, but both share the other component Hogarth finds in beauty, "variety." Hogarth's beauty includes dimensions that later aestheticians felt they must detach and assign a separate name. Basically, beauty is the variety of the undulating serpentine line, which appears so labeled on the title page of *The Analysis of Beauty* (fig. 19). But directly above the Line of Beauty, which stands upright and has a small serpent's head, is an epigraph from *Paradise Lost*:

16. William Hogarth, *Boys Peeping at Nature*. Etching, ca. 1731.

17. Thomas Rowlandson, *Intrusion on Study, or the Painter Disturbed*. Etching, ca. 1785.

18. William Hogarth, *The Enraged Musician*. Etching and engraving, ca. 1741.

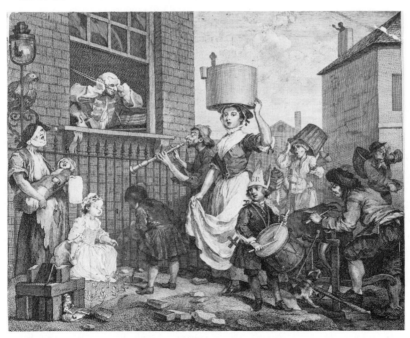

18a. William Hogarth, *The Enraged Musician*. Etching and engraving, proof state, ca. 1741.

So vary'd he, and of his tortuous train
Curl'd many a wanton wreath, in sight of Eve,
To lure her eye.

This conjunction is the clearest acknowledgment Hogarth makes that his aesthetic, centering on woman and the serpent as graceful forms, must focus morally on the scene of man's fall from another kind of grace. The original power and vision of beauty are inseparable from the original sin.

Eve and the serpent together suggest a potential for entrapment within nature which Hogarth obliquely develops in his first illustrative plate (fig. 20). Here the Medici Venus (a Venus *pudica* like the one in Rowlandson's *Intrusion on Study*) is placed so that we see behind her the Laocoön group with its humans entangled in snaky coils. Within the text Hogarth recalls how he introduced the subject of the serpentine line in conversation as a bait to trap stupid artists and ignorant connoisseurs; later he discusses the lady's lock of hair curling across her temple which "has an effect too alluring to be strictly decent, as is very well known to the loose and lowest class of women." (He is drawing upon memories of Belinda's locks, those "labyrinths," "slender chains," "hairy Sprindges," which trap men.) In the illustrative plate Venus appears to be turning to catch the Apollo Belvedere's eye while the Farnese Hercules' back is turned, creating a romantic triangle. Below their status are a pair of doves and Dürer's diagrams of the female and male anatomy printed on the page of a book held by a "real" man (once again the "man with the book"), who seems to be looking up from his book at Venus, the nude female statue. Some kind of love-play as well as an example of pure form is also implicit in the relationship between the effeminate dancing master and the statue of Antinous, Hadrian's minion. As the illustration extends and complicates the purely formal distinctions made in the text, so its own configurations shift from one aspect to another, from the aesthetic to the sexual to the political. Depending on how we look at him, Apollo is either gesturing to Venus or hitting on the head the Roman senator who appears to be assassinating the dictator Julius Caesar.[24]

Hogarth seems to have seen nothing odd in combining all these connotations, all this intellectual play, with his formal concept of beauty. Later, Burke showed in his *Philosophical Enquiry into . . . the Sublime and Beautiful*, that he was not unaware of the beauty of a woman's neck and breasts, of "the variety of the surface, which is never for the smallest space, the same; the deceitful maze, through which the unsteady eye slides giddily, without knowing where to fix, or whither it is carried." But for Burke it is the

24. Meanwhile, in plate 2 the old husband, his wife, and her lover make a romantic triangle, supported by the Woman of Samaria in the margin opposite, and Sancho Panza (in the adjacent margin), who recoils in amazement at their behavior. Henry VIII and the group below his statue contribute another case of the sensual/intellectual play.

19. William Hogarth, *The Analysis of Beauty*. Vignette from title page, ca. 1753.

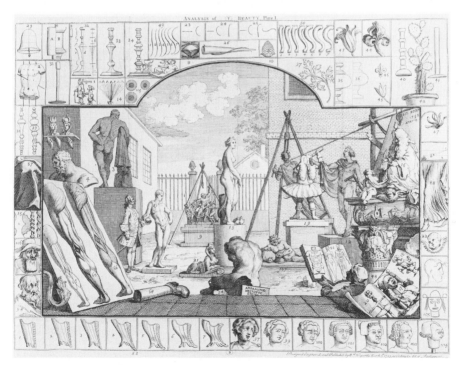

20. William Hogarth, *The Analysis of Beauty*, plate 1, ca. 1753.

mother's breast, and the experience of beauty is quiet, passive, and regres-
sive, a return to childhood experiences. The active, though ambivalent,
attack on authority is what Burke associates with the sublime (and later
with the French Revolution). Hogarth declines to accept this categorization
that separates beautiful and sublime, and he consistently emphasizes the
connotations of disobedience, rebellion, and entanglement as well as beauty—
in, for example, his earlier portrayal of Milton's "snaky Sorceress" Sin (in
Satan, Sin, and Death, probably painted in the late 1730s) but also consist-
ently in "modern moral subjects" such as *Marriage à la Mode* (1745). In his
last print, *Tailpiece: or the Bathos* (1764), he includes an attempt to connect
the Line of Beauty with the worship of Venus, represented (as he shows)
by some of her votaries as simply a serpentine line coiled around a cone. In
the design itself he depicts his Line of Beauty overwhelmed by Burke's
sublime, which is essentially a breaking of serpentine continuities, replacing
sensuous and intellectual connections by negation, exhaustion, and stasis.

That Hogarth's text was misunderstood (and his illustrations ignored) is
clear from contemporary reactions. As late as the mid-nineteenth century
Charles Eastlake saw only the static dimension of Hogarth's Line: It "con-
stantly repeats itself, and is therefore devoid of variety and elasticity, the
never-failing accompaniements of perfect vitality."[25] Eastlake, unawares, is
agreeing with Hogarth when he argues that beauty involves "perfect vital-
ity" and cites the flame and the serpent as examples of change and variety.
William Gilpin and Uvedale Price, however, chose to separate out the vi-
tality and call it picturesque, leaving behind the static, gentle curves of the
beautiful on one side, and on the other the mind-riveting terror or the sub-
lime. The basic characteristic of picturesque art, according to Price, is the
portrayal and inducement of energy—and so of motion and change. "What
most delights us in the intricacy of varied ground . . . is, that according to
Hogarth's expression, it leads the eye a kind of wanton chace . . . "[26]—
which can be both physiological and mental in the object viewed, in the
viewer whose eye is led a "wanton chace," and in the viewer's mind or
"working" imagination.

According to Price, the two chief qualities stimulated by the picturesque
are "irritation" and "curiosity," and through these he sustains Hogarth's
paradigm of the Fall. The picturesque "by its variety, its intricacy, its partial
concealments, . . . excites that active curiosity which gives play to the mind
. . . "; and this takes the form of amorous intrigues. The examples Price

25. *Contributions to the Literature of the Fine Arts* (1848), ed. H. Bellenden Ker; cited in Jack
Lindsay, *The Sunset Ship: The Poems of J. M. W. Turner* (London, 1966), pp. 73–74. Turner's
one verbal reference to the Line is in his poetic fragment "The Origin of Vermillion or the
Loves of Painting and Music": "As snails trace o'er the morning dew / He thus the lines of
Beauty drew" (Lindsay, p. 121).

26. The quotations are from *An Essay on the Picturesque*, pp. 103–10.

gives of irritation are birds who "when inflamed with anger or with desire" ruffle their plumage. "The game cock," he explains,

> when he attacks his rival, raises the feathers of his neck, the purple pheasant his crest, and the peacock, when he feels the return of spring, shews his passion in the same manner, 'And every feather shivers with delight, . . .'
>
> We talk of the stings of pleasure, of being goaded on by desire. The god of love (and who will deny love to be a source of pleasure?) is armed with flames, with envenomed shafts, with every instrument of irritation. . . .

All this Price relates to the belief that movement and change are biological necessities of life.

The serpentine line began, of course, as a decorative device, without meaning, in rococo art and design; Hogarth filled it with meaning, both aesthetic and moral, on the way to the transformation of the Line by the Romantics into a Line of Sublimity and thence into vortical, vertigo-producing constructions like whirlwinds and whirlpools. Meanwhile, Rowlandson takes up Hogarth's Line together with his other terms—artist, book learning, beautiful girl, and unruly crowd—and gives a central place to the sexual triangle and sexual energy. This centering explains why his drawings lead to a violent explosion of the Hogarthian forms—including the serpentine line—from the essentially centripetal into the wildly centrifugal; why his drawings find their logical subject matter in pornography. Compared to *Intrusion on Study*, only a trace of the sexual component appeared in *The Enraged Musician* in the form of the pretty milkmaid, in the little boy and girl occupied beneath the celibate Musician's window, and the pregnant ballad singer. The triangle was more overt in the first version of the plate (fig. 18a), where the boy-grenadier was handsome and his eye wandered to the little girl, the girl's doll was a lure in the doorway of a bird-catcher, and the dustman was syphilitic. Hogarth changed the details in order to focus on the conflict of sheer unstructured noise with the order of art. But what mediates between the two incompatibles of nature and the artist's representation, for Hogarth as for Rowlandson, is the serpentine lines of a desirable woman juxtaposed with a crowd of energetic but ugly low-life figures.

There is a drawing by Rowlandson in the Metropolitan Museum (fig. 21), which shows a terrified young man and woman intertwined in S-curves as they recoil from a large, rearing S-curving serpent, a fleshed-out version of the upright Line of Beauty on the title page of *The Analysis of Beauty*. These figures, who recall the artist and his model recoiling from another source of energy in *Intrusion on Study*, are echoed across the right two-thirds of the picture space by nature itself, whose trees and branches twist into grotesquely distorted S's. The serpent is the force of disruption at the same time that he gives his shape to that disruption. The whole landscape, even the

torrential stream, seems to be recoiling with this couple from the snake—but in so doing becomes itself serpentine. The Fall, alluded to on Hogarth's title page, is here literal; this is the mythologized version of Rowlandson's romantic triangles. The old man, husband or father, is now Nature itself, as helpless in the wake of the serpent's energy as is the young couple. (It is worth remembering that Blake's revolutionary Orc is both flame and serpent.)

THE CROWD (JOHN WILKES)

As sexual or animal energy activates the romantic triangle, so it sets in motion the crowd, bringing it to chaotic life, which means a state of violence. Sometimes it is a student tripping his college don, often in order to enjoy the pretty young girl who stands nearby. At its purest, liveliest, and . most natural, this figure of disorder is the quite unserpentine dog who (in Hogarth's *Distressed Poet*) stole the chop. The dog is an emphatic male principle, often a surrogate for a young woman's absent lover, deriving equally from Hogarth and from the boudoir scenes of Watteau and Fragonard. In Rowlandson's *Kew Bridge* (fig. 22) there is, at one extreme, the dog as animal catalyst in the midst of varying degrees of stasis; disorder is emerging from order, with the dog the cause.[27] Another cause of disruption is also given, off to the right, in the narrow, closed structure of the toll bridge, which evokes Paine's concern with toll roads and barriers, ultimately with the "custom" which blocks the way: the "succession of barriers, or sort of turnpike gates . . . set up between man and his maker" by the ancien régime. The bridge is related to the carriages and other containing structures in the scene that will not hold human energy, but we should also recall that the first thing the French revolutionaries did on Bastille Day was to destroy the barriers and the books of excise officers who operated the tolls. (Kew Bridge was opened for traffic as a toll bridge in 1789, which helps to date Rowlandson's drawing.)

After 1780 the crowd was inextricably linked, in the minds of the English, with the burnings and devastations of the Gordon Riots—an event which provided the terms that would be used in the first accounts of the French Revolution in 1789. But in the years leading up to 1780 the crowd had signified Wilkite celebration, parades and demonstrations in which John Wilkes's followers harnessed themselves to his coach, pulling him to and from prison, or dragged representatives of the crown out of their carriages and made them drink to "Wilkes and Liberty" and sing "God save great Wilkes the King."

If there is a representation, or only a reflection, of these curious scenes in

27. Paulson, "The English Dog," in *Popular and Polite Art in the Age of Hogarth and Fielding* (Notre Dame, 1979), pp. 49–63.

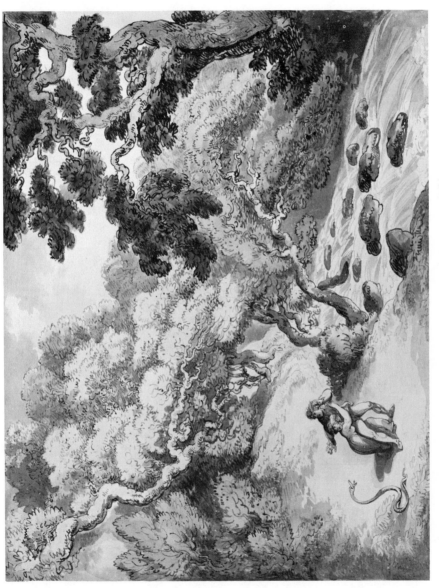

21. Thomas Rowlandson, *Landscape with Snake*. Watercolor drawing, ca. 1790s.

22. Thomas Rowlandson, *Kew Bridge*. Watercolor drawing, ca. 1790.

art it appears in Rowlandson's compositions of the 1780s and 1790s. A more accurate way to put it would be: If you add to Hogarth's crowds (*Burning the Rumps at Temple Bar*, *The Skimmington*, and *Industry and Idleness*, pl. 12) the iconography of the Wilkite crowd, you get the representations of Rowlandson. Wilkes, for whom the ancien régime was simply a bore and whose personal value was more as a nuisance than as a purposeful founder of organized radicalism, was the historical prototype of the figure who emerged in somewhat more aristocratic form (by way of Fox and Sheridan) in Rowlandson. During the St. George's Fields Massacre (1768) members of the mob were reported to have cried, along with "No Wilkes, no King!" and "Damn the King, damn the Government, damn the Justices!": "This is the most glorious opportunity for a Revolution that ever offered!"[28]

These saturnalian explosions often began in merriment and ended in a seriocomic muddle of accidents that shaded off into catastrophe. The St. George's Fields Massacre is only the most obvious case; Wilkes's triumphant inauguration as Lord Mayor in 1774 sounds like a Rowlandson drawing:

> . . . immense crowds of people were assembled at the Three Cranes, hundreds of whom took possession of the lighters and other vessels, one of which, having a large mast, about thirty people hung to the shrouds, and one man sat on the top of the mast, smoking his pipe. . . . Two women fell from barges into the Thames, but were soon got out. . . . Two barges, with about a hundred people on board, slipped from their moorings, and drove towards London Bridge, . . . While the procession was passing up Ludgate Hill, a woman with a child in her arms was thrown down by the crowd at the end of Fleet Street, and both trampled upon by the mob. They were both taken up dead. . . . A man was run over by a coach at Queenhithe and killed. A boat was overset near Queenhithe stairs by the waterman attempting to row the passengers nigh enough to see the Lord Mayer take water, and, it is said, six people were drowned.[29]

But under (or above) this apparent chaos and real disaster, we have to note the structure adapted by Wilkes and his supporters for their processions. (The slippage was perhaps part of its apparent spontaneity and liberty-libertinism.) The three assumptions involved were of a repressive superstructure of society: the code of the governing class; a free, spontaneous uprising of the "people"; and the catalytic figure of Wilkes himself.

The iconography of the celebrations corresponds to the figure of Wilkes. Wilkes is released from prison in Bradford:

28. BM Add. MSS. 30884, f. 72; quoted in George Rudé, *Wilkes & Liberty: A Society Study of 1763 to 1774* (Oxford, 1962), p. 50.

29. Quoted in Audrey Williamson, *Wilkes* (London, 1974), pp. 175–76; on the St. George's Fields Massacre, see p. 132, and also George Rudé, *Wilkes & Liberty* (Oxford, 1962), pp. 49–50. The seriocomic muddle in which accident shades off into disaster in Rowlandson's renderings reveals that such disasters could be joked about.

> ... the morning was ushered in with the ringing of bells, which continued till ten at night, and in the evening were illuminations, and the following, we hear, was given at the sole expence of Mr Richard Shackleton, at the Bull's Head, viz. A bonfire of 45 of coals: a curious representation of the figures 45, composed of 45 candles, under which was wrote in large characters, Wilkes at Liberty: also a supper to the sons of Liberty, which consisted of 45 lbs. of roast beef, . . . [30]

And so on: forty-five fowls, loaves of bread, and bowls of punch. The magic number of the *North Briton* that started Wilkes's persecution and fame was set on everything in sight. The other qualities we notice in the passage are the use of light—illuminations, bonfires, and at other times the lighting or (if this was refused) breaking of windows. Those were days when citizens saved their windows from being broken by inscribing a 45 on them in the daytime and lighting them at night: "some persons who had voted for Mr. Wilkes having put out lights," we are told on another occasion, "the mob paraded the whole town from east to west, obliging every body to illuminate and breaking the windows of such as did not do it immediately." [31] Lighting up is an important element, perhaps part of (or linked to) the motif in Wilkes's case of the release from prison.

Food and drink are other significant elements. When the Wilkite Lord Mayor Brass Crosby and Alderman Richard Oliver were put into prison for contempt of Parliament, the crowd unharnessed the horses and dragged the coach to Temple Bar, and there followed stops at taverns and many healths drunk before they reached the Tower. The government representatives—those who *put* Wilkes and his supporters in prison—had their coaches stopped and were forced out to drink toasts to "Wilkes and Liberty" and to sing "God Save Great Wilkes our King"—which not many years later would be modified to "God save great Thomas Paine." [32]

When he finally took his seat in the House of Commons, Wilkes's first speech on 26 January 1775 opposed a special motion that the anniversary of the execution of Charles I be commemorated with a fast. He argued that it should be "celebrated as a festival, as a day of triumph, not kept as a fast." [33] Here as elsewhere Wilkes is trying in the most general sense to substitute carnival for Lent, but also a "popular," working-class, or radical celebration for one sanctioned by the governing class. Thus the mock executions held on Tower Hill, where Bute, the Princess Dowager, and the rest were beheaded by a chimney sweep and burned, were an acting out of the function of a true judge and executioner, as opposed to the official ones controlled

30. Quoted in Williamson, p. 152.

31. *Annual Register* (1768), p. 86.

32. Williamson, p. 138.

33. One recalls Hogarth's *Night* (1738), with the celebration of "restoration" and gin going on in the foreground and Charles the Martyr's statue in the background. See Paulson, *Popular and Polite Art*, pp. 24–30.

by Bute and the count. It is also, as John Brewer (who discusses these points) notes, a "ritual retribution on a parallel with that actually exacted during the Revolution in France" a few years later.[34] The crowd was going back to the way justice used to be carried out in the good old days, just as in their bread riots they enacted the ancient mercantilist custom of paying the equitable amount for bread, replacing the current laissez-faire practice.[35]

The illuminations, the bonfires, the twenty-gun salutes were, as Brewer has shown, "the celebratory rituals of popular jubilation."[36] These were a transvaluation of "the rituals of authority" which conferred a kind of legitimacy on the crowd's actions. More important, they assumed the cyclic meaning of revolution: Go back to a golden age when laws had not been corrupted. The Wilkite crowd was, however, loyalist. It was revolutionary not in the sense of overthrow and reconstitution, only in the old sense of moving back to regain lost freedoms. Every Wilkite ballad combines support for the crown with celebration of "Wilkes and Liberty," and "as an alternative 'order,' it resembles disorder and misrule, rather than offering a competing value system."[37]

The mythic figure of Wilkes worked the same way. He adopted the royal symbols and was treated by his crowds as their monarch. "God save great Wilkes our King" was the song, and handbills posted on church walls prayed not for the monarch but for "Wilkes and Liberty." "Royal and loyal toasts were drunk to him, as 'the King over the waters'" when he was in exile and imprisonment, and his birthday, "like that of the monarch, was the occasion for popular celebration and public rejoicing." Even taverns were named after him. Thus the symbolic number 45, "rich with irony in view of its associations with Jacobitism and yet, by virtue of that fact, was also a badge of revolt," summed it all up: the ambivalence, the comic splendor of it all.[38]

A silver cup was presented to Wilkes by the Court of Common Council of the City of London in 1772 on which were engraved a picture of Julius Caesar and Charles Churchill's lines, "Let every tyrant feel / The keen, deep searchings of a Patriot's steel." It is impossible not to recall the concatenation of Caesar's assassination and Venus's assignation with Apollo in Hogarth's *Analysis*, plate 1 (fig. 20).[39] For Wilkes was, of course, a Lord of

34. John Brewer, *Party Ideology and Popular Politics at the Accession of George III* (Cambridge, 1976), pp. 184–89.

35. See E. P. Thompson, "The Moral Economy of the English Crowd in the Eighteenth Century," *Past and Present*, no. 50 (Feb. 1971), 76–136.

36. Brewer, *Party Ideology*, p. 186.

37. Ibid., p. 190.

38. Ibid., p. 185.

39. Hogarth and Wilkes were good friends until they broke over the issue of Bute's peace plans in 1762.

Misrule, as his parade was saturnalia, and his iconography was based on the images of court jesters and Punchinellos. Much was made of physical deformity—his eyes and ugly face, of his sexual potency and of his persistent violation of property, public and private. The parliamentary speech to which I referred earlier shows him in the role of the Lord of Misrule. It was all part of the same image. The iconography continued after Wilkes became mayor. In the procession celebrating his Lord Mayor's Feast on Easter Monday 1775 there appeared figures of "Pleasure" and "Freedom" accompanied by three cupid-like genii; a painting of Bacchus and Ariadne decorated the feast, with mottoes of drink and love; and the ballroom was dominated by a huge painting of a landscape with dancing nymphs and their lovers.

In his parody of Pope's *Essay on Man*, his *Essay on Woman* ("By Pego Borewell Esq."), Wilkes perpetuated the kind of parody that all his actions and parades represent in the public realm. For Pope's lines

> Who sees with equal eye, as God of all
> A hero perish, or a sparrow fall,
> Atoms or systems into ruin hurl'd,
> And now a bubble burst, and now a world. [I, ll. 87–90]

Wilkes substituted his subculture alternative:

> Who sees with equal Eye, as God of all,
> The Man just mounting, and the Virgin's fall;
> Prick, cunt, and ballocks in convulsions hurl'd,
> And now a Hymen burst, and now a world.

The progression in this poem—the hierarchy that is usually thought of as by birth alone—is based on the size of the sexual organ but it loyally proceeds upward to Bute and then to the monarch. This is, of course, the natural order, and we can trace it back to the imagery of Charles II as King David, Dryden's immensely potent whoremonger in *Absalom and Achitophel*, or to Rochester's anti-Charles satires. But what happens when this potency is displaced from the monarch to the subject? Wilkes has become the subculture, perhaps the true, king, or at least one who has to coexist with the official (or is it the natural?) one.

As soon as Wilkes sank from prominence after the Gordon Riots (which he condemned), this Dionysian figure was perpetuated in the form of the rolypoly Charles James Fox, whose emergence as a liberal politician coincided with Rowlandson's as an artist and with the last chaotic stages of the war with the Colonies, and was summed up in Fox's equal opposition to the British role in the American Revolution and to the Marriage Act. Behind all this was Rowlandson, in his modest way speaking to the central issue—which concerned the French as well as the English—of the Marriage Act: in favor of passion rather than prudential contracts as the best basis for

marriage, against (to use Paine's words) the aristocratic father's "power of binding and controlling posterity to the 'end of time.'"

For such patrons as Fox, Sheridan, and the Prince of Wales the focus of interest was naturally the young hero who elopes with the woman he loves or who happily moves from one love affair to another, warding off guardians, fathers, and old friends. With this antidomestic crew, life and Rowlandson's art were virtually one. The great Whig advocates of liberty, who supported the French Revolution in the 1790s, gave liberty the form of sexual perambulation and disruption produced by drinking, gambling, wenching, and other forms of disinterested, wasted energy, or rather, of energy for its own sake erupting in playful violence, always directed against the old guardian, the written document or legal contract, the toll gate or barrier.

Insofar as it is related to the events of his time, Rowlandson's crowd can be seen as a confusion of the classical res publica and the rule of the crowd, just as his use of the sexual situation can be seen as a confusion in regard to the meaning of the term *pursuit of happiness*, which Jefferson had substituted in the Declaration of Independence for the final term in the phrase *life, liberty, and property*. (Rowlandson sees the girl as *property* from her guardian's point of view and *pursuit of happiness* from the young man's.) In general Rowlandson and his circle represent, vis-à-vis the French Revolution, a confusion of private and public realms of liberty and happiness—going off into the pursuit of private happiness and liberty against public authority, as if happiness were located and enjoyed only in private life.

SHERIDAN, THE THEATER, AND SEXUAL LICENSE

Fox shocked Burke by his panegyric of 30 July 1789: "How much the greatest event it is that ever happened in the world! and how much the best!" But, though he was instinctively responding to the French struggle for liberty, his words over the next several months were a mixture of expedience and muddled thinking while he played a waiting game.[40] It was Richard Brinsley Sheridan, Burke believed, who was going to guide the Whig party into Jacobinism, whose influence on Fox was undermining the party and

40. As F. O'Gorman has said of Fox: "His opinions were not based on the lengthy perusal of letters and official documents, as were Burke's. For long afterwards, Fox was prepared to shade over into obscurity his views on the French Revolution and to use them as a political means of composing dissensions within his own party. The careless ambiguity, the lack of logic and, sometimes, the ruthlessness which characterized his opinions on the French Revolution are all an indication of the fact that Fox possessed no systematic or profound interpretation of it to which he might stubbornly have clung" (*The Whig Party and the French Revolution* [London, 1967], pp. 45–46).

turning it revolutionary, even contaminating its patron the Prince of Wales.[41] After Burke had published his *Reflections* the rumor spread that Sheridan was planning to publish a reply and render the split within the Whigs irreconcilable. Sheridan and Burke, the two Irishmen, acted as the poles between which Fox and the other Whigs had to choose or vacillate.

Sheridan was the one active politician who supported the Revolution and was also a figure of literary stature. His speeches in the House of Commons, however, were too politic to tell very much.[42] In 1792, discussing parliamentary reform (the demands of the radical politicians), he used metaphors of the people as a young lion and as a storm; but he also, a few months later, distinguished between his rejoicing in the Revolution itself and his disapproval of the subsequent excesses, and he added that he would certainly fight any French soldier who landed on English soil.[43] When Louis XVI was condemned to death Sheridan blamed the incompetent administration of English affairs for not having prevented it. The significant and revelatory fact of the debate, however, was his juxtaposition of the death of Louis XVI and declaration of war with the question that followed of whether the diners at White's Coffeehouse in Paris had toasted Fox and Sheridan.[44]

During the Revolutionary debates Sheridan came to life when he proposed "To except the Ladies from the restrictions of the [Alien] bill; which, he said, would not defeat the object of it, and would shew" (presumably turning toward Burke at this point) "that the age of chivalry was not gone in this country, whatever might have become of it any where else."[45] In the

41. Ibid., p. 52.

42. In his speech of 9 February 1790 on the army estimates he asks (giving Mackintosh one of his arguments) what is the lesson of the "outrages of the populace" in France: "What, but a superior abhorrence of that accursed system of despotic government, which had so deformed and corrupted human nature, as to make its subjects capable of such acts; a government that sets at naught the property, the liberty, and lives of the subjects; a government that deals in extortion, dungeons, and tortures; sets an example of depravity to the slaves it rules over. . . ." (*Speeches of the late Right Honourable Richard Brinsley Sheridan* [London, 1816], 2, 243.) As to the new constitution Burke says Louis XVI was preparing for the people: "What!" replies Sheridan, "was it preparing for them in the camp of Marshal Broglio? or were they to search for it in the ruins of the Bastille?" (p. 244).

43. Ibid., 3, 28–37 (30 Apr. 1792), 39 (13 Dec. 1792), 41 (14 Dec. 1792).

44. 12 February 1793, 3, 68. Then, following the death of Louis XVI and the declaration of war (12 Feb. 1793): The excesses must be attributed to this cause, "that a despotic government degrades and depraves human nature, and renders its subjects, on the first recovery of their rights, unfit for the exercise of them. But was the inference to be, that those who had been long slaves, ought therefore to remain so for ever, because, in the first wildness and strangeness of liberty, they would probably dash their broken chains almost to the present injury of themselves, and of all those who were near them? No! the lesson ought to be a tenfold horror of the despotism, which had so profaned and changed the nature of social men; and a more jealous apprehension of withholding rights and liberties from our fellow creatures . . . " (3, 72).

45. 31 December 1792, in *Speeches*, 3, 55.

Hastings trial his romantic rhetoric about the free young Indian girl coincides with Burke's own about the chivalric protection of mothers.

The true measure of Sheridan's radicalism can be made out earlier in his speech of 20 June 1781 on Fox's amendment to the Marriage Act: that women at sixteen and men at eighteen could marry without the permission of parent or guardian. Sheridan opposes, arguing that Fox seemed unaware

> that if he carried the clause, enabling girls to marry at sixteen, he would do an injury to that liberty of which he had always shewn himself the friend; and promote domestic tyranny, which he could consider only as little less intolerable than public tyranny. If girls were allowed to marry at sixteen, they would, he conceived, be abridged of that happy freedom of intercourse, which modern custom had introduced between the youth of both sexes; and which was, in his opinion, the best nursery of happy marriages. Guardians would, in that case, look on their wards with a jealous eye, from a fear that footmen and those about them, might take advantage of their tender years, and immature judgment, and persuade them into marriage, as soon as they attained the age of sixteen. In like manner young men, when mere boys, in a moment of passion, however ill-directed, or perhaps in a moment of intoxication, might be prevailed upon to make an imprudent match, and probably be united to a common prostitute.[46]

To this Fox replied "that his honourable friend Mr. Sheridan had so much ingenuity of mind, that he could contrive to give an argument what turn he pleased; he considered not therefore, when what he said was really in support of domestic tyranny, he should ground it on a wish to preserve liberty."[47] But Sheridan's insight into domestic tyranny was as subtle and personal as had been that of Fox's father, both being the result of a personal experience of elopement against the wishes of parental authority. Sheridan saw with the eye of a profound (though comic) psychologist, but Fox also recognized that Sheridan the wit was playing games and perhaps never emerged from his theatrical persona.

The true Sheridan was brought into the light not by the carefully censored speeches, constructed of skillful debating points, that were directly connected with the French Revolution, but by his speeches on the Marriage Act and later on the crisis over the Regency Bill—the question of whether a mad old king and his haggish queen should rule through their skeletal minister Pitt, or whether the handsome, gallant young Prince of Wales should rule.

As to the theater, his métier, Sheridan warned: "Beware, and listen to the

46. Ibid., 1, 20–21. See also the speeches against police interference (5 Mar. 1781 [1, 6–16] on measures in response to the Gordon Riots).

47. Ibid. Fox's motion passed.

wise. Keep politics out of the theatre."[48] *Pizarro* (1799), Sheridan's one "po-
litical" play, was actually his belated return to the patriotic fold, an attempt
to be all things to all men—and, as Gillray noted in his caricature on the
occasion, to write a great popular success. Defining Pizarro in terms of
political analogues (Napoleon, Warren Hastings, but also Pitt), Sheridan is
writing in the tradition of Fielding's allusive, analogically constructed farces;
on the other hand, the autobiographical bent of the author goes back to *The
Rivals* (1775). Alonzo makes sense only in relation to the English situation,
as an amalgam of Sheridan himself and Fox. Las Casas is Joseph Priestley
or one of the Wilberforce–Price group of reformers. Speaking of his inspirer
Las Casas, Alonzo-Sheridan slips into Paine's famous metaphor:

> . . . I would gently lead him by the hand through all the lovely fields of Quito;
> there, in many a spot where late was barrenness and waste, I would show him
> how now the opening blossom, blade, or perfumed bud, sweet bashful pledges
> of delicious harvest, wasting their incense to the ripening sun, give chearful promise
> to the hope of industry. This, I would say, is my work![49]

With *Pizarro*, however, the *circumstances* of composition are more signifi-
cant—expressive of Sheridan the "revolutionary" artist—than the play it-
self. Michael Kelly (who prepared the music) describes the first night with
Sheridan upstairs in the prompter's room writing the fifth act, "while [on
stage] the earlier parts were acting; and every ten minutes he brought down
as much of the dialogue as he had done, piece-meal" to the actors. What
emerges is the libertine dilatoriness of the playwright and the sense of ex-
citement and risk, but contained within a shrewd professionalism and an
intimate knowledge of his actors, for as he was perfectly aware, they were
up to the challenge and he was really *not* taking a risk.[50] The fact that, as

48. This was said in 1815 in a letter to Samuel Whitbread (7 Mar., in *Letters*, ed. Price, 3,
20). But in 1795 Sheridan spoke in Commons on the subject: "For his own part, he deemed a
theatre no fit place for politics, nor would he think much of the principles or taste of the men
who should wish to introduce them into stage representations. With respect to the London
stage, the fact however was, that the players were considered as the king's servants, and the
theatre the king's theatre; and there was nothing so natural as that no pieces should be permit-
ted that were not agreeable to His Majesty" (3 Dec. 1795, in *Speeches*, 4, 188–89).

49. Sheridan, *Plays*, ed. Cecil Price (Oxford, 1975), p. 682.

50. Kelly's explanation is that "No man was more careful in his carelessness; he was quite
aware of his power over his performers, and of the veneration in which they held his great
talents; had he not been so, he would not have ventured to keep them (Mrs. Siddons particu-
larly) in the dreadful anxiety which they were suffering through the whole of the evening."
Moreover, he "perfectly knew" that Mrs. Siddons and the other leading Drury Lane actors
"were quicker in study than any other performers concerned, and that he could trust them to
be perfect in what they had to say, even at half-an-hour's notice" (*Reminiscences of Michael Kelly*
[2d ed., 1826], 2, 146–47). John Britton's account emphasizes revision rather than composition
and pushes this back to the end of the first act (*The Auto-Biography of John Britton, F.S.A.*
[1850], 1, 130).

with his other plays, Sheridan treated the first night as a dress rehearsal contributed to the sense of process over product, of a close dialogue with his audience as he crafted the play exactly to their wishes (and to his actors' capabilities): this, significantly, and not to "revolutionary" self-expression.

One's first literary referent in any revolutionary period is the drama, the danger spot most closely scrutinized by politicians; witness Walpole's Licensing Act and Corbyn Morris's supporting opinion that it is far more difficult to efface the impression of what is seen and heard than what is merely read.[51] It is therefore no surprise to find the dramatic response to the French Revolution in operatic entertainments and interludes. The plays that went seriously, although clumsily, at the real issues and took sides were prohibited and never performed. Even so, the surviving texts show that they generally took the allegorical way out through parallels in earlier English history or in Roman or Swiss history (just as the French were doing across the channel). The republicans went back to the Peasants' Rebellion with plays about Wat Tyler and John Ball or to the rebellion of the Swiss Republic against the Austrians with William Tell the hero. The conservatives went all the way back to the Bible or to the English War of the Roses. After the death of Louis XVI the conservatives wrote plays about the poor doomed family, sometimes with historical parallels, sometimes in direct pseudorapportage. A few attempted to dramatize the current events in Paris, with Charlotte Corday or Robespierre as protagonist.[52]

In general, sympathy was expressed in the first phase (1790–91) and afterward, following the direction of government policy, hostility. Nothing of much interest is to be found in this body of material. And yet we know Fox's dramatic interests, the "prodigious numbers" of plays he knew, and his frequent use of quotations and allusions from plays in his speeches.[53] We know his friendship with Sheridan, and Sheridan's life in the theater. Perhaps we should look at the theater as source instead of as reflection of revolutionary attitudes. Certainly it is true that scholars examining this material tend to look for specific references to France or liberty or rebellion and have overlooked the area of greatest literary interest: the analogical plots developed by writers who were prerevolutionary or who during the Revolution could not, or did not wish to, express their feelings directly. We are told that Thomas Holcroft's play *Love's Frailties* (1794) was hissed off the stage for the line "I was bred to the most useless, and often the most worthless, of all professions; that of a gentleman."[54] Such a sentence conveyed

51. Corbyn Morris, *An Essay towards Fixing the True Standards of Wit, Humour, Raillery, Satire, and Ridicule* (1744), p. x.

52. See Theodore G. Grieder, Jr., "The French Revolution in the British Drama: A Study in British Popular Literature of the Decade of Revolution" (Diss., Stanford University 1957).

53. 3d Lord Holland, *Fox Correspondence*, 1, 31–32.

54. *Love's Frailties: A Comedy* (London, 1794), p. 66; noted in the author's preface.

Jacobin sentiment. When he published the play, Holcroft emphasized the
offending passages with italics, and they are all like the one quoted. What
distinguishes *Love's Frailties*, however, is its modification of the *Marriage of
Figaro* plot, brought up into the revolutionary period. There is every indi-
cation that the theater audience of the 1780s and 1790s was uneasy with
explicit sexuality, as it was with explicit politics. The closest thing to rev-
olutionary theater was, therefore, Beaumarchais's *Marriage of Figaro* (1784),
which appeared only in a mutilated form in London (translated by Hol-
croft). Here the common factor in the conflict between servant and master
(Figaro and Count Almaviva) was once again sexual prowess, ending in
total defeat of the aristocrat. The English version of the droit du seigneur is
an uncle who controls the marriages of his charges: siblings, each of whom
is in love with an unsuitable person, a soldier for her and a painter's daugh-
ter for him. The old guardian who prohibits these matches pursues young
girls himself, and the plot of *Love's Frailties* is an animated version of a
Rowlandson situation with the old guardian, the young girl he pursues, and
her young lover (who, of course, turns out to be the old man's charge). On
the one hand the young folk rebel and marry as they please, and on the
other the old man is thwarted in his personal designs on the young girl.
Love, it is made clear, is both the great leveler and the great catalyst for
rebellious action, and the battle is between generations (whether the partic-
ipants are called father–son–daughter or guardian–brother–sister).

There is also an artist who comes in conflict with the aristocratic patron.
This is Craig Campbell, who speaks the offending line about "the most
worthless of all professions." He is the father of the heroine, and in one of
the italicized (censored) passages says: "They may clothe me in rags, feed
me on offals, load me with fetters; but there is that here, [pointing, I sup-
pose, to his heart] which contemns their injustice, and defies their persecu-
tion" (p. 19). On the same page an uncensored passage reads: "The lord
within, sits in state, reveling, banqueting, and tantalizing the palled appe-
titie; while the wretch without [i.e., the artist] repulsed, insulted, and re-
fused his due, is perhaps perishing with hunger!" And Campbell is painting
(p. 51) a "progress of seduction; beginning in perjury, ending in suicide"—
a series that draws upon memories of Hogarth, Morland, Greuze, and
Loutherbourg, in which both his daughter and the hero of the play see
themselves represented. But like Rowlandson's artists, this one (though the
girl's father) never knows what is going on around him. He can see through
to the heart of the evil in the abstract but not in the particular. It takes the
daughter to exclaim of the old guardian: "Ought hoary seduction like this
to pass unreproved?" (p. 70).

Plays such as Holcroft's reveal that Rowlandson's drawings, looked at in
the right way, are also less about a rake than about a decent, loving, senti-
mental young man who (as if he were a Physiocrat) is prevented by the

forces of society from carrying out his natural impules.[55] What does characterize his great plays? *The Rivals* and *The Duenna* are simply about the situation of Hogarth's *Marriage à la Mode*, in which the older generation tries to impose its tyranny on the younger by directing their affairs, and this forces the children into the various lovers' stratagems we are familiar with from Rowlandson's drawings. As John Loftis writes, "The willingness of both Lydia and Julia to marry a man for love whom they mistakenly assume has no fortune represents a financial disinterest for which it would be difficult to find a parallel in Restoration comedy"—although, like Fielding, Sheridan has it both ways since his lovers do prove to be wealthy.[56] The words and deeds of Sir Anthony Absolute and Mrs. Malaprop produce ridicule of tyranny far beyond that found in Etherege, Wycherley, Congreve, or Vanbrugh, where the hero's sex-oriented strategems take center stage.[57]

Shelley's comment on *The School for Scandal* (1777) was: "I see the purpose of this comedy. It is to associate virtue with bottles and glasses, and villainy with books."[58] So much of revolutionary imagery in Great Britain was just this. At about the same time as Paine's first formulation of primogeniture and books, ledgers, and charters versus youthful energy in *Common Sense*, Sheridan was writing mild forms of dramatic revolution in his simplification of *Tom Jones* to a confrontation between Joseph and Charles Surface.

The case of a genuine revolutionary who died for his beliefs was Wolfe Tone, like Sheridan Irish with a similar sense of personal grievance. While going about his revolutionary activities (to get the French to invade Ireland and the Irish to rise against the English), he kept up the refrain in his journal:

55. What we notice in the comedy of the pre-Sheridan stage is that they are "explicit and emphatic in recommending matrimonial fidelity," as in Arthur Murphy's *The Way to Keep Him* (1760). See John Loftis, *Sheridan and the Drama of Georgian England* (Oxford, 1976), p. 30.

56. Loftis, p. 46. Both Rowlandson and Sheridan built to a remarkable degree on the works of others and yet chose just those elements that suited them, making the borrowing their own by means of a wonderful stylishness, which in Sheridan's case Loftis refers to as burlesque. See Loftis's lists of the plays out of which Sheridan constructed his own.

57. Garrick's emasculation of *The Country Wife* into *The Country Girl* (1766) shows one aspect of the times, Sheridan's plays the other. The old husband or *senex amans* is hardly recognizable in Garrick's mild version of Wycherley or in Frances Sheridan's *The Discovery* (1763), Hugh Kelly's *The School for Wives* (1773), and even Sheridan's own comedies. Sheridan drops the suggestions of impotence and evokes partial sympathy for Sir Peter Teazle in his *School for Scandal* (1777); indeed, there is evidence that he had originally conceived the Teazles in the spirit of the Pinchwifes; then he toned down the characterization and seems to have wished Sir Peter to be played sympathetically. See Sheridan, *Plays*, ed. Price, p. 304.

58. Thomas Love Peacock, *Memoirs of Percy Bysshe Shelley*, in *Works*, ed. H. F. B. Brett-Smith and C. E. Jones (London, 1934), pp. 8, 81.

> Something will come out of all this. Agree to talk the matter over to-morrow when we are all cool. Huzza: Generally drunk. Vive la Nation! . . . Generally very drunk. Bed. God knows how.[59]

His "optimistic frivolity" and his drinking may have been "no more than any spirited young man of his background engaged in."[60] It is part of the jokey, light-hearted quality of the "sophisticated republicans" of the late 1790s who call each other "citizen," whose behavior forces poor Cockayne the double-agent every night to down "at least three bottles of claret, whereas he was used to no more than a pint of wine."[61] It is simply the imagery of intoxicated enthusiasm in Paine's *Rights of Man*, which seen from the other perspective became "the whiskey of infidelity and treason," as the Irish Soliciter General put it (or Burke might have).[62]

If Wolfe Tone is Sheridan the revolutionary tippler carried to an extreme, the Marquis de Sade does the same with his sexual aspect. Sade demonstrates, to his own satisfaction at least, that pornography is a response to social and personal repression. As he wrote to his wife from prison in 1783 (but addressing himself to the public at large):

> I'll bet you thought you had a brilliant idea in imposing a revolting abstinence on me with regard to the sins of the flesh. Well, you were mistaken: you brought my brain to the boiling point. You caused me to conjure up phantoms which I shall have to bring into being.[63]

And by "bring into being" he means create in words on paper, although he would obviously like to be the artist who, like Pygmalion, could carry the process one step further to reality.

Sade could be explicit in his French prison, as John Cleland had been thirty years earlier when also imprisoned he had written *Fanny Hill* (1749). Fanny's dedication of her story to "Truth! stark naked truth" can be related to Rousseau's claim to have stripped Nature bare to reveal the truth. But in a larger sense, as William H. Epstein has said in his study of Cleland, pornography is "a representational or written depiction which arouses sexual instincts and which, because it asserts existence, pleases."[64] That is, pornog-

59. William Theobald Tone, *Life of Theobold Wolf Tone* (Washington, 1826), 1, 115–16.

60. Robert Kee, *The Green Flag: The Turbulent History of the Irish National Movement, 1603–1923* (London, 1966), p. 55.

61. Tone, *Life*, p. 202; Kee, *Green Flag*, pp. 63–64.

62. Thomas MacNevin, *Leading State Trials 1794–1803* (London, 1844), p. 387.

63. "Vous avez imaginé faire merveille, je le parierais, en me réduisant à une abstinence atroce sur le péché de la chair. Eh bien, vous êtes trompés: vouz avez échauffé ma tête, vous m'avez fait former des fantômes qu'il faudra que je réalise" (July 1783, in *Oeuvres complètes du Marquis de Sade* (Paris, 1964), 12, 397).

64. *John Cleland: Images of a Life* (New York, 1974), p. 87. Cf. David Foxon's thesis that the emergence of pornography in the 1660s corresponded to a general European revolt against the authority of church and state (*Libertine Literature in England 1660–1745* [London, 1965], p. 51),

raphy asserts the will to live, and it does so by loosing psychic energy or libido through the id, which operates outside the laws of reason, logic, and morality. Sheridan in a weak way and Rowlandson in a strong way reflect the libertine tradition (both domestic and religious) of Rochester and Cleland that equates the intellectual and physical liberation of self. Sheridan the public man (politician and theater manager) obviously could not carry the matter very far. The images he skirts were more explicitly presented in the prints and drawings of Rowlandson, which at an extreme were pornographic. I am suggesting that Rowlandson expressed in simpler and less censored form the assumptions about liberty which bordered on rebellion (if not revolution) shared by Sheridan, Fox, and the members of their circle. The pornographic works that have survived are from a later stage of his career (the prints, at least, only began to appear in the 1800s); they are, however, a logical extension of all his earlier figure drawings—a stripping away of society's illusions to show people liberated and controlled by their sexual energy.

The representation of revolution by pornography sounds peculiarly inadequate compared to the events taking place in France. And yet the young revolutionary's own pattern seemed to mix sex and revolt: Saint-Just emerged on the scene in Paris having (as if emerging from the pages of Burke) seduced a local aristocrat's daughter and been forced to flee to Paris, where he wrote a long pornographic novel. Even more the case of Camille Desmoulins or of Danton makes one suspect that liberty and luxury (wenching and drinking) were as much in the minds of many French revolutionaries as of the English Whigs. Even among the sans-culottes one notices the ostentatious common law marriages and flaunting of illegitimate children. The case is made by the Section de Bon-Conseil to the Convention for "women who, out of a sincere feeling of affection, have given birth to children before fulfilling their legal obligations; that is, by omitting the formality which authorizes their union in the eyes of the law." [65] This is only a stronger version of Sheridan's and Fox's attacks on the Marriage Act.

Sex was an important aspect of the "nature" that replaced church and state. Joel Barlow proposed "natural" origins in sex for many of the revolutionary symbols used in the great festivals: Trees of Liberty, he argued,

which with *Venus dans le Cloître* (1683) made the reaction against monastic imprisonment part of its message. For the background of this subject, see Jean Hagstrum, *Sex and Sensibility: Ideal and Erotic Love from Milton to Mozart* (Chicago, 1980).

65. Quoted in Soboul, *Sans-Culottes*, p. 246. On the subject of sex and revolution, see Herbert Marcuse, *Eros and Civilization* (Boston, 1955), *Reason and Revolution* (Boston, 1960), and E. J. Hobsbaum, "Revolution and Sex," in *Revolutionaries: Contemporary Essays* (New York, 1973), pp. 216–19. For a view of Sade's writings as "a caricature of the fear among the ruling classes of the rise of the masses," see Heer, *Europe, Mother of Revolutions,* (New York, 1972) pp. 28–30.

came from the phallus of the Osiris cult of the Egyptians, which through the Roman Bacchus became the emblem of Libertas. Even the Phrygian cap he traced to a Roman symbol for the head of the phallus.[66]

Once into the Revolution, however, past the phase of rebellion, liberty was replaced by fraternity, the erotic by the puritan, and the fun-loving Danton was succeeded by Robespierre and by a soberer Saint-Just. At Strasbourg Saint-Just overthrew the mayor for his sexual distractions as well as for taking a German wife, and with his close male friends he became an example of the "exclusive, Spartan, and homophile" phase of the Revolution, which emphasized fraternity, became anti-feminine, staged executions of "the great symbolic women of the era," and was haunted by fears of being assassinated by women.[67]

England itself never suffered involvement beyond that first stage of subversive gestures relating to "nature" and sexual liberation. Fox, Sheridan, and Rowlandson did not have to put forward a program or to control the sexual energies they had released. It could, of course, be argued that they were merely using harmless forms (analogous to the crowd rituals) offered by the state itself for the release they sought. For the question remains: Is the sexual-sensual act only (as Saint-Just would have concluded) a sublimation of revolutionary urges? Is it an image that could be safely presented when the author was thinking of other, more questionable matters? Or when he was thinking of revolution, was he in fact thinking only of drinking and lovemaking?

Of course, Sheridan's protagonist tends to be Sheridan himself, and *The Rivals* is based on the Linley family and Sheridan's elopement with Elizabeth. As with Wilkes, life rather than writing is the place to look for the revolutionary Sheridan, who in fact gave up the written product in favor of the exciting life of ephemeral speeches, gestures, and conversation. The crucial fact of his life—the one from which his fictions flowed—was his elopement with Liza Linley. But there was also the ironically distanced hero within the play—the fearful Falkland, or the Don Juan or even the artist Craig Campbell—*and* the artist outside the play who renders him with extraordinary style, as he also contains the apparent spontaneity of his invention within an antithetical form and a professional grasp of the theater.

Uvedale Price, who, coincidentally, was Charles James Fox's companion on his Grand Tour, advocated a further sublimation of "revolutionary" urges through energetic travel from one picturesque sight or experience to another. Rowlandson, joining politics and aesthetics, is obsessed with the pic-

66. Barlow, "Genealogy of the Tree of Liberty," unpublished, undated MS, Houghton Library, Harvard, bMS Am 1448 (13), 22; cited in Billington, *Fire in the Minds*, p. 52.
67. Billington, pp. 67–68.

turesque moment of change, the borderline situation in which a ship is neither at sea nor in dry dock, an old man is neither alive nor quite dead; his interest extends from a scene in which mutability is seen creeping along, to the violent, abrupt change that is occurring in the drawing of *George III and Queen Charlotte driving through Deptford* (fig. 23). All hell is breaking loose, uniting horses, dogs, pugilists, and pretty women. John Hayes dates this drawing around 1785; if he is correct it is a remarkable anticipation of the day in 1795 when the window of George III's carriage was broken by the crowd (and stylistically the drawing could be that late).[68] In any case it is an adaptation of Hogarth's *Industry and Idleness*, plate 12, showing the Industrious Apprentice on his way to being inaugurated Lord Mayor of London, with Frederick Prince of Wales appearing in about the same far-right position as George III. In Rowlandson's drawing the royal family and the line of grenadiers are even more obscured and overwhelmed by the crowd than the Lord Mayor and his procession. "The Old Ship" sign at the right, nearest the royal coach, evokes the old ship of state and is commented on by parallel signs announcing the "Learned Pig" and "The Surprising Irish Giant."[69]

Rowlandson's crowd must, however, be compared with a direct representation of the French Revolution, John Zoffany's history painting called *Plundering the King's Cellar at Paris* (1794, fig. 24), whose engraved copy carries the reference to the attack on the Tuilleries on 10 August 1792 (misdated 1793 by Zoffany). The statue of Hercules slaying the Hydra is Zoffany's emblematic reference to the many-headed mob that is engaged in tearing away the royal arms from the pediment of the palace. The composition is a disorderly version (including the three anchoring foreground groups) of Hogarth's *March to Finchley* (1750), but far more open, constructed on a single receding diagonal toward the right. The people literally overflow the architecture, or at best cram themselves into the pediment over the entrance, living versions of the statues of Raving and Melancholy Madness over the portal of Bedlam. The *Finchley* echo is appropriate since both paintings are celebrations of drunkenness, riot, and rebellion; here the few soldiers, members of Louis XVI's Swiss Guard, are being killed by the mob. The Bedlam echo is corroborated (as is the Hogarth) by the center foreground group, a flattened version of the group of Tom Rakewell and Sarah Young in the Bedlam of *A Rake's Progress*, plate 8.[70] Probably all that

68. See Hayes, *Rowlandson*, p. 88.

69. Cf. Hogarth's engraving *The Stage Coach, or Country Inn Yard* (1747), in which the inn has the sign of the Angel and is labeled "The Old Angle [*sic*] In," a punning way of saying Old England; the coach is getting ready to depart filled with typical Englishmen (and one Frenchman on top). Rowlandson's drawing is a version of Hogarth's print.

70. A final curious fact in this very Hogarthian painting, even whose handling of paint is Hogarthian, is that the main figure at the basket of wine bottles, face in profile, bears a striking

23. Thomas Rowlandson, *George III and Queen Charlotte driving through Deptford.* Watercolor drawing, ca. 1785–95?

Zoffany wanted to express was the equation of drunkenness, madness, and revolution; in a larger sense it is not inappropriate that Zoffany, the painter in the 1770s–80s of *The Tribuna of the Uffizi* and *Charles Towneley and his Friends*, images of gentlemen among art collections, should later paint scenes of the revolutionary crowd overwhelming the architecture and sculpture which are the last signs of civilization.

The effect is superficially similar to Rowlandson's *George III and Queen Charlotte driving through Deptford*. I must cite James Sherry's interpretation of this drawing, which is a response and, I think, a necessary corrective to mine. I have probably made it sound too like the Zoffany. Sherry's point is that "here everything is distanced and rendered enjoyable—in part by the pastel colors which, like Gilpin's 'mists,' soften the roughness of this very English landscape and make its irregularities picturesque"—and in part by Rowlandson's comedy, which prevents immersion in the violence and disorientation portrayed:

> For this medley of characters—from the fat saleswoman, to the handsome guardsman, to the one-eyed fiddler, to the unperturbed smoker—is the "Old Ship" which is "Old England." These are the humors which the lightness of British rule, suggested by the lack of prominence of the King and Queen, allows to express themselves unhindered and undisguised. In this land of Originals, including the "Learned Pig" and "The Surprising Irish Giant" on the billboards in the background, there is no need to be alarmed at the combination of order and disorder, regularity and license, elegance and grotesqueness which characterizes the scene.[71]

Rowlandson's "style," the comic-picturesque, and the operation of his "inimitable humor" act as an aesthetic protection against the violence and disorder; they allow us to take the picture as a representation of violence and as a defense against either the euphoria or the fear of such violence.

resemblance to the best-known contemporary likeness of Hogarth, reproduced in many copies. Recall the stories of how Zoffany put friends and enemies into his *Last Supper*. Zoffany apparently painted at least two other responses to the French Revolution. One was called *A Scene in the Champ de Mars on the 12th of August, with a Portrait of the Duke of Orleans* (no. 85 in Zoffany's sale catalogue; last recorded when sold by C. Wolley, 30 Nov. 1867, lot no. 88, bought by W. Graves). The reference here is probably to the fifteenth of July 1791, the massacres by the National Guard on the Champ de Mars following the king's flight and capture, one of the issues of the confrontation being whether power should go to the duc d'Orléans. The final outcome of these outrages was the storming of the Tuilleries a year later, which is the subject of *Plundering the King's Cellar at Paris*. A third painting, an unfinished sketch called *The Triumph of Reason, French Revolution* (lot no. 59 in Zoffany's sale catalogue) is also lost.

71. See Sherry, "Distance and Humor; The Art of Thomas Rowlandson," *Eighteenth-Century Studies*, 11 (1976), 462, which is an answer to my *Rowlandson: A New Interpretation*, and "The Artist, the Beautiful Girl, and the Crowd." See also Sherry's brilliant analysis of the structure of perception in a 1784 sketch, "The Angel Inn at Lymington" (Huntington), ibid., pp. 468–70.

24. John Zoffany, *Plundering the King's Cellar at Paris.* Painting, 1794.

I use "humor" rather than comedy because Freud uses that word (*Humor* as opposed to *Witz*, joke). The phenomenon is summed up in the example of the condemned man being led to the gallows on a Monday: "Well," he remarks, "the week's getting off to a good start." Humor, says Freud, is "among the great series of methods which the human mind has constructed in order to evade the compulsion to suffer."[72] In short, Rowlandson's comic style serves as a defense: equally against the threat of authority (or the establishment) and one's own aging decline into the vulnerability of authority; equally against the release and the danger of violence.

The point at which release and danger join can be seen in an etching, dated 1791, called *Chaos is come again* (fig. 25), ostensibly on the plight of the Italian Opera Company in London, which shows a floor collapsing and people falling in much the way they do in Goya's *Desastres de la guerra*, no. 30 (fig. 26, which may owe something to Rowlandson's print). I need only mention an advertisement in the London *Times* on the anniversary of Bastille Day 1792, signed "Horne Payne" (alluding to those two "revolutionaries," Horne Tooke and Tom Paine), which ends ironically:

Pray to the being who directs your actions that his evil genius may assist our French brethren, and that in order to make the Revolution general, and give opportunity for one new and universal system, CHAOS MAY COME AGAIN.

In Goya's close-up it is much easier for the viewer to experience and share the terror of the falling figures. Rowlandson's is a more panoramic view, with the additional context of Life-as-Theater (and Pope's "Now a bubble burst, and now a world"). The print's caption, "Music has charms to soothe the savage breast / To soften Bricks and bend the knotted Oak," indicates the cause of the disaster in the voice of the opera singer on the stage (who is in the position of the serpent in *Landscape with Snake*), and beyond the disheveled bodies of the victims we see the gently undulating curves of theater boxes opposite, a scene of art gone awry, collapsed by nature in the form of the weight of human bodies, but still held in the delicate control of the artist who restrains terror with comedy.[73]

The most famous of Rowlandson's many scenes of art *cum* collapse/rebellion/sexual release is the so-called *Exhibition Stare-Case* (fig. 27).[74] This

72. Freud, "On Humour," in *Standard Edition*, 21, 161, 163. "Thanks to this connection [with the "methods . . . to evade the compulsion to suffer"], humour possesses a dignity which is wholly lacking, for instance, in jokes, for jokes either serve simply to obtain a yield of pleasure or place the yield of pleasure that has been obtained in the service of aggression."

73. One wonders whether Rowlandson was present in the Great Room of Somerset House 10 December 1790 when, during the delivery of Reynolds's last presidential Discourse, the floor threatened to collapse.

74. The drawing in the Mellon Collection (reproduced, fig. 27) corresponds to the print. The University of London drawing (reproduced, Hayes, *Rowlandson*, pl. 101) is much less finished: the niche is there but with only a vase in it, and the frieze is only sketched in. The

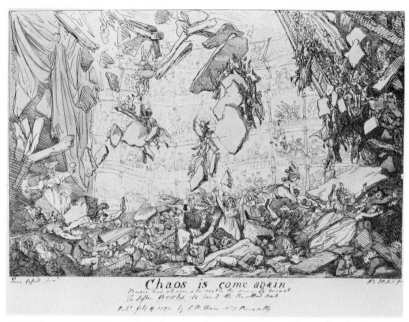

25. Thomas Rowlandson, *Chaos is come again*. Etching, ca. 1791.

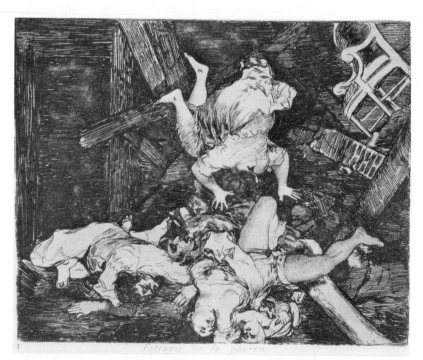

26. Francisco Goya, *Desastres de la guerra*, no. 30. Etching and aquatint, 1810–20.

is the staircase of the Royal Academy during one of its annual exhibitions.
Neither Rowlandson *nor* Reynolds is present, but the staircase everyone is
disastrously falling down is a Line of Beauty, and the message seems to be
how awkward, dangerous, yet exhilarating this form may be when intro-
duced into life as a structure to live by. The serpentine staircase *causes* the
fall in that it will not accommodate the human crowd. Yet it is not broken
through by the energy (like coaches and bridges and tollgates) but channels
it into a beautiful cascading form—itself consisting of mostly ugly, certainly
awkward bodies. The fall is also a Fortunate Fall, for, presided over by two
Venuses (one carried in a triumphal procession in the frieze, the other watching
approvingly from a niche), it not only permits voyeurism for the old (as
the title emphasizes) but providentially positions the young for the com-
mencement of lovemaking. It makes the point that these voyeurs who are
at the R.A. as "art-lovers" are instead ogling nature. A close look reveals
that a small furry animal—a dog, I believe—is the immediate cause of the
fall.

Rowlandson, although he often places us inside the crowd, in fact always
sees it from the outside. He sees it not as an expression of any spontaneous
levée en masse but as being set in motion by the energetic dog. For him it
is sufficient to observe that nature as animal has contributed to the cata-
clysm, in the form of a human crowd which is not quite contained, though
it is given form, by art. The sculpted Venuses (whose curves generate the
serpentine lines in the staircase) are there to contrast love in art with love in
life, while the dog unites the sexes as the consequence of energy and col-
lapse but with an aesthetic form not different in its use of serpentine lines
from that of the Venuses or of the bodies of the girls in the pornographic
drawings. Art has become a container or an armature which, in the process
of proving utterly inadequate, draws attention to its own necessity—like
the father figure of the historian against whom Rowlandson is reacting but
who nevertheless contributes the form of his representation.

Rowlandson conflates the plebeian crowd and the claque of aristocratic
rakes in search of pleasure. He portrays a crowd impinging upon royalty in
George III and Queen Charlotte, and the respectable gentry falling down in
Kew Bridge, *Chaos is come again*, and *Exhibition Stare-Case*. The only con-
nection is that both plebeian and patrician groups represent a breaking down
(or out) of barriers and a stimulus to destroy accepted categories. But the
second, the patrician crowd, is always acted upon rather than acting, is
always associated with spectators rather than participants.[75]

actual staircase in Somerset House has no frieze or Venus in the niche such as Rowlandson
shows. The staircase is elongated by Rowlandson to make his point about its steepness.

75. But Rowlandson, no respecter of persons, also allows servants to fall downstairs (ob-
served by their betters at the head of the stairs) and uses cats to trip them (drawing, collection
Mr. and Mrs. Philip Pinsof).

Those young men in the early drawing *Intrusion on Study* (fig. 17) combined both aspects of the crowd. They broke in not only to disturb the artist but to look at the model (as opposed to the artist's painting of her). "Peeping" for Hogarth meant getting a truthful look at nature; it still carries much of this positive sense for Rowlandson, but in his later pictures it has turned into voyeurism, the preserve of impotent old men. Far worse, however, is merely to look at the image of a body displaced to a canvas, and this is what Rowlandson's artists continue to do. A drawing in the Mellon Collection (fig. 28) shows the artist joining his patrons to look at his painting *Susannah and the Elders*, which itself is a representation of voyeurism, the elders having the same aim as the spectators outside the canvas. The artist has now become a Dr. Syntax in relation to the picturesque, entirely ignoring life, which goes on outside his range of experience; no model, no living woman, is present. In a variant (Huntington) the artist's landlady, an ugly old woman, stands for the outside world, watching artist and patrons with undisguised amusement. The artist is no longer young; he is seedy and his canvas shows "The Fall of Phaeton." He is simply mythologizing his own life-as-artist, romanticizing himself as Phaeton and the landlady and her clamoring cat as the forces of nature that send him plunging.

In another drawing, one of the *Comforts of Bath* (1798), nature is returned to the picture in the form of the young wife and her lover. The artist is peripheral to the subject of the romantic triangle juxtaposing youth and age. Life is fecundity, energy, and sex, from which the artist withdraws into art or connoisseurship or flattery. Life goes on *around* him; he is as oblivious as the old husband whose portrait he is painting. He is there only to flatter the old man; another has to carry on life with the young wife, whom he *should* be painting if not fondling. Almost all Rowlandson's artists fail to meet the challenge, continuing to paint Venuses and Jupiters, while his young Orc-figures go frolicking ahead into adultery and the disruption of static families. The "tension between rebellion and submission" to which I referred earlier becomes, in these later artist satires, a total submission of the artist within the picture. The artist without, who is demonstrating the fact that sexuality in art is less than real, that it is in fact cut off from its object of desire, finds himself in a position where his own art is turning the sexual object into an object of voyeurism. This knowledge probably led to the many repetitions of the artist theme parallel to the production of pornographic drawings.

Whenever an antimythological artist such as Rowlandson paints a mythological scene it is useful to note which myth. His favorite Biblical story is Susannah and the Elders and his favorite Greek myths involve aging satyrs pursuing young nymphs—just as his pornographic drawings often show old men staring at naked women. When he mythologizes the artist he does not use the story of the Corinthian Maid, the popular one of the time (treated

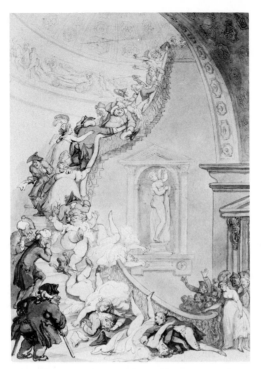

27. Thomas Rowlandson, *Exhibition Stare-Case*. Watercolor drawing, ca. 1800.

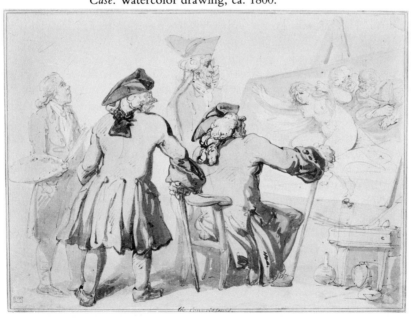

28. Thomas Rowlandson, *The Connoisseurs*. Watercolor drawing, ca. 1790s?

by Wright of Derby and many other artists between the 1770s and 1820s), which reflects the norm of nature in his own artist satires: one lover traces the shadow of the other, asleep and soon to depart for the wars, as a way of retaining the loved one. Instead Rowlandson depicts the story of Pygmalion and Galatea, in which the artist creates an image of the ideal woman out of his imagination or out of the *Discourses* of Reynolds, falls in love with the image, and through his love brings it to life. Rowlandson's etching (fig. 29), however, is his clearest statement that art represses or seeks to sublimate or displace the sexual instinct. A sculptor's kiss, or better his sexual organ, and not his chisel will bring his statue to life. (In Hogarth's *Analysis* [fig. 20] a sexual instinct caused Venus and Apollo to break through the stasis of stone to engage each other's attention.) But once alive, in Rowlandson's version, Galatea takes control, mounts Pygmalion, holding the sculptor's "tool" in her hand, about to insert and engulf it. As long as she was a statue on a pedestal she posed no threat; once alive, she proceeds to castrate him. And yet she is within a representation so stylized as to look part of an obscene frieze on a Greek vase and thus part of an object of voyeurism for both artist and audience outside the picture.

Rowlandson's artist is a voyeur analogous to the old men, to the clergymen and physicians. The clergyman's admonitory finger, the physician's scalpel, the old voyeur's eyeglass or telescope, and the artist's brush all have their phallic significance. If the body is threatening, one way to make it safe is to place it on a cross, an operating table, or a pedestal or canvas, and to look at it. The fascination the vulva has for these figures in Rowlandson's pornographic drawings is because it is a wound (he colors it blood-red), and one that is so much their own.

In his final version of the artist (1814, fig. 30), Rowlandson replaces him with Death. The young nonartist is still left to carry on life while the artist Death no longer flatters but paints the cuckold horns on the rich old man's brow. The pretense of art was the best that the old man could ask for, and the artist in the earlier versions gave it to him. But Death, the true artist, has destroyed even that illusion—and he has done so by introducing his self-portrait *within* his portrait in the position of the amorous young wife kissing the old man. Death is the equivalent of the serpent who gives structure to the chaos that he engenders, who shows its significance, who (in short) kisses it.[76] He is distinct from the timorous artist who cuts himself off from animal nature, for whom life has to remain a representation distanced on canvas. But (Rowlandson's ultimate defense) while Death brings down men of all ranks and riches, he himself is reduced and distanced through

76. In the published print, in *The English Dance of Death* (1814), Rowlandson removed the old man's cuckold horns and the amorous figure of Death, rendering the image more palatable.

the artist's line and the endless series of *The English Dance of Death* into something comprehensible and "humorous."

Rowlandson's artist simply embodies the fear of the aging man—and did so even for the young Rowlandson; but when he himself grows older he sees the artist and the old man as faced with the same violent disruption, the same need for defenses, which takes the form now of a gallows humor closer than in the earlier work to the condemned man's remark, "Well, the week's getting off to a good start."

In Rowlandson's pornography both male and female represent the natural drives that defy convention and morals, nature's revenge against culture. At the same time, as the old men (often looking through lorgnettes) reveal, pornography can also be rooted in the fear of nature—not a yearning for sexual liberation but its opposite, whose perception is, however, different from voyeurism. His picture depicts the sexual act (or, which is the same, revolution) and his own exclusion from its threat as he depicts it. (He does not share David's delusion, in his speeches and fêtes if not his paintings, that he himself was part of the Revolution.) The Rowlandson drawing presents in an explicit way, distanced by comedy—which is the perception that transcends voyeurism—the relationship of the artist to the essential elements of the decade: youth and beauty, violence and the sublime, crowd action and catastrophe.

The common term is metamorphosis: the Ovidian metamorphosis, which could be used to express a sense of revolution that is more favorable than the story of Pandora's box. We need only recall the stories of Daphne and Syrinx to see the revolution relating to the idea of a new order (beauty or art) emerging from rape, agony, and violent overturn. The sense of waste and loss (Syrinx's death, at least in human terms) is acknowledged along with the gain in an absolute sense (the musician's pipes). The Comte D'Artois's metaphor of breaking eggs in order to make an omlet was merely a folk version of this notion of change.

In all Rowlandson's artist satires, a safe restructuring of life or society comes down from above: from the king, from God, from a father, from the muse, from a statue of Venus, and from Sir Joshua. This is the world represented in all those statuary yards (adapted from Hogarth's *Analysis*), the sculpture or picture galleries or auction rooms in which Rowlandson so often places his people. These are in effect the father's metamorphosis of the pretty girl into art to save her from the young man's embrace—but a transformation in which the young artist must take part. This restructuring can take various forms, and in some of them (whether Reynolds's compositions of "art" or an abstract form like the "Line of Beauty") it is needed to hold together the precarious materials of nature. David and the propagandists of the French Revolution chose their representations from above, linking the revolution with images of heroic virtue, whereas in fact, or so it seemed to

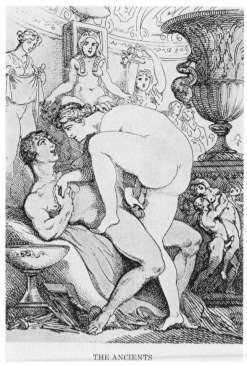

THE ANCIENTS

29. Thomas Rowlandson, *Pygmalion and Galatea*. Etching, ca. 1800.

30. Thomas Rowlandson, *Death and the Portrait*. Watercolor drawing, 1814.

Rowlandson, revolution comes from below, from the grotto so to speak. The figure of the artist in Rowlandson is, from the 1780s onward, placed so as to choose which is the true way—"inspiration" from traditional sources, which turn pretty girls into Venuses, or pure sexual energy from the low-life crowds, which disrupts the old traditional structures starting with the family but including the Royal Academy and reaching to the artist himself. For the artist satires begin by advocating a kind of painting concerned with life/sex/crowds rather than heroic or conventional subjects but end by revealing the either/or quality of painting and living for an artist in a situation of revolt. The artist's subject ought to be undifferentiation and energy but his method is by difference, demarcation, and pedestaling. The artist satire is simply one genre within the Rowlandson oeuvre in which the problem can be seen in its purest aesthetic terms, for the artist is the most poignant example of the individual whose inner world is riven from the universe of things. He creates his own world on paper; doing so prevents him from living it; and inevitably—whether he becomes a fetishist or not—he is denied access to the world he creates. His fantasy is bound to be that of Pygmalion. At bottom the artist satires hint at an awareness that if the artist passes fully into the world of nature he loses his identity as an artist, for if he becomes one with nature he can no longer perceive it. Rowlandson portrays, and in doing so embodies, the sad comedy of the artist's otherness as he chooses to paint his pictures of discrepancy and loss rather than accept the advice of his own pictures and follow nature into revolution.

MACKINTOSH

As a coda to this discussion of Rowlandson, I will mention James Mackintosh, a writer ordinarily thought to have as little relation to Rowlandson as William Blake. *Metamorphosis* is the common term. Beneath the surface of reasoned argument in Mackintosh's *Vindiciae Gallicae* (1791), in which he meets more or less successfully Burke's main points in his *Reflections*, we find a metaphor of the revolution as rapid change of one thing into another. This is the quality Mackintosh feels most in need of explanation, and on which it is almost impossible for an observer to retain a proper perspective. Partly his emphasis is on change as a natural phenomenon to counter Burke's picture of a "conspiracy of individuals, or bodies" (p. 10), and this also leads him to talk (as Wollstonecraft will also in her *Historical and Moral View*) of "the actions of great bodies," of the mass of "the people" as a force of natural change. The spontaneous change—that is, disobedience—of citizens and soldiers to the crown, their duty to a higher authority (nature, fellow-feeling), Mackintosh connects with Hume's remark that "what depends on a few may be often attributed to chance (*secret circumstances*), but the actions of great bodies must ever be ascribed to general causes" (p. 29). His prin-

ciple is that "in the French revolution all is to be attributed to general causes, influencing the whole body of the people, and almost nothing to the schemes and the ascendant of individuals" (p. 31).

In the second place his emphasis on change has to do with events. The change in France was so rapid that "Doctrines were universally received in May," he writes, "which in January would have been deemed treasonable, and which in March were derided as the vision of a few deluded fanatics" (p. 20). Although in the same passage he refers to change as "this rapid diffusion of light," its essence is the idea of alloy: What now appears to be "the mixed mass, called the revolution," is a mixture of both wonderful legislative acts and popular excesses, "transient confusion and future establishment" (p. 10). He describes the nature of the alloy in chapter 3: "that no great revolutions can be accomplished without excesses and miseries at which humanity revolts, is a truth which cannot be denied" (p. 82).

On one level, on which moral and aesthetic assumptions merge, Mackintosh denies the absurdity, according to Burke, of thinking "to establish order from principles of confusion, or, with the materials and instruments of rebellion, to build up a solid and stable government." He insists that "beauty is achieved through orderly means only." But Mackintosh goes beyond Hannah More's view (1793) that "from the ruins of tyranny, and rubbish of popery a beautiful and finely framed edifice would in time have been constructed," had the Revolution not gone wrong. Out of the chaos of the Revolution itself beauty would emerge: as "beauty rising out of confusion" (Helen Maria Williams's words, 1790) or as "a fairer government . . . that has ever shed the sweets of social life on the world" rising "out of this chaotic mass" (Wollstonecraft, 1794).[77] All these metamorphoses are aesthetic categorizations in that they see the Revolution in terms of the work of art emerging from chaos.

The contrast of Burke's words "beauty is achieved [only] through orderly means" best defines Mackintosh's position: beauty can *only* be achieved through some unpleasantness; an omelet or any good can come only out of a process that includes ugliness and evil. Mackintosh phrases his case in philosophical terms: "Has any moralist ever pretended, that we are to decline the pursuit of a good which our duty prescribed to us, because we foresaw that some partial and incidental evil would arise from it?" (pp. 83–84). But his examples are from the world of experience:

> The sensibility which shrinks at a present evil, without extending its views to future good, is not a virtue, for it is not a quality beneficial to mankind: It would

77. Burke, preface to Brissot's *Letter to his Constituents* (1794), in *Works*, 3, 528; Williams and More, cited in Ben-Israel, *English Historians and the French Revolution* (Cambridge, 1968), p. 12; Wollstonecraft, *Historical and Moral View*, p. 73.

arrest the arm of a Surgeon in amputating a gangrened limb, or the hand of a Judge in signing the sentence of a parricide.

The France he sees ahead is one in which "New arts are called forth, when all seemed to have passed their zenith. France enjoyed one Augustan age, fostered by the favour of despotism," he writes, recalling Louis XIV. "She seems about to witness another, created by the energy of freedom" (p. 101). This is the metamorphosis that brings about a work of art through a process that inevitably involves loss (vs. Burke's belief that France "is advancing by rapid strides to ignorance and barbarism"). It is based on the assumption that man must, indeed "is destined to refuse every abject and arrogant doctrine that would limit the human powers."

The particular case of the French Revolution depends on the fact that it is "popular" and not the work of a few men: "Where the people are led by a faction, its leaders find no difficulty in the re-establishment of that order," but in a popular movement,

> when a general movement of the popular mind levels a despotism with the ground, it is far less easy to restrain excess. There is more resentment to satiate, and less authority to control. The passion which produced an effect so tremendous, is too violent to subside in a moment into serenity and submission. The spirit of revolt breaks out with fatal violence after its object is destroyed, and turns against the order of freedom those arms by which it had subdued the strength of tyranny. [pp. 82–83]

Although Mackintosh is speaking of experience and is not concerned with aesthetic categories as such, he is outlining a kind of plot. It is not only an open-ended plot, one that expands as it intensifies in what we would regard (in literary terms) as "romantic," it also relies on ironies connecting past and present. Of Louis XIV's support of literature he writes:

> But the despotism of this reign was pregnant with the great events which have signalized our age. It fostered that literature which was one day destined to destroy it. Its profligate conquests have eventually proved the acquisitions of humanity; and the usurpations of Louis XIV have served only to add a large portion to the great body of freemen. [p.12]

The revolution of the Americans, assisted by the French king to free another people for his own selfish anti-English ends, leads to the freeing of his own (from him). The king increases his domestic army but in doing so proves that it "cannot be numerous enough to enslave the people, without becoming the people itself" (p. 29).

These are ironic metamorphoses, and the most ironic is the transformation of the French nation itself "from that abject and frivolous people," which was the English caricature of the French fop, into the vigorous and aggressive male image which Burke excoriates—which, Mackintosh notes,

"exhibited the tumult and clamour of a London mob" (p. 15). This is not only another case of seeing the Bastille mob and the mob that conducted the king and queen to Paris as the mob of the Gordon Riots, but rather of seeing the French citizen transformed by revolution into an ideal figure. This is a figure of man reduced to basic elements: that "necessity of frequently recalling governments to their first principles" (p. 55) that the English intellectuals had been advocating. This man is very close to embodying revolutionary violence itself as an ideal. "Whatever is good," Mackintosh says, sounding like Blake in his "Proverbs of Hell," "ought to be pursued at the moment it is attainable." This man of the moment—and he is still a composite man, the "people"—is a force that brings about violent change:

> The public voice, irresistible in a period of convulsion, is contemned with impunity, when dictated by that lethargy into which nations are lulled by the tranquil course of their ordinary affairs. The ardor of reform languishes in unsupported tediousness. . . . No hope of great political improvement . . . is to be entertained from tranquility, for its natural operation is to strengthen all those, who are interested in perpetuating abuse. [pp. 55–56]

One cannot brook delay "because the enthusiasm which carries nations to such enterprises is short-lived, and the opportunity of reform, if once neglected, might be irrevocably fled."[78]

Stated a little differently, Mackintosh's idea lies behind a passage in Mary Wollstonecraft's *Historical and Moral View*:

> What is to hinder man, at each epoch of civilization, from making a stand, and new modelling the materials, that have been hastily thrown into a rude mass, which time alone has consolidated and rendered venerable? [p. 15]

Once an artist is introduced—even if a composite "people"—the underlying myth becomes one of Ovidian metamorphosis. Wollstonecraft has touched on the Pygmalion story of the artist who is disillusioned with what *is* and so creates out of inert substances his ideal, and then falls in love with it and prays that it can be enlivened. This myth was popular among the French philosophes, but the text to which one would have turned was Rousseau's

78. Mackintosh does not extend his figure to sexual aggressiveness, but in one amusing slip he writes: "Talent seemed, in that reign [of Louis XIV], robbed of the conscious elevation, of the erect and manly part, which is its noblest associate and its surest indication" (p. 11). We know how Swift would have detected the motive force of the Revolution, of the energy and violence Mackintosh was seeing and admiring in it. Cf. Wollstonecraft, who remarks that the Regent (duc d'Orléans) by "introducing the fashion of admiring the english, . . . led men to read and translate some of their masculine writers, which greater contributed to rouse the sleeping manhood of the french" (*Historical and Moral View*, p. 31).

opera *Pygmalion* (published in 1762, produced in 1780).[79] Here is the germ of the idea of the inanimate mass (the people still?) vivified by education and love—and most importantly in Rousseau's myth by an artist, by his art *and* his love. For the revolutionary this myth had the advantage of being an alternative to the metamorphosis in which something beautiful but dead is produced and human life is sacrificed to the work of art. The Pygmalion story is the only Ovidian metamorphosis upward, from inanimate to human; it is preferable both to the Ovidian metamorphosis and to the myth of Pandora's box (another myth discredited by Wollstonecraft) as an equivalent of revolution.

Rowlandson's artist and his young man—the one inspired by his art and the other by his love—embody both myths. Rowlandson's whole oeuvre, as we have seen, revolves around these myths. The Ovidian metamorphosis includes the father, who is a rival metamorphoser to the young man: One turns the girl into stone (immuring her) and the other into flesh—though Rowlandson is very aware of the ambiguities in the artist's role in Pygmalion's metamorphosis of Galatea. Parallel transformations are constantly taking place: Men, including young men, are seen degenerating into old men, fattening or shriveling before our eyes into vegetables; at the same time, the handsome young man liberates the pretty young girl from her paternal protectors, becoming a Pygmalion to her Galatea.

For Mackintosh art *requires* a certain breakage or ugliness in order to produce beauty; Rowlandson, the artist, goes a step further to show that art also curbs that breakage, offering a corrective that is not revolutionary. And in this respect the tension of rebellion and submission in Rowlandson's drawings can also be seen expressed in formal terms in the works of some contemporary artists, for example Fuseli.[80] Sheridan's need to craft his plays (or speeches) toward an audience rather than toward self-expression is another example, this time of the prerevolutionary artist's risk constrained less within a form than within a shrewd professionalism. In all these cases of form/content ratio the artist seems to say that he *cannot* simply rebel and that liberty has to be followed by law rather than license.

79. Cf. the awakening stature which Condillac, in the *Traité des sensations* (1754), employed to demonstrate the conceivable derivation of thought from sense experience—an example put to similar use by Buffon and Charles Bonnet. See Isobel F. Knight, *The Geometric Spirit: The Abbé de Condillac and the French Enlightenment* (New Haven, 1968), p. 83. I am using metamorphosis in a sense documented in, for example, the poems of Marvell ("Horatian Ode") and Pope ("Windsor Forest"), but cf. Hegel on the subject, in *Philosophy of Fine Art*, trans. F. P. B. Osmaston (London, 1920), 2, 125–27.

80. On Fuseli, revolution, and formal closure, see Paulson, *Book and Painting*, pp. 128–37.

CHAPTER 6 🎕 THE GROTESQUE, GILLRAY, AND POLITICAL CARICATURE

The sublime in art is the attempt to express the infinite without finding in the realm of phenomena any object which proves itself fitting for this representation.

As a case of inadequate expression it is akin to the ugly or at least to the deformed and monstrous. . . . But yet these monstrosities have only 'an echo of the sublime,' because they half satisfy, or are taken to satisfy, the need of expression by the very distortion, or magnitude, . . . which makes them monstrous; whereas, in the true sublime, a sharp consciousness of inadequacy is required.

—Hegel[1]

Had Burke been asked if he regarded the French Revolution as sublime, he would have replied: No, grotesque. In his sense grotesque is a burlesque sublime. "All the designs I have chanced to meet of the temptations of St. Anthony," Burke wrote in the *Philosophical Enquiry*, "were rather a sort of odd, wild grotesques, than anything capable of producing a serious passion."[2] The grotesque trivializes; but even as he spoke, Burke would have known that what he described produced in him "a serious passion." There was an obvious area of agreement between sublime and grotesque, for example, in the assertions that "a clear idea is another name for a little idea" (p. 63); that obscurity, formlessness, and the ugly are sublime elements (p. 119); and that the suggestive power of words is more sublime than their rational content (p. 61). As Kant also saw, the

1. Georg Wilhelm Friedrich Hegel, quoted without citation by Arthur Clayborough, *The Grotesque in English Literature* (Oxford, rev. ed., 1967), p. 31.

2. *Philosophical Enquiry*, ed. J. T. Boulton, p. 64. See Clayborough, *The Grotesque in English Literature*, pp. 26–27.

sublime itself does not depend on form and indeed may require a kind of nonform: "may depend on 'Unform,' a useful idiom which may cover both formlessness and deformity."[3] Both sublime and grotesque have gone far beyond the classical norms—beyond, for example, the neoclassical order of David's rationalizations of the French Revolution—but the sublime experience is distinguished by the spectator's awareness of his failure to find a corresponding form.

I have begun this chapter with a quotation from Hegel, although none of the artists I discuss can have read him, because he expresses an attitude toward art that some of them were developing independently. Hegel, for whom the French Revolution was the great formative event of his youth, sees history moving toward ever higher stages of freedom. The aesthetic problem he raises is one of representation. He begins with the assumption that the function of art is "to represent the Idea to immediate vision in sensuous shape."[4] But he acknowledges that

> the Idea [say of freedom] is foreign to natural phenomena; and the Idea having no other reality to express it, expatiates in all these shapes, seeks itself in them in all their unrest and defects of genuine proportion, but nevertheless does not find them adequate to itself. Then it proceeds to exaggerate the natural shapes and the phenomena of nature into indefiniteness and disproportion; to flounder about in them like a drunkard, to seethe and ferment in them, doing violence to their truth with the distorted growth of unnatural shapes, and to strive vainly by the variety, hugeness, and splendour of the forms employed to exalt the phenomenon to the level of the Idea.

This formulation can be applied to one interpretation of the historical phenomenon of the Revolution—the attempts of men to make their actions correspond to the Idea—and to a segment of the artistic response to the Idea *and* the experience.

The representation often "becomes bizarre, grotesque, and tasteless, or turns the infinite but abstract freedom of the substantive Idea disdainfully against all phenomenal being as dull and evanescent." But whether the artistic equivalent involves forms that are sublime or grotesque, the result is the same: "in spite of all aspiration and endeavour the reciprocal inadequacy of shape and Idea remains insuperable." And the difference is essentially that in the sublime the correspondence is "understood to be inadequate" while the grotesque is characterized by "its inability to perceive its futility."[5]

With Hegel's postrevolutionary theory in mind, we can return to the his-

3. Bernard Bosanquet, *A History of Aesthetic* (London, ed., 1934), p. 276.

4. Hegel, *The Philosophy of Fine Art*, trans. F. P. B. Osmaston (London, 1920), 1, 98, 103–04. My translation is a conflation of Osmaston's and Bosenquet's (*A History of Aesthetic*, pp. 476–77). Hegel's example is oriental art, and the subject is pursued in Osmaston's trans., 2, 47–65

5. The last words are Clayborough's (p. 31).

torical sense of the grotesque prior to the French Revolution. Horace's passage about the mermaid (*Ars poetica* 11.6–13), besides being a locus classicus for the issue of ut pictura poesis, was also the text quoted on the subject of the grotesque as it related to writing and painting. If Burke saw the Revolution as the sublime of terror and Paine saw it as a beautiful pastoral, Blake, by bringing together the two interpretations, the sublime *and* the beautiful, emphasized the incongruous and unnatural juxtaposition—the tiger that is half-lamb—and so implicitly classified the phenomenon, or at least the complex phenomenon that appeared to external observers such as the artist, as grotesque—as in Hegel's sense unclassifiable and unrepresentable. At the same time, Blake does not necessarily mean for his readers to take this as an adverse judgment either of the Revolution or of the correlative subject of his own art.

Horace's original intention was to use the mermaid figure to compare the character of bad poetry with bad art in terms of a monstrous shape, a beautiful woman's body (*mulier formosa*) ending in a fish's tail. The example was taken up by Vitruvius in his *De Architectura*, another work of the Roman Augustan Age that carried great weight in the eighteenth century:

> For our contemporary artists decorate the walls with monstrous forms rather than reproducing clear images of the familiar world. Instead of columns they paint fluted stems with oddly shaped leaves and volutes, and instead of pediments arabesques, the same with candelabra and painted edicules, on the pediments of which grow dainty flowers unrolling out of roots and topped, without rhyme or reason, by figurines. The little stems, finally, support half-figures crowned by human or animal heads. Such things, however, never existed, do not now exist, and shall never come into being. For how can the stem of a flower support a roof, or a candelabrum pedimental sculpture? How can a tender shoot carry a human figure, and how can bastard forms composed of flowers and human bodies grow out of roots and tendrils? [VII.v.4]

Thus seen from the Vitruvian–Palladian pejorative point of view, grotesque decoration of this sort presented things that "never existed, do not now exist, and shall never come into being." These are deviations from nature, from mathematical proportions, from decorum, from the orders of architecture, and (as Alberti added to the indictment) they fill spaces that should be left open. Wolfgang Kayser, in his study of the grotesque, has observed that mixed animal and human forms are images of a world breaking apart, and other writers on the subject (from Hegel to Ruskin) have felt that the grotesque flourished in times of uncertainty, its distortions expressing doubts over human achievement.[6] These doubts might, however, be seen ultimately to confirm rather than deny man's unique potentials.

6. Kayser, *The Grotesque in Art and Literature*, trans. Ulrich Weisstein (New York, 1966), pp. 184–89; Ruskin, "Grotesque Renaissance," in *The Stones of Venice*, in *Works*, ed. E. T. Cook and A. D. Wedderburn (London, 1903–12), 11, 135–95.

For, on the other hand, *grotesque* was the term Vasari applied to the composite style used by Michelangelo in the Medici Chapel, which Vasari defended as "a breakthrough to freedom."[7] It was a breakthrough from the order, rule, and proportion of the quattrocento artists made by the man who for Vasari (as for Blake, Fuseli, and even Reynolds) was the master of the final, greatest stage of Renaissance painting, architecture, and sculpture. Of the artists of the earlier ages Vasari writes:

> There was wanting in their rule a certain freedom which, without being of rule, might be directed by the rule and might be able to exist without causing confusion or spoiling the order; which order had need of an invention abundant in every respect . . . so as to reveal all that order with more adornment.[8]

This manner was achieved, according to Vasari, in ascending order by Leonardo, Raphael, and Michelangelo. For an English artist of Blake's time, Leonardo was known for his monstrous heads as well as for the *Mona Lisa*, Raphael for his "grotesque" decorations of the Vatican Loggia as well as for the Tapestries, and Michelangelo for the *Last Judgment* and the Paoline Chapel as well as the earlier parts of the Sistine ceiling.

These Vasarian assumptions about greatness and grotesque excess fell into disrepute in the later seventeenth and eighteenth centuries but they were returning again in the last decades of the century. At the time Blake was working (and Rowlandson and Gillray as well as Fuseli[9]) the term *grotesque* carried both connotations of deviations from nature (the monstrous) and of a breakthrough to a higher art. If the French Revolution was regarded by some as monstrous, it also offered an opportunity to make use of an art that is not tied down to academic rules. Historically, as an aesthetic concept, the grotesque was a way, closely related to the sublime, to disregard the principles of mimesis and the laws of proportion on which all art theory was based. In the last decade of the century this notion may have joined with the subject of the Revolution, which to many who observed it seemed to disregard all principles of mimesis.

By 1 October 1789 Burke was writing that "the Elements which compose Human Society seem all to be dissolved, and a world of *Monsters* to be produced in the place of it—where," he adds, returning to the Miltonic reference, "Mirabeau presides as the Grand Anarch."[10] Burke may also be introducing the biological sense of grotesque, the sort of specimen Dr. John Hunter collected in his medical museum. The decorative merging of forms could be regarded as either a regression into or an emergence out of a lower state of nature—a situation that lent itself to the ambiguous attitudes toward

7. Frances K. Barasch, *The Grotesque: A Study in Meanings* (The Hague, 1971), p. 25.
8. Vasari, *Lives*, 4, 81.
9. See above, p. 167, n. 80.
10. *Correspondence*, 6, 30.

various sorts of experience in the later eighteenth century, whether the clas-
sification of natural types and species or the attempts to come to terms with
the most puzzling of all contemporaries species, the French Revolution.

As Burke also shows, it was only a question of judgment whether this
"grotesque" phenomenon involving undifferentiation (in an age devoted to
difference) was a good or bad thing. Earlier in the century marvelous ex-
periments in grotesque representation were produced by the writers Pope
and Swift, who themselves adhered to Vitruvian principles about propor-
tion but depicted Horace's monsters as admonitory examples of the irra-
tional in writing, politics, and religion. Pope defined the aim of the gro-
tesque artist in *Peri Bathous* (1727):

> He is to mingle bits of the most various or discordant kinds, landscape, history,
> portraits, animals, and connect them with a great deal of flourishing by heads or
> tails, as it shall please his imagination, and contribute to his principal end which
> is to glare by strong oppositions of colours and surprise by contrariety of im-
> ages.[11]

But he also knew what evocative poetry could be made of this formula.

Behind the delight revealed by Swift and Pope in their depictions, one
hears also the opinion of romance-writers such as Roger Boyle, who in
Parthenissa (1776) brought together the grotesque, Horace's monster, and
the tiger with the idea that the presence of such monsters was a sure sign
(like the ugly face of Socrates on a box of precious unguents) that allegory
was present: "Sphynxes, Harpies, and the Claws of Lyons and Tygers, [are]
to evidence that within inhabited Mysteries and Riddles."[12] The well-known

11. *Pope: Selected Poetry and Prose*, ed. W. K. Wimsatt (New York, 1951), p. 313.
12. *Parthenissa* (1676), p. 517. The ambivalence artists felt toward the grotesque can be seen
in a writer like Montaigne, who, citing Horace's lines associating grotesques with artless or
disordered writing, apologized for his own prose style as grotesque, his mind as one that gives
birth to chimeras and fantastic monsters. He was obviously of two minds about the allusion,
explaining a new kind of writing with an apology that was at least in part ironic. While in
general Horace's lines continued to support the Vitruvian or classical position, a list of the
writers in English who alluded to hybrid figures or "monsters against nature" (chimeras, har-
pies, sphinxes, and seahorses) with mixed repugnance and yearning include such diverse fig-
ures as Ben Jonson, Sir William Davenant, Roger Boyle, Lord Orrery, and Sir Thomas Browne.
There was something strangely attractive in the creature "with a man's [humano] head, a
horse's neck, the wings of a bird, and a fish's tail; parts of different species jumbled together,
according to the mad imagination of the dauber" (to use Dryden's words). See Montaigne,
Essays, bk. 1, essay 9 (2d ed., Bordeaux, 1582), 1, 150–51. Vauquelin de la Fresnaye set a model
for the use of "grotesque" in connection with Horace's *Ars poetica* in his translation when he
interpolated the lines: "Comme en crotesque on voit part entremeslemens / De bestes et d'oys-
eaux divers accouplemens" (*L'Art poetique* [Caen, 1605], 1, 9, quoted in Edmond E. A. Hu-
guet, *Dictionnaire de la langue française du seizième siècle* (Paris, 1950), s.v. "grotesque." For
Jonson, *Discoveries* (1641), in *Works*, ed. C. H. Herford, P. Simpson, and B. Simpson, 8, 611;
Dryden, *A Parallel of Painting and Poetry* (1695), in *Essays*, ed. W. P. Ker (New York, 1961), 2,
132–33. See Barasch, p. 69.

example in *Paradise Lost*, to which Addison took exception in *Spectator* no. 273, was Satan, Sin, and Death—which Burke then chose as his example of sublime obscurity: Sin was bound to remind one of Horace's description of the painting that "began as a lovely woman at the top / Tapered off into a slimy, discolored fish."

John Hughes's "On Allegorical Poetry," prefixed to his edition of Spenser (1715), discusses grotesque poems in which "it is impossible for the Reader to rest in the literal Sense, but he is of necessity driven to seek for another Meaning under these wild Types and Shadows. This Grotesque Invention claims, as I have observ'd, a License peculiar to it self, and is that I wou'd be understood in this Discourse more particularly to mean by the word Allegory." Hughes notices how the effects of the grotesque border on the sublime: such grotesque creatures as the harpies in Virgil are "commonly call'd *the Wonderful*; which is a Property as essential to Epick Poetry, as Probability" and is "design'd to fill the reader with Astonishment and Concern, and with an Apprehension of the Greatness of an Occasion, which by the bold Fiction of the Poet is suppos'd to have produc'd such extraordinary Effects." Thus when the grotesque functions as allegory it is to be commended; when it is mere spectacle or decoration—what the earlier writers referred to as "only to please the eye"—it is to be condemned.[13]

In the twentieth century we have lost most of the etymological significance of *grotesque*, which still very much surrounded the word in the 1700s. It derived from the Italian *grottesche* from *grotta*, the underground cavern, specifically beneath (but at that time confused with) the Baths of Titus in Rome, which when excavated at the beginning of the sixteenth century revealed a type of decoration consisting of arabesques of plant–animal–human mergers and characterized by a horror vacui.[14]

In the eighteenth-century garden the grotto, the dark, wet hole in the smooth lawn (rocks, running water, vines, roots), was situated among the classical temples and sculptures of Stowe, Stourhead, and Twickenham. The grotto might well have served as the source of a counteraesthetic which uneasily coexisted with the order and (in Burke's sense) beauty of the Palladian style. Hogarth's Line of Beauty, which had one of its sources in the

13. In Willard H. Durham, ed. *Critical Essays of the Eighteenth Century, 1700–1725* (2d ed., New York, 1961), pp. 92, 95. Nathan Bailey, in his *Universal Etymological Dictionary* (1721), defines *grotesque* as "antique [i.e., antic] work, either in Painting or Carving; rude Figures made at the Pleasure of the Artist, or Pictures representing odd kinds of things, without any peculiar meaning, but only to please the Eye" (following Edward Phillips's *Dictionarie of the French and English Tongues* of 1611), and adds that it "is sometimes used for any misshapen thing."

14. For an early English definition, see William Aglionby, *Painting Illustrated* (1685), sig. d.: "Grotesk is properly the Painting that is found under Ground in the ruines of Rome; but it signifies more commonly a sort of Painting that expressed odd Figures of Animals, Birds, Flowers, Leaves, or such like, mingled together in one ornament or Border."

shellwork (*rocaille*) of the grotto, carried the beautiful off into an energy and irregularity (irritation) that was most un-Palladian. The grotto itself was a gap in the smooth, graveled surface of the garden walks, the opposite or contrary of the Palladian temples. The stroller in the garden passed from one to the other, from geometry and the classical orders to a dark, dank cave, down in the ground, whose sanction came in part from the epic descent into the underworld. Samuel Johnson, who most famously said, "A grotto is a very pleasant place—for a Toad," also spoke with contempt of Pope's grotto. He could justify it only on the grounds of utility:

> A grotto is not often the wish of pleasure of an Englishman, who has more frequent need to solicit than exclude the sun; but Pope's excavation was requisite as an entrance to his garden.[15]

It was indeed the entrance (needed to connect the two parts of Pope's estate divided by a busy highway) to the classical ornaments and the relatively open, serpentine paths of his garden proper, but it was in the grotto that he wrote his poetry and mythologized the act of writing. For Pope, the dwarfish hunchback whose religion made it necessary for him to live beyond the ten-mile limit from London, there must have been a poignant personal meaning in Swift's remark to him that in his "Subterranean Passage" he had "turned a blunder into a beauty."[16] The grotto can be seen to have broken the rational, enlightened surface of the Augustan world and in one of its manifestations to have been the source of inspiration for poets. The grotto, according to ancient texts, was the residing place of deities, nymphs, and the muses; it offered access to the vapors arising from underground streams (as Thomas Burnet put it in his *Theory of the Earth*) that "gave a kind of Divine fury or inspiration."[17] Other traditions fictionalized the grotto as a dwelling place for a religious hermit or a sage, as a home for philosophy, wisdom, retirement, and frugal virtue. Livy's story that King Numa descended into a grotto to be inspired before making state decisions was often invoked.[18] In England the grotto came to be associated in particular with retirement from court and city politics, with the anti-Walpole Patriots, both progressive Whigs and proscribed Tories, who went to the grottoes to imbibe the truth and the memory of English liberty.[19]

15. *Lives of the English Poets*, ed. G. B. Hill (Oxford, 1905), 3, 135.

16. Swift, *Correspondence*, ed. Harold Williams (Oxford, 1963), 3, 103; Johnson's version was that he "extracted an ornament from an inconvenience" [Ibid.]). See Maynard Mack, *The Garden and the City* (Toronto, 1969), p. 61.

17. *The Theory of the Earth* (2d ed., 1691), p. 115.

18. Titus Livius, *Livy*, trans. B. O. Foster (New York, 1919), 1, 72–75.

19. Mack, *The Garden and the City*, pp. 47–48. When Pope's gardener John Serle published his account of the Twickenham garden (*A Plan of Pope's Garden*, 1745), the word that dominated the title page in large capitals was GROTTO, and appended to the pamphlet was a poem

The terms *grotto* and *grotesque* were therefore closely connected by the eighteenth century, on the Continent and in England, and associated with the further suggestions of creativity and liberty, as well as the fantastic, the ominous, and the sinister. Grotesque is here an attitude, a point of view out of which to write poetry, related in unacknowledged ways to the representations of inimical unreason. The grotesque was the underground, both in the sense of Pope's Cave of Spleen and in the sense of a source of rivers and of primal poetic inspiration; both a subject of satire and a powerful mode of poetic creation. Thus as we approach the new age of politics centered on the grotesque figures of squint-eyed John Wilkes and the fat unshaven Charles James Fox, the grotto was associated with both political and artistic freedom and creativity, and in the first case especially it carried the sense of both art and politics extended beyond the rules.

This was the heritage Blake accepted along with some other implications he developed in a personal way. His myth of the engraver-poet's art is visualized as a series of caves (*Marriage of Heaven and Hell*, p. 15), and the process itself is described as a burning out of interiors to reveal a hidden truth. Blake's illuminated designs tend to take place inside grottoes, which are both a source of inspiration and inhuman holes that imprison. Orc is shown buried in one of these and then climbing out into freedom in the first two plates of the Preludium to *America*, and thereafter rising up majestically against the horizon.

It is pretty clear that Blake associates Orc climbing up out of the ground, bursting out of darkness into light, and his own writings emerging from dark caves with nonrational processes of thought. In general we can agree with him that the quality most commonly associated with the unconscious mind, and so with the grotesque as a poetic mode, is energy. All the categories that transcend the beautiful—the picturesque, grotesque, even sublime—tend to invoke energy as opposition, as something that breaks through rules or barriers.[20]

that summed up the grotto as retirement, inspiration, and social exchange with like-minded friends:

> Sequester'd from the fool, and Coxcomb-Wit,
> Beneath this silent Roof the Muse he found;
> 'Twas here he slept inspir'd, or sate and writ,
> Here with his Friends the social Glass went round. [pp. 19–20]

James L. Skinner, from whom I have these insights, is preparing a study, "The Melancholy Grotto: Creative Uses of the Grotesque Tradition in Eighteenth-Century England."

20. G. K. Chesterton, writing of Robert Browning, noticed how the freedom of rules in the grotesque mode tended to lead into the fantastic but also suggested the "energy which disregards the standard of classical art" (*Robert Browning* [London, 1903], p. 150). The grotesque is "whatever is incongruous with the accepted norm, in life or art" (Clayborough, *The Grotesque*, p. 16).

Orc and Urizen are constantly changing into each other, as Blake's lion changes into a lamb, but all his other figures are transformational as well. Plants turn into flames or into human forms, figures like Nebuchadnezzar degenerate into animals and root themselves in the ground as if they were plants, and Orc (or Albion) rises transformed into a sunburst. The Blakean image shows the human either emerging from a lower state of nature or regressing into some former state of being. In an image like the Orc amid flames or a double image like Orc and Urizen, he is doing both (figs. 8, 9).

The gothic was the form with which man supposedly returned from geometrical to natural shapes; for his cathedrals he had sought the model of forests that were unmediated by man's reason. Blake makes plain his preference for the gothic, and the books on the gothic that were appearing in the eighteenth century show that the grotto and the grotesque were essentially synonyms for gothic. The common enemy was the classical mode. As Batty Langley said in 1742, "every ancient building, which is not in the Grecian mode, is called a Gothic building."[21] The grotto was only an extreme form of the gothic. Thomas Wrighte's *Grotesque Architecture, or Rural Amusement* (1790) is filled with gothic designs for grottoes, called by this time "root houses," most of them incorporating root-patterns of the sort Blake shows in the Preludium to *America*.[22]

At the same time the Blakean "Bible of Hell" teeters between the terrible and the ridiculous. The Michelangeloesque figures and the elevated-sounding verses are constantly at odds with the slapstick activities of Orc, Urizen, Los, Fuzon, and the rest, which have been related in sometimes more than superficial ways to James Gillray's contemporary cartoons.[23] As Lee Byron Jennings has written, "The Grotesque object always displays a combination of fearsome and ludicrous qualities—or, to be more precise, it simultaneously arouses reactions of fear and amusement in the observer."[24] The fearsome is in the ascendant but there is no denying fringes of the ludicrous. The Blakean image itself is in a process of transformation from one meaning to another, often (as in the coloring of Orc in the flames) from one printing to the next. An image in *Marriage of Heaven and Hell* (p. 16), accompanied by lines explaining the contrary "prolific" and "devouring" aspects of man, becomes a reference to Ugolino and the sons he devoured. In one copy a bloody gob of flesh is visible.[25] The bloody flesh may have been added when Blake looked back on Vergniaud's Revolution, which devoured its young. It transforms "prolific" into "devouring."

21. *Gothic Architecture* (1742), p. 1.
22. See *Grotesque Architecture* (1790), plates 10, 11, 13, 14, and 20.
23. Erdman, *Blake, Prophet against Empire*, pp. 218–19.
24. Jennings, *The Ludicrous Demon: Aspects of the Grotesque in Post-Romantic German Prose* (Berkeley and Los Angeles, 1953), p. 10.
25. Erdman, *Illuminated Blake*, p. 113.

In Rowlandson this teetering took the form of a transition from one substance or state of being to another, as a human face becomes an animal; a man, a jug, as a crowd slips toward chaotic disaster, or as a youth challenges old age. A question as pertinent as the relation of the artist to his subject (nature) is the relation of the picturesque mode to the grotesque. The former is essentially a landscape mode, but then Rowlandson's figures are often based on landscape forms or find themselves merging into or retreating from landscape forms. Ruskin, I suspect, made the pertinent distinction that the picturesque is a function (or pretends to be) of time, of nature itself—of organic change, decay, and collapse. The grotesque, however, is produced "exclusively by the fancy of man."[26] It supposed, from Horace's mermaid onward, an artist whose sensibility is reflected in the amalgam, one for which nature cannot be responsible. Looking back over Rowlandson's work, we can see the picturesque at work in the process of aging and decaying and the grotesque at work in the hand of the artist. It is the artist who connects the serpentine forms shared by the pretty girls, handsome young men, and his own line. The picturesque, therefore, may be thought of as being transformed by the man-made change of a kind of revolution (on the level of plot and of artistic execution) into the grotesque. As Rowlandson in the 1790s adapted to his times he would have added as another context to his drawings of the 1780s the knowledge that the seasonal change of a hillside cottage into ruin is picturesque; the more rapid change brought about by a fire, an avalanche, or a volcanic eruption (the sort of catastrophe he parodies in falls down staircases) is something else—possibly sublime, possibly grotesque. In Rowlandson we have seen both possibilities played against each other: a constant interaction of natural and man-made change.

Rowlandson (followed by Gillray) is the chief practitioner of the comic grotesque, and in his work above all others we can see the relevance of what was technically known as the grotesque style. He actually drew harpies and satyrs and plants changing into animals or human figures (fig. 31), and he ended his career drawing human–animal transformations in his *Comparative Anatomy* (as indeed did a very different contemporary, George Stubbs, at about the same time).[27]

26. Ch. 3, "Grotesque Renaissance," in *The Stones of Venice*, p. xxxvii.

27. See Paulson, *Emblem and Expression*, pp. 180–81, and *Rowlandson: A New Interpretation*, pp. 33–34, 66–70 (on the grotesque, pp. 45–66). A figure drawing, *The Cat's Concert* (Huntington), contains much that is typical of Rowlandson in the strange shapes varying from animal to human. And yet I have discovered that this drawing is copied directly from an engraving after Teniers's *Concert de chats* (Munich; engraved by Le Bas). The main addition is of the old lady's face at the window. But for Rowlandson this was essential to finish out the spectrum from inanimate, animal to human (or not quite human); to further fill in the animal–human spectrum he makes Teniers's cats at the far left into monkeys. For Teniers, who was interested only in cats performing human actions, the table legs, carved fish, were what cats would

But with Rowlandson another sense of grotesque also becomes relevant: that this ornamental style was used to fill surfaces around or within historical scenes. One of the standard treatments of the grotesque saw the painter finishing his picture "with his utmost care, and art, and [then] the vacuity about it he fills with *Grotesque*; which are odd Fantastick Figures without any grace but what they derive from their variety, and the extravagance of their shapes."[28] Post-Renaissance writers took to comparing their own way of writing to this graphic grotesque: "and in truth what are these things I scribble, other than Grotesques, and Monstrous Bodies, made of dissenting parts. . . ."[29] It is a kind of art that follows in time the traditional, conventional, finished painting, that fills in the empty spaces, the areas beyond the composition of the heroic image. This horror vacui, this plenitude or excess, is easily related to the disruptive or insurgent vitality we have identified in Rowlandson and connected with sexuality (the mermaid).

Sir Thomas Browne saw the parallel between the filling of empty spaces on a wall with grotesques and the notion that the air, earth, and sea—the world and all within it—were peopled with demons and the grotesque creatures outside nature who fill the white spaces on a map. Browne wrote in *Religio Medici* (1743):

> Natura nihil agit frustra, is the only indisputable Axiom in Philosophy [there are no *Grotesques* in nature;] not anything framed to fill up empty Cantons and unnecessary spaces. . . .[30]

In *Pseudodoxia Epidemica* (1646) Browne extends the analogy to old wives' tales perpetuated in ancient lore:

> As for Sea-horses which much confirm this assertion; in their common descriptions, they are but Crotesco delineations which fill up empty spaces in Maps, and meer pictorial inventions, not any Physical shapes: suitable unto those which (as Pliny delivereth) Praxiteles long ago set out in the Temple of Domitius.[31]

design for their dining room and the bagpipe was simply a pastoral instrument of humans adapted to feline needs. For Rowlandson—seen in the context of his other work—the table itself becomes an intermediate species, and the legs are somewhere between the table legs and fish; the bagpipe next to the very monkey-like creatures carries its popular sexual significance. For Teniers—as for Hogarth—the structure is one of analogy: man and cat. For Rowlandson it is rather a grotesque spectrum in which many creatures and things are arranged and comically classified in relation to one another. And this is the easiest way to sum up the fact that whereas for both Teniers and Hogarth art is a moral concern, for Rowlandson it is taxonomical and ontological, a matter of significant natural relationships between things, seen, of course, as comic incongruity.

28. Charles Cotton, *Essays* (London, 1685), 1, 32.

29. Ibid. Montaigne made much the same comparison of his writings to grotesque decorations (see above, n. 12). Davenant refers to grotesque ornament as "that enclosed the Scene" of a court masque (*Works* [1673], p. 360).

30. *Religio Medici*, in *Works* (1686), 1, 8.

31. *Pseudodoxia Epidemica*, in *Works*, 3, 184.

31. Thomas Rowlandson, *Satyr Family*. Watercolor drawing, ca. 1800.

The grotesque or diabolic is thus whatever inhabits the empty spaces of rational, charted life—associated with both visual images and notions, words, and thoughts. For John Hall in his *Paradoxes* (1650) *grotesque* meant also ancient superstitions, misguided concepts, and whatever way the mind went wrong.[32]

It is not difficult to see how grotesque also came to cover follies in general, foolish low and subculture characters, which also served as grotesque in the other sense of changing forms. Callot's *Caprices* (1616) depicted demons but also low characters, beggars and cripples, and masqueraders. Fair scenes with large shifting crowds of people also qualified. By 1620 in Monet's *Dictionnaire* the Callot caprice was being called grotesque, and Dryden associated "grotesque" decoration with the street plays of London, the commedia's improvisatory theater.[33] As the work of Dryden and Pope shows, grotesque included for the Augustan poet chinoiserie, Italian opera, farces, harlequinades, bad poetry, and romances—but also the lower classes. Thus grotesque came to cover low burlesque or farce. Both Dennis and Dryden, as well as Shaftesbury, pointed out the resemblance between the low burlesque, in poetry and drama, and grotesque painting.[34]

Milton sums up this strand in his one usage of grotesque in *Paradise Lost*, book 4:

> So on he [Satan] fares, and to the border comes
> Of Eden, where delicious Paradise,
> Now nearer, Crowns with her enclosure green,
> As with a rural mound the champion head
> Of a steep wilderness, whose hairie sides
> With thicket overgrown, grottesque and wilde,
> Access deni'd. . . . [ll. 131–37]

Satan is the traveler, and the wilderness that must be passed through is contrasted with Paradise itself, an orderly arrangement of concentric circles crowning the hill. For Milton grotesque means literally "full of grots, caverns or dens, hollow, cavernous" with fearsome connotations.[35] But in fact it is the ascent, the path upward, that is grotesque. Allegorically (in Hughes's sense) it is the chaos of this world through which one has to pass in order to reach paradise or salvation. And by extension it is the world of Callot, Bosch, and Brueghel, and also the world of burlesque and farce. In Rowlandson's terms it is the blocking characters of comedy with whom the

32. Paradox 2, "That Content is but lazy Patience, if not misery," in *Paradoxes*, ed. D. C. Allen (Gainesville, 1956), pp. 30–54.
33. 2d part of *A Parallel of Painting and Poetry* (1695), in *Essays*, ed. W. P. Ker, 2, 132–33.
34. See, e.g., John Dennis's dedication to *Poems in Burlesque* (1692).
35. See Giovanni Toviano, *Vocabolario* (1690), s.v. "Grottoso."

handsome young couple has to deal. It is the world of contingencies that precedes and/or surrounds any act of liberation.

One final aspect of the syndrome I am trying to describe which falls under the general heading of grotesque is caricature. An aristocratic import from Italy that originated with the Carracci studio in the sixteenth century and was defined in the classic art treatises of the seventeenth century,[36] it could be seen either as another form of idealization, a comic equivalent of the high style advocated by Agucchi and Bellori, or as an interesting case of license, permissible on the part of a proven master of the high style. It was distinguished from Leonardo's studies of aberrant physiognomy on the one hand and the grotesque on the other. What was consistently stressed, based on the derivation of the word itself from *caricare* (to load or charge), was the distortion of the actual: that is, less invention than elaboration. Annibale Carracci, usually credited with developing and making caricature fashionable, regarded it as a joking way of demonstrating his artistic power. It was a game, a puzzle (how do you draw an opera singer with a single line?), or a quick shorthand language (give your servant a caricature with which to identify the stranger he is to meet in the marketplace), but in any case a sign of artistic self-consciousness. The two elements emphasized are equivalence and exaggeration, and the wit lies in the joining of the actuality and the distortion.

The grotesque, on the other hand, was said to lose sight of the actuality and so of the thing imitated. The grotesque leaves behind mimesis, which is still the essence of caricature. And yet it was also recognized that the grotesque, although not the distortion of the actual, was an amalgamation by an artist of actual features from different species or places.

The difference between caricature and grotesque is set out in Baldinucci's *Vocabulario Toscano dell' Arte del Disegno* (1681):

> And "to caricature" is used also by Painters or Sculptors to mean a style practiced by them of producing portraits as like as possible to the totality of the person depicted; but for play, and sometimes for mockery, they aggravate or increase the defects of the imitated parts out of all proportion, in such a way that on the whole the figures appear to be themselves, and in the individual parts they seem different.

> *Grotesque*: Applied to any painting, sculpture, or drawing, which, distancing itself from the imitation of the Natural, seems rather to be a work made from

36. The best account I know of the seventeenth-century theories of caricature (and their application in the eighteenth) is Giulia Giuffré's first three chapters in her "Tobias Smollett, William Hogarth, and the Art of Caricature" (Diss., Oxford University, 1979).

grotesque elements, than drawn from the real, and more at the whim of the Artist, than otherwise.[37]

An artist approaching the subject of the French Revolution would draw a caricature if he wanted to bring out, as an artist, some aspect, some part, while claiming to be participating still in an ordinary act of mimesis. The artist who could no longer comprehend the phenomenon and was vainly searching for equivalents might, abandoning the law of contradiction, introduce contraries by joining a pretty girl and a fish's tail. In doing so he might be using the fish's tail as the part (the "defect") the caricaturist "aggravates or increases."

In England Hogarth eschewed caricature and reviled anyone who called him a caricaturist. In the 1750s the young aristocrat George Townshend introduced Italian caricature to the political print, producing exaggerated likenesses of Pitt, Henry Fox, and the Duke of Newcastle. Rowlandson, we have said, turned likenesses of contemporaries into horribly melting, swelling, or exploding shapes that were related to caricature but—insofar as the faces and bodies were made to resemble nonhuman creatures—were in the grotesque mode. It took James Gillray in the 1780s and 1790s to join caricatured faces to caricatured (in the same sense of exaggerating a defect) bodies, and these to the Hogarthian symbolic scene and the Rowlandsonian grotesque or monstrous metamorphosis.

Caricature was seen as a main way of portraying nature as worse than the actuality, and so as the opposite of the classical ideal. Excess is its watchword, not the restraint of classicism; abbreviation, not careful finish; physical imperfection, not graceful form; and distortion, not controlled and idealized forms. This is partly because caricature deliberately dares us to notice its excess instead of concealing its workings—its artistic personality—and so, in the later eighteenth century, it emerged as one possible form of opposition to the cold, impersonal neoclassical style of Hamilton, West, and Thomas Flaxman in England, and David in France.

Of course, caricature as a sideline of Annibale Carracci was either reaction to the ideal or another aspect of idealism; as a sideline (a century later) of Bernini, the apostle of the baroque, it was more exclusively the latter, an extension of sensibility—a foil to the idealized movements of his St. Theresa. From either source it is easy to see that caricature and the grotesque, while clearly distinguishable, could in practice amount to the same thing.

37. Baldinucci's definition of *caricare*: "E caricare dicesi anche da' Pittori o Scultori, un modo tenuto da essi in far ritratti, quanto si puo somiglianti al tutto della persona rittratta; ma per giuoco, e talora per ischerno, aggravando o crescendo i difetti delle parti imitate sproporzionatamente, talmente che nel tutto appariscano essere essi, e nelle parti sieno variati" (*Vocabulario Toscano dell'Arte del Disegno* [1681], p. 29). Of *aggrottescato*: "Dicesi a quella pittura, scultura, o disegno, che discostandosi dall' imitazione del Naturale, par piu tosto opera fatta a grottesche, che rivavata dal vero, e anzi a capriccio dell'Artefice, che alt[r]imenti" (*Vocabulario*, p. 6).

Once reality is defined in terms of the artist's sensibility instead of the out-
side world, in particular in a time when outside reality cannot be matched
by the greatest leap of the human imagination, caricature and grotesque
offer complementary alternatives to an ideal of beauty.

GILLRAY

At the end of 1790, following the publication of Burke's *Reflections on the
Revolution in France*, Gillray made a political print with the title *Smelling out
a Rat, or the Atheistical Revolutionist Disturbed at his Midnight Calculations* (fig.
32). The atheistical revolutionist is Dr. Richard Price, who is discovered at
his writing desk, penning a tract "on the benefits of Anarchy, Regicide,
Atheism," and along with his seditious documents he has a picture on the
wall of the execution of Charles I. The title, the inscriptions, and even the
Hogarthian picture on the wall (which identifies and establishes the char-
acter of its owner) are stereotypes that tell us the cartoon is about the rev-
olutionary Price.

But then there is the cat who is smelling out the rat: Burke, whose for-
midable *Reflections* was written as a reply to Price. His nose and spectacles
are as big as Price's body, and the symbols (crown and cross) which he
flourishes in his hands glow like the tacky halos of department store nativity
scenes. All nose and eyes, he is to say the very least an image of officious-
ness. The caricature of Burke's head is further emphasized by the uncarica-
tured figure of Price. Were it not for the inscriptions (and emblems), Price
would appear to be an innocent victim of this encroaching monster.

As Draper Hill noted in his biography of Gillray, "It is typical of Gillray's
ambiguity that the content should criticize Price while the form ridicules
Burke."[38] More specifically than content and form, it is the words as op-
posed to the graphic image that create the ambiguity or (I should suppose a
better word) ambivalence. For it is also possible that Gillray has been as-
signed the "story" (or content) of Burke exposing the treasonous Price but
has represented graphically the innocent Price—or any innocent man—being
smelled out by the assiduous and slightly mad (as he was generally thought
to be at this time) Burke: This Burke is nosing out dissidence in the manner
of Senator Joseph McCarthy.

Contemporaries thought Gillray simply venal. Looking back from the
1830s, *The Athenaeum* noted that "He first appeared as a sharp caricaturist
on the side of the whigs: time, or some other remedy, softened his hostil-

38. Hill, *Mr. Gillray the Caricaturist* (London, 1965), p. 138. For my reproductions I have
used the plates from the Henry G. Bohn folios of 1851 ff. rather than the hand-colored im-
pressions. It has seemed worth sacrificing the color for the clarity of the image. This section
appears in a somewhat different form in *Satire in the Eighteenth Century*, ed. John D. Browning
(New York, 1982).

ity."[39] The "some other remedy" is explained in 1818 by William Cobbett, who remarked that Gillray "received a pension of 200 pounds a year" from the Tories for his "blasphemous" parodies.[40] That was at a later time than the Burke–Price cartoon, but he did get on Pitt's payroll and took instructions from the Pittite and *Anti-Jacobin* polemicist George Canning.

His first response to the French Revolution, however, had been sympathetic—as were so many others. A cartoon about the fall of the Bastille in the summer of 1789 was called *Freedom and Slavery* (27 July) and showed Necker standing on the ruins of the Bastille, balanced by Pitt trampling on the English crown while the king, nobility, and people are bound in chains of gold and iron. Another cartoon, *The Offering to Liberty* (in August), showed the Goddess of Liberty standing on the ruins of the Bastille offering Louis XVI back his crown. "Receive from Liberty your crown again," she says, "and He that wears the crown immortally long guard it yours." Necker (Virtue) and Philippe d'Orléans (Honour) drag Marie Antoinette in fetters: "Messalina drinking Rhenish" she is labeled, alluding to her reputation for sexual dissipation and her Austrian origins. Lafayette, the popular liberator, bears a white flag "Libertas," and patriot soldiers and free citizens are labeled "Extirpators of Tyranny."[41]

Rebutting the image of Gillray the venal Tory, John Landseer argued that Gillray was "a reluctant ally of the tory faction . . . his heart was always on the side of whiggism and liberty."[42] He had been drawn into the arms of the Tories, says Landseer, by a blasphemy prosecution arising from a 1796 print showing Fox and Sheridan as Magi. Landseer recalled an occasion on which he and Gillray were drinking toasts:

> And when it came to his turn to name a public character, the Juvenal of caricature surprised those who knew him but superficially, by proposing that we should drink David (the French painter)! . . . [Gillray] was by this time a little elated, having become pleased with his associates, and having drowned his reserve in the flow of the soul, and kneeling reverentially on his chair as he pronounced the name of the (*supposed*) first painter and patriot in Europe, he expressed a wish that the rest of the company would do the same.

To Thomas Wright, the chronicler of Gillray's career and the history of English caricature, Gillray expressed the view of the ordinary decent Englishman, the via media between anarchy and oppression.[43]

39. *Athenaeum*, no. 205, 1 October 1831, p. 633.

40. *Weekly Political Register*, 33 (30 May 1818), 625.

41. Joseph Grego, *The Works of James Gillray, the Caricaturist* (London, 1873), p. 113. The prints are in the Metropolitan Museum, New York, and the Beinecke Rare Book Library, Yale University.

42. *Athenaeum*, no. 207, 15 October 1831, p. 667.

43. Thomas Wright, *The Works of James Gillray, the Caricaturist. With The Story of his Life and Times* (1873), p. 19. Cf. George Piltz, *James Gillray* (Munich, 1971), who sees Gillray as a

[Gillray] subjects them. By being made something less or other than human, he is made more sinister. . . ."[48] Whether we respond with anxiety because these figures "are strange and alien and yet seem to resemble human qualities" or with relief because they are so clearly nonhuman and thus unthreatening,

> depends, perhaps, on whether we are responding with our fully adult, "rational" mind, or with the remnants in us of childhood fears and fantasies. The sensitive reader or spectator of the grotesque responds in both ways simultaneously.[49]

Steig's formulation sums up a great deal of the grotesque fiction we encounter in Gillray (as also in Goya).

Beyond the creation or reduction of anxieties, however, is the question of where the subversive implications stop. In a print of 1791 drawn for the Whig opposition (fig. 36) Gillray labels Pitt "an Excrescence; a Fungus; alias a Toadstool upon a Dung-hill." The issue in this case is larger than whether he is attacking Pitt or Fox: What is the dunghill on which Pitt is an excrescence? And what has Gillray made the fungoid tentacles that root the Pitt-fungus in the dunghill? They are part of the royal crown. His verbal source is something like Samuel Johnson's definition of mushroom as "an upstart, sprung from a dunghill." That is Pitt. But the dunghill itself is royal favor, and the crown as well as the toadstool is part of this dirt. We can look at Pitt and block out the crown as merely a submerged aspect of the toadstool's etiology, or we can focus on the crown as the real subject.

For a man who had nothing very good to say about the left, Gillray was remarkably free in his criticisms of the right. Members of the royal family appear as misers, wastrels, and fornicators. Burke before his break with the Whigs is commonly represented as a Jesuit; after the Revolution, as a beggar and a poseur as well. Gillray's Foxites, however, could have been drawn by Burke. In print after print we follow the serial adventures of these low, poor, shabby sans-culottes—fat, drunken, and speechifying. They take their amusing energy from the hacks and dunces of Swift and Pope; they are quite different from the handsome, sexually inclined, Greek or Michelangeloesque figures who appear in the imagery of Blake and Rowlandson. In Gillray they are forces playing around the stasis of the royal family and the skeletal Death figure of Pitt. Of all the conservatives Pitt assumes the greatest variety of unflattering shapes, appearing as a huckster, a vulture, a drunkard, a toadstool, a sleepwalker, an alchemist, a glutton, a highwayman, and Death on the white horse of Hanover—even as Death in the Miltonic parody, *Sin, Death, and the Devil*. As the war with France progressed and the government became more deeply engaged with enemies whom

48. "Defining the Grotesque: An Attempt at Synthesis," *Journal of Aesthetics and Art Criticism*, 29 (1970), 256 (Steig's example is Faulkner and his creation Flem Snopes).
49. Ibid.

Gillray considered to be yet more dangerous, his assaults on Pitt slackened. But the possibility of sudden attack never vanished, pension or no pension.

If there is a moral center of any sort in Gillray's work, it is the typical Englishman John Bull. Fox and Sheridan pick his pockets; Pitt runs him through a coffee grinder; the French enslave him, and George III madly accosts him in rustic lanes (fig. 37); sometimes the English and the French set upon him all at once, as in *Opening the Budget* or *Doctor Sangrado curing John Bull of Repletion* (2 May 1803, fig. 38), in which Hawkesbury and Addington bleed him to death while Napoleon, Fox, and Sheridan assist. His sufferings are constant and, in most cases, undeserved, and he frequently shows more common sense than his tormenters. Yet all his sympathetic qualities are countered by his gross face, body, actions, and words: by his doltish stupidity. There are times when in appearance he is distinguishable from the French canaille only by his greater girth. He is rabble: the "lower sort," "plebeian," and (to use Burke's phrase) "swinish multitude."

Perhaps the paradigmatic situation is *The Tree of Liberty—with The Devil tempting John Bull* (23 May 1798, fig. 39). Here are the two trees, the revolutionaries' Tree of Liberty and the British Royal Oak (with its sign of the "king's head"). Fox is the serpent, winding around the Tree of Liberty (or Opposition), associated with profligacy, temptation, and so with the original Tree of the Knowledge of Good and Evil. Gillray gets almost everything of the Revolutionary situation into his compaction of the two symbolic trees. Fox is holding the apple of "Reform," and whispering, "nice Apple, Johnny!—nice Apple." John Bull does not accept the apple but his reasoning is elemental: "Very nice Napple indeed!—but my Pokes are all full of Pippins from off t'other Tree: & besides I hates Medlars, they're so domn'd rotten, that I'se afraid they'll gee me the Guts-ach for all their vine looks!" Paradise is inhabited by this "brother to the ox," whose only bulwark between the two trees is ignorance, and (Gillray seems to be saying) man's only means of averting the Fall is a kind of stupid animal sense.[50]

For Gillray the significant turning point in the Revolution was the French royal family's flight to Varennes and recapture in June 1791. This, rather than the confrontation at Versailles which Burke described so graphically in his *Reflections*, produced the definitive image for Gillray. But in fact the images were remarkably similar—Gillray's was almost a delayed response, perhaps conditioned by his earlier reading of the *Reflections*. His print of 27

50. Occasionally Gillray gives John Bull other guises. *Horrors of the Irish-Union;—Botheration of poor Pat* (24 Dec. 1798) shows an Irish yokel much like John Bull, skeptically attending to the lies of Fox: "by Jasus: if you was not my old friend, charley, I should think you meant to bother me with your whisperings. . . ."

36. James Gillray, *An Excrescence; a Fungus; Alias a Toadstool upon a Dung-hill*. Etching, 1791.

37. James Gillray, *Affability*. Etching, 1795.

38. James Gillray, *Dr. Sangrado curing John Bull of Repletion*. Etching,
1803.

39. James Gillray, *The Tree of Liberty*. Etching, 1798.

June, *French Democrats surprizing the Royal Runaways* (fig. 40), showed the revolutionaries bursting into the shabby chamber in which the royal family has taken refuge (not Burke's Versailles) armed with swords, blunderbusses, daggers, brooms, hammers, and the like mechanic utensils—far in excess of the threat posed by this helpless family. But Gillray's representation of the scene makes the distinction only one of weight and shape: both groups are ugly and unsympathetic. There is no courage or dignity on the part of the royal family, faced with this horrible and grotesque rabble. The best that can be said for the royal family is that it is in the John Bull role of passive acceptance, undignified but (at least) helpless.

The effect is repeated two years later in *Louis XVI taking leave of his Wife & Family* (20 Mar. 1793), which shows a horrified Louis being dragged off to death by grinning sans-culottes. The accompanying note claims that

> The above is an exact copy of an infamous French Print . . . intended to bring the Conduct of their late Monarch in his last moments, into Contempt & Ridi-cule;—It is now Copied & publish'd in order to hold up a Nation of unfeeling Assassins to that detestation which every true Englishman must feel for Wretches, who can sport with the sufferings of the unfortunate.

The ostensible target, in the words of the inscription, is the brutality of the French artist. But the French artist's manner is very much like Gillray's own. Gillray may not have been enraged by the "infamous French Print" at all; he may simply have seen it as one more presentation of his favorite motif, stupidity encountering wickedness. Even the motif of the family, of the domestic couple as king and queen, was secondary to this dialectical encounter.

Just as he was publishing *French Democrats surprizing the Royal Runaways* Gillray also published *Frying Sprats, vide Royal Supper*, and *Toasting Muffins, vide Royal Breakfast* (23 Nov. 1791), showing an equally unprepossessing George III and Queen Charlotte. In short, around that time there was be-ginning to be a clear concern with both French and English royal families, and the physical resemblance between the French and English kings began to emerge. Indeed, *French Democrats* and even Gillray's print of the execu-tion of Louis XVI in 1793 should be compared with the earlier mock exe-cution he projects of George III (celebrating Bastille Day 1791; figs. 41, 42). This is a Jacobin wish-fulfillment dream, based on the execution of Charles I (as in the print on Richard Price's wall). But the discomfort of George is comic and the resemblance between the shapes of the French and English kings is unsettling.

If one caricaturist was responsible for the subversion of the royal icon (the image of the English sovereign stylized into ideal anonymity), it was Gillray, who individualized George III and Queen Charlotte in remarkable ways (fig. 43) and gradually turned them into a couple that corresponded

40. James Gillray, *French Democrats surprizing the Royal Runaways*. Etching, 1792.

41. James Gillray, *The Blood of the Murdered crying for Vengeance*. Etching, 1793.

to Louis and Marie Antoinette in France and Maria Luisa and Carlos IV in Spain.[51] George's tormented incapacity in the domestic and public scenes depicted by Gillray recalls Louis XVI in similar though more tragic predicaments.

Wollstonecraft, for example, indicates both parallels and contrasts between the two royal families. George III is "Surely as harmless a character as Lewis XVIth; and the queen of Great Britain, though her heart may not be enlarged by generosity, who will presume to compare her character with that of the queen of France?"[52] Wollstonecraft is revealing an inconsistency in Burke's response to the Regency crisis (put away the mad George III) and to the Revolution in France (depose Louis XVI). Gillray characteristically elides difference: all kings and queens, his caricatures tell us, are the same.

Equally interesting, however, are the instances in which George III resembles, and even tends to become, his social opposite John Bull. As George grew crazier and more beleaguered, and the external threat of France mounted, Gillray's treatment softened until the king resembles a second persecuted fool like John Bull. In *A Kick at the Broad-Bottoms?* (23 Mar. 1807), for example, George turns upon the Whig rogues who have been harassing him with typically John Bullish irrationality: "—What!—what! bring in the Papist!—O you cunning Jesuits you!—what you thought I was like little Boney & would turn Turk or anything?—" In a few prints the identification is even more direct. The subtitle of *The French Invasion* (5 Nov. 1793) identifies the defecating map of England with George III, labeled "John Bull, bombarding the Bum-Boats," while the John Bull farmer of *More Pigs than Teats* (5 Mar. 1806, fig. 44) becomes "Farmer George" in *The Pigs Possessed* (18 Apr. 1807, fig. 45).

My suspicion is that John Bull, and even at times in the later years George III, represents for Gillray the impervious core of human nature: innocent, dumb, and intractable but ultimately enduring and perhaps endearing. My point can be seen by looking at the prints about Napoleon's Egyptian cam-

51. The image of George III that Gillray had created was apparently popular not only with those who viewed and purchased his prints but with other artists as well. For more than a decade after the introduction of Gillray's royal caricature it appeared again and again in caricatures of the king by Kingsbury, Newton, Isaac Cruikshank, Rowlandson, Nixon, Bearblock, and Dent. Equally significant was the reliance on this royal likeness during the peak years of the French Revolution. To 1789 for Gillray and to 1791 for his contemporaries the royal likeness was used to caricature the king with more humor than ridicule. Political missteps and personal or family foibles were held up to view. From 1789 to 1794 for Gillray and from 1791 to 1794 for his contemporaries, a critical element of ridicule was added to the humor. While missteps and foibles continued to be held up to view, Gillray in particular often added an international political context, revealing at least an awareness of contemporary events throughout Western Europe.

52. *Vindication of the Rights of Men* (1790), facsimile ed. Eleanor Louise Nicholes (Gainesville, Fla., 1960), p. 60.

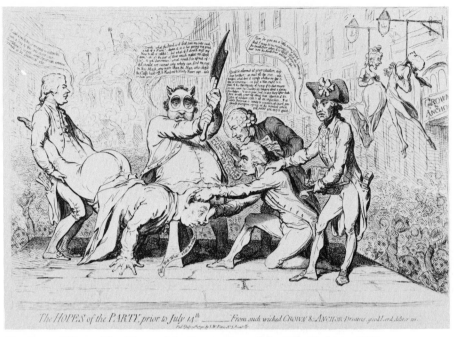

42. James Gillray, *The Hopes of the Party, prior to July 14th*. Etching, 1791.

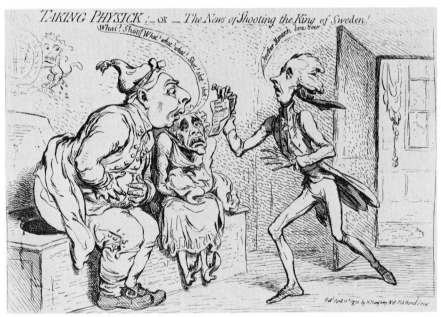

43. James Gillray, *Taking Physic: or the News of Shooting the King of Sweden*. Etching, 1792.

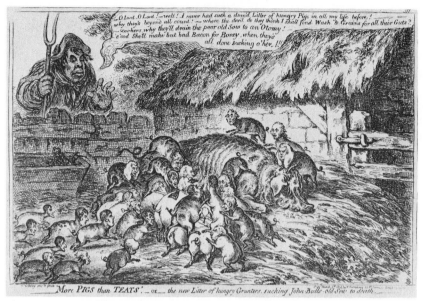

44. James Gillray, *More Pigs than Teats*. Etching, 1806.

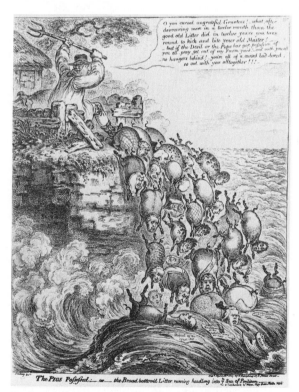

45. James Gillray, *The Pigs Possessed*. Etching, 1807.

paign of 1799, *Siège de la Colonne de Pompée* and *Egyptian Sketches*, in which the Frenchmen are almost all scientists. They are crushing no states, committing no atrocities, but they are still villains trying to change the face of ancient Egypt. The pursuit of knowledge by itself is sufficient to deliver them into the most terrible difficulties. The educators of the crocodiles are devoured by the crocodiles (fig. 46); in other plates, the student of immortality plunges to his death from the column; the aeronauts fall from a punctured balloon. Globes, telescopes, tracts, and folios impale themselves on spears or tumble into the flames. The hostile Bedouins and crocodiles are the John Bulls of these scenes. Men may try to transcend this hard core of human nature with ideals and aspirations but they will come tumbling down.

If *Smelling out a Rat* is one example of Gillray's contemptuous evenhandedness, another of nearly two decades later is *Spanish-Patriots attacking the French-Banditti* (15 Aug. 1808, fig. 47). Here the French are repulsive monkeys, and we are obviously meant to rejoice that the Spanish are routing them. But the Spanish army is composed of nuns waving daggers and crucifixes; their trumpeter is a fat friar on horseback; and their cannon is being loaded by a monk, a nobleman, and two whores. The insight is a terribly accurate one into the situation of the Spanish "revolution." Gillray anticipates the terrible "curse on both your houses" of Goya's *Desastres de la guerra*, which show exactly this conformation. Almost but not quite: for Gillray does include a single English soldier who is a relatively idealized version of John Bull fighting for the Spanish cause. The English contingent had not, in fact, arrived in Spain at the time Gillray made this cartoon, and that soldier is a projection of the satirist's sense of decorum—his need for an indication of the ideal somewhere in his print. The British soldier is, certainly by Goya's standards and by the standards of many of Gillray's cartoons, irrelevant—an embellishment in the same class as the inscriptions that give the official "meaning" of the prints. He fits only insofar as he is related to the stolid John Bull figure or the hungry crocodile of the *Egyptian Sketches*.

If we censor that imaginary English soldier, we can ask a question that follows from the subject of the Spanish "revolution" or civil war: Is Gillray's treatment inherent in the subject itself? Or have his neither/nor prints—which Goya knew—contributed to the negativity of the *Desastres de la guerra*, perhaps even of the *Caprichos*? Or is there something in the very process of revolution (the French Revolution—that absolutely new phenomenon that was unfolding before the amazed eyes of Gillray in England and Goya in Spain) that leaves both sides leveled in iniquity?

One way of putting this is to ask whether there is a rock-bottom humanity or slightly-less-than-humanity, of the John Bull sort, that also explains the starving French canaille who formerly ate leeks and frogs and now are eating aristocrats. *Un petit Souper à la Parisiènne* (29 Sept. 1792, fig. 48) was

46. James Gillray, *L'Insurrection de l'Institut Amphibie*. Etching, 1799.

47. James Gillray, *Spanish-Patriots Attacking the French-Banditti*. Etching, 1808.

published following the September massacres, which took place on 2–6 September. But there is also a rock-bottom John Bullish logic in the situation: If (as we have been told of the French since Hogarth's *Calais Gate* and *Invasion* prints) the French do not have roast beef to eat, and they have even run out of leeks and frogs, then they eat their aristocrats. One wonders whether the sans-culotte is only a French John Bull in different circumstances, as Louis XVI is only a French George III.

The French are in another sense more closely akin to the gluttonous Prince of Wales and the gourmandizing Englishman of *British Slavery* (fig. 34). Both John Bull and General Dumouriez are characterized by their eating habits (figs. 49, 50). But whether eating is excessive or the opposite, the figures on both sides of the channel share the lowest common denominator of regression to orality and anality. Orality extends from cannibalism to the peculiar diet of the royal family, to both England and France devouring the globe, to the Jacobins firing the bread of liberty into the mouths of other European nations and being devoured themselves by hungry crocodiles. The scatology that distinguished the imagery of Burke's anti-Jacobin tracts becomes in Gillray's cartoons the extraordinary emphasis on both food and feces, both eating and excreting. Scatological references extend from Pitt as a toadstool on a royal dunghill to John Bull's guts-ache and George III sitting on the royal closestool or defecating ships onto the European mainland, to the Napoleon who (in one of Gillray's funniest drawings) tries to pass himself, in fact a horse turd, off as a golden pippin.

One basic revolutionary image, as Burke saw, was (perhaps always has been) oedipal, showing the family romance disrupted by outside sexual energy of the rampant son. There was, however, no "other man" in England to make the romantic trio that played such a large part in the revolutionary and counterrevolutionary propaganda of France and Spain. Only now and then Gillray links Pitt and Queen Charlotte (fig. 42, and perhaps *Sin, Death, and the Devil*).[53] Ordinarily the aim in his caricatures is to elide difference rather than set up oppositions such as the oedipal one which played so large a part in Rowlandson's drawings. Even the father–son contrasts are largely to equalize the extremes of the son's extravagance and the father's frugality. He sees the time of revolution not as an oedipal struggle but as a process of regressional transformations in the direction of undifferentiation with all kings the same, kings and subjects equally alike cannibals or tyrants. George III and Queen Charlotte take on the properties of Louis XVI and Marie

53. In *Sin, Death, and the Devil* Gillray has destroyed any possibility of the father–son confrontation by opposing Pitt and Thurlow, essentially brothers. The suggestion remains, however: Queen Charlotte's right hand serves as a fig leaf—or something worse—for Pitt (derived from Felix's misplaced hand in Hogarth's *Paul before Felix*). The allusion is to the innuendos about the relations of Charlotte and the prime minister, more fully suggested in their dangling joined figures in *The Hopes of the Party* (19 July 1791).

48. James Gillray, *Un petit Souper à la Parisiènne*. Etching, 1792.

49. James Gillray, *John Bull taking a Luncheon*. Etching, 1798.

Antoinette, and through their shabbiness they are also related to the sans-culottes and the Foxites, as through his stupidity George is to John Bull, and the sans-culottes as voracious cannibals are related to the Prince of Wales and another elemental aspect of John Bull. With a kind of desperation Gillray is showing what the only representation of a revolution like the French one could be, at least in the 1790s by a foreign cartoonist surrounded by people who saw themselves in both the French oppressors and oppressed.

Some conclusions can be drawn. The tradition of emblematic caricature inaugurated by Gillray in the 1780s served as model for his revolutionary caricatures of the 1790s, which in turn served as one model—perhaps the most striking—for a withdrawal from the normative forms and representations of the Johnson–Reynolds tradition in literature and art. The artist's subject was no longer a hero whose portrait is to be painted or a hero in conflict with a villain but unrelieved villainy, or at best knavery augmented by folly. His subject is the Enemy, whom he wants to exorcise, to whom he wants to do damage in terms both of his form and of the situations in which he places himself. These cartoons were an artist's uniformly destructive representation of what appears dangerous in the people who guide our destinies, as well as in those who do not. Gillray therefore shows these people always in the process of being in some sense overthrown; they are physically in the midst of a revolution of their own making. Revolution (whether the focus is on the rebels or the royalists) is the milieu of the Gillray cartoon. It is no accident that he created this genre (or at least intensified it) at precisely the time that the French Revolution was exploding all conventional loyalties and accepted norms of behavior.

Students of political caricature usually begin with the assumption that graphic satire was created out of emblems from Ripa's *Iconologia* and Alciati's *Emblemata* and then transformed by the introduction of caricature by George Townshend in the 1750s. There appears to be no real distinction to be made between images in the emblem books and images in a popular cartoon tradition, between normative images and subversive subculture sign systems. As far as I can see, what happened was that the political cartoonists employed emblems freely, without any corresponding subculture tradition of imagery. The popular aspect of their imagery emerged rather from the rearranging of the emblems into other conjunctions that do have subculture meanings. Gillray's turning England into an image of its king defecating a barrage of ships against the French coast is a case of the body politic metaphor travestied in a manner that Rochester or Swift would have understood. Some images draw on deeper, less rational—less conceptualized—sources than were acknowledged by the written explanations that accompanied Alciati's emblems. The emblematic image was defined by its verses, which made normative a parasite-infested tree or a royal body politic by

conceptualizing it. Because the emblem itself began as a verbal concept the added visual image carried enough of the irrelevant and irrational to allow for a remythologizing when removed from its verses and mottoes and placed in a jarringly different context, as it is in a Gillray cartoon.

The enjambment of body analogies with caricature explains much of the sense of "a plague on both your houses" in the works of Gillray. Political "caricature" means that a politician is foolish or evil *because* he is physically ugly or deformed (or has a huge nose); the aesthetic and moral categories are dangerously close to merging in a way that Hogarth, for example, never allowed. And so graphic satire carries two built-in problems (or opportunities) for the artist. It is impossible to render a positive image, a noncaricatured figure, without violating decorum. Given the conventions of caricature, the artist's charging (*caricare*) of his subject must apply equally to the enemy and to the hero and to any Other. In consistently applied caricature there are no "heroes." And second, it is quite possible to render a negative image so consistent and so exaggerated that it may be taken as ridicule of the mind that conceived it (the mind that sees all else as Other), turning the caricaturist into his own protagonist.

Especially in his early prints Gillray often employs differing degrees of caricature in a single print. Price, the ostensible villain of *Smelling out a Rat*, is not caricatured whereas Burke, with his gigantic nose sniffing out revolution in the remotest places, decidedly is. The effect is sometimes not unlike the mixing of genres, or when a novel or play presents both a set of idealized characters and another of comic or low types. What happens can be seen in *Wife & no Wife* (Mar. 1788) representing the marriage of the Prince of Wales and Mrs. Fitzherbert. Gillray makes Burke (the officiant) a caricature, a milder version of the cat smelling out the rat; Charles James Fox is a heavily expressive portrait but the prince and Mrs. Fitzherbert are idealized figures. One wonders whether the idealization was called for by decorum—perhaps the royal decorum that Gillray would later triumphantly overthrow. Whatever the intention, the print communicates through its conventions of graphic representation the message that these sinister caricatured figures are somehow imposing this ceremony on the prince and Mrs. Fitzherbert. As images the caricatures relate to the idealized figures as the grotesque heads do to the idealized head of Christ in North European pictures of *Christ Mocked*. Such instances of discrepancy between the pictorial image and the ostensible intention of a print are, we have seen, not uncommon in Gillray's work.

On the other hand the alternative causes its own problems. Both Fox and Pitt are caricatured by Gillray. The French Revolution is one way of explaining this phenomenon, and the conventions of caricature another. Both amount to the leveling of difference that acts either as defense mechanism or as exposure of the bottomlessness of the revolutionary situation in which

the tyrants are bad and the freedom-fighters who overthrow them worse.

The second point to notice is that Gillray shows how a negative image can be so exaggerated as to be taken as ridicule of the mind that conceived it. It is hard to know whether the print called *Barbarities in the West-Indias* (23 Apr. 1791, fig. 51) is an assault on the barbarities of the slavers or on the rhetoric used by the abolitionists to condemn them. The inscription beneath consists of a quotation from Philip Francis's speech ("corroborated by Mr. Fox, Mr. Wilberforce, &c. &c."): "An English Negro Driver, because a young Negro thro sickness was unable to work, threw him into a Copper of Boiling Sugar-juice, & after keeping him steeped over head & ears for above Three Quarters of an hour in the boiling liquid, whipt him with such severity, that it was near Six Months before he recover'd of his Wounds & Scalding." On the walls can be discerned slaves' arms and ears severed and nailed between chicken and lizard carcasses.

Certainly George Cruikshank's images a few years later of the radical reformers, as, for example, a gigantic guillotine and a rapist, may evoke the imagination of Edmund Burke rather than appear as a real threat.[54] In Gillray's time we can quote Richard Brinsley Sheridan's way of treating the rumors and fictions of the French Revolution being bandied about. He tells his fellow Members of Parliament with mock seriousness

54. George Cruikshank picked up the story just where Gillray, now mad and confined to Mrs Humphreys's house, left off: the end of Napoleon followed by the conservative reaction, the radical reformers versus the Prince Regent and his crew of Liverpool, Castlereagh, and Sidmouth. Cruikshank's satires pose the same basic question as Gillray's: Whose side is he really on? Like Gillray he allowed himself to be bought off by the government (in his case personally by the Prince Regent) but he continued to draw Prinny with an unseemly ambivalence. Sometimes he drew at the same time for opposite sides—as in the years when he both illustrated Hone and attacked him and the reform movement. One suspects that he is summed up adequately by the words his brother put in his mouth: "Damn all things." There is no question of his hatred of both positions insofar as they were positions. When he reached an impasse with the accession of the Prince Regent as George IV, his own agreement not to caricature his "immorality," and the impossibility of either government or reform as ideal, he ground to a halt. There were flashes of his best work in his unambiguous attacks on the Holy Alliance, the Spanish tyranny of Ferdinand VII (and the returning Inquisition), and the French restoration. A professional artist like Cruikshank draws what he is paid to draw, but I have no doubt that he felt strongly the evil of whichever side his patron unleashed him to satirize. He seldom found himself trapped into representing normative figures, even in his depictions of the opponents of Napoleon. He only caricatures—whether it was Napoleon, the Prince Regent, or Painite reformers. There is hardly even a John Bull figure but only the oppressed people who are summed up in the image of poor thin Oliver Twist and the other children of the workhouse. His images naturally parse into oppressors and oppressed, with little or nothing between. The only departure in the later work is that villainy is located in a bottle rather than in a fat, preening Prince Regent, and its representation is distressingly outside the old conventions of caricature.

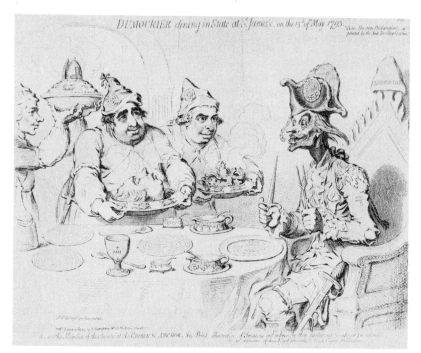

50. James Gillray, *Dumourier dining in State at St. James's on the 15th of May, 1793.*
Etching, 1793.

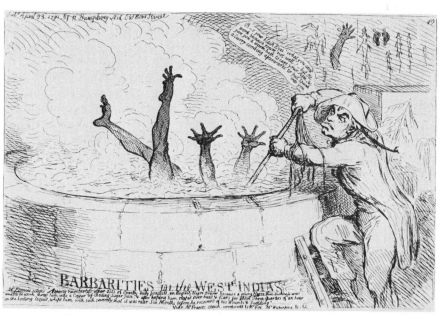

51. James Gillray, *Barbarities in the West-Indias.* Etching, 1791.

That there was a plan for taking the Tower by the French; after which, the whole of our constitution was to be overturned, and the Royal Family were to be murdered. At the head of this plot was to be placed that most execrable character, Marat.

There was also to be an attempt to poison the New River (which supplied London with water). But the insurrection in fact comes down to the planting of a Liberty Tree by some schoolboys: "Birnam wood coming to Dunsinane," as Sheridan put it.[55]

Of course, Gillray takes his melodramatic gestures equally from Burke's behavior in the House of Commons (producing a dagger) and from the melodramatic gestures to which Burke's refer (thousands of daggers stamped "Rights of Man" ordered from a Birmingham firm by Dr. William Maxwell). We have to remember that Burke told, and Paine (in order to refute) repeated, the story that the French were shouting after the fall of the Bastille, "Tous les évêques à la lanterne" (Hang all the bishops from the lampposts), and Gillray takes up this image in one of his best-known prints.[56] Paris newspapers and propaganda sometimes spoke of having an aristocrat for breakfast, and this braggadocio reappears in Gillray's *Un petit Souper* (fig. 48), literally depicting the French as cannibals.

We can compare Gillray's and Rowlandson's treatment of the romantic triangle of Lord Nelson, Lady Hamilton, and Sir William Hamilton. Gillray focuses on Nelson's sailing off to meet Napoleon's navy (fig. 52). The myth he adopts is Aeneas's finally breaking away from Dido to carry out his duty and sail to Rome. But by showing Dido grieving at his departure he shifts the emphasis from Nelson to Emma Hamilton, from the hero to the obstacle to his heroism. The parallel is exact down to the historically heroic stature of Nelson and his mission, to the heroic playacting of Emma, notorious for the "attitudes" she performed at stag parties before meeting Sir William. Her present view of the departure, it is implied, is a continuation of her attitudes. Gillray shows the difficulty of easy distinctions between high and low. Emma's alluring attitudes were already parodies of classical poses like that of Dido, in which the mockery of the antique allowed a stage for the prurience and seductiveness of the modern. To judge by contemporary reports, Gillray hardly even had to travesty Dido-Emma's figure.

On another level from either of these, Sir William's well-known love of antiquity directs us to the appropriate vehicle of the *Aeneid*, and thence down to the allusions to Priapus (he had uncovered and reported to the Dilettanti Society on a priapic cult in Italy) with its echoes in the present love affair.

For Rowlandson, this was simply the oedipal relationship of an old hus-

55. *Speeches of the late Right Honourable Richard Brinsley Sheridan* (London, 1816), III, 89–91.
56. Burke, *Reflections on the Revolution in France*, ed. Todd, p. 87.

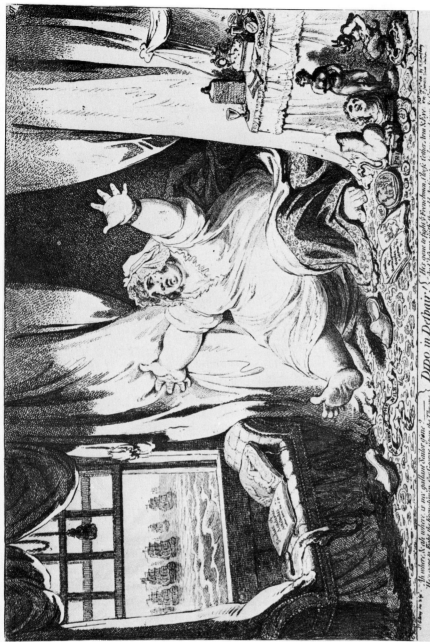

52. James Gillray, *Dido in Despair!* Etching, 1801.

band, a young wife, and her lover. The fact that the husband was an anti-
quary allowed Rowlandson to imagine him with his nose in some priapic
statuette while his wife and her lover have an assignation inside a mummy
case (fig. 53). Rowlandson's print, although it changes the story, sustains
the civilized, Virgilian world of the Dido–Aeneas Story in which ego drive
contests sexual drive. Sir William's devotion to his antiquarian pursuits, like
Aeneas's devotion to duty, is contrasted with the loving couple in their
simulated cave.

If Rowlandson's satire is expressed as a situation spelling out an interper-
sonal relationship, Gillray's is expressed as a point of view. Since only Emma
is present, hers is the immediate and comic point of view but substantiated
by the points of view (heroic and unheroic) of the two absent characters. I
suggest that the mock-heroic mode of the Augustan satirists Swift, Pope,
and Fielding has become for Gillray a grotesque downward transformation
analogous to that of John Bull's peg-leg (replacement for a loss in George
III's wars), which is also a bone gnawed on by his hungry dog.[57] If Row-
landson's is still a Virgilian world, Gillray's is an Ovidian world of monistic
desire, the dualism of ego and sexual drives becoming only Eros and Than-
atos, presence and absence, and the transformation of one into the other.
Lady Hamilton is only partaking in a process of change from the beautiful
young posture-woman of Romney's portraits to a Dido of her own imag-
ining to the image of a fat aging lone woman, which, carried far beyond
the sad-enough reality, is of Gillray's imagining. It is not exactly clear whether
he is representing a state of metamorphosis in the direction of regression,
or rather Emma's sensibility, or Gillray's own.

Both Rowlandson and Gillray depict the world reflected in acute and dis-
torting sensibilities. The perspective system they employ in their drawings
is based on curves rather than the straight lines and the spatial box of, say,
Hogarth. Everything moving toward the periphery is affected by curvilin-
ear distortion. Objects in all directions from the central point are foreshor-
tened, their size determined by the visual angle and not the distance as in
the old perspective box. The effect is hallucinatory: there is no closure to
right, left, top, or bottom. Objects and actions seem to be flowing off the
picture space, and the center looms up at the spectator threateningly. Even
the use of color in their prints is significant (though which colors was often
determined by other factors, including convention). Hogarth showed the
black and white world as it was in Lockean epistemology, simply extension
and motion, while Rowlandson and Gillray show it in color and with wild
distortion as it looks to the feverish eye of an individual, a satirist.

The art of political caricature, I am suggesting, offers two strategies. One
is the search for equivalents—metaphors, metonymies, synecdoches. Ho-

57. See *John Bull and his Dog Faithful*, 20 April 1796.

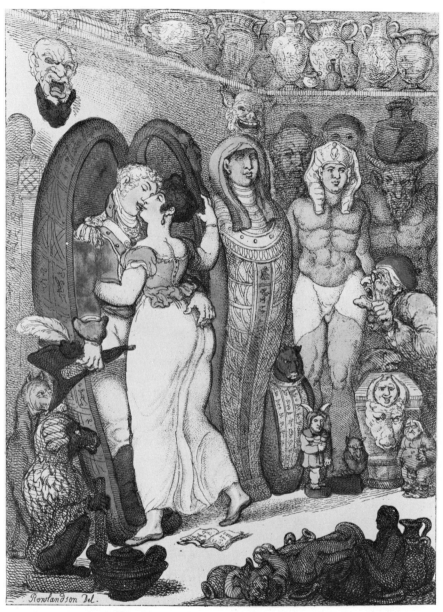

53. Thomas Rowlandson, *Modern Antiques*. Drawing, 1811?

garth manifests this necessity as he shifts from the majority of his works, which are about domesticating metaphors and allegories, into politics, where he begins to seek conventional equivalents: The situation of the ordinary Englishman is like Gulliver in Lilliput, or like a house in a city on fire when the firemen are hindered by hostile neighbors. The other is proposed by Alan Ramsay, who in his *Essay on Ridicule* (1754) shows his dislike for simple reductive ridicule of this sort and recommends something more specifically related to the Augustan satiric mode of accepting and exploring the enemy's own metaphors. He provides some diverting examples based on the Moravians that are not too different from Swift's in *A Tale of a Tub*. (Perhaps it is well to remember that Gillray was brought up a Moravian.) His exact recommendation, citing *Spectator* no. 595, is "to call in the assistance of the pencil, and try what effect such metaphors or imagery would have, when exhibited upon canvas." Hogarth, perhaps with Ramsay's words in mind, did precisely this in *Enthusiasm Delineated* and its revision *Credulity, Superstition, and Fanaticism* (1762); Gillray, I am suggesting, developed a mode in which he burlesques the metaphors of those politicians who interest him.

Rowlandson saw everything in the same way; everything he touched became Rowlandsonian. Even his imitations of Rembrandt and Boucher (let alone of Gainsborough, whose landscape style he genuinely imitated) came out looking like Rowlandson's own. Gillray's drawings are posited on a certain baroque view (distinguishable from his own) of heroism, high art, and delusion which corresponds to the way most of his protagonists saw themselves; but he is also capable of a style of extravagant meanness if he is representing the sans-culottes cannibalizing aristocrats or calling for their king's head. He exaggerates the gestures and sentiments with which fools delude themselves. But if Pitt sees himself as a financial wizard spewing riches on the grateful English, Gillray also shows the death's head and skeletal limbs, which are part of the reality, not the illusion. If Sheridan sees himself as a great statesman and orator, Gillray, however, sees him as a fiery-nosed harlequin shinnying up a greased pole. In other words there are two or more points of view, sometimes in the same print. Gillray may intend us to take one as hallucinatory, the other as actual, one as illusion and the other as reality, but they are equally hallucinatory, equally in the mode of caricature.

The baroque travesties that are some of Gillray's most remarkable conceptions tend to be the fantasy of the guilty party, as materialized warmly—not coldly but in fact torridly—by the satirist. In *The Giants storming Heaven* (fig. 54) the Broad-Bottom Ministry think they are Titans, and these grotesque shapes are the caricatures they really become in the baroque swirling lines of their imaginary scenario. Gillray learned the trick originally from Hogarth's depiction of Hudibras in heroic compositions out of Raphael and Carracci. But the features of Hogarth's people remained naturalistic repre-

sentations; even Hudibras was merely a deformed, ugly man. Gillray's cari-catured politicians are as monstrous in their own way as the fantasy of the titans in which they imagine themselves. It is almost as if Gillray saw cari-cature itself as a baroque art form, a reasonable extension of baroque forms and assumptions. This was, of course, an especially striking insight in an age in which neoclassicism was associated (in some quarters at least) with progressive politics. Every Gillray caricature is a comment upon the French *and* English norm of art with its hard outlines and rational ethos. Even his Roman myths are materializations of Rubens joined with a low-Dutch equivalent like Ostade; a Rubens composition is filled with Ostade figures.

The problem arises when, as in *St. George and the Dragon* (fig. 55), Gillray ought to be expressing a normative image: Nelson as Aeneas, not Emma as Dido. Here the English St. George is killing the Napoleonic dragon. The fantasy (as it has to be given the forms as well as the context of all Gillray's other satires) is George III's. Even if we argued that it was every patriotic Englishman's, it still seems to be seen with the same eye as *The Giants storming Heaven*. Who indeed is the villain, Napoleon or George? The same is true of other prints: the Prince of Wales dreaming of Caroline of Bruns-wick, and more obviously yet the reconciliation (patently ridiculous) of king and prince of Wales as envisioned by the ordinary optimistic English-man as Father and Prodigal Son (*The Reconciliation*, 1804). These are only wish fulfillments.

Gillray shows himself to be the transmitter of other people's myths. The enemy's, the general Public's, even his friends' visions all emerge ridiculous as myths. Even his own, as his *Death of Admiral Nelson* (fig. 56) must surely be, is ridiculous in the context of the convention established by his other pseudomyths. The only character who never deludes himself with mythol-ogizing is, of course, John Bull, who has no brains, few words, and hardly any personal identity. John is also the only major Gillray character who is not a real (or particular) person. Perhaps having a personality, and thus an illusion or a fantasy, is for Gillray the original sin. As an artist he spins all his conceits from the delusions of others (even his own). Although Gillray the moralist is at least nominally on the side of the realities, he was living in a time when it seemed no longer possible to affirm that anything was not a delusion. What is remarkable (or not remarkable considering the context of the French Revolution) is the degree to which he equates delusion with hope, thought, speech, and almost every other positive characteristic, as well as with folly and knavery.

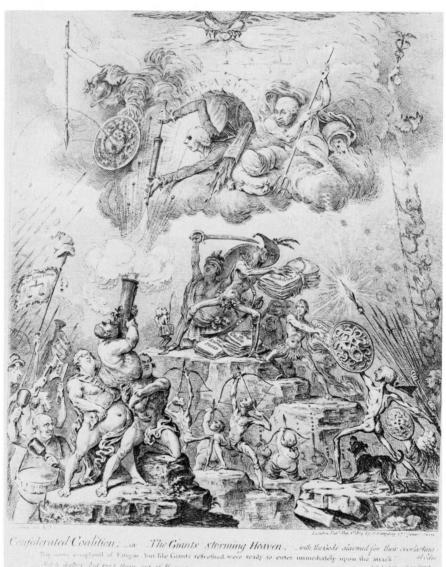

54. James Gillray, *Confederated-Coalition: or the Giants storming Heaven.* Etching, 1804.

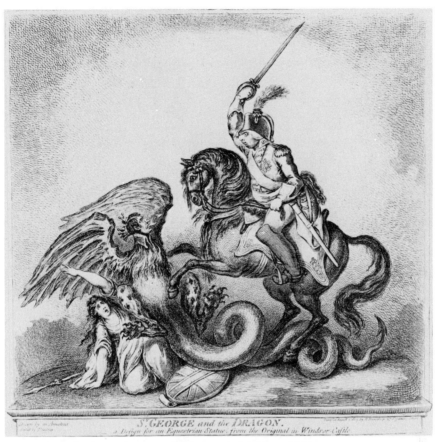

St. GEORGE and the DRAGON.
a Design for an Equestrian Statue, from the Original in Windsor Castle

55. James Gillray, *St. George and the Dragon*. Etching, 1805.

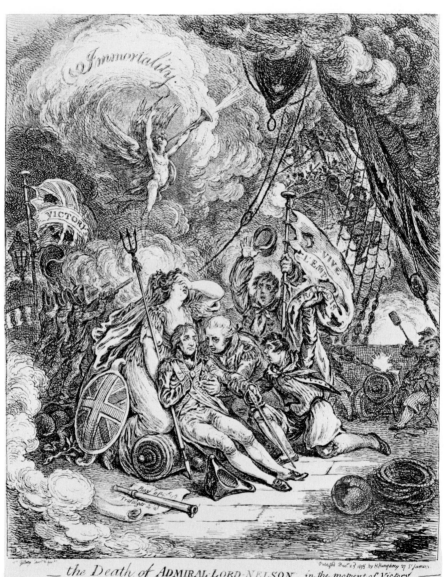

_ the Death of ADMIRAL·LORD·NELSON _ in the moment of Victory

56. James Gillray, *The Death of Admiral Lord Nelson at the Moment of Victory*. Etching, 1805.

CHAPTER 7 🐚 THE GOTHIC: AMBROSIO TO FRANKENSTEIN

In chapter 5, volume 2, of Jane Austen's *Northanger Abbey* Henry Tilney regales Catherine Morland with his version of the gothic fantasy she loves to read. When she arrives at Northanger Abbey, he says, she will be taken by the housekeeper "along many gloomy passages, into an apartment never used since some cousin or kin died in it about twenty years before."[1] She will discover that the door has no lock, and shortly (a couple of nights later), there will be a violent storm. "Peals of thunder so loud as to seem to shake the edifice to its foundation will roll round the neighbouring mountains—and during the frightful gusts of wind which accompany it, you will probably think you discern (for your lamp is now extinguished) one part of the hanging more violently agitated than the rest." These details are punctuated by "Will not your heart sink within you?" The next step is to lift the tapestry, try the door found behind it, and proceed into "a small vaulted room." The walk through several such chambers reveals a dagger, some drops of blood, torture instruments, and an old cabinet in a secret drawer of which is found a roll of paper: "you seize it—it contains many sheets of manuscript—you hasten with the precious treasure into your own chamber, but scarcely have you been able to decipher 'Oh! thou—whomsoever thou mayst be, into whose hands these memoirs of the wretched Matilda may fall'—when your lamp suddenly expires in the socket, and leaves you in total darkness."

1. *The Novels of Jane Austen*, ed. R. W. Chapman (London, 1923), 5, 158–60. This chapter appeared in a somewhat different form as "Gothic Fiction and the French Revolution," in *ELH*, 48 (1981), 532–54.

Certain elements of Ann Radcliffe's gothic are here, including the passiv-
ity of the sensitive heroine, the labyrinthine passages and chambers through
which she wanders, the violent storm, and the perusal of written docu-
ments that record experiences with which she herself never makes contact.
Elsewhere in *Northanger Abbey* the gothic fiction is reflected in vocabulary:
in, for example, Isabella's "amazing" or "in-conceivable, incredible, impos-
sible!" or Catherine's remark "Udolpho [is] the nicest book in the world,"
to which Henry replies, "The nicest;—by which I suppose you mean the
neatest. That must depend upon the binding" (p. 107). The adjective is just
another sort of exaggeration, another expression of a point of view, a way
of looking at the world as if it were a book.

Henry Tilney himself, we have learned in an earlier chapter (1, ch. 14), is
a reader of history ("Yes, I am fond of history," he says). Catherine reads
history only "as a duty, but it tells me nothing that does not either vex or
weary me" (p. 108), whereas from gothic novels she presumably gains
comfort. Henry, however, has his own quixotic version of sensibility: He
is a student of the picturesque, believing that a "beautiful" sky does not
signify good weather but a drawable picture. He instructs Catherine in these
mysteries until she views "the country with the eyes of persons accustomed
to drawing"—and at length "voluntarily rejected the whole city of Bath, as
unworthy to make part of a landscape" (pp. 110–11).

At this point in the conversation Tilney moves from the subject of the
picturesque to politics, "and from politics, it was an easy step to silence." It
is in this context (of the gothic, history, the picturesque, and politics) that
Catherine remarks, "I have heard that something very shocking indeed,
will soon come out of London . . . more horrible than any thing we have
met with yet"—by which of course she means the publication of a new
gothic novel. Miss Tilney, however, thinks she means a riot. It is left to
Henry to explain the discrepancy between a new publication "in three duo-
decimo volumes, two hundred and seventy-six pages in each, with a fron-
tispiece to the first," and (in a fantasy parallel to the gothic fantasy I have
quoted above) "a mob of three thousand men assembling in St. George's
Fields; the Bank attacked, the Tower threatened, the streets of London flow-
ing with blood, a detachment of the 12th Light Dragoons . . . ," and so on.
This was written in 1797 or 1798, when Austen if not Tilney was thinking
of history: the Gordon Riots of 1780 and the French Revolution of 1789, as
well as the crowd of 150,000 that gathered at the meeting of the London
Corresponding Society in Copenhagen Fields in 1795 (and the 200,000 cheap
copies of *Rights of Man* sold in 1793), the riots of 1794–95 with their death
toll, and the naval mutinies at Spithead and the Nore in 1797.[2]

2. Part of the context of the passage is the sort of response a revolutionary-sympathizer
such as Sheridan made to the rumors being bandied about. See above, p. 204–06.

In the context of *Northanger Abbey* the irony is that the exaggeration of the sign falls short of the grim reality. But precisely *what* reality? The lies of the Thorpes and the fantasy of General Tilney as wife-murderer generated by the gothic-infatuated Catherine turn out to signify, but not something close to the sign, not a gothic but rather a worse, because more banal, more historical evil—one perhaps like the French Revolution itself: General Tilney's abrupt dismissal of Catherine because he thinks she will interfere with his dynastic plans for Henry.[3]

In *Northanger Abbey* there is posited something we might call the real, or the thing itself, and then something else we can call the word, and Austen shows that they can come together only in formalized, conventionalized ways.[4] We notice the difference between the gothic fiction and history, but also the similarity. General Tilney is indeed the reality beneath Manfred, Montoni, and the other gothic villains: a man concerned with property, heirs, and wealth; a man who tries unscrupulously to preserve his family and fortune against the incursions of a penniless outsider, who in fact does disrupt it. In the real world, the gothic casts up (or is bettered by) the reality of a General Tilney or a French Revolution in which, in Burke's terms, penniless parvenues infiltrate the aristocratic family—or the royal family itself, ultimately breaking through its doors into the bedroom of the queen— and ravish the wife-mother-daughter. The principal elements are the same: The gothic supplies only the metaphors and the gushing response of the safely distant spectator, who hears the storm (remembering perhaps the metaphors of natural upheaval—hurricanes and erupting volcanoes—that were immediately applied to the Revolution), notices the bloody daggers and racks, and reads—or starts to, until her candle is extinguished—a letter from an actual participant.

The gothic did in fact serve as a metaphor with which some contemporaries in England tried to understand what was happening across the channel in the 1790s. The first Revolutionary emblem was the castle-prison, the Bastille and its destruction by an angry mob, which was fitted by the En-

3. As John K. Mathison put it: "From the gothic novels, Catherine had come to believe in the possibility of cruelty, violence, and crime that her sheltered life had shown no signs of" ("*Northanger Abbey* and Jane Austen's Conception of the Value of Fiction," *ELH*, 24 [1957], 149). See also Marilyn Butler, *Jane Austen and the War of Ideas* (Oxford, 1975), for an interesting account of the background of Austen's novels in anti-Jacobin fiction.

4. At one point Henry tells Catherine, "I consider a country-dance as an emblem of marriage," and fills in the analogies. "But they are such very different things!—" says Catherine, the reader of gothic romances. Tilney extends the comparison to other details, and we remember that his view is through most of the novel normative of the real as opposed to gothic fictions. " . . . but still they are so very different," Catherine, however, responds again; and indeed they are. Both Henry and Catherine are right. They are talking about the relation of the sign or the representation to reality—which finds a particularly interesting case in the French Revolution.

glish into the model of the Gordon Riots. But if one way of dealing with the Revolution (in its earliest stages) was to see the castle-prison through the eyes of a sensitive young girl who responds to terror in the form of forced marriage and stolen property, another was to see it through the case history of her threatening oppressor, Horace Walpole's Manfred or M. G. Lewis's Ambrosio—the less comforting reality Austen was heralding in the historical fact of London riots. In Lewis's *The Monk* (1795) the two striking phenomena dramatized are first the explosion—the bursting out of his bonds—of a repressed monk imprisoned from earliest childhood in a monastery, with the havoc wreaked by his self-liberation on the Church and his own family, who were indirectly (through the father) responsible for his being immured; and second, the bloodthirsty mob that lynches—literally grinds into a bloody pulp—the wicked prioress who has murdered those of her nuns who succumb to sexual temptation (and who represents the Church that locked away Ambrosio). Both are cases of justification followed by horrible excess. Ambrosio deserves to break out and the mob is justified in punishing the evil prioress, but Ambrosio's liberty leads him to the shattering of his vow of celibacy, to repression, murder, and rape not unlike the ecclesiastical compulsion against which he was reacting; the mob not only destroys the prioress but (recalling the massacres of September 1792) the whole community and the convent itself:

> The incensed Populace, confounding the innocent with the guilty, had resolved to sacrifice all the Nuns of that order to their rage, and not to leave one stone of the building upon another. . . . They battered the walls, threw lighted torches in at the windows, and swore that by break of day not a Nun of St. Clare's order should be left alive. . . . The Rioters poured into the interior part of the Building, where they exercised their vengeance upon every thing which found itself in their passage. They broke the furniture into pieces, tore down the pictures, destroyed the reliques, and in their hatred of her Servant forgot all respect to the Saint. Some employed themselves in searching out the Nuns, Others in pulling down parts of the Convent, and Others again in setting fire to the pictures and furniture, which it contained. These latter produced the most decisive desolation: Indeed the consequences of their action were more sudden, than themselves had expected or wished. The Flames rising from the burning piles caught part of the Building, which being old and dry, the conflagration spread with rapidity from room to room. The Walls were soon shaken by the devouring element: The Columns gave way: The Roofs came tumbling down upon the Rioters, and crushed many of them beneath their weight. Nothing was to be heard but shrieks and groans; the Convent was wrapped in flames, and the whole presented a scene of devastation and horror.[5]

The end, of course, as it appeared to the English in 1794, remembering Thomas Paine's words ("From a small spark, kindled in America, a flame

5. *The Monk*, ed. Howard Anderson (London, 1973), pp. 357–58.

has arisen, not to be extinguished") and the imagery of light and fire associated with the Revolution, was the destruction of the revolutionaries themselves in the general collapse.

REBEL/TYRANT: AMBROSIO

I do not mean to suggest that Ann Radcliffe or Monk Lewis was producing propaganda either for or against the French Revolution. Lewis's treatment of the lynching scene, for example, is far removed from the morally clear-cut renderings of anticlericalism exemplified by the *drames monacals* popular in the theaters of Revolutionary Paris. In one of these plays (de Menuel's *Les Victimes cloîtrées* of 1791, which Lewis saw, admired, and translated) the wretched prisoners held in the dungeons below a convent are finally rescued by a Republican mayor brandishing the *tricolore*. Lewis exploits the dramatic resonances of the Revolution and its anticlericalism but simultaneously portrays the rioting mob as bloodthirsty, completely out of control, animal-like in its ferocity. The convent of St. Clare represents corruption, superstition, and repression but its overthrowers, no more admirable than the tyrants, are capable of the same atrocities or worse.

The plot of *The Monk* emerges to a remarkable extent from a historical referent. Ambrosio lives out a plot that had its source in the events of the Revolution and the Terror. Literary sources were, however, available. The protagonist could be traced back to Doctor Faustus (or Malevole or Vendice) of Elizabethan tragedy, or to Walpole's Manfred. Long before Burke wrote his *Reflections*,[6] his theory of the sublime as terror had already helped to launch the gothic novel, which itself became part of the tradition of the sublime he drew upon in his formulation of revolution.

In Walpole's *Castle of Otranto* (1764) the terror (and the supernatural intervention) followed from domestic perversion: from Manfred's defiance of the lawful inheritance, manifested in the huge paternal image of Alfonso the Good, and then from his implicit rivalry with his own son and his attempt to take his place, marry his intended, and propagate his own heirs ("Instead of a sickly boy," he tells Matilda, "you shall have a husband in the prime of his age"). In short, Manfred is another example of the protagonist who is both rebellious son and tyrannic father. With the advent of the French Revolution, and Burke's own imagery in his *Reflections*, the situation intensified into the confrontation of servant and master, Caleb Williams and Falkland, in Godwin's novel called *Things as They Are* (1794), over the trunk containing evidence that Falkland is a murderer: Death faces Satan over Sin, in a scene remarkable for its sexual overtones. Out of this scene grows the

6. In later works, the sublime takes on supernatural associations for Burke: *First Letter of a Regicide Peace* (1796), in *Works*, 5, 237; see above, p. 72.

ambiguous pursuit in which Caleb and Falkland become both pursuer and pursued, virtually interchangeable figures by the time they reach the end, which is not an end but a cyclic exchange of roles: Caleb himself is now the murderer. A year after *Caleb Williams*, Lewis's *The Monk* was published, and the alternation of attraction and repulsion we noticed in Burke's account of revolution appears as Ambrosio's revolt from the monastic life in which he has been confined into a sexual explosion, which leads to his own assumption of pious hypocrisy, compulsion, rape, incest, and murder.

The model of the sublime as it emerges in "Monk" Lewis does correspond to one version of the general pattern Burke at once detected in the French Revolution: first destroy the father and then of necessity become more repressive than he was. In Burke's horrified response they may at first appear as one, a single ambivalence, not entirely recognized, within himself. In the Revolution proper they followed in sequence, and in the response of the monk Ambrosio they appear as stages of a cycle expressed first by an explosion of liberation-energy-sexuality, and then by counter-compulsion, in which the rebel Satan first attacks and then becomes himself the God-the-Father he rebelled against.

In his critical essay "Idée sur les romans" (1800) the Marquis de Sade said of *The Monk*: " 'twas the inevitable result of the revolutionary shocks which all of Europe had suffered."[7] He saw Lewis as someone "familiar with the full range of misfortunes wherewith evildoers can beset mankind" and he refers to all the "misfortunes" of the early 1790s. This may explain Godwin; it hardly explains Lewis, for whom *The Monk* was largely an aesthetic expression. The Bastille had to fall again, repressed desires be released, incest committed, but basically it was the aesthetic of sublimity Lewis was playing with—and it was play because while the mixed tones of *The Monk* are usually explained in terms of Jacobean tragicomedy, they also perfectly fit Burke's explanation of the effect the French Revolution had on him as "this strange chaos of levity and ferocity, and of all sorts of crimes jumbled together with all sorts of follies."[8]

Sade, who considered *The Monk* superior to all other works of its kind, asserted that the bloody upheavals of the French Revolution had rendered everyday reality so horrific that contemporary writers necessarily had to invoke the supernatural and demonic realms for material which could still shock or startle their readers, but he also admits that the dynamic change of events made such novels banal. I do not think there is any doubt that the popularity of gothic fiction in the 1790s and well into the nineteenth century was due in part to the widespread anxieties and fears in Europe aroused by

7. "Reflections on the Novel" (1800), in *The 120 Days of Sodom and Other Writings*, ed. Austryn Wainhouse and Richard Weaver (New York, 1966), p. 109.
 8. *Reflections*, p. 9.

the turmoil in France finding a kind of sublimation or catharsis in tales of darkness, confusion, blood, and horror.

However, the gothic had existed from the 1760s onward. The castle as prison was already implicit in *The Castle of Otranto* and Radcliffe's *Castles of Athlin and Dynbayne* (1789), and it may only have been this image and this frame of mind that made the fall of the Bastille an automatic image of revolution for French as well as English writers. By the time *The Mysteries of Udolpho* appeared (1794), the castle, prison, tyrant, and sensitive young girl could no longer be presented naively; they had all been familiarized and sophisticated by the events in France.

We are talking about a particular development in the 1790s, a specific plot that was either at hand for writers to use in the light of the French Revolution, or was in some sense projected by the Revolution and borrowed by writers who may or may not have wished to express anything specifically about the troubles in France. For example, Ambrosio has to be seen as a more sympathetic descendant of Walpole's Manfred, another conflation of rebelling son and tyrant father, but notably unconcerned with property. Although his pact with the Devil introduces the Faustus story, he is not seeking the intellectual, spiritual, or specifically political power called for by the Enlightenment. He wants only sexual liberty and fulfillment. The Revolution, in Burke's as in Lewis's terms, exposed the reality under the intellectual and social knowledge of the Enlightenment to be unrestrained sexual "knowledge." Faustus's Mephistopheles becomes Ambrosio's Matilda. It is Ambrosio's desire for her that draws him in deeper and the unleashing of repressed sexual desires that shatters the barrier between the natural and supernatural worlds in *The Monk*. (In the subplot Raymond's passion for Agnes permits the supernatural to penetrate the human world, for it is as he waits to elope with her and consummate his desire that the Bleeding Nun appears to him in her place.)

This overtly sexual passion is what makes Ambrosio sympathetic in a way that Manfred is not, even given Walpole's assurance to the reader that Manfred is otherwise a great soul. *The Monk* is about the act of liberation whereas *The Castle of Otranto* was about a man's attempt to hold together his crumbling estate and cheat others of their rightful inheritance. One is a fable of revolution, the other of the ancien régime.

Arthur Young, an early firsthand witness of the evolving Revolution, emphasized (1793) that its uncontrolled violence was only a consequence of oppression. He asks whether it is "really the people to whom we are to impute" the excesses they are committing:

> —Or to their oppressors who had kept them so long in a state of bondage? He who chooses to be served by slaves, and by ill-treated slaves, must know that he holds both his property and life by a tenure far different from those who prefer the service of well treated freemen; and he who dines to the music of groaning

sufferers, must not, in the moment of insurrection, complain that his daughters are ravished, and then destroyed; and that his sons' throats are cut.[9]

The fact that Lewis does not stress the cruelty of the master, only the effect of repression and immurement, does not alter the general point that Ambrosio's revolt is understood in terms of the oppression against which he reacts. For if from one point of view he is the cruel hypocrite, matricide, and incestuous rapist, whose hypocrisy and aggression he had learned from his master the Church, from another he is still—at every step of his way—the helpless, passive victim of his repressive environment, and this is allegorized in the story of his Satanic persecution. For he is not only rendered vulnerable by his miseducation, he is also seduced by a demon, tricked into ravishing his own sister, driven to sell his soul when an earthly reprieve is at hand, and definitively betrayed and destroyed by the Arch-Fiend.

Lewis's joining of the repressive environment on the realistic level with the Faustus story on the allegorical is his way of representing the view of observers like Young who saw the worst excesses of the Revolution determined by forces external to the revolutionaries themselves. One result is the blurring of the old black–white moral distinctions of earlier gothic fiction. Ambrosio is characterized, as was the Revolution, by the appalling ease with which his nature could be inverted, either by assuming the vices of the tyrant he has overthrown or by a simple shift of moral perspective.

Young, arguing that the violent, destructive actions of the French crowd were a consequence of oppression, adds: "Let it be remembered that the populace in no country ever use power with moderation; excess is inherent in their aggregate constitution. . . ."[10] It is this unpredictable crowd that acts as a correlative to the irrational level of Ambrosio's actions. But for Lewis the crowd had a reality so powerful that it might as truthfully be said that Ambrosio's actions were a correlative on the personal level to the mass actions of the crowd. The crowd, with the related terms *national sovereignty* and *General Will* (or Burke's *swinish multitude*), was in many ways the central, most ambiguous phenomenon of the Revolution. Ambrosio, it should be recalled, was at the very outset presented as a spellbinding orator, the master of the crowd that later proves beyond mastering in the same way that his own desires exceed all bounds.

What the crowd does to the prioress is, of course, not only what Ambrosio does to the church and family that immured him but also what he does, almost simultaneously, to Antonia. There is a strong element of sexual release and sadism—fulfillment but also the satisfaction of unrestricted power over another person. Both Ambrosio and the crowd represent the aspect of

9. *Travels during the Years 1787, 1788, and 1789* (Dublin, 1793), 2, 515.
10. Ibid., p. 516.

pornography we did not find in Rowlandson: the need, compulsively re-
peated, to degrade the female body in a futile desire to silence eros. It is in
the sense of these suggestive parallels between Ambrosio and the crowd
that the gothic offered a form in which inexpressible, hitherto unthinkable
aspects of the human psyche could be symbolized and silenced.

The crowd, the *mobile vulgus*, was an image that was ready to hand in the
literature of conservative Anglo-Catholic royalists such as Dryden and Swift,
seen as a restless, unruly mass (like the unconscious) but controlled, as in
Absalom and Achitophel and *The Medal*, by an evil schemer, a Shaftsbury
who directs its violence to his own personal ends. With its past history in
the Gordon Riots and in the actual events in France, the crowd merged with
the conflicting or overlapping fictions of, on the one hand, the cabal or
small secret society that governs the crowd and determines events and, on
the other, the single great man who expresses in himself the General Will.

The disturbances in Ireland, for example, the *Times* of 22 February 1793
reported, "arise from the pure wantonness of a set of desperadoes called
Defenders . . . encouraged and abetted by a secret junto, that like the French
Jacobins, wish to throw all government into confusion." The largest such
fiction was the one woven by the Abbé Augustin de Barruel, who argued
that the illuminati masterminded the whole Revolution. As J. M. Roberts
has written in his *Mythology of the Secret Societies*:

> Educated and conservative men raised in the tradition of Christianity, with its
> stress on individual responsibility and the independence of the will, found con-
> spiracy theories plausible as an explanation of such changes: it must have come
> about, they thought, because somebody planned it so.[11]

Such myths as plots of the freemasons, philosophes, and illuminati were
"an attempt to impose some sort of order on the bewildering variety of
changes which suddenly showered upon Europe with the Revolution and
its aftermath." The assumption of individual agency (as opposed to the more
popular modern explanation of social and economic determinism) is evident
in the allegorizations of revolution as the actions of a single man—an Am-
brosio—but also in the comforting retreat to Satanic responsibility in the
Miltonic fictions of rebellion in heaven and in the Garden of Eden—in Ro-
sario–Matilda, the Devil who in fact determines all the events that Ambro-
sio seemed responsible for.

The crowd could thus mean either complete uncontrol of unruly passions
or the carrying out of the designs of a single man or a very small group of
schemers—or even diabolic possession or inspiration. The historical villain
(as in many of the theories Barruel collects) is the Duc d'Orléans type (Phi-

11. *Mythology of the Secret Societies* (London, 1972), p. 10 (on Barruel in general, pp. 188–
202); Barruel, *Mémoires pour servir a l'histoire du jacobinisme* (1797–98; English eds. publ. 1797–
98 also).

lippe Égalité), the cadet who wants power himself and therefore topples the rightful older brother or cousin by masterminding a plot that moves the crowd (Satan in heaven, jealous of the raising of his "brother" Christ, or Schedoni in Radcliffe's *The Italian*), and is himself swept away by the tempest he has unleashed. The force then becomes the Jacobin Club or a Robespierre, who eventually loses his own head, and ultimately a Napoleon.

General Tilney (or Montoni or Schedoni) and the rioters are, of course, polarities; one is concerned with the preservation and the other with the destruction of property but both with its appropriation. Tilney is the malign individual, the Radcliffe villain; the rioters, something she only hints at in the vague figures of the sexually threatening soldiers of Montoni whom Emily fears (in this sense related to Burke's mob that threatens Marie Antoinette), are mere misdirected action, chance, the natural force of a crowd—in some ways even more terrifying to contemplate. Both, however, were historical phenomena, not exactly unthinkable before 1789 but largely gothic fantasies or satiric exaggerations. Nevertheless, taken together they represent the two chief explanations offered for the phenomenon of the Revolution by conservative theorists, the spokesmen of counterrevolution.

One more gothic convention calls for comment. The sense of unresolved mystery that was one aspect of the gothic fiction of Walpole, Clara Reeve, and Radcliffe also fitted the way many contemporaries read the Revolution. The feeling the reader has in gothic fiction is of never knowing exactly where he is, where he is going, or what is happening. This feeling corresponds to the puzzlement of the protagonist too, whether a passive Emily or an active plotter like Ambrosio. The gothic describes a situation in which no one can understand or fathom anyone else's motives or actions. The narrative structure the gothic inherited, and carried to its greatest degree of subtlety in Radcliffe's novels (and of formal innovation in Maturin's *Melmoth the Wanderer* and Hogg's *Confessions of a Justified Sinner*), involved a theme of communication, the unresolved difficulty of understanding actions; this was expressed in the aposiopesis of Sterne's and Mackenzie's novels, in the authentic manuscript lost in gun-wadding or hair curlers, the resort to typographical excesses, and the alternative accounts that leave the reader as uncertain of the responsibility for the protagonist's actions as the protagonist himself. This is, of course, also a feature of the sublime style, "where half is left out to be supplied by the hearer"—and so a logical and syntactical obscurity joins revolution and sublimity.[12]

Behind all this obscurity, however, is the elaborate plot, masterminded but slipping out of control, which involves the overthrow of a property owner. When the Revolution itself came, and as it progressed, it was pre-

12. Abraham Cowley, quoted in Martin Price, "The Sublime Poem: Pictures and Powers," *Yale Review*, 58 (1969), 206.

cisely this inability to make out the events on a day-to-day basis, but with the suspicion of personal skulduggery beneath each new changing-hands of property, that made the gothic novel a roughly equivalent narrative form. Depending on what stage a spectator looked back from, he saw a different structure, but one increasingly colored on the dark side by the Terror. The standard features of the rebellion were the vast possibilities and hopes it opened up, followed by delusions, dangerous and unforeseen contingencies, horrible consequences, and disillusionment. Behind all was a new sense of history, of what could or should happen in history, and what history was in fact about. From being about the kings, it became, in certain ways, about larger groups of subjects and their attempts to come to terms with, or create a new order from, the disorder consequent upon the overthrow of an old established order.

SENTIMENTAL RESPONSE AND SEXUAL ENERGY

It is difficult not to agree with Nelson Smith that in many ways Emily St. Aubert is regarded by Radcliffe in precisely the critical way Jane Austen regards Catherine Morland.[13] The (remote) potential of Ambrosio in Emily is broached at the beginning in M. St. Aubert's deathbed warning to her, "do not indulge in the pride of fine feeling" or "ill-governed sensibility," which is dangerous to its possessor and to others as well; it is materialized at the end in the nun Agnes's expostulation to Emily based on her own slip from sentiment into sexual passion. In general, however, Radcliffe contrasts Emily's gentle sentiments in Udolpho with the "fierce and terrible passions . . . which so often agitated the inhabitants of this edifice," "those mysterious workings, that rouse the elements of man's nature into tempest." Emily's, she assures us,

> was a silent anguish, weeping, yet enduring; not the *wild energy of passion, inflaming imagination, bearing down the barriers of reason and living in a world of its own.*[14]

The terms I have emphasized are precisely those applied by contemporaries such as Burke to the Revolution. The deeply intuitive feelings of Emily are the quite English virtues of the spectator of sublime overthrow across the channel; the "wild energy" of Montoni is what Burke associates with the French rabble. Both derive from the sentimental novel but one is the delicate sensibility of a Toby Shandy or a Harley, the friendship and compassion that can join parental duty, justice, and prudence; the other is the dangerous love of a Clarissa, even the benevolence of a Charles Surface, and the "Jaco-

13. Nelson C. Smith, "Sense, Sensibility and Ann Radcliffe," *SEL*, 12 (1973), 577–90. See also Mary Poovey, "Ideology in *The Mysteries of Udolpho*," *Criticism*, 21 (1979), 307–30.

14. *Mysteries of Udolpho*, ed. Bonamy Dobrée (London, 1966), p. 329.

bin" view that "It is the quality of feeling that sanctifies the marriage; not, as the anti-jacobins were to have it, the other way around."[15]

Wollstonecraft's *Historical and Moral View* conveys some sense of the Radcliffian gothic. Although writing of the events of July 1789, Wollstonecraft is looking back from the events of 1794, and she produces a meditation-among-the-ruins similar to those of Emily and Radcliffe's other heroines in the moldering castles they visit:

> How silent is now Versailles!—The solitary foot, that mounts the sumptuous stair-case, rests on each landing-place, whilst the eye traverses the void, almost expecting to see the strong images of fancy burst into life. . . . [pp. 161–64]

Speaking of the Tennis Court Oath, Wollstonecraft attributes this great event to "an overflow of sensibility that kindled into a blaze of patriotism every social feeling" (p. 114). In the *Rights of Woman* she distinguishes false sensibility, which is Swift's self-delusion of the fool among knaves, from true sensibility, which is aware not of trivialities but the sublime. A passage in the *Rights of Woman* could describe the pitfalls Emily manages to avoid: "These pretty nothings—these caricatures of the real beauty of sensibility, dropping glibly from the tongue, vitiate the taste, and create a kind of sickly delicacy that turns away from the simple unadorned truth . . . " (p. 23). All these quotations have to be seen in the context of such Burkean remarks as "This is the state of things that excites the warm and tender passions, the sweet sentimental love and admiration of our English enthusiasts for liberty."[16]

15. Butler, *Jane Austen*, p. 28. Sheridan's indulgence toward Charles Surface in *School for Scandal* was attacked by Henry Mackenzie in *Anecdotes and Egotisms*, ed. H. W. Thompson (London, 1927), p. 204, and by the anti-Jacobins in Robert Bisset, *Douglas, or the Highlander* (1801), 3, 111–14, and Charles Lucas, *The Infernal Quixote* (1801), 1 252.

16. The words are actually his son Richard's (*Correspondence*, 6, 126). In her novel of 1788, *Mary*, Wollstonecraft sets up the revolutionary situation as domestic fiction. She has a mother who is all sensibility out of novels, and a daughter Mary whose mind is filled with "sublime ideas" of religious perfection. "Could she have loved her father or mother, had they returned her affections, she would not so soon, perhaps, have sought out a new world" (p. 5). She is contrasted with her lovesick friend Ann: "In every thing it was not the great, but the beautiful, or the pretty, that caught her attention" (p. 13). The story is of a contracted marriage without love by her parents. The relationship between Mary and her real father and mother and her friend Ann is complicated by her relationship with Henry as a father substitute and Ann as a mother substitute (see p. 36). In the background is the absent and invisible but still oppressive husband.

Thus in *The Rights of Woman* there is a chapter on "Parental Affection": "Parental affection, indeed, in many minds, is but a pretext to tyrannize where it can be done with impunity . . . " (p. 264). She makes quite clear that parents are to their children as husbands to their wives: "A slavish bondage to parents cramps every faculty of the mind," and this passage is followed by a quotation from Locke on the indolence that follows if the minds of children are too "curbed and humbled." This is especially true of the female child: "For girls, from various causes, are more kept down by their parents, in every sense of the word, than boys. . . .and

Emily St. Aubert is therefore, as Mary Poovey has argued, the susceptible young spectator who *might* be seduced away from the admonition of her father by the real center of energy into becoming another Agnes, and this center of energy, Montoni, is based on a need to dominate that draws on the conventions of both gothic and revolutionary mythology.[17] There is, in short, a distinction between misperception—believing a General Tilney to be a Montoni, or (to take Blake's contemporary case, in "The Tyger") a lamb to be a tiger, a gallant French Revolution to be a bloodthirsty uprising or vice versa—and exploitation either of the sensitive soul by others or of others by the sensitive soul expanded until out of control. Emily is obviously the former, but this is because she never allows herself to slip completely out of control and because Radcliffe has already given us this rebel figure in the male villain, whose motives are unrelievedly bad.

If Radcliffe produces a fiction about a spectator of revolutionary activity who can be confused by her experience, whose response though virtuous is both ambivalent and liable to the temptation to misperceive, then Lewis's *Monk* reproduces the exhilarating but ultimately depressing experience of the revolutionary himself.

At this point another strand, the novel of reform (the so-called Jacobin novel), joins the gothic in the representation of tyranny and revolution. The gothic tended to be the form adopted by those who were either against or merely intrigued by the Revolution, or by problems of freedom and compulsion. The reformers William Godwin, Thomas Holcroft, Robert Bage, and Elizabeth Inchbald are *for* the Revolution; they call their works "Things as they Are," "Man as he Is," or "Man as he is Not"; they avoid the gothic and theatrical trappings Burke associated with the Revolution; they have a sometimes dismaying singleness of purpose and go straight to the contemporary Englishman, the General Tilney, illustrating Arthur Young's insistence that "The true judgment to be formed of the French Revolution, must surely be gained from an attentive consideration of the evils of the old government."[18] This was, of course, what the English Jacobins usually represented in their novels, tracts, and poems, for their real subject was not France but forms of compulsion in England.

thus taught plausibly to submit to their parents, they are prepared for the slavery of marriage." And if not slaves, "they then become tyrants." Wollstonecraft's general message follows from the case of parents and husbands: "I can only insist that when they [girls, women] are obliged to submit to authority blindly, their faculties are weakened, and their tempers rendered imperious or abject" (p. 271).

17. See Poovey, "Ideology in *The Mysteries of Udolpho*."

18. Young, *Travels*, p. 517. For the Jacobin novel, see Butler, *Jane Austen*, pp. 29–87; Gary Kelly, *The English Jacobin Novel 1780–1805* (Oxford, 1976); and Paulson, review of Kelly, *Blake: An Illustrated Quarterly*, 11 (1978), 293–97, on which I draw in these pages.

It was the women writers who picked up most poignantly the aspect of property in the gothic novel of Walpole: "Security of property!" Wollstonecraft writes in *Vindication of the Rights of Men*, "Behold, in a few words, the definition of English liberty" (p. 24). She moves to the center of the stage, now with ideological implications, the principle of "hereditary property" (p. 12), the figure of the selfish father (p. 22), and the case of the daughter. The woman's experience, like that of the black slave, was a model waiting ready for use when the Revolution erupted in 1789. The experience of the female chattel, of oppression with no recourse to law, of sexual pursuit and assault upon body and mind, all provided the woman novelist (who had also read *Clarissa* and *Otranto*) with the experience and the point of view for a protorevolutionary novel that could be adapted by Holcroft and Godwin when the moment was ripe. Wollstonecraft's *Vindication of the Rights of Woman* and her novel *The Wrongs of Woman: or, Maria* (publ. 1798) are only the discursive and melodramatic extremes of this plot.

In the 1780s and into the 1790s the women of Charlotte Smith's novels are peripheral, a fragile ideal in the wife who remains faithful to her worthless, tyrannical husband; Smith's strength lies in her depiction of the husband's tyranny. If revolt takes place in the form of adultery, it is off stage and usually the resort of secondary characters only. Then in *Desmond* (1792) the characters begin to talk about the Revolution in France, underlining the parallel between the French and English situations, including that of domestic tyranny, and the wife's passive virtue begins to assume a positive bravery more in tune with the times.

Inchbald, Bage, Holcroft, and Godwin stand apart from Smith and other contemporary novelists in their adherence to a rational strain of literary-political-philosophical theorizing. This appears not only in the dialogues on philosophical issues in their novels but in the formal structure that raises their best novels above other English fiction of the 1790s. They consciously sought the "unity of design" Holcroft was advocating as early as 1780 in the preface to *Alwyn*, and so "the simplicity which is requisite" (and was taken up in the title of Inchbald's *Simple Story*). Unity and simplicity also derived from integration of plot and character through the "doctrine of necessity," the belief that "The characters of men originate in their external circumstances." The formal result at its best was an unprecedented union of character and incident.

The tightly knit novel they produced had as its objective, in Holcroft's words, to "develop the emotions that preceded and the causes that produced the passion, and, afterward, trace it through all its consequences."[19] The action was, in short, a passion—a relationship or an entanglement, with its emotions and causes as well as its consequences analyzed in some

19. *Monthly Review*, 2d ser. 12 (Dec. 1793), 393.

depth—and the form the passion took was one based on the model of *Clarissa* involving love and compulsion, rape of one sort or another, and mastery. The line of transmission was from the Clarissa–Lovelace relationship, which ends in mutual destruction, a consequence of his need to subjugate and hers to maintain her freedom, to Rousseau's Julie and Mackenzie's Julia de Roubigné, caught in an impossible love for a younger man and a marriage with an older (in Julia's case the husband's jealousy leads to her murder).

Thus we arrive at Inchbald's *Simple Story* (1791). On one level its two parts, contrasting Miss Milner with the wrong education and her daughter Matilda with the right one, merely correspond to the antithetical protagonists of her later novel *Nature and Art* (1796). This is not, however, the simple *Industry and Idleness* or *Sandford and Merton* plot that dominates Inchbald's less inspired work. For the two parts correspond to two versions, in two generations, of the same power struggle between an older father-lover and the young girl. Dorriforth is guardian, Catholic priest, moralist, substitute for Miss Milner's dead father, eventually (ennobled as Lord Elmwood) a titled aristocrat, and the actual but invisible father of Matilda, the next generation's version of Miss Milner. Inchbald manages to get in all the oppressive relationships that materialize in the imagery of Burke and Paine after the outbreak of the Revolution. Against the authority figure appears natural, untutored, giddy, freedom-loving Miss Milner. She loves Dorriforth and he her, but the love includes subjugation (and self-subjugation) and is tested by her rebellion through adultery and by his consequent tyranny, which affects the next generation. Unlike the escalating violence of Ambrosio's revolt, Miss Milner's finds an ameliorist solution, Matilda's corrective to her mother's rebellious act. Inchbald projects Dorriforth's house as a world that is strangely like the Garden of Eden with its tempter God (Dorriforth) in Blake's "Poison Tree" or for that matter in *Caleb Williams*, where Falkland plays the role of the deity.

The situation *A Simple Story* dramatizes is remarkably appropriate to the time, without being related allegorically or analogically to what was happening in France (or even was about to happen since it was largely written before 1789).

Gary Kelly has it exactly right when he sums up the strength of the novel as Inchbald's portrayal of "the repression and the force of powerful but natural feelings."[20] He identifies here the strand connecting *A Simple Story* to Sterne's *Sentimental Journey*, and even to *Joseph Andrews*. It is still part of the sentimental tradition, where the inauthenticity of words was an essential ingredient. ("But how unimportant, how weak, how ineffectual are *words* in conversation," we read in *A Simple Story*, "—looks and manners alone

20. Kelly, *English Jacobin Novel*, p. 79.

express—.") But *A Simple Story* also shows how these assumptions can become Jacobin, either by placing Sterne's caged starling, or even Rousseau's, in a context of the fall of the Bastille, or by intensifying the feeling and the symbolism of the situation by adding, however implicitly, a political dimension.

Without *A Simple Story* Holcroft's *Anna St. Ives* and Godwin's *Caleb Williams* would have been inconceivable. If one theme, as Holcroft states his aim in *Anna St. Ives* (1792), is "teaching fortitude to females," and this in the face of oppression by a guardian or husband, another that follows is the conflict between generations. Here it is the old Sir Arthur St. Ives and Abimilech Henley pitted against young Anna and Frank, and the relationship of the oppressive or foolish parents and the rebellious children joins the Jacobin thesis that education and changing circumstances affect character. In Anna's terms, her love for Frank conflicts with her duty to Sir Arthur as passion conflicts with reason: "Indeed indeed, Frank, it is not my heart that refuses you; it is my understanding; it is principle; it is a determination not to do that which my reason cannot justify. . . ." But of the real problem, she says: "I cannot encounter the malediction of a father!—What! Behold him in an agony of cursing his child?—I cannot!—I cannot!—It must not be!" "Because," says Frank, "this wise world has decreed that to abhor, reprove, and avoid vice in a father, instead of being the performance of a duty, is offensive to all moral feeling."[21]

CALEB WILLIAMS

The lesson of these fine though minor novels is that the important precursors of *Caleb Williams* are not the overt radical novels but some granddaughters of *Clarissa*. Godwin changes only the sex, making his struggle man against man, father against son, instead of the father (husband) against the daughter (wife) of Inchbald and Holcroft. It is Godwin also who adds to a sense of time and its progress a sense of history. The successive authority figures who appear in Caleb's story are associated with progressive epochs of government. Tyrrel is linked to Hercules and Antaeus, primitive mythical heroes, Falkland to Alexander, Nero, and Caligula, classical kings and tyrants, and even the thief Raymond is labeled a "democrat." It is this aspect of the Jacobin novel that sets it off from the gothic genre. For whereas the practitioners of the gothic focused primarily on the *Then* of fiction, in opposition to the Richardsonian sentimentalists, who concentrated upon the *Now*, Godwin and the Jacobin novelists combined the two in order to see the past as the source of the present. Godwin's example introduces the idea of historicity into the novel.

21. *Anna St. Ives*, ed. Peter Faulkner (London, 1970), p. 134.

In his initial, discursive response to the Revolution, *Political Justice* (1793), Godwin argued that "the great cause of humanity" is hindered by both the ancient tradition of Burkean thought (in his *Reflections*) *and* by the "friends of innovation." He focuses on the second, bringing to bear Burke's own argument that "to dragoon men into the adoption of what we think right is an intolerable tyranny": The French have shown that to overthrow tyranny is to have to become greater tyrants themselves.[22] Godwin's own theory is that the orderly process of growing philosophical awareness—a passive process—was dangerously interrupted by the Revolution and perhaps directed into the wrong channels. His second point is that "Coercion first annihilates the understanding of the subject upon whom it is exercised, and then of him who employs it." Unlike Lewis, who focused on the subject alone (filling in the "him who employs it" in the Church and the Devil), Godwin explores the relationship between subject and master.

Caleb is, like Ambrosio, a Faustus figure who describes his "crime" or "offence" as "a mistaken thirst of knowledge" (knowledge of his master's crime) but couches his obsessive quest in sexual terms. He feels a "thrill" in his "very vitals" when he approaches the secret, and Falkland responds by insisting that Caleb "shall not watch my privacies with impunity" and threatening him with a pistol. Such words as *pleasure, pains, perpetual stimulus, insatiable desire, satisfaction,* and *gratification,* all directed to the subject of his quest, have the same sexual overtones we observed in Burke's description of the revolutionaries. When Caleb realizes that Falkland is a murderer, he says, "My blood boiled within me"—as we are told that Ambrosio's "blood boiled in his veins" when he looked upon Rosario–Matilda's bosom. "I was conscious to a kind of rapture for which I could not account," Caleb goes on. "I was solemn, yet full of rapid emotion, burning with indignation and energy."[23] Based on Godwin's insight into the nature of the servant–master relationship for both parties, Caleb's almost sexual curiosity releases all the darker potentialities of Falkland's inner self and so lays Caleb open to both inhuman pursuit and persecution by his master and the corruption of his own nature.

If the sexual urge is implied, however, there is no Matilda, Marie Antoinette, or Sin present as its object. The object of desire—the invisible figure of Sin in the Satan–Death confrontation—is Falkland's box and its secret. Only because the chest is so precious to Falkland (in the manner of Bluebeard's locked closet) does it take on for Caleb the attributes of a sacred object. When he is seized by "infatuation" in its presence, attempts to open

22. *Political Justice,* ed. Isaac Kramnick (London, 1978), pp. 262, 639; see also pp. 639–41.
23. *Things as they Are; or the Adventures of Caleb Williams,* ed. David McCracken (London, 1970), pp. 7–8, 129, 133.

it with "uncontrollable passion," and feels that it holds "all for which [his] heart panted" (p. 132), he is demonstrating René Girard's contention that for the subject of desire "the object is only a means of reaching the mediator."[24] The actual object of his curiosity and desire is, in effect, Falkland—his father, master, tyrant. By showing that it is really Falkland he wants to possess, or wants to identify with, and that it hardly matters what the object of desire itself is (we never know what, if anything, is in the box), Godwin demystifies the gothic fiction of the pursuit of both the young maiden and the domestic property; he exposes as a screen fiction the oedipal romance both Burke and Blake saw in the events of revolution.

Caleb's exclamation upon discovering Falkland's secret, "Guilty upon my soul," represents the metaphorical attainment of his desire. It establishes the intimacy he has sought and acts out through his flight in the remainder of the novel. Just as Falkland must hide his guilt in a "miserable project of imposture" (p. 326), Caleb must now conceal his own secret, assuming one disguise after another. (He admits to his "considerable facility in the art of imitation" [p. 238].) Even while physically separated (indeed fleeing) from Falkland, Caleb, carrying his secret which like Falkland's cannot be revealed, maintains the imitation of his model. The final stage of this process is Caleb's seeming renunciation of Falkland, which is in fact his complete identification with him, the assuming of his being as murderer, criminal, and tyrant. Caleb tells himself that he must be "bold as a lion" (p. 314) in his project, just as Falkland has been the "hungry lion" (p. 261) who sought to devour him. With his pen he seeks to "stab" Falkland as the latter had stabbed Tyrrel. His design becomes a "secret carefully locked up in his own breast" (p. 316), recalling the evidence of guilt which he sought in Falkland's box.[25] Having completed the identification process with his mediator, it is not surprising that Caleb fears he "should never again be master of" himself (p. 316).

The increasing identification with Falkland sums up one aspect of the relationship of subject and master, especially of the subject forced into rebellion. But in his identification with Falkland, Caleb also links himself to the other master-tyrant, Tyrrel, who was also described as a "lion" (p. 40) and whose summons, delivered at Emily's sickbed, is paralleled by Caleb's warrant for Falkland, which had been "delivered to him at his bedside" (p.

24. See Girard, *Desire, Deceit, and the Novel*, trans. Yvonne Freccero (Baltimore, 1965), p. 53.

25. While Falkland had appeared to be a devil earlier ("His complexion was a dun and tarnished red . . . and suggested the idea of its being burnt and parched by the eternal fire that burned within him" [p. 280]), Caleb's body seems to "scorch" his own hands with "the fervency of its heat" (p. 318), and he wonders how he could be "so obstinate in a purpose so diabolical" (p. 320).

319). All three "tyrants" use the law as a means to avenge themselves, and all are associated in their tyranny with the language of religion.[26]

With Tyrrel too the object of contention is secondary, gaining its importance only from association with the mediator, Falkland. Thus Tyrrel, who has no reason to expect or wish Clare to be his confidant, becomes incensed when he sees Falkland's friendship for him and is outraged by not being chosen executor of the poet's estate. Before Emily became associated in his mind with Falkland, Tyrrel had looked upon her with "paternal interest" but little else: "Nearness of kindred and Emily's want of personal beauty prevented him from ever looking on her with the eyes of desire" (p. 40). Once he believes that Falkland desires her, however, he enlists Grimes to marry and, when this fails, to rape her. As Robert Kiely points out, Grimes is a double for Tyrrel himself, and the words used to describe him (as Tyrrel's engine or instrument) are euphemisms for his sexual function.[27] At the same time, Tyrrel thinks that *he* is being persecuted by Falkland; their conflict appears to him absolutely reciprocal. The accident that places Emily under Falkland's care thus becomes to Tyrrel the intentional plotting of a rival, "that devil that haunted him at every moment, that crossed him at every step, that fixed at pleasure his arrows in his heart" (p. 80).

Falkland is, of course, an obvious mediator for the desires of these people because the community associates him with the ultimate master and model, God the Father. He is known "only by the benevolence of his actions and the principles of inflexible integrity by which he was ordinarily guided . . . ," and he is regarded "with veneration as a being of superior order" (p. 7). When he catches Caleb at his box, he cries: "Begone, devil! . . . Quit the room, or I will trample you into atoms" (p. 8). Indeed, Caleb's "state of mental elevation" at his discovery of Falkland's guilt—which is a discovery of the knowledge of good and evil—takes place "while I was in the garden," and "when I thought myself most alone, the shadow of a man as avoiding me passed transiently by me at a small distance" (p. 130), recalling Genesis 3.8 (where Adam and Eve "heard the voice of the Lord God walking in the garden in the cool of the day").

On one level, Godwin is demystifying the story of the Fall in terms as unmistakable as Blake's in "The Poison Tree" and his "Bible of Hell." Part of the demystification is the fact that *all* the characters, including Falkland

26. Tyrrel has "certain rude notions of religion" (p. 36) and takes the tone of a preacher: "True, Sir, all this is fine talking. But I return to my text; we are all as God made us" (p. 30). Falkland describes his reputation as a "deity . . . that he has chosen for his worship" (p. 102); he speaks of his trial as a "solemn examination" (p. 120), and like Mephistopheles, adjures Caleb "by everything that is sacred and that is tremendous" to preserve his faith in the compact of guilt. Caleb similarly, in his denunciation of Falkland, speaks in biblical tones, adjures Collins to respect his wishes, and is rendered "solemn" (p. 316) by his purpose.

27. Kiely, *The Romantic Novel in England* (Cambridge, Mass., 1972), pp. 88–89.

himself, behave according to the principle of imitative desire. Falkland has found "something to imitate" in the chivalric code (p. 10) and his whole life is brought down by his rigid imitation of this model. The villagers read poetry "from the mere force of imitation," and in their applause for Falkland's "Ode on Chivalry" they "emulated each other" (p. 26). They are unable to control the fire that threatens their village because "they had no previous experience of a similar calamity" (p. 42). The thieves who attack Caleb are also urged on by the "spirit of imitation" (p. 212), and Gines is surrounded by comrades who have "imitated his conduct" (p. 217). In *Thoughts on Man*, written in 1831, Godwin proposed that the dominant mode of man's behavior is imitative: "Our religion, our civil practices, our political creed, are all imitation."[28]

Virtually nothing is incited or resolved directly in the world of *Caleb Williams*; it is instead brought about through a third or mediating agency. Falkland is involved in disputes with Malvesi and Tyrrel over the affections of Lady Pisani and Miss Hardingham. Tyrrel wreaks his vengeance on Emily through Grimes and the law and similarly reduces Hawkins through court actions. Caleb probes Falkland by discussing Alexander the Great and poor Hawkins, and Falkland in turn sets Gines (whose name Godwin changed from Jones in the second edition, thus rhyming it with Grimes) on Caleb's track. Even the old hag at the robbers' den does not hate Caleb for his own sake but because he was the instrument that brought about the expulsion of Gines, for whom she had a particular regard.

Caleb describes the judge to whom he applies for Falkland's warrant as the "medium of a charge of murder" (p. 316), and the hearing is arranged "to find a medium between the suspicious air of a private examination, and the indelicacy, as it was styled, of an examination exposed to the remark of every casual spectator" (p. 318). The law, like mediated desire, divides men and cuts off intersubjectivity, and the triangular conflicts of mediated desire are reflected in the triangular structure of courtroom conflict. All the passionate triangular conflicts are concerned with "rights." Malvesi, for example, "alternately thought that the injustice might be hers or his own"; Falkland insists on his rights at the dance ("I will suffer no man to intrude upon my claims . . . no man shall prevent my asserting that to which I have once acquired a claim" [pp. 13, 22]), and Caleb's search for justice in the second volume is actually a passionate quest. It becomes clear that Godwin is drawing a parallel between the mediation that directs desire and the laws which are mediators for society.

Caleb Williams presents a fallen world (the word itself and synonyms such as *precipitate* occur at least thirty times) in which divinity is denied and the temptation is to make gods or devils of others through mediated desire. As

28. *Thoughts on Man* (1831), p. 186.

Girard notes (p. 59), "The denial of God does not eliminate transcendency but diverts it . . . the imitation of Christ becomes the imitation of one's neighbor," and the "need for transcendency is satisfied by mediation." In his three main characters Godwin represents this same "deviated transcendency," but in Caleb's ultimate renunciation of self and recognition of Falkland he implies the necessity for sympathy and impartiality through direct communication. The ideal of direct, unmediated action was earlier suggested by the position which Clare, perhaps the only good character in the novel, had taken when he rejected the notion that mediation was necessary. In drawing up his will he "did not choose . . . to call an attorney. In fact it would be strange if a man of sense with pure and direct intentions should not be able to perform such a function for himself" (p. 33).

In his treatment of the servant's revolt against his master, Godwin reveals beneath the apparent fiction of the oedipal conflict a more basic one of sheer repetitive confrontation between a pair that at its most elemental (even more primal than father and son) is model and imitator or disciple—between the model's desire and the disciple's desire. The latter, Caleb, is faced with double injunctions to imitate and not to imitate, to be like the master in every way but in a crucial way not to be like him. Caleb cannot cope with this double bind and so disobeys or revolts, incidentally seizing the object of desire sequestered by the king/father/model (and thus made desirable). It is not, as Burke supposed, a single predetermined object that causes the conflict between subject and master. Rather it is *any* object as long as it is desired by one party in a relationship of power with another. Patricide-incest, only one such case, is shown to be subsumed under a more general fratricidal violence. "Patricide," as Girard says in *Violence and the Sacred*, "represents the establishment of violent reciprocity between father and son, the reduction of the paternal relationship to 'fraternal' revenge." A further reduction of difference is taking place, the more spectacular in a political revolution because "the hierarchical distance between the characters, the amount of respect due from one to the other," is so great between king and subject.[29]

The sort of merging into undifferentiation we noted as a formal characteristic of the grotesque in art is also taking place in *Caleb Williams*. Falkland tries to create a grotesque monster of Caleb by the double injunctions to imitate and not to imitate, and by disobeying him Caleb creates another monster, the subject who is also monarch, the son who is also father. Whenever this sort of merger takes place (father and son reduced to brothers or to the monster father-son) violence must follow, leading to a never-ending cycle of retaliation which is in its own way another form of undifferentiation.

Burke would have agreed that what the Revolution was all about, in its

29. *Violence and the Sacred*, trans. Patrick Gregory (Baltimore, 1972), pp. 47, 74.

social dimension at least, was *difference*. Once it had achieved its first aim of "liberty," its second aim (perhaps a consequence of the first) was to bring about the "equality" of undifferentiation, which he predicted would produce uncurbable violence. It may be that in his revolutionary fiction Burke tried to restrain the conflict at the oedipal stage, where it was still safe and manageable. This could be seen in his fear and loathing of the transformation of a beautiful woman into something he associated with male energy and power, therefore into a grotesque. Wollstonecraft, by contrast, recognized in the women who marched on Versailles the loss of sexual difference as just the self-transformation into aggressive male figures that was necessary to bring about a revolution of the sexes.

We have followed a progression, formal and thematic, from the problem of liberty to the problem of equality in Blake's lamb-tiger or his Orc-Urizen to Rowlandson's strange amalgams to Gillray's George III, who is also Louis XVI and also John Bull. In each case, whether as comedy, tragedy, or the grotesque, the elision of difference is presented as leading to uncontrollable reciprocal violence. Rowlandson, the great celebrator of undifferentiation, depicted the violence that always (by being placed in contiguity with undifferentiation) seems a consequence of it. He expressed the duality of this violence, seemingly both harmful and beneficial, destructive and purgative, a threat and (as his artist satires showed) the true subject of art. Gillray's response was yet more deeply ambivalent: The undifferentiation itself was what he presented, and significantly he omitted Rowlandson's reference to the object of desire, the woman. His picture was more that of two parties joining to destroy a third, the extremes of a Pitt and a Napoleon devouring the world, and perhaps mediated by the same desire of each other that directs them to consume the same pudding. Thus a Pitt and a Fox join to destroy John Bull. It is in *this* sense that Gillray sees the disappearance of difference in endless reciprocal aggression that eliminates any distinction between antagonists.

If Gillray exposes the undifferentiation of the sources of violence, making it clear that both sides are evil, both fratricidal (Laius as culpable as Oedipus), then Godwin levels the master and his servant, as well as all the other masters and servants, into reciprocal fratricides based on a single principle of mediated desire. These figures allow themselves to regress toward both an undifferentiation and interchangeability in which the prioress and the mob, the monk Ambrosio and the Church's tyranny, Caleb and his master Falkland, and the French as starving cannibals and the English royal family as miserly noneaters are all one. All these artists are producing monsters in the grotesque sense of doubles or figures possessed by other figures. The only difference is that Godwin does not offer us the kind of fetish created by Gillray or Rowlandson on which to displace our anxiety from the harsh reality.

Undifferentiation is a characteristic shared by the gothic and the gro-
tesque. They also share the expression of the radical alienness of an experi-
ence, in this case the French Revolution as seen by nonparticipants. There
was a double irony in that the English saw the French also feeling an "es-
trangement" (Kayser's term) from the original aims of their revolution (lib-
erty, equality, and fraternity). One way of seeing this phenomenon was as
a normal world under the influence of demonic forces, with familiar ele-
ments suddenly transformed into the strange and ominous. But both gothic
and grotesque focus on the moment of estrangement, the transition be-
tween this world and that, when plant and human are in metamorphosis
and in the process of growing indistinguishable.

Among the lesser novelists the alternatives seem to have been to portray
a hero who goes out into the world and learns how corruptly society op-
erates, and is disillusioned; or to portray a hero who, once he has learned
this, goes around setting things straight. The first was Holcroft's strategy
in *Hugh Trevor* (1794–97), which is hardly an advance on Smollett's *Roderick
Random* (1747). The second solution was followed by Bage in *Hermsprong,
or Man as He Is Not* (1796). An American, an echo of the Huron in Voltaire's
L'Ingenu with no clear past, enters and disrupts the remote, over-
conventionalized society of Grondale. He talks about the French Revolution
and the clamp-down on freedom of speech and thought in England, seeing
from the vantage of an American who has come to England by way of
France.

It is no surprise to find a great many children either disowned or cut off
by their fathers. (Hugh Trevor has the same sort of relationship with his
grandfather.) In *Hermsprong* Glen's father will not acknowledge him; Miss
Campinet's will barely acknowledge her, sending her off to live with an
aunt; Miss Fluart's father has died, turning her over to a lawyer-guardian.
Bage takes up Burke's panegyric on primogeniture and aristocratic chivalry
and gives us appalling examples in Lord Grondale and Sir Philip Shestrum,
with Dr. Blick their toady clergyman. A sprightly dialogue between Miss
Campinet and Miss Fluart replays the argument between Anna and Frank
Henley on the loyalty to a father, concluding that a tie of blood is not suf-
ficient sanction for tyranny. Hermsprong is lucky enough to have no such
ties. Asked where the "price" of custom "is *not* paid," he answers Miss
Campinet: "Amongst the aborigines of America, Miss Campinet. There
. . . I was born a savage." "I am a young American, without father or mother;
but with a fortune that sets me above the necessity of employment." Thus
he operates as an Orc figure who shatters the image of the decadent, self-
indulgent aristocracy (Bage's image of leading strings recalls Goya's *Capri-
cho* no. 4). Having assumed their inherited role as protector in emergencies
when they are absent or unable to act, he proceeds to defeat their strategies

to discredit him and at the end reveals himself to be the rightful heir to the land and title which Lord Grondale has usurped.

Being an aristocrat himself is a convention that keeps the novel safe. Another is Bage's denouement. After preparing for an uprising of Lord Grondale's miners, with his fiefdom collapsing around his ears and this English Louis XVI even planning a "flight to Varennes," Bage has the revolt fail to materialize when Hermsprong dissuades the miners, using arguments of an almost Pittite hue.

One can detect in these novelists various kinds of revision or Jacobinizing of the conventional forms, both social and fictional. The Jacobinization of the Smollettian picaresque in *Hugh Trevor* involves making the "impetuosity" of the picaro reflect on the French, who were regarded by the English as excessively impetuous (Burke's *energetic*), and more so in their catastrophically overzealous revolution. Richardson's Sir Charles Grandison, the perfect Christian hero, may be thought of as Jacobinized by Godwin into Ferdinando Falkland. Jacobinization is a way of allegorizing, or re-allegorizing, conventional forms or topoi. In *Anna St. Ives*, in its own terms a strong novel in the *Simple Story* and *Caleb Williams* line, one also finds a general allegory of class in Sir Arthur's mania for improvement and his factotum Abimelech Henley's exploitation of this mania, and the central triangle of Coke Clifton, Anna, and Frank represents values of chivalry, reform, and perhaps "nature," respectively.[30]

The allegorization extends also to some easily identifiable "parallels" with historical personages. Burke becomes a fictional type: Sir Barnard Bray and Falkland (and to some extent Godwin's St. Leon) are all portraits of him; as Dr. Blick, the fat bishop in *Hugh Trevor* and other bad clergymen are portraits of Bishop Horsley; Lord Idford alludes to the Duke of Portland; and *Bryan Perdue* contains references to the "English Pit" and to pitfalls. Gary Kelly makes the point that allegorical resonance is achieved by the play on names. He gives us elaborate sources for Coke Clifton and other Holcroft names but focuses on *Caleb Williams*. Falkland's name is meant to recall the Lord Falkland of the Civil War (down to the fact that he fought a celebrated duel) and Ferdinando is a specific reference to the "heroic and chivalric King of Spain." We can at least accept Ferdinando as a generally chivalric name,

30. If we put aside the Godwin model for a "Jacobin novel" embodied in this succession of novels, we are left with a number of more traditional models. These are masked by the tendency to call Jacobin fiction (plays as well as novels) *Such Things Are* or *Wives as They Were and Maids as They Are* (Inchbald, 1787, 1797), *Man as He Is*, *Things as They Are*, *Elinor, or The World As It Is* (Mary J. Hanaway, 1798), and *What Has Been* (Mrs. Mathews, 1803). These titles, usually disingenuous, do express the attempt to get out from behind the conventions of fiction and show conditions as they were. The greatest and most successful case was Goya's *Desastres* with the inscriptions "Can such things be?" or "Such things are" or "I saw this myself."

and certainly Godwin, like many of his contemporaries, brought the present conflict into the context of the English Civil War. It is even possible that Falkland therefore equals ancien régime France, and Caleb the early moderate reformers of the Revolution—Lafayette and the Girondins, and in particular General Dumouriez, who was "faced with the agonizing decision of having to join France's enemies and seek her downfall, or leaving the national distemper to run its course." (Dumouriez's *Memoirs* were translated by a friend of Godwin's in 1794.) Somewhere within all of these novels lurked the allegorical mode with its simple equivalents.

THE RETROSPECT OF *FRANKENSTEIN*

Man searches for body equivalents for any important, unexplained phenomenon, from unordered nature to revolutions. But if, as H. L. Mencken said, "Revolution is the sex of politics," and at the outset the most common metaphor was of sexual release—whether spring's bursting buds (in Paine's *Rights of Man*) or Blake's Orc breaking his chains and raping his tyrant-captor's daughter—by the end it had become images of parturition, of giving birth to creatures such as Victor Frankenstein's, regarded as (depending on the point of view) a victim or a monster.

The relationship between love and revolution is epitomized in *The Monk* by the story of Agnes the nun, whose love is a human reaction against immurement and whose child is the consequence and sign of her rebellion. The model for a rebellion in the style either of Rowlandson or of Lewis has a woman locked away, a lover who penetrates her cell and her body, and the child that proves the rebellion to the world. In *The Monk* the nun is the subplot equivalent of Ambrosio, whose sexual energy is unproductive. By its telltale presence, however, the baby also exposes Agnes to the prioress's wrath and itself dies in the dungeons of St. Clare.

The plot of *The Monk* can be seen as a version of the revolutionary scenario as far as the Terror; Mary Shelley's *Frankenstein* (1818, the year in which *Northanger Abbey* was finally published) was to some extent a retrospect on the whole process of maturation through Waterloo, with the Enlightenment-created monster leaving behind its wake of terror and destruction across France and Europe, partly because it had been disowned and misunderstood and partly because it was created unnaturally by reason rather than love within the instinctive relationships of the Burkean family.

One aspect of Shelley's fable is recalled in her remark, on her elopement journey across France in July 1814, on the swath of devastation cut across France by the Russian troops following Napoleon's retreat from Moscow.[31]

31. *History of a Six Weeks' Tour through a Part of France, Switzerland, Germany, and Holland* (1817), pp. 19–24. We should also recall Mary Shelley's account of her visit to Versailles and of seeing a particular boar hunt illustrated in a book in the royal library, and reading into it the

The cossack terror was in some sense the final consequence of Napoleon's—ultimately the French Revolution's or the French ancien régime's—Frankenstein monster. In this crescendo of destruction can be read an allegory of the French Revolution, the attempt to recreate man and the disillusionment and terror that followed, not ending until Waterloo in 1815, the year between the Shelleys' two trips to Switzerland.[32]

We also know that in 1816 they toured revolutionary landmarks, even trying to locate the famous rooms in Versailles where the outrages described by Burke had taken place. Shelley had read the Abbé Barruel's *Mémoires pour servir à l'histoire du jacobinisme* (1797–98) while at Oxford, and both Shelleys read it during their 1814 tour. Mary was reading as well her mother Mary Wollstonecraft's *Historical and Moral View of the Origin and Progress of the French Revolution* (1794). In the first of these, Barruel uncovered sources of the Revolution in the occult practices of the Freemasons, the illuminati, and the Albigensians, Manichaeans, and Assassins.[33]

Victor Frankenstein initially apprentices himself spiritually to Cornelius Agrippa, Albertus Magnus, and Paracelsus, and he goes off to college at Ingolstadt, which (as the Shelleys knew from the *Histoire du jacobinisme*) was where Adam Weishaupt, the symbolic archdemon of revolutionary thought, founded the Bavarian illuminati in that significant year 1776, and from this secret society supposedly grew the French Revolution. The illuminati were sworn to further knowledge for the betterment of mankind, no matter what the cost or the means. The words of M. Waldman to Victor could have been Weishaupt's own: "These [Agrippa and Paracelsus] were men to whose indefatigable zeal modern philosophers were indebted for most of the foundations of their knowledge. . . . The labours of men of genius, however erroneously directed, scarcely ever fail in ultimately turning to the solid advantage of mankind."[34]

We feel the pervasive influence of Barruel, who saw the essence of the illuminati and of the Revolution he believed they propagated to be atheism,

origin of a chain of events that had only now come to an end in the prostration of France (*Mary Shelley's Journal*, ed. Frederick L. Jones [Norman, 1947], 11, 63).

32. Shelley's next novel, *Valperga* (1823), was about Castruccio, who, to use Percy Shelley's description, "was a little Napoleon, and, with a dukedom instead of an empire for his theatre, brought upon the same all the passions and errors of his antitype" (Letters, 2, 353–54). She shows the development (to quote *Blackwood's*, 13, 284) of "an innocent, open-hearted, and deeply feeling youth" into "a crafty and bloody Italian tyrant," whose only vestige of his youth is his love for the liberty-loving Euthanasia. *Valperga* was conceived in 1817, when Percy Shelley was writing *The Revolt of Islam*.

33. See *Journals*, 1, 431; T. J. Hogg, *The Life of Percy Bysshe Shelley*, ed. Humbert Wolfe (London, 1933), 1, 367; W. E. Peck, "Shelley and Abbé Barruel," *PMLA*, 36 (1921), 347–53; and Gerald McNiece, *Shelley and the Revolutionary Idea* (Cambridge, Mass., 1969), pp. 22–24.

34. *Frankenstein*, 1818 text, ed. James Rieger (New York, 1974), pp. 42–43.

universal anarchy, and the destruction of property.[35] The three elements of the Frankenstein syndrome are the aim to replace God the creator with man, to destroy the family and its ties, and to destroy property and human life. Barruel offered an extremely symbolic explanation (down to the detection of the masonic triangle in the guillotine blade, invented by Dr. Guillotine, a freemason), one that could be called gothic in its emphasis on historical explanations and extreme causality, on devious and secret plotting, and on pseudoscience and occult philosophy.

Lee Sterrenburg argues convincingly[36] that Mary Shelley has taken from anti-Jacobin polemics Burke's parricidal monster (that "vast, tremendous, unformed spectre," cited above, p. 72). In Barruel's words this is the "disastrous monster called Jacobin, raging uncontrolled, and almost unopposed, in these days of horror and devastation," who is "engendered" by the "Illuminizing Code," that is, the secret cabal of the illuminati.

Elsewhere Barruel writes that "the French Revolution has been a true child of its parent Sect," and that "those black deeds and atrocious acts have been the natural consequences of the principles and systems that gave it birth."[37] There is, in short, a monstrous birth attributed to the illuminati, followed by the misunderstanding, persecution, and built-in monstrosity that produced the Terror and the destruction that attended it.

The *Frankenstein* plot is about the birth of a new "Promethean" man, who turns out—in the eyes of his maker and of the world—to be a monster. The actual birth is played out as the creature suddenly looms up at the foot of his maker's bed, terrifyingly off-putting, and is rejected and cast out into the world to wander alone and despised (like Adam "with all the world before him," expelled by *his* Maker). The story unfolds as monster and creator, pursuer and pursued, become as interchangeable as Caleb and Falkland in a rivalry, a triangular desire, uniting creator, monster, and the creator's mate (whom the monster, denied a mate of his own, kills).

As Sterrenburg interprets the Shelleyan allegory, two symbolic traditions join in the monster:

> From the Burkean tradition of horrific, evil, and revolutionary monsters, he seems to have derived the grotesque features that physically mark him and set him

35. Roberts, *Mythology of the Secret Societies*, p. 196. See also Clarke Garrett, "Joseph Priestly, the Millennium, and the French Revolution," *Journal of the History of Ideas*, 34 (1973), 51–66.

36. Since originally drafting this chapter (in the form that appeared in ELH, as in n. 1 above), I read Sterrenburg's excellent essay, "Mary Shelley's Monster: Politics and Psyche in *Frankenstein*," in *The Endurance of "Frankenstein": Essays on Mary Shelley's Novel*, ed. George Levine and U. C. Knoepflmacher (Berkeley and Los Angeles, 1979), pp. 143–71. This paragraph and the next have been added to the earlier version in an attempt to incorporate some of Sterrenburg's insights.

37. *Memoirs Illustrating the History of Jacobinism*, trans. Robert Clifford (London, 1793), 3, 414: 1, viii.

apart. . . . From the republican tradition of social monsters, he seems to have derived his acerbic, verbal critique of poverty and injustice, which serves as his stated rationale for insurrection. As he tells us with pointed eloquence, monsters are driven to rebellion by suffering and oppression. [p. 165]

Shelley enters the monster's mind "and asks what it is like to be labelled, defined, and even physically distorted by a political stereotype" (ibid.). For Victor's misperception of the monster, like Burke's of the revolutionary tiger or leviathan according to Blake, takes the form of nightmare: "I felt the fiend's grasp in my neck, and could not free myself from it; groans and cries rung in my ears" (p. 181). In fact the so-called monster is a stereotype into which each of the narrators—Victor, Robert Walton, and the creature himself—is locked.

The reading of her mother's book on "the Origin and Progress" of the Revolution was for Mary Shelley a way of connecting the personal and the public reality of history with Barruel's gothic fictions of origins. Mary Wollstonecraft, writing about this "revolution, the most important that has ever been recorded in the annals of man," made it very clear that its cruelties were the consequence of its origin in the ancien régime. From the court's imprisonment of representatives to the assembly, the troops' crushing public demonstrations, and the king's substituting retaliation for justice, she says, "we may date the commencement of those butcheries, which have brought on that devoted country so many dreadful calamities, by teaching the people to avenge themselves with blood!"[38] The origin of the Revolutionary bloodbath was in the cruelty of the tyrant himself, much as Arthur Young and Godwin had asserted. Percy Shelley offered the same explanation in his preface to *The Revolt of Islam* (1817–18): "can he who the day before was a trampled slave suddenly become liberal-minded, forbearing, and independent?" And he wrote in his review of *Frankenstein*:

> Treat a person ill, and he will become wicked. Requite affection with scorn:—let one being be selected, for whatever cause, as the refuse of his kind—divide him, a social being, from society, and you impose upon him the irresistible obligations—malevolence and selfishness.[39]

If these texts were the ambience, the immediate experience behind Mary Shelley's writing was the trauma of her giving birth in February 1815 to a premature baby, who died in March, and the memory of her own birth which had killed her mother twenty years before in 1797.[40] Birth trauma is

38. *Historical and Moral View*, p. 57.
39. *The Complete Poetical Works of Shelley*, ed. Thomas Hutchinson (Oxford, 1904), p. 36; *Shelley's Prose*, ed. D. L. Clark (Albuquerque, 1966), pp. 307–08.
40. See Ellen Moers, *Literary Women: The Great Writers* (New York, 1976), pp. 91–100, and *Mary Shelley's Journal*, 11, 40–41; also her letter to T. J. Hogg, 6 March 1815, in *Shelley and His Circle*, ed. K. N. Cameron (Cambridge, Mass., 1970), 3, 453.

one of the central concerns of *Frankenstein*, as it was metaphorically of Woll-stonecraft's history of the "Origin and Progress" of the Revolution, and in Mary Shelley the points of view of the parent and child merge.

Private and public life first joined in Mary Wollstonecraft's love affair with Gilbert Imlay, their idyll in Paris during the Revolution, and his be-trayal of her at the same time the Revolution itself betrayed her. The result was the commonplace similitude between revolution and sexual love, end-ing in the birth of a child rejected by its father. Wollstonecraft's recovery was through her relationship with Godwin, and this time the offspring was Mary Shelley—in whose birth (the symbolic joining of these two revolu-tionary spirits) the mother died, leaving Mary with the trauma of seeming rejection by the mother/creator, as well as by the father, who held her re-sponsible for the death of his beloved wife. She was further rejected at four by her father when he took Mary Jane Clairmont as his second wife.[41] Now to the guilt of having killed (or been rejected by) her mother was added the birth and death of her own first child, and the birth in January 1816 of her second (who survived until 1819) not long before the trip to Switzerland and at a time when she was seeing the French Revolution in its final stage, political reaction following the rejected/rejecting Revolution.

The construction of the monster, as of the makeshift, nonorganic family, is the final aspect of the *Frankenstein* plot. Burke's conception of the state as organic and the Revolution as a family convulsed was joined by Mary Shel-ley with the fact of her own "family," the haphazard one in which she grew up with other children of different mothers and with a stepmother.[42] This creation of a family of children by some method other than natural, organic procreation within a single love relationship is projected to the Frankenstein family, a family assembled by the additive process of adoptions and the like, and so to Victor's own creation of a child without parents or sexual love. The autochthonous family, made up of bits and pieces, a substitute for or-ganic growth, begins with Victor's father and leads to his own putting to-gether of his creature from a variety of different bodies. The construction of the "child" is then followed by its rejection by its "father," and then by the creature's desire for a mate of its own, the "father's" refusal, and the

41. She later recalled the "excessive and romantic attachment to my father," which she said the second Mrs. Godwin "had discovered" (*Letters of Mary W. Shelley*, ed. Frederick L. Jones [Norman, 1946], 2, 88).

42. When Mary was four, Godwin married a widow with two children of her own, to which were added Fanny Imlay, Mary Wollstonecraft's illegitimate child by Gilbert Imlay, and the child of Godwin's second marriage, William. Sterrenburg also points out (1) that Godwin, Mary's father, was referred to in conservative polemics as a "monster" of various sorts (pp. 146–47); and (2) that in *Political Justice* Godwin himself, like Victor, prophesies a new human race "to be produced by social engineering, not sexual intercourse. Godwin's scheme summar-ily dispenses with sexual reproduction, mothers, and children" (p. 148).

creature/son's systematic destruction of the father's whole family—including his bride (who would have been the mother had there been one).

A conventionally tyrannical family (Turkish in this case) is contrasted with the new rational family Frankenstein projects:

> A new species would bless me as its creator and source; many happy and excellent natures would owe their being to me. No father could claim the gratitude of his child so completely as I should deserve their's. [p. 49]

Frankenstein predictably sees himself as the father who "deserves" the gratitude of his children more "completely" than any other, and in saying so he becomes the tyrant himself. As an allegory of the French Revolution, his experiment corresponds to the possibility of ignoring the paternal (and matenial) power by constructing one's own offspring out of sheer reason—but shows that the creator is still only a "father" and his creation another "son" locked in the same love–tyrant relationship that Mary's own father had described so strikingly in *Caleb Williams* (another book Mary had reread as she undertook her novel).

Seen from the aesthetic perspective, the monster was created as an amalgam of beautiful parts. Like Apelles, Victor Frankenstein had "selected his features as beautiful," putting together these ideal elements into one figure. The result, however, was (in the technical sense) like Horace's mermaid grotesque:

> his hair was of a lustrous black, and flowing; his teeth of a pearly whiteness; but these luxuriances only formed a more horrid contrast with his watery eyes, that seemed almost of the same colour as the dun white sockets in which they were set, his shrivelled complexion and straight black lips. [p. 57]

For the artist, now inspecting his creation, "the beauty of the dream vanished, and breathless horror and disgust filled my heart"—and he flees the monster. "Beautiful!—Great God!"

We have by now distinguished two phases of the Revolution, one seen from the point of view of a lover, and the other from the point of view of the child of the union—or from the points of view of the artist and his creation. These are not so distinct as they might at first appear. The first is an Oedipus, or in Blake's terms an Orc, who becomes a rival to his father; the second is Electra or Polynices, the child of the incestuous union, the offspring of the Revolution. It is precisely this juxtaposition (or conflation) of points of view, including the parallel one of the author (expressed again, looking back from the preface of 1831, when she says, "And now, once again, I bid my hideous progeny go forth and prosper"), that distinguishes *Frankenstein* as a fictional work.

The description of the creator and his creature looking at each other in turn (pp. 52, 53), and thereafter reporting the same scenes from their re-

spective viewpoints, inevitably evokes the passage in Burke's *Philosophical Enquiry* (1757) in which, as an example of how the sublime operates, Milton's Satan and Death are described as if facing each other, each seeing the other from his own point of view, as mutual challengers. There is, of course, no mother in the case of Frankenstein's creature, and so no Sin of the Satan–Sin–Death paradigm, because Victor thinks he can create out of himself alone (as Satan originally did Sin). But the mutually destructive conflict proves to be over the creature's mate, and the victim is Victor's own mate. As in Burke's example, Sin is the invisible third party standing between the father and son.

The world seen by creator and creature is constructed of the most familiar image patterns associated with the Revolution, beginning with Barruel's illuminati. The word *illuminé* was, of course, radically ambiguous, "used by people in diametrically opposed ways" as reason and as revelation, as right and as wrong, as royal authority and as human liberty.[43] When Victor reads Cornelius Agrippa he finds that a "new light seemed to dawn upon my mind" (p. 32), and this is the familiar illumination which (as in Paine's usage) becomes fire in the thunderstorm that first suggests the idea of how to galvanize inert matter into life:

> on a sudden I beheld a stream of fire issue from an old and beautiful oak, which stood about twenty yards from our house; and so soon as the dazzling light vanished, the oak had disappeared, and nothing remained but a blasted stump. When we visited it the next morning, we found the tree shattered in a singular manner. It was not splintered by the shock, but entirely reduced to thin ribbands of wood. I never beheld any thing so utterly destroyed. [p. 35]

This description of lightning/electricity as both life-giving and utterly destructive, aimed at "an old and beautiful oak," is a final echo of the vocabulary in which Mary Shelley's mother and her opponents (in particular Burke with his British oak) had described the Revolution. The effect is that of the crowd's vengeance in *The Monk*, but the image leads into the Promethean associations of light and fire, benevolence and destruction. (Napoleon was associated with Prometheus by Byron and his own propaganda machine.)

The creature is born into light, so strong that (he says) "I was obliged to shut my eyes" (p. 97), and darkness and light alternate as he closes and opens his eyes. While light allows him to move about and "wander on at liberty," it leads him to seek relief in its opposite: "The light became more and more oppressive to me; and, the heat wearying me as I walked, I sought a place where I could receive shade" (p. 98). His enlightenment-oriented master, we recall, was given to remarking that "Darkness had no effect upon my fancy" (p. 47).

43. Roberts, p. 134. See also Andrew Griffin, "Fire and Ice in *Frankenstein*," in *The Endurance of Frankenstein*, pp. 49–73.

As the creature's eyes became "accustomed to the light" so that he can now "perceive objects in their right forms," he comes upon light in its next higher incarnation, fire:

> I . . . was overcome with delight at the warmth I experienced from it. In my joy I thrust my hand into the live embers, but quickly drew it out again with a cry of pain. How strange, I thought, that the same cause should produce such opposite effects. [p. 99]

Frankenstein's monster runs the gamut of the associations of birth, springtime, and the heat that becomes destructive fire, found in so many of the writings of the Revolution. His birth is described as a kind of emergence into spring, and his progress is to the beautiful spot of the cottagers, from winter to spring (p. 111), followed by the disastrous confrontation and dispersal of himself and the foster-family he had tried to join. Victor describes his own breakdown after the "birth" of the monster, and then his recovery, in terms of the seasons:

> I perceived that the fallen leaves had disappeared, and that the young buds were shooting forth from the trees that shaded my window. It was a divine spring; and the season contributed greatly to my convalescence. I felt also sentiments of joy and affection revive in my bosom. . . . [p. 57]

The irony is that Victor fails to recognize the connection between his production of the monster and this rebirth and the conventional imagery going back to Paine and Mary Wollstonecraft of the Revolution seen from a positive point of view as the beautiful. Victor sees it instead as the grotesque and horrible, and the tragedy of his reaction is that like Burke he turns the creature into the destructive force he reads into his aesthetic response to it. The creature *is* a monster, as its rational principles of organization should have predicted, but, Shelley seems to be saying, what is needed is the beautiful love of a mother, not the sublime fear of a father who cannot come to terms with the unmanageable male-threatening force he has loosed.

The warmth of spring ends as destructive and then self-destructive fire. The creature tells us that he is going to end his life on a funeral pyre at the North Pole:

> Soon these burning miseries will be extinct. I shall ascend my funeral pile triumphantly, and exult in the agony of the torturing flames. The light of that conflagration will fade away; my ashes will be swept into the sea by the winds. My spirit will sleep in peace. . . .

And having said this, he makes off on his ice raft, and the novel ends: "He was soon borne away by the waves, and lost in darkness and distance" (p. 221)—transformed into a final sublime object of contemplation.

It seems not possible to write about the Revolution and avoid the aesthetic categories first introduced by Burke in his *Reflections*. Victor has made

his creature out of beautiful features but the scale is too large and the juxtapositions are grotesque—and the whole inspires terror. The beautiful cottage, its surrounding scenery, "the perfect forms of my cottagers" (as the creature says), and Safie with her "countenance of angelic beauty and expression" (pp. 109, 112), are set against the looming incomprehensible presence of the monster which destroys the locus amoenus and disperses this, yet another family.

Made of bits and pieces, not a synthesis but a formless and grotesque mixture, Frankenstein's monster is the ultimate in the mergers we have seen of man and woman, father and son, master and servant, oppressor and oppressed, violence and victim: an amalgam that includes Victor Frankenstein, the monster's creator and double. The merger produces the same blind violence we have seen, but after the killing has reached to the creator/master the creature goes off to make of himself an ultimate sacrifice on a pyre, an echo of Caleb's realization at the end of Godwin's novel. There is an aspect of the monster in this fiction that involves his atonement, either in his death or in an access of understanding, for the violence that was engendered upon him and that he himself has engendered.

CHAPTER 8 🖎
WORDSWORTH'S *PRELUDE*

O *pleasant* exercise of *hope* and *joy*!
For mighty were the auxiliars which then
 stood
Upon our side, us who were strong in *love*!
Bliss was it in that *dawn* to be alive,
But to be *young* was very heaven! O times,
In which the meagre, stale forbidding ways
Of *custom, law, and statute* took at once
The attraction of a country in *romance*!
 [*Prelude*, bk. XI, ll. 105–12]

The emphasis falls on those by now familiar terms of the revolutionary experience outlined positively by Paine and Blake and negatively by Burke. Books IX–XI are the "revolutionary" books of *The Prelude*, in which Wordsworth recreates his experience of the 1790s. But his invocation to book I, although it never mentions the French Revolution, is couched in the vocabulary that will dominate the poem. It is a vocabulary of double meanings, strong and weak, manifest and latent, which designate the poem's most basic polarities of external and internal, political and poetic.

When Wordsworth starts a verse paragraph, "Dear Liberty" (l. 31), he cannot but introduce the two senses of *liberty*, including the French *liberté*, which he later contrasts in the episodes of boat-stealing and ice-skating: one is a challenge to social authority followed by retreat and internalization, the other a free play of private imagination in a form of art. He skates on ice that covers the waters of the lake into which he had been plunging the oars of the stolen boat.

So also the "correspondent breeze" (l. 35), the echo within him of the natural forces without, is both a metaphor for the creative process that emerges in the course of *The Prelude* and a memory of the political vocabulary associated with the Revo-

lution. It is this "correspondent breeze" that is

> gently moved
> With quickening *virtue*, but is now become
> A *tempest*, a redundant *energy*,
> Vexing its own creation. [ll. 35–38]

The poet moves from "breeze," the constructive poetic inspiration (as in the "Aeolian visitations" of l. 96), to "tempest," the breeze transformed into a destructive force that will "vex" its own creation (the central metaphor of book V); and also from "virtue" to "energy," the word used by both Burke and Fox for the revolutionary stimulus to liberation. Virtue/breeze becomes, in the actual experience of the Revolution, energy/tempest.

Thus at the end of the passage "A cheerful confidence in things to come" (l. 58) refers both to the future of the poet now that he has moved beyond the political-social experience, away from the city and into the bower of nature, and also to the still hopeful future of the social organism as a whole. Or perhaps the second meaning has by this time been canceled out, or internalized, in the first—the tempest in the "gentle breeze" of the first line of the poem.

Other familiar revolutionary associations run through book I. Both the breeze and the tempest "join / In breaking up a long-continued frost, / Bring[ing] with them vernal promises": the imagery of winter breaking and dissolving into spring from Paine's *Rights of Man*. In a general way the epic-invocation of book I is laid out on a pattern of *choice* (a word repeatedly used) between the threat/lure of the "tempest" of "this passion" and the withdrawal to a "green shady place," a locus amoenus where the poet will settle "into gentler happiness" (ll. 60–64):

> Content and not unwilling now to give
> A respite to this passion, I paced on
> With brisk and eager steps; and came, at length,
> To a green shady place, where down I sate
> Beneath a tree, slackening my thoughts by choice,
> And settling into gentler happiness.

This refuge from the "passion" of tempest/energy also reflects the transition Wordsworth works out in *The Prelude* between the sublime and the beautiful. The latter is "the sheltered and the sheltering grove / A perfect stillness," the "soft couch" of line 86 and the "hermitage" of line 107, all of which develop the associations of Burke and others with the beautiful experience that is being swept irretrievably away by the French Revolution.

Again, speaking of "hope" that "hath been discouraged," the poet introduces the familiar imagery of light: "welcome light / Dawns from the east [i.e., from France], but dawns to disappear / And mock me with a sky that ripens now / Into a steady morning . . . " (ll. 124–27). One possibility, or

"choice," is to recall "the bold promise of the past," of the revolutionary years, and thus "grapple with some noble theme," but this possibility has been rejected for the reasons cited ("Impediments from day to day renewed"). Thus he is going to turn from "those lofty hopes" toward "present gifts / Of humbler industry," another transition from the sublime to the beautiful.

Here, addressing Coleridge, he makes a crucial equation:

> But, oh, dear Friend!
> The Poet, gentle creature as he is,
> Hath, like the Lover, his unruly times. . . . [ll. 134–36]

The poet, though a "gentle creature," is nevertheless compared to a lover with his "unruly times," and later linked to "his own / Unmanageable thoughts," his "passion." Into the ambience of political upheaval—the passionate and sublime experience Wordsworth has tested and somehow contrived to pass beyond—has now slipped the metaphor of the lover's passion, which will in turn have been transmuted by the end of the poem into the gentle love of his two "friends," his sister Dorothy and Coleridge.

The poet's "choice" of an epic subject then takes him back to traditional literary themes like those of Milton's *Paradise Lost*, even of chivalry, which he rejects, and thence at length back to his own youth. This originary time is both his chosen subject and the world of the locus amoenus seen as maternal solicitude ("a babe in arms," "infant softness," ll. 276, 278) and the world of Burke's aesthetic category the beautiful, though constantly threatened by the temptations to sublime "liberty."

In the passage that opens his recollection of childhood the opposing terms (public, private; political, poetic; sublime, beautiful) begin to intermingle. The images are mostly of maternal softness, peace, shelter, and love, but the "more than infant softness" appears "Amid the fretful dwellings of mankind" (l. 280), and the "smooth breast" of the mountain lies in the "shadow of those towers / That yet survive," the "shattered monument / Of feudal sway" (ll. 283–85). The passage describing the pleasures of a five-year-old boy leads from bathing in streams and basking in the sun to the view of "distant Skiddaw's lofty height," and finally to the first "spot of time," which follows from the formulation of the hints that have been gathering: that this "Fair seed-time" was "Fostered alike by beauty and by fear," by forces both beautiful and sublime. The poet goes out with bird-traps over his shoulder; his "visitation" now becomes "anxious," and as earlier in the presence of "Skiddaw's lofty height,"

> I was alone,
> And seemed to be a trouble to the peace
> That dwelt among [the moon and stars]. [ll. 315–17]

And in these "night wanderings," sometimes "a strong desire / O'erpowered [his] better reason," and the birds became his "prey," his "captive." At this moment the "solitary hills" seem to rise and pursue him, his guilt materialized in an apparent retribution by the offended shapes of towers and mountains, the images of paternal authority ("Thou shalt not steal").

There is a strong sense in book I of indirection, of euphemism, even of writing in the presence of a censor whom the poet has to placate by using words with double or triple meanings. It is nevertheless possible to read Wordsworth's *Prelude*, in the manner of Burke's *Reflections* or Blake's prophetic books, as about the experience of coming to terms with the Revolution, not simply as a representation of the phenomenon itself. *The Prelude* draws upon the externalizing stereotypes of dawn, youth, love, and passion (as well as pleasure and bliss), but as secondary to the poet's own developing imagination, and as a retrospect, looking back from the end of the century and the end of the Revolution.

Burke and Blake had already set out the kind of progression we can call the revolutionary plot. It took two forms: a movement from circular to irreversible change with internalization of the fallen tyrant by the rebel, and a story about an observer at some distance from the conflagration but with a stake of his own and a progression from innocence to experience (or failure to make this transition and adjustment), involving an internalization (or transcendence) of the revolutionary experience. In Blake's later works, especially *Milton* and *Jerusalem* (1804), the general quest became a personal one, not altogether unlike Wordsworth's but with a crucial difference.

We can see this difference by noting the literary model for both writers: Milton's *Paradise Lost*. Blake took, revised, and criticized the revolutionary poet Milton, who was personally involved in a real revolution, suffered in its failure, and sublimated or internalized (or externalized) his experience of it in *Paradise Lost*, as an imaginary construct, essentially a vision. Blake's persona—his bard—is the poet who lives through revolution and is himself a revolutionary force, a prophet (of the Old Testament sort who speaks the truth against kings and anticipates the Messiah of the New Testament) who projects and in some sense *is* the revolution. In *Milton* Blake is trying to correct a revolutionary position in John Milton, and in *Jerusalem* he himself is the revolutionary who can no longer fight it out on the ground but must raise the battle to a higher, imaginary plane.

At a certain point, carefully defined, Wordsworth commits the revolutionary act. But he slips into and out of the role; in *The Prelude* he looks back on the French Revolution as a shaping force on his youth. It was something that kept him from writing poetry or offered him an alternative to poetry in action. But above all it forced upon him a new identity or a choice of identities. In *The Mysteries of Udolpho* M. St. Aubert told M. Quesnel that he preferred the "happiness" of monotonous constancy to "life" if the

latter involved the risk of losing one's true self. Wordsworth's poem puts the "true self" in doubt; the Revolution produces a new self and questions the old one, whether it is a Roman identity or one involving (as with Emily St. Aubert) her property and her sex. Conversion is therefore one of the basic revolutionary plots, followed by disillusionment or an alternating ambivalence (once more a form of Burke's plot spread out in time).

The "I" is the person who is affected by the Revolution, not (like Ambrosio) an embodiment of it; and the essential elements now become psychological categories such as absorption, sublimation, displacement, and repression. We are entering with these writers a phase of spiritual autobiography but one markedly different from the Puritan tradition embodied in John Bunyan or Robinson Crusoe. Spiritual autobiography of the earlier dispensation universalized the private events of a life history: Crusoe was an Adam or a Prodigal Son whose experience was applicable to all his readers. Private life became public history. The people of Wordsworth's generation make history (the particular events of the French Revolution, its phases and aftermath) the structuring matter of their private lives. The moment of Revolution releases man's utmost potentialities, opening for him what he may become rather than what he has been; it sees him in terms of his ultimate desires and suggests that the outer reaches of historical man can be known only through his contact with a revolution of some sort, with its attributes of cataclysm as well as sunrise. The peripety or transformation of revolution in the public realm can produce definition of the private individual.[1]

The contemporary who wrote a spiritual autobiography of the Revolution internalized this public history as a crucial part of the structure of his life, either to transmute this public experience or to escape it. The Milton of *Paradise Lost*, whom Wordsworth adopted as his model, sublimated his experience in the writing of his great epic. But his epic plot was also applicable. The Revolution equaled the redemptive value of the Enlightenment—and so its failure could be regarded either as a Fall or as a false or failed Redemption following the Fall. Blake's was the second explanation.

1. A novelist-historian such as Sir Walter Scott takes as his subject, as the nodal point of his stories, the fact of a great reversal in human consciousness and human affairs. He displaces the experience of the French Revolution back to the English revolution/civil war of the seventeenth century and makes this the situation of a social revolution: the peripety, reversal, or fall which defines his major characters, the problem of the claims of opposing historical forces in revolutionary conflict. For Scott, as later in his different way for Carlyle, political revolution is the moment that releases man's potentialities. For Scott the revolution brings about definition and definable change in the individual; for Carlyle the revolution may be only a chaotic static presence which attenuates or confuses definition or difference. But in either case it is the great moment that settles the question central to the historian. See Donald Davie, *The Heyday of Sir Walter Scott* (London, 1961), and Hedva Ben-Israel, *English Historians and the French Revolution* (Cambridge, 1968), p. 19.

The first simply supposed a fallible mankind and a need after the Fall to work out, in the manner of Crusoe, your own redemption by means of Crusoe-like constructions, whether political, personal, or imaginary. In both cases, however, a new mode of redemption was sought outside the structure of the conventional Christian religion that informed *Paradise Lost*, and this was itself a sign of the revolutionary representation.

The *Preludes* of 1805 and 1850 can be construed as Wordsworth's attempt to understand in an increasingly discursive way those childhood memories he called "spots of time" first recorded in the 1799 two-book *Prelude*. The stealing of birds' eggs and boat, the skating scene, and the drowned man are simply divided off by a mass of explanation from the official "spots of time," the gibbet and the fatal Christmas homecoming. The primal scenes Wordsworth may have been screening with those memories seemed explicable to him only in terms of other subjects: his growth as a poet and the important events (personal and political) of 1790–94. The final 1850 version then suppressed the fictional lovers Vaudracour and Julia, who even in 1805 had served to conceal Wordsworth's real love affair with Annette Vallon.[2] If there was a five-book version ending with the experience of Mount Snowden,[3] book V of the full text must represent the beginning of Wordsworth's attempt to fill in a middle which bridges the earlier and later spots of time (the stealings and the punishings), or more specifically bridges his schooldays and the Mount Snowden revelation with his experience of the French Revolution.

In book V two public images emerge: the Revolution as deluge/holocaust and the Revolution as precocious child, the book-reader who does not grow up, does not use books properly. Both are related, however, to the overarching concern of the poet's vocation: the ends to which his writing can be used, that is, either as an alternative to experience or as an ability to render it. Book V comes to a climax in the alarming experience of the drowned man whose head shoots up out of the lake, and Wordsworth promptly adds (not part of the 1799 version) that this did not faze him as a small boy because he was able to assimilate such an experience to stories he had read

2. "Vaudracour and Julia" was published separately in 1820, harmless outside the context of book IX of *The Prelude*. Citations are to *The Prelude*, ed. Ernest de Selincourt and Helen Darbishire, 2d rev. ed. (Oxford, 1959). But cf. the 1799 edition, ed. Stephen Parrish (Ithaca, 1977), and *The Prelude, 1799, 1805, 1850*, ed. Jonathan Wordsworth, M. H. Abrams, and Stephen Gill (New York, 1979), which includes the 1799 text and critical essays. Unless otherwise noted, I quote from the 1850 text in de Selincourt and Darbishire.

3. Mark L. Reed, *Wordsworth: The Chronology of the Middle Years, 1800–1815* (Cambridge, Mass.), pp. 638–44. Jonathan Wordsworth ("The Five-book *Prelude* of Early Spring 1804," *JEGP*, 76 [1977], 1–25) believes that in March 1804 Wordsworth wrote a "fifth book" which concluded a five-book version of *The Prelude* but bore little or no resemblance to what we now know as book V.

of "faery." However convincing we may find this passage as adumbration of the larger thesis of *The Prelude*, as the point of intersection between the observation of the drowned man and its absorption into literature, there is nevertheless a discrepancy of feeling here that is not as noticeable elsewhere in the poem. This is the book where Wordsworth most obviously loses his way, as if grappling without total awareness, himself part of a process of discovery. The whole book seems to be written to explain that one experience of the drowned man, and just below the surface all the subjects and themes surge forward that will surface in book IX.

The process begins with the Arab dream, a "Revolutionary dream."[4] The elements of the dream are books and the products of intellect, a seaside, the poet's anxiety at the rising tide ("the fleet waters of a drowning world / In chase of him"), and the question of survival in the face of natural disaster. The natural disaster was introduced in the opening lines and much labored over in the various drafts. Wordsworth's effort to describe his response to this "deluge," and the effect it has on his writing, is the center of book V. "Deluge" was, of course, one of the stereotyped images applied to the French Revolution. If we look ahead to the consequences of the Revolution in the Terror, we find in book X (ll. 567–68) the same seaside setting ("the great sea meanwhile / Heaved at safe distance, far retired," as well as references to rocks, shells, and horses along the strand) that appears in the dream, this time summoning up the announcement of Robespierre's execution. The Revolution is described (ll. 477–80) as

> a terrific reservoir of guilt
> And ignorance filled up from age to age,
> That could no longer hold its loathsome charge,
> But burst and spread in deluge through the land.[5]

In the dream Wordsworth settles on deluge instead of on the apocalyptic fire and earthquake he had invoked in the opening passage of book V. The

4. Mary Moorman, *William Wordsworth: A Biography. The Early Years* (Oxford, 1957), p. 250. See also J. Hillis Miller, "The Stone and the Shell: The Problem of Poetic Form in Wordsworth's Dream of the Arab," in *Mouvements Premiers* (Paris: Librairie Jose Corti, 1972), 140; Michael Ragussis, "Language and Metamorphosis in Wordsworth's Arab Dream," *Modern Language Quarterly*, 36 (1975), 148–65; Jane Worthington Smyser, "Wordsworth's Dream of Poetry and Science: *The Prelude*, V," *PMLA*, 71 (1956), 269–75; and Newton P. Stallknecht, "On Poetry and Geometric Truth," *Kenyon Review*, 18 (1956), 1–20. In Thomas DeQuincey's schema of knowledge versus power, often imputed to Wordsworth, the stone represents knowledge while the shell represents power or genius. See W. J. B. Owen, *Wordsworth as Critic* (Toronto: University of Toronto Press, 1969), p. 192. I am also indebted to Theresa M. Kelley, "Spirit and Geometric Form: The Stone and the Shell in Wordsworth's Arab Dream," forthcoming.

5. The evocation of deluge remains in "swept away" by the "river of blood" (ll. 584, 586). Further evidence can be found in the specific connection of the imagery of fire and deluge with the French Revolution in *Descriptive Sketches*, ll. 774–83, 791–809.

Deluge was what physically separated the human face from Eden, for (as Thomas Burnet, for one, argued in _The Theory of the Earth_) it was after the waters receded that the earth no longer bore any resemblance to the ordered landscape of Eden. It is appropriate that Wordsworth returns to the boundary between the fallen and unfallen worlds, experience and innocence, because his own theme is focused on childhood and on the losses and gains of maturity. But he has also turned back to the point at which the Fall and Deluge converge with the Tower of Babel. For as the Deluge carries out the geographical cutting off of the human race from Eden, the multiplicity of languages following the Babel experiment carries out (more important for the poet) the linguistic dislocation from the universal prelapsarian language. The ostensible subject, of course, is the function of writing in a world of experience and catastrophe. The shell, according to the dream, is the poetic symbol that explains that what is lost will be recreated by other words, images, and poems—which will be the language Wordsworth has to work out for himself in order to survive the Deluge.

We could argue that the elaborate discussion of water and perishable books, the stone and the shell, in book V essentially explains and rationalizes the scene in book I of the boy skating over the unmanageable water on a sheet of ice, retiring into an inlet and turning in circles, then stopping and letting the world seem to whirl around him. Those early "spots of time" were said to have

> Impressed upon all forms the characters
> Of _danger or desire_; and thus did make
> The _surface_ of the universal earth
> With _triumph and delight_, with _hope and fear_,
> Work like _a sea_. [I, ll. 471–75]

I have emphasized the words denoting the polarities we have already discussed in book I, which here lead into the image of the sea. _Choice_ is between the indeterminate, incalculable world of the sublime and the "determined bounds" of the beautiful, the memory of childhood comfort—life as a card game or as ice-skating, in which even the chase, to which war had been sublimated in Pope's _Windsor Forest_, has been transmuted to a mimicked chase on the icy surface of a lake (ll. 435), a very different situation from the "hope and fear" of the incomprehensible "sea."

It is probably significant that Wordsworth opens book V by turning from nature to man's reason (or in other versions, "reason and exalted thoughts," "reason or . . . faith," and "contemplation"), its triumphs and dangers. These are manifested in books, those that were alleged to have led men into the Revolution and those that he hopes will, through his intervention, lead at least himself out of it. The dreamer—in the 1805 version Coleridge, in the 1850 the poet himself—has been reading _Don Quixote_ and dreams of a knight

who by the end of the dream has become Don Quixote in relation to the deluge of the French Revolution. The dreamer's temptation is to follow Quixote with his books, pursued by the ocean's rising tide. (Quixote carried connotations of general book-learned folly and misguided chivalry as well as the particular reference to Edmund Burke, and a personal allusion to a nickname attached to Wordsworth himself.)

The next image after the dream is of the mother hen, the proper mother (Wordsworth's own mother) who guides her child according to nature, in effect, an un-Enlightenment/un-Revolutionary mother, whose child

> Was not puffed up by false unnatural hopes,
> Nor selfish with unnecessary cares,
> Nor with impatience from the season asked
> More than its timely produce; rather loved
> The hours for what they are, than from regard
> Glanced on their promises in restless pride. [V, ll. 282–87]

Throughout book V Wordsworth seems to be talking about something else—skirting the subject that really interests him. This passage not surprisingly ends with a break, and in the 1805 version reads:

> My drift hath scarcely,
> I fear, been obvious; for I have recoil'd
> From showing as it is the monster birth
> Engender'd by these too industrious times.
> Let few words paint it: 'tis a Child, no Child,
> But a dwarf Man. . . . [ll. 290–95]

This "monster birth" (partly suppressed in the 1850 version) is obviously more than just the child whose book-learning perverts rather than opens his imagination. He is one of the Abbé Barruel's images of the Revolution as the consequence of the Enlightenment, the philosophes, and the illuminati—of too much reading and thought dissociated from contact with experience (or nature). The child believes, and thinks he represents, the ultimate perfectibility of man ("Know that he grows wiser every day"):

> For, ever as a thought of purer birth
> Rises to lead him toward a better clime,
> Some intermeddler still is on the watch
> To drive him back, and pound him, like a stray,
> Within the pinfold of his own conceit. [ll. 332–36]

The figure is then expanded from the prodigious child to Sin and Death building the bridge which will serve as a channel for these evils to enter the earth (ll. 347–50). Later in book X the child will be connected with the specific reference to the French Terror as a child who does not grow up, playing now with a guillotine (ll. 364–74). In much the same way Words-

worth in book X pinned down the deluge, ambiguously offered in book V, to its explicit referent, the French Revolution.

In retrospect a monstrous arrested child (a grotesque), at the time it seemed a (beautiful) "purer birth," conceived by the young. Wordsworth saw the Revolution as inextricably involved with his own youth, with young men like himself as its metaphorical progenitor. In *Descriptive Sketches* (1793), which recorded his first trip to France in 1790, Wordsworth had suggested a surprisingly close analogue to Blake's youthful Orc of about the same time: "Lo! from th' innocuous flames, a lovely birth!" (l. 782). In *The Prelude* he shows "What happens when the child fails to grow up. . . . The child's self-centeredness makes it by nature imperial," recalling for Wordsworth the absolutism of Robespierre and later Napoleon.[6]

This child is contrasted in book V with the Boy of Winander, who exemplifies the origin of poetry in the imitation of animal sounds to stimulate their response; who does not grow up either to play with a guillotine or to write *The Prelude* because he is arrested at this primal stage of give-and-take, when he is still at one with nature. He therefore does not progress to the next stage of development, toward which Wordsworth himself is for better or worse striving. On the one hand Wordsworth contrasts himself with the prodigious child, on the other with the boy who dies at the threshold of experience, and, in the final episode, with the drowned man.

The experience of the drowned man sums up the poet's fear of drowning and engulfment by the deluge, but it also recalls the spot of time at the end of book IV which described the discharged soldier the poet met during a school holiday. The soldier appears as the young poet takes a "sudden" turn in the road—"stiff, lank, and upright . . . ghastly in the moonlight . . . " (IV, ll. 393–96); whereas the drowned man "bolt upright / Rose, with his ghastly face, a spectre shape / of Terror. . . ." The drowned man also anticipates the blind beggar of book VII ("London") who "with upright face, / Stood, propped against a wall." In the 1799 *Prelude* the drowned man was alone; the other two versions were added presumably to further explain him. He can be thought of by himself only as a bridge between the crimes of the first spots of time and the punishments (hanging and loss of father) of the last: here an ambiguous accident or suicide that is witnessed by the boy who has already been pursued by "low breathings" and by a mountain that "like a living thing, / Strode after me" (I, ll. 323, 384–85). As I have already noted, the horror of the drowned man is now explained, under-

6. Lawrence Goldstein, *Ruins and Empire: The Evolution of a Theme in Augustan and Romantic Literature* (Pittsburgh, 1977), p. 191; also pp. 184–95 on "The Child of Revolution." On the general subject of Wordsworth, youth, and the Revolution, see David Ellis, "Wordsworth's Revolutionary Youth: How We Read *The Prelude*," *Critical Quarterly*, 19 (1977), 59–67, and John Beer, "The Revolutionary Youth of William Wordsworth and Coleridge: Another View," ibid., 79–87.

stood, or in effect absorbed by being placed in the context of books the child Wordsworth has read. The old soldier explains himself in words ("From his lips, ere long, / Issued low muttered sounds, as if of pain / Of some uneasy thought . . . "), and the blind beggar has a "written paper, to explain / His story" affixed to his chest.

The story of the soldier fighting for his country, only to be abandoned to destitution, sets him up as another victim of the government and society Wordsworth described in his poems of the late 1790s. Alongside this victim of society, and in the context of deluge and revolution, he helps to place the drowned man. The historical referent, the schoolmaster James Jackson, was drowned in 1779 while bathing in Esthwaite Water, but Wordsworth does not specify either accident or suicide. He is simply a man who immersed himself in water and drowned, and in that sense has been made a figure parallel to Quixote, the monstrous child, the Boy of Winander, and the poet himself. But none of this appears in the 1799 version. The passages about books and the additional "upright" figures are fixed in the context of Wordsworth's revolutionary experience.

He knows what has happened in both versions of the story by seeing "a heap of garments" on the lakeside. *Garments* was the word connected earlier in book V with books (the books lost in the deluge are "garments," l. 24) and with language as the "garment" of thought.[7] These "garments" now constitute the evidence that prevents the uprising of the drowned man from being so "sudden" or shocking as the appearance of the soldier: Wordsworth has seen the "garments" the day before and knows what to expect, as in the passage immediately following, he claims (somewhat lamely in fact) that the reading of stories had "hallowed the sad spectacle / With decoration of ideal grace." The "garments" seem in fact the more significant explanation: It was the "garments vexed and tossed" of the woman with the pitcher that fixed that figure in his memory, seen near the gibbet in the first designated "spot of time" that immediately followed the drowned man in the 1799 text. Books of "faery" are an attempt to explain that "garment."

I doubt if we shall ever know what that garment meant to Wordsworth in its earlier contexts, as opposed to the 1805/1850 *Prelude*. But this scene, whose resolution is more satisfactory as metaphor than as fact, is followed by his return to his father's house for the holidays—an anticipation of the later spot of time (bk. XII) that will involve his return for a holiday coincident with his father's death. His "impatience" as he waited to be taken home from school suffers the "chastisement" of his father's death. But

7. See Rosemund Tuve, *Elizabethan and Metaphysical Imagery* (Chicago, 1947), pp. 61–78. An essay, come to my attention since the writing of this chapter, connects the linguistic and psychoanalytic aspects of the Revolutionary books: Gayatri C. Spivak, "Sex and History in *The Prelude* (1805): Books Nine to Thirteen," *Texas Studies in Language and Literature*, 23 (1981), 324–60.

"chastisement" obviously covers a deeper guilt, presumably a subconscious wish for his father's death, suggested by the reference to how God has "thus corrected my desires." The guilt felt for the discharged soldier (he is "from self-blame / Not wholly free") may be for the mistreatment of soldiers who serve their country, but more likely it reiterates the vague guilt of the first spots of time in book I. For this "uncouth shape," "Stiff, lank, and upright," suddenly appearing, carries with it the memory of the "huge peak, black and huge" that "Upreared its head" in the boat-stealing episode, and with it come also the associations of stealing and guilt. In the stealing episodes—of birds from traps, eggs from birds' nests, and of a boat—nature itself is in some sense being challenged by the boy, but in each case a more imme-diate antagonist appears: the man who set out the traps, the parent birds, and the man who owns the boat (as well as the boy's father, who taught him the injunction "Thou shalt not steal").

All these events and details seem gathered around some central, inexpli-cable, and terrible experience, which Wordsworth now chooses to label (or screen) as the French Revolution. Every spot of time he recounts connects in one way or another with a looming, uprisen figure of terror and the unknown, one dispossessed or killed, with whom a crime or guilt of some sort connects Wordsworth the experiencer. The issue in book V is this trau-matic experience, on one level the French Revolution and the way the poet can cope with such an experience through his imagination—by using books or texts in a proper way to meet the demands of nature, rather than in an unnatural way that leads to monstrous intelligence and the Terror or to drowning in a sea of Babel.

One final way in which Wordsworth elaborates the drowned man in the later versions is to add to the first version, which read,

> At length the dead man, 'mid that beauteous scene
> Of trees and hills and water, bolt upright
> Rose with his ghastly face,—

the further words: "a spectre shape / Of terror" (ll. 278–81). He has rec-ognized by this time that he can place his experience in a wider context in the contrast between the aesthetic categories of the beautiful and the sub-lime (the essence of which for Burke was terror).

The pattern set forth in book V is pursued in VI. The subject, the disil-lusionment in experience that is compensated for by imagination, is pre-sented in Wordsworth's visit to France in 1790 at the moment of the first celebration of Bastille Day, followed by a visit to the Grande Chartreuse and finally to the Simplon Pass. The third summer of Cambridge, he says, "freed us from restraint." It sent him to the Continent: an experience that linked climbing the Alps ("mighty forms, seizing a youthful fancy, / Had

given a charter to irregular hopes," ll. 334–35) with his stopover in revo-
lutionary France, and that other sense of "hope." For

> . . . Europe at that time was thrilled with joy,
> France standing on the top of golden hours,
> And human nature seeming born again. [ll. 339–41]

He participates in the Fête de la Fédération, a mass performed joining the
king, the Constituent Assembly, and the National Guard of the people,
with everyone swear1ng an oath of federation that materialized once again
the *Oath of the Horatii* and the *Oath of the Jeu de Paume*. This was a coherent
structure of order, an ideal Wordsworth must have seen collapsing on his
return trip two years later, but already in 1790 threatened in his sad passage
on the destruction carried out by French revolutionary troops on the beau-
tiful Grande Chartreuse.

But the way of political reason and the way of mountain climbing lead to
the same failure. As the poet and his friend ascend the pass they learn that
they cannot climb farther—they have already "crossed the Alps," and now
they "must descend," for the path "was downwards, with the current of the
stream." They are "Loth to believe what we so grieved to hear, / For still
we had hopes that pointed to the clouds . . . " (ll. 575–87). "Hopes" again
join the natural and political realms, and the book ends with the great pas-
sage on the power of imagination to compensate for these disappointments,
its resolution found in experience through the imaginative transformation
on Mount Snowden (bk. XIV). The passage is again colored by terms of
overt political action. First the imagination's "hope that can never die" and
"something evermore about to be"; and second:

> Under such banners militant, the soul
> Seeks no trophies, struggles for no spoils
> That amay attest its prowess. . . . [ll. 609–11]

The reference to "spoils" may be to the sacking of the Chartreuse, but the
soul is rather "blest in thoughts / That are their own perfection and reward
. . . ," and again the book ends with an overt paean to the Revolution:

> a glorious time,
> A happy time that was; triumphant looks
> Were then the common language of all eyes;
> As if awaked from sleep, the Nations hailed
> Their great expectancy. . . . [ll. 754–58]

And yet Wordsworth is not yet himself "intimately" involved:

> . . . I looked upon these things
> As from a distance; heard, and saw, and felt,
> Was touched, but with no intimate concern. . . . [ll. 767–69]

As yet he neither experiences nor needs the Revolution, which does not impinge upon him until book IX and his "Residence in France." But book VII, "Residence in London," represents the stage in which he "bade / Farewell for ever to the sheltered seats / Of gownèd Students . . . " and pitched "a vagrant tent among / The unfenced regions of society" (ll. 52–57). It is also the book where Burke makes his appearance, and while not specifically connected with his revolutionary writings, his appearance ("like an oak") would seem best explained by the hovering presence of the Revolution. Wordsworth sees him in the context of theatricals and the theatricality of London life, which lead him to think of oratory and so of Burke. "Like a hero in romance" (the Don Quixote figure of the Arab dream), he made the Revolution into a theatrical experience in his *Reflections*. He represents the power of literature to which a youth like Wordsworth is susceptible. Such words as Burke's allow him to absorb painlessly the drowned man, the soldier, and perhaps the blind beggar, and also the Maid of Buttermere, who is seduced and traduced and then transformed into a ballad.[8]

Jonathan Wordsworth has argued that the discharged soldier and blind beggar are naturalizations of eighteenth-century personifications of the Satan, Sin, and Death sort of which Burke makes so much in his *Enquiry*.[9] I am arguing that something else lies behind these images, but I would not want to deny the possibility that in their first manifestation in the 1799 *Prelude* they are already distanced to some degree by being seen as horror personifications in the manner of Collins; they also, however, pick up in revision the associations of Burke's sublime, and return to something like the allegorical denominations of Pity and Terror—another example of what Burke's *Enquiry* had taught him about the distancing that converts a troubling experience into pleasing art.

The most famous of such confrontations occurs in the *Lyrical Ballads* with "The Leech-Gatherer," who is in the technical sense of the term a grotesque, embodying a transitional state between human and natural or inanimate forms. All these figures (the prodigious child as well as the drowned man and the blind beggar) show the very close relation between grotesque and sublime. They appear grotesque, but for Wordsworth they are sublime: They terrify and move precisely because they are neither human nor other but both. These figures become in the "Revolution" book IX the hideous

8. Jonathan Wordsworth, in criticizing Wordsworth's revisions of the gibbet "spot of time," misses the point that the addition of "the inscription of the murderer's name," the "monumental letters," is another case of Wordsworth's attempting to come to terms with experience through the use of words (another "garment"). See Wordsworth and Stephen Gill, "The Two-Part *Prelude* of 1798–99," *JEGP*, 72 (1973), 503–25.

9. "William Wordsworth 1770–1969," *Proceedings of the British Academy*, 55 (1969), 211–28; also see Herbert Lindenberger, *On Wordsworth's Prelude* (Princeton, 1963), p. 23, where he divides these agencies of Wordsworth's mind's growth as beautiful and sublime.

subhuman related to Gillray's John Bull or Burke's (or Wollstonecraft's) masculine women marching on Versailles—in effect the immeasurable wrong that the Revolution tried to correct and that the poet tries to comprehend: the "hunger-bitten girl, / Who crept along fitting her languid gait / Unto a heifer's motion." She and her heifer are a single entity moving down the road and "picking thus from the lane / Its sustenance" (ll. 510–14).

This is the ultimate degradation of the woman that begins with the Maid of Buttermere, transforming the beautiful woman seduced and deserted into the terrifying figure of the animal-woman. Wordsworth runs the gamut of the aesthetic categories as he tries to comprehend the phenomenon of the French Revolution. Like Milton, he tells us that he began by going through all the possible subjects for an epic and finding them all inadequate to the task of charting the development of his mind. This is the same procedure he follows in trying to describe the "Revolution" in book IX (which as in his model *Paradise Lost* is his book of the Fall). He is trying to fit the central experience of his public life into an aesthetic category, or a literary genre, in the manner of Burke's *Reflections*. The Revolution is in one sense the great subject matter that may explain to him his spots of time, and in another the great public subject matter he is turning *away* from as less suitable than the development of his own mind (or of his imagination). At the same time its complexity, its refusal to be formulated, demonstrates to him (and implicitly to Burke) that no literary form can be used to express or fathom the experience, any more than the inscription "Blind Beggar" can do justice to the human being who wears it.

Thus when he arrives at book IX, he first seeks imaginative solace in Paine's metaphor of pastoral beauty: "Even as a river" turns and twists (partly for fear that a direct way "would engulph him in the ravenous sea," he says, reviving the metaphor of drowning), "Or as a traveller" pauses on the brow of the hill "to review / The region left behind him," and this allows him to slip into London as into a pasture in which he ("a colt") ranges. He leaves the book-stalls ("hedge-row fruit") of London for a visit to the very unpastoral world of France.

Significantly, the reason he gives (in the 1805 text) for his trip to France is "To speak the language more familiarly" (1805, l. 37).[10] The language barrier leads him to *see* "the revolutionary Power," which (he still employs a locodescriptive mode) will "Toss like a Ship at anchor, rock'd by storms," and to *listen* to the "hubbub wild" "with a stranger's ears." Still detached from the Revolution, trying to frame the experience as a tourist does ("the

10. I am indebted here to Alan Liu's "'Shapeless Eagerness': The Genre of Revolution in Books IX–X of Wordsworth's *Prelude*," *Modern Language Quarterly*, forthcoming (originally "History and the Text: The Authority of Language," ch. 3 in his unpublished dissertation "The 'Darkness' in Language: Wordsworth's 'Prelude' and Metaphors for Speech," Stanford, 1979).

sauntering traveller"), he "look'd for something that I could not find." The most telling evocation of the "temper of [his] mind" was that the Revolution in Paris moved him less than a painting, Le Brun's *Penitent Magdalen*. As it had done for Burke, visual art, moving him more, holds him at a distance from the raw reality of the Revolution, rendering it more comprehensible.

But the *Magdalen* also prepares us for the great absence in book IX, the story of his love affair with Annette Vallon, whose role Wordsworth gives to the male friend Beaupuy. And the soldier Beaupuy himself is absorbed into another fictional context, that of tales of chivalry (as Vallon is in the 1805 text in the tale of Vaudracour and Julia); he is, again alluding to Burke, part of "the chivalry of France," a knight on a quest.

Wordsworth evokes one genre after another. From line 94 onward he mingles the metaphor of theater with that of journey, the mode of tragedy with locodescriptive poetry. Like a painter the poet keeps trying to construct a manageable landscape: "the first storm was overblown, / And the strong hand of outward violence / Locked up in quiet". He does this in the face of an actual landscape becoming increasingly unmanageable: "all swarm'd with passion, like a Plain / Devour'd by locusts . . . earthquakes, shocks repeated day by day," he concludes, referring back to the holocaust at the beginning of book V and summoning up the category of the sublime. This transformation is taking place at the same time that he himself is being absorbed—and not altogether acknowledging it—into the scene as participant rather than tourist-observer. As the pastoral and locodescriptive categories fail him, he finds that the "Tales of the Poets" do not fit the circumstances in France and then that Beaupuy (who is killed in action) is a knight who does not survive his quest.

With the tale of Vaudracour and Julia (another fiction that veils a painful fact), Wordsworth says he is turning from romance to "a tragic Tale"—but still a "tale." Book X modulates from romance to stage tragedy: the king falls, is tried, and executed. In a room high in a building in Paris, the poet meditates on reports of the September massacres augmented by thoughts or dreams "conjured up / from tragic fictions or true history" of hurricanes and earthquakes—"Until I seemed to hear a voice that cried, / To the whole city, 'Sleep no more'"—the words of Macbeth after killing *his* king. And suddenly Paris seems to him (as it did to so many others) "unfit for the repose of night, / Defenceless as a wood where tigers roam" (ll. 93–94).

From one point of view these are outmoded literary forms, as inappropriate as Collins's Pity and Fear to the Leach Gatherer or as poetic diction to the lives of Simon Lee or Harry Gill. From another the Revolution is such a staggering experience that it simply (in Alan Liu's words) "refuses to obey an Aristotelian order of beginning, middle, and end and so juts out of the framing structures implicit in fictional idioms. Both its origin and

'end' (and *un*-ending succession of violence and betrayal) are unaccountable according to the poet's available languages." [11]

None of the formal ways of thinking succeeds for Wordsworth, and before the end of book X he has begun to recover himself and his subject by returning to a language closer to the everyday, as in the climactic account of Robespierre's death (once again on the edge of the sea, as in the Arab dream). He has learned a great deal since he came to terms, by an optimistic utilization of romance, with the drowned man. But his access of knowledge coincides with his turn from joy at the fall of Robespierre to disillusion again at the pragmatism of the Directory, the tyranny of the Pitt Ministry in his own England, and the ruthless conquests of Napoleon.

His return from the external, "tempestuous" world of politics to the internal "correspondent breeze" of poetic imagination is not, however, manipulated without benefit of the Burkean categories. [12] He follows a progression from a topographical landscape poem to a sublime one as his awareness of the Revolution grows, but he repudiates this dark and terrible landscape—both metaphor and historical phenomenon—for a more peaceful one (he has already associated with England) which he can dominate with his own imagination. This is consistent with his belief, expressed in his essay on "The Sublime and Beautiful," that temporally the sublime must be succeeded by the beautiful:

> Hence, as we advance in life, we can escape upon the invitation of our more placid & gentle nature from those obtrusive qualities in an object sublime in its general character; which qualities, at an earlier age, precluded imperiously the perception of beauty which that object if contemplated under another relation would have been capable of imparting. [13]

In *The Prelude*, as Theresa Kelley has shown, a "spot" which the poet cannot control—"the terror of being confronted with the enormous failures and gaps in human experience"—is corrected by a further stage that Wordsworth designates as the beautiful. [14] This may be a second "spot" to succeed the sublime one "so as to make the mind momentarily safe for human habitation." It may be a closure of the sense of engulfment in the sublime experience (as in book V) with a determinate significance. On the level of the "spots" this is the addition of naming and explaining, and on a higher level the sort of signification the whole of *The Prelude* is attempting to impose

11. Ibid.

12. See Geoffrey Hartman, *Wordsworth's Poetry, 1787–1814* (New Haven, 1964), pp. 242–46.

13. *Prose Works of William Wordsworth*, ed. W. J. B. Owen and Jane Worthington Smyser (Oxford, 1974), 2, 349.

14. I am indebted in this paragraph to Kelley's "The Economics of the Heart: Wordsworth's Sublime and Beautiful," *Romanticism Past and Present*, 5 (1981), 15–32 (the final quotation is on p. 27).

on these intractable moments. The stealing of birds and boats, episodes concerned with the violation of known limits, are followed by the skating scene: A sublime experience is followed by a beautiful, and one of indeterminacy by one in which the child controls the unruly waters of the lake (into which he has aggressively plunged his boat and oars) by making patterns on its icy surface, an experience which replaces "visionary dreariness" with an access of joy. In the same way, the gibbet "spot" is followed by the still young Wordsworth's return visit with Dorothy and Mary, sister and wife, which blesses the scene, renaming and redefining all the elements from sublime to beautiful (as from illicit passion to domestic harmony). The "visionary dreariness" of the place is now closed by the human affections of the three friends, which (as Kelley says) "comprise the domesticated beauty of the Wordsworthian aesthetic. And, as clearly, this revisitation suppresses the sublime recognition that the poet once encountered there."

The nodal point, the hidden center of Wordsworth's revolutionary experience, comes in book IX, and this is the experience of Annette Vallon, their love affair, their child, and his desertion of mother and child. In his experience woman and revolution are interchangeable phenomena, both involving (as in Ambrosio–Matilda or even Mary Wollstonecraft–Gilbert Imlay) liberation and betrayal, involving a crime that is nevertheless necessary for the poet's transition from innocence to experience.[15]

The ballad recounted in the pre-Revolutionary residence in London (bk. VII) is "The Maid of Buttermere," a tale of love, childbirth, and desertion anticipating "Vaudracour and Julia" in book IX. The poet writes a hopeful epitaph on the maid enduring "In quietness, without anxiety," and her child buried near a mountain chapel "fearless as a lamb": "Happy are they both— / Mother and child!" outside the roar and rush of London and "the times." But the image of the dead child, the product of the maid's love affair and desertion by a "spoiler," is followed by the story of the "lovely Boy," another Boy of Winander who sits untouched in the center of "dissolute men / Like one of those who walked with hair unsinged / Amid the fiery furnace" (ll. 328–29, 360–70). Like the maid's child, this boy "by special privilege of Nature's love, / Should in his childhood be detained for ever!" (ll. 375–76).

The Maid of Buttermere was a final externalization of the figure Wordsworth tries to come to terms with in book IX. The revolutionary images of his earlier poems (besides the imagery of sun, fire, and deluge) consisted of stories of a female vagrant and a discharged soldier, leading eventually to

15. In Hartman's words this is a transition from "a prior, nature-involved and relatively blind state of consciousness to the enlightened pain of self-consciousness" (*Wordsworth's Poetry*, p. 134).

the poor soldier of book IV and the hungry girl Beaupuy points to in book IX as the cause of the French Revolution.[16] These are images of the victims of tyranny which we might refer to as stimuli to revolutionary consciousness. The most significant element in the gestalt is the woman with child, deserted or widowed, perhaps as a displacement of the guilty image Wordsworth does not show. It is not simply that he invents the image, of course, for as Carl Woodring writes: "From the beginning of the war with the Colonies, such figures had been seen on the roads with increasing frequency. To the prevalence of actual derelicts, letters and journals of the poet and others in his family testify as eloquently as the poetry."[17] But Wordsworth's deserted women stand out in "Evening Walk," "The Thorn" and the poems of the *Lyrical Ballads*, in "Ruth," and in "The Deserted Cottage."

Wordsworth's own "grievances as a dislodged orphan" may have led him to read himself into "The Female Vagrant" and other victims of the old system prior to the Revolution. His experience with Sir James Lowther showed him how a nobleman can defraud his dependents.[18] At this point in 1792, the moment of grievance, Wordsworth went to France, but also with his memory of the experience of 1790, when he had arrived in France on the anniversary of Bastille Day and watched the French joyously celebrate the Feast of Federation. He goes to Paris and admits that he feels at the moment more emotion before Le Brun's *Magdalen* than the Revolution, which

> Less mov'd me, gave me less delight than did
> Among other sights, the Magdalene of le Brun,
> A Beauty exquisitely wrought, fair face
> And rueful, with its ever-flowing tears. [1805, ll. 76–79]

The Magdalen, with its echoes of the Maid of Buttermere and anticipation of Julia, was in fact thought to be a portrait of Louise de la Vallière, Louis XIV's mistress, looking up rapturously at a burst of sunlight from above, a Danae awaiting the Sun King's impregnation (the whole title was *Sainte Madeleine renonçant aux vanités de la vie*).

About the Revolution itself he was still, he says, "affecting more emotion than I felt." It is only after the affair with Annette Vallon that he becomes a "delighted" supporter of the Revolution. Mary Moorman puts it simply,

16. *Descriptive Sketches* is full of the familiar revolutionary imagery: light and fire: "Tho' Liberty shall soon, indignant, raise / Red on his hills his beacon's comet blaze . . . " (ll. 774–75); deluge: "Oh give, great God, to Freedom's waves to ride / Sublime O'er Conquest, Avarice, and Pride . . . " (ll. 792–93); "And grant that every sceptred child of clay, / Who cries, presumptuous, 'here their tides shall stay,' / Swept in their anger from th' affrighted shore, / With all his creature sink—to rise no more" (ll. 806–09).

17. Carl Woodring, *Politics in English Romantic Poetry* (Cambridge, Mass., 1970), p. 87.

18. Moorman, *William Wordsworth*, p. 169; also p. 189.

speaking of the summer of 1792: "A double tension racked him: he was deeply and anxiously in love, and he was also becoming a proselyte of the Revolution."[19] He represses Annette, attributing his "conversion" to Beaupuy, and to Beaupuy's showing him a hungry, oppressed girl. And of course Annette could not have "converted" him to the Revolution because her sympathies were presumably royalist.[20] But the ambivalent feelings of books IX and X arise from his love of her.

Beaupuy is brought closest to the Wordsworth–Annette situation (with Burke's Marie Antoinette as with the Quixote of book V, who was "crazed / By love and feeling") by his associations with chivalry and "old romance, or tale / Of Fairy, or some dream of actions wrought / Behind the summer clouds." For romance seems to refer to

> A passion and a gallantry, like that
> Which he, a soldier, in his idler day
> Had paid to woman. . . . [ll. 300–03, 311–13]

He was covered, we are told, by "a kind of radiant joy" when "he was bent on works of love or freedom"; while Wordsworth himself at this time "was scarcely dipp'd / Into the turmoil." These are the words that carry the central revolutionary vibrations. But there is also the passage about satyrs "rejoicing o'er a female in the midst, / A mortal beauty, their unhappy thrall" (ll. 460–61), which recalls the less romanticized Maid of Buttermere. The poet moves on to thoughts of one of François I's mistresses "bound to him / In chains of mutual passion" (ll. 485–86), who recalls the Magdalen based on Louix XIV's mistress and introduces a discussion of droit du seigneur, royal (male) tyranny over a female. This is finally translated into the "hunger-bitten girl" Beaupuy shows Wordsworth—female beauty degraded into grotesque heifer-like servitude: "'Tis against *that* / That we are fighting," he says; and this leads into the exemplum of ancien régime tyranny, "Vaudracour and Julia," with which book IX ends.

In the same way, the most enigmatic aspect of the gibbet "spot of time" is the girl with the pitcher, an image of beauty buffeted by the wind. Her blowing "garments" (that significant word, joining language and body) may beautify the sublime experience of the gibbet as it did earlier the experience of the drowned man. Or it may point to one center of the experience, the

19. Ibid., p. 187.

20. Unless she was revolting against *both* her family's morals and politics when she took Wordsworth as a lover. We do know she was later a prominent member of the royalist "resistance movement," but she may have acted parallel to her cousins Charles and Claude, priests who took the oaths required of them by the Civil Constitution of the Clergy and welcomed the new order but later opposed the Convention's pressure to make the clergy give up their ministries. And, indeed, her attitude toward the Revolution could have corresponded to Wordsworth's own as the Jacobin excesses followed.

one linked with the abandoned Maid of Buttermere or Julia, and so with the Revolution.

As we have seen so often in the revolutionary literature of the 1790s, love itself is the symbol of revolution—even if the loved one happens to be a royalist. The act of love was (among other things) an act of rebellion, or at least a scandalous act, in the context of a society of arranged marriages, closed families, and decorous art and literature. In France the overt symbolism of sexual "liberty" in the early phases of the Revolution was succeeded by the suppression of the erotic in the later puritan phases. Wordsworth can be said to follow the same trajectory, but as we trace his own suppression of the story of his love from the text of *The Prelude*, we can also see the sexual love of woman being sublimated, as the sublime is sublimated by the beautiful, in a dedication to a supposedly higher, or at least more refined, goal first social and then poetic. In human terms, the "passion" and "love" of the revolutionary situation is replaced by the "Friend" to whom he repeatedly addresses himself in the final books.

But Wordsworth is the young student of Rowlandson's *The Milk Sop* (fig. 12), whose love has a consequence, and in the stories he retells love is followed by a birth and disillusion, by the child's death and the father's guilt. If in book V Wordsworth associates himself with the child, and in IX with the father, in the later books it becomes clear that he is the boy himself. He has displaced the object of guilt from the product of his love onto the mother/lover. This allows him to associate himself with the child: the Boy of Winander and even the potentially monstrous child who remains arrested in childhood but with an adult brain—and so with the sons of the "spots of time" who are waiting for something, for whom something unexpected suddenly appears—a soldier, a corpse, above all a father who, instead of appearing, dies. Thus although a father himself, Wordsworth can place himself invariably in the role of the rebellious son—as lover and as little boy who steals boats and wishes his father dead.

If we recall the story of Agnes the nun in *The Monk*, we will notice that in one revolutionary scenario the lover penetrates the woman's cell, liberating himself from his father and her from her imprisonment, and the child who follows from their union is a demonstration of their rebellion. It is, however, the woman, not the lover, who suffers the wrath of the Church and the child who invariably dies. The baby, says Agnes, was her lover Raymond's fault, and Vaudracour is said to have been responsible (through negligence perhaps) for his baby's death.

The story of Vaudracour and Julia moves the plot from revolution/love/ betrayal back to the ancien régime and repression and betrayal of *both* lovers by the father. The fact remains that Vaudracour is guilty in much the same way as Wordsworth. Used to represent the paternal/contractual tyranny of the ancien régime about which Paine and others wrote, the story is a dis-

placed paradigm of Wordsworth's experience of the Revolution: he falls in love with the alien woman (alien by class and nationality), challenges his father, runs away with her, but eventually succumbs to the external, paternal pressures. The act of loving with this slightly alien woman *is* the act of revolution—and in fact corresponds to it in Wordsworth's experience as well as in his poetry—and the total story of the Revolution is played out in their failed relationship. The Fall, like that of *Paradise Lost*, is both betrayal and liberation, on the public level the French Revolution (and Wordsworth's involvement with it) and on the personal the suppressed Adam–Eve affair. Both are presented as disobedience, as rebellion against a father—the England that declares war on France and Vaudracour's father who will not hear of a marriage with Julia—and behind this somewhere is Wordsworth's own dead father, who keeps cropping up in one form or another in the spots of time.

I am referring most generally to the masculine figure whom Wordsworth associates with guilt and retribution in the mountain that rears up and pursues him when he steals the boat,[21] and the startlingly phallic figure (the word *upright* is used in each case) he associates with terror, crime, and personal guilt or the figure who confronts or proclaims his guilt (ultimately Vaudracour's). The gap he is trying to bridge by dividing the spots of time, moving the crucial so-called spots back to book XII, is between those paternal figures and the death of his father, which he acknowledges in the memory of the holiday in which his impatience was punished with his father's death. The gibbet presumably refers to his own feelings of guilt. The crime is stipulated in the 1799 version: "A man, the murderer of his wife, was hung / In irons . . ." (I, ll. 309–10), but softened to a more general murder in the later versions. Thus the sexual passion and guilt of the gibbet image, localized and refined in the cathected image of the girl with the pitcher and blowing garments, form a final—and perhaps the original— symptom of the revolutionary guilt against the father in the 1799 *Prelude*.

Following the Fall of book IX, book X had described the development of the Revolution and Wordsworth's involvement with it in terms of betrayal, murder, and guilt—of the revolutionaries and in particular Robespierre destroying the king. The sequence that is stressed in book X is a series of nightmare scenes: Wordsworth's "Sleep no more" dream (and the killing of Louis XVI); the Girondin who in the morning rises to the tribune and cries "I, Robespierre, accuse thee!" only to find himself abandoned and alone; Wordsworth's association with the Girondin in his own nightmare of delivering "long orations, which I strove to plead / Before unjust tribu-

21. See Weiskel's analysis of this passage, *The Romantic Sublime* (Baltimore, 1976), pp. 101–02.

nals"; and finally his hearing of the deaths of both his old schoolmaster Taylor and of Robespierre as he walks on the seashore.

What disturbs him on his return to England is his homeland's own entrance into the war against France. This, he tells us, was the real stimulus to "revolution" for him (ll. 269–85). He means that this was the frightening phenomenon, but also the event that turned him into a revolutionary in the sense of an enemy of his own *father*land. And yet the English intervention coincides with the Terror in France, summed up in the images of the monstrous child playing with a guillotine and the deluge of burst contagion from the "terrific reservoir of guilt." Robespierre is a "cruel son"; as the fierce winds are to King Lear, a father-king, he is to his native city of Arras (l. 506). It is in this context that Wordsworth tells of his old teacher Taylor (who had encouraged him to be a poet), whose parting words to him were "My head will soon lie low" (l. 539), and of the stranger who says to him, "Robespierre is dead!" (l. 573)—after which he can say, "Come now, ye golden times" (l. 587).

As Jonathan Bishop has observed: "Taylor, his amiable foster father, had predicted a death, and the prediction unexpectedly comes true for a man with whom Wordsworth has for many years felt a profound connection, a villain who acted out fantasies of murderous rebellion in which Wordsworth, it is not too much to say, half-consciously participated"[22]—though the point of Robespierre's fantasies was their fratricidal as well as patricidal flavor. Thus the regicide/betrayer of the Revolution has been punished and the guilt (including Wordsworth's) purged in the "river of blood." But the death of the schoolmaster and surrogate father, followed by the death of Robespierre, points toward the death of the father in the "spots of time": Wordsworth wished Robespierre dead—he died; he wished his father dead—and he died. The "terrific reservoir of guilt" is both public (the French) and personal (Wordsworth's own). The political books, in short, have a powerful effect on the final spots of time, showing the relationship on a poetic level between the killing of the king and of Robespierre and the death of Wordsworth's own father.

I do not mean that *The Prelude* can be understood merely by finding the repressed subject but rather by recognizing a complex cluster of subjects: love of a woman, political revolution, the son's disobedience to his father, and the making of a poet. All these represent one side of an exchange be-

22. "Wordsworth and the 'Spots of Time,'" *ELH*, 26 (1959), 45–65; reprinted in *Wordsworth: A Collection of Critical Essays*, ed. M. H. Abrams (Englewood Cliffs, N.J., 1972), p. 142. Bishop comments on the girl and pitcher: "Can we read the extraordinary concentration upon the separate images of pool, beacon, and girl as a displacement of feeling from the evidences of crime and punishment to accidental concomitants of an experience too over-whelming to be faced directly?" (p. 145). This scene with which he associates the young girl and young love takes place close to the death of his mother.

tween what is acknowledged and what is repressed, what is understood and what the poet does not want to understand. For even if an oedipal conflict is thought to be the repressed subject, it is only a sign for some larger sense of loss which is not yet, and perhaps cannot ever be, defined.

Wordsworth produces both internalized and externalized versions of this plot—in the development of his own mind in *The Prelude* and in the history of the Solitary in *The Excursion*, books II–IV. The allegorical version in *The Excursion* is far less compelling than the autobiographical one in *The Prelude* but it does reveal interesting similarities. It progresses from Margaret's plight, deserted by her husband, to the Solitary's love affair followed by the tragic loss of both his bride and his children, and then the joy of the French Revolution followed by his disillusionment. In the background is the series of shorter poems like "The Thorn," even like "Nutting," in which the boy feels he has to rape/murder the trees before he can have his crop: he commits the crime, against the wood nymph, the father or the king, which is necessary for the increase of consciousness.[23]

Even in "Home at Grasmere," the fragment that was to connect *The Prelude* and *The Recluse*, Wordsworth repeats again the story of the man who seduces the maiden and is driven by his guilt to wander far and wide—but here

> he dies of his own grief
> He could not bear the weight of his own shame. [ll. 531–32, MS. B]

The whole passage was suppressed in the final version of the manuscript (MS. D) Wordsworth prepared in the 1840s, sharing the fate of the Vaudracour and Julia story.

These elements recall the prominent association of love, loss, and guilt with revolution in *The Prelude*. And as we follow their revisions from the 1790s to the 1840s we also see the same process of secondary revision or repression (the different versions of "Salisbury Plain" are a case in point). We can also, however, follow another progress within the poetry as a whole, analogous to that of *The Prelude*, from an early poem such as "Salisbury Plain," where the benevolent man is oppressed by the treatment of government and society until he is forced to commit murder, to book I of *The Excursion*, where Margaret responds to the same pressures with "weak endurance, without hatred or any thought of revenge for her undeserved wrongs."[24]

23. It is possible that Wordsworth's suggestion to Coleridge for *The Rime of the Ancient Mariner* ("some crime was to be committed which should bring upon the Old Navigator . . . the spectral persecution") was another version of the trauma he was representing in his own poems of the time. See *Poetical Works*, ed. Ernest de Selincourt and Helen Darbishire, 2d ed. (Oxford, 1952), 1, 361, note to "We are seven."

24. Moorman, *William Wordsworth*, p. 316.

Something like Wordsworth's plot was already outlined by Coleridge in 1794 in "To a Young Lady with a Poem on the French Revolution." This is an allegory of his own poetic development and his youth (when in college he first "heard of guilt and wonder'd at the tale"), which are suddenly interrupted by the Revolution. He uses Pity and other figures that recall Collins's odes to produce a more pedestrian version of the opening of Blake's *America*:

> When slumbering Freedom roused by high Disdain
> With giant Fury burst her triple chain! [ll. 17–18]

Freedom (or Liberty) is a fierce Orc-like figure, a woman, but with Coleridge personally assisting her:

> Red from the Tyrant's wound I shook my lance,
> And strode in joy the reeking plains of France! [ll. 25–26]

What connects the poem with *The Prelude* is the subsequent stage of the poet's disillusioned withdrawal:

> Fallen is the Oppressor, friendless, ghastly, low,
> And my heart aches, though Mercy struck the blow.
> With wearied thought once more I seek the shade,
> When peaceful Virtue weaves the Myrtle braid. [ll. 28–30]

A figure of love comes (or returns) to replace these public, social emotions, and so poetry can be written.

Immeasurably expanded and complicated, this is the plot Wordsworth weaves in *The Prelude*. But the lyric subject of the poet's inspiration has become epic; the poet, like Aeneas, still has to choose between duty and eros, between public and private desires, and he begins as Milton's Adam saying, "The earth is all before me" (I, 14). In other words the 1799 *Prelude* is altered (or glossed) in two crucial ways in the 1805 *Prelude*: It is Miltonized into an epic, and it is given as its central crisis the French Revolution. The verse of the 1799 version is, of course, already Miltonized in diction, but the revision makes it explicitly an alternative to *Paradise Lost*. The French Revolution is already implicit in the 1799 version, and by making it explicit Wordsworth may only be offering one explanation for the spots of time in their original formulation. But perhaps more important the Revolution grows from a stimulus (as in Coleridge's poem) to a model, despite his ostensible rejection of it, for Wordsworth's career as a poet.

The Revolution is a model, first, for the artist's relationship to action, love, violence, and catastrophe ("deluge")—a scenario of which Rowlandson's artist satires were a comic version. As such it inevitably involves his disillusion and withdrawal. But second, and more particularly, it is a model for Wordsworth's writing this kind of an "epic of the mind of the poet,"

which is a struggle with (as Harold Bloom would put it) his poetic father John Milton reflecting in microcosm the oedipal conflict of the Revolution itself. As soon as he identifies himself with Adam, he turns to the choice of a subject for his great poem—which in fact becomes a Shandyan telling of how he would come to write the poem—and puts himself in the place of Milton, rejecting the idea of writing "some old / Romantic tale by Milton left unsung" (ll. 168–69). He will not write a chivalric romance of the sort he had used to understand the incident of the drowned man and seeks unsuccessfully to identify with the French Revolution.

The plot of the development of the poet's mind turns, like the Revolution, on incidents of personal violence: his betrayal of Annette or behind her of a parent and/or of a poetic father. As we have seen, Wordsworth censors the explicit crime, the Annette–Julia betrayal, transferring it in the version of "Vaudracour and Julia" to the relation of Vaudracour and his father, which on a public level is embodied in Robespierre and the Revolution, on a poetic level in Adam's defiance of God's will, and on a private but still essentially poetic level (though it may mask something about his natural father) in the Wordsworth–Milton relationship.

Looked at from the end of the century, the poet's view of the Revolution defines itself in progressions and personal odysseys: broken, circular, open-ended, or closed. Wordsworth forcibly accomplishes the last by the addition of Milton and the Revolution; this amounts to an assertion that the external, public life of the Revolution, the external, public story of Adam and Eve, have been internalized, and that the sublime must be followed by the beautiful, which means, in terms of his writing poetry, that he has transformed a sublime into a beautiful experience. He has gentled the most terrible part of the experience even while showing the progress itself from one category to the other. Surely Milton's *Paradise Lost* is the poetic equivalent of the Revolution in this context, the sublime action transformed into a beautiful and inward truth. Both *Paradise Lost* and the French Revolution represent for Wordsworth upheavals which have to be internalized/beautified in order for him to survive as a poet.

The Prelude involves types of progression very different from the old plot of action–consequence or even progress which may in fact be regress (as in the Hogarthian "progress"). It may well utilize old plots, perhaps the only ones available, and adapt them to its purpose. But there is a marked difference: The progression is characterized by trial and error, by the employment of this genre and that, by breaks and discontinuities, new and false starts, pauses ("my drift I fear / Is scarcely obvious"), and most importantly by a series of displacements of one realm of experience or subject onto another. Indeed in some cases it is achieved by an avoidance of the chief subject or a confusion as to what the main subject is, whether this proves ultimately to be personal or public, the writing of poetry, a guilty

love affair, or the French Revolution. The progression, however, is at the end unambiguous. Wordsworth is saying what Blake said in *Milton* and *Jerusalem*: After the lesson of the French Revolution, one knows that change can be effected only within the individual personality or within the art of poetry. If art is the daughter of freedom, after the Revolution art must be used to subdue and control.

At the heart of *The Prelude* is the assertion of Wordsworth's own "revolutionary" art as freedom ("to be young was very heaven"), which refers back to the "revolutionary" stage of his poetry in the *Lyrical Ballads* or perhaps the 1799 *Prelude*. The art itself was more immediately overturning eighteenth-century ideas of poetry and poetic diction, while more generally replacing the great model of the Miltonic epic. Wordsworth's description of this process in *The Prelude* (VIII, ll. 365 ff.) sounds like a description of the ancien régime—from which the poet like the politician feels the need to rebel. The two plots prove to be parallel: art like the Revolution overturns and starts anew but then returns after excess and disillusion to first things— to peace and closure, the imaginative experience of Mount Snowdon—in order to work out a perspective that infolds the experience of the Revolution itself.

There is, however, a difference. Rebellious action at the political level is sublimated into writing, but it remains on the level of writing itself in the rebellion against Milton (and more overtly against Pope and the Post-Miltonic tradition of poetry): a successful version of the Vaudracour–Julia story in which the father *is* defied.

The image of the poet has come a long way from the craftsman or the "vindicator of God's ways to man" to the revolutionary, a figure who grows with the potential of the French Revolution itself. By the end the model for the poet is a political one based on struggle, power, and desire, which expresses itself in the preface to *Lyrical Ballads*, but one which also includes the resolution in which the father-poet is internalized. This is the poet whom Bloom describes in *The Anxiety of Influence*, for whom power and priority are at issue (just as they were for the political revolutionaries), for whom poetry is a struggle with forebears, precursors, and poetic fathers. This is Bloom's way of explaining the tendency of late eighteenth-century poets toward self-consciousness and subjectivity and the writing of poems about the writing of poetry. They begin (as W. J. Bate has shown) to feel the "burden of the past," to revolt *against* tradition rather than living with it or using it as a norm (as Pope ostensibly did). The emergent poet, on the contrary, is left with only himself and his autonomous, solipsistic powers. I would not want to preclude the possibility that the sort of poetic sensibility that was developing under the "burden of the past" by Collins in poetry and Sterne in prose simply found a political analogue that expressed more clearly and forcibly its privately earned insights. But the Bloomian fight

with the poetic father is, in one aspect, merely a historical phenomenon and a literary consequence of the internalizing of external sociopolitical experience, which has become that of the powerful tyrannic father and the rebellious son—a formula that was not so thinkable before the Revolution, or at least so charged with significance.[25]

In *The Prelude* Wordsworth comes to be the poet who joins the worlds of poetry and politics, connecting them by the common term *revolution*. The artist now not only depicts an oedipal situation as the fiction for revolutionary violence; he himself is in an oedipal situation. Now that will and power are prime elements of existence, the poet sees himself (not as Pope did as a doomed Orpheus) as the sinner Adam or Oedipus the outsider chosen to take all the guilt upon himself, the one who suffers in order to atone for the violence of political revolution. How does he serve this function? By relating the private to the public Fall in a Wordsworthian version of the theme of *Paradise Lost*. He thereby gives art itself a new definition or emphasis: It is a response to catastrophe, to betrayal or loss and absence; by implication, it is now a less satisfactory reflector of plenitude or of God's ways to man.

BYRON AND SHELLEY

I have placed this heavy burden of significance on a poem that was not read by more than a few people until 1850. Wordsworth, of course, only reflects with genius the insights of many other English experiencers of the French Revolution. The poets who epitomized the poet as politician were Byron and Shelley, both a generation younger than Wordsworth.

Byron was a child during the Revolution proper and passed through adolescence in the shadow of Napoleon. He missed the phase of the people as constituent power—of the General Will tested by the events of 1794–95—and came on the scene when it was ultimately embodied in a single man, the great man who rises above cliques and factions and regards the Revolution itself as only an intermediate phase of anarchy which he has happily brought to an end. His problem was less the son's rebellion against the father, the first stage of the Revolution, than the later one, the General Will and how to manifest it. His solution was, with important qualifications, Napoleon's. The not unprejudiced Lady Byron wrote of him: "He is the absolute monarch of words, and uses them, as Bonaparte did lives, for conquest, without more regard to their intrinsic value."[26] His own words put the matter differently:

25. See Harold Bloom, *The Anxiety of Influence: A Theory of Poetry* (New York, 1973), and W. J. Bate, *The Burden of the Past and the English Poet* (Cambridge, Mass, 1970).

26. To Lady Anne Barnard, 2 December 1816, first published in the *Times*, 7 September 1869.

Who would write, who had anything better to do? "Action— action—action"—
said Demosthenes: "Actions—actions," I say and not writing,——least of all,
rhyme.[27]

To the very end at Missolonghi Byron did not lose the notion that his pri-
mary vocation was a public one, and essentially an aristocratic one—a pub-
lic, political gesture. A person with this belief will write poetry that is in
itself faute de mieux, certainly a substitute for public action, whether in the
provocative mode of *The Corsair* (1814) or the reflective, conversational
mode of *Don Juan* (1819–24).

Byron's own behavior during the two years following Napoleon's fall
was remarkable in its creation of studied parallels to the events abroad. As
E. Tangye Lean has remarked, "often we get an impression that he was
mimicking Napoleon in adversity."[28] Having had a coach like Napoleon's
built for himself, he went into his own "exile" six months after Napoleon
landed on St. Helena and took with him his own private physician (his Dr.
Polidori to Napoleon's Dr. O'Meara). From the first Byron saw himself as
a leading participant looking backward and forward on events from the
height of Napoleon's Empire—or his rock on St. Helena.

Byron's exile, however, was the result of sexual scandal and innuendo.
With an emphasis that helps to distinguish those very different poets, Byron
flaunted the sexual–political parallel that Wordsworth sought to suppress.
(What Byron suppressed was his physical defect, his lame foot.) At the
beginning, Byron, the young aristocrat, derived his ideas from the Fox–
Sheridan–Rowlandson representation of the Revolution. By 1807 he had
joined at Cambridge a Foxite club that advocated liberty in the Foxite sense
of "freedom for yourself and others and therefore toleration at home and
abroad," and "*peace*, even at considerable cost to ministers and monarchy."[29]
He read Roman history and talked of republican virtue, but the important
stimuli were the reviews of his first book of poems, *Hours of Idleness*, and
personal affronts. Byron was a very different case from Wordsworth, who
gradually associated himself with the Revolution through the plight of the
poor and oppressed, even if it was by way of his own oppression (as he
regarded it) of one of the "poor."

27. *The Works of Lord Byron: Letters and Journals*, ed. R. E. Prothero, 6 vols. (London, 1898–
1901), 2, 345.

28. Lean, *The Napoleonists: A Study in Political Disaffection, 1760–1960* (London, 1970), p.
82; see also p. 84; and F. J. Maccunn, *The Contemporary View of Napoleon* (London, 1914).

29. Woodring, *Politics in English Romantic Poetry*, p. 148. Woodring sums up the tenor of
Byron's juvenilia: "freedom, noble exploits, leadership and fame, fate and death, contempt for
demagogues and the demos, angry opposition to tyranny, reproof of commercial gain and
luxury, disdain for unreason and dullness, discovery of cant, self-deflation, mountains and
ocean, melancholy, tears, Weltschmerz . . . , erotic fervor, eternal friendship, sudden passion,
flippancy, misogyny, defiance, bile, hauteur, . . . bravura, domination . . . , wit, . . ." (p. 149).

In *Don Juan*, as in *The Prelude*, the poet starts off from Milton's *Paradise Lost*. But whereas Wordsworth began by saying, "the earth is all before me" (I, l. 14), with confidence in the progress of the mind he is going to trace, Byron puts it differently (and in his Shandyan way much later in time): "The World is all before me—or behind" (XIV, ix). For if Wordsworth internalizes the experience of the Revolution, or rather turns inward for a substitute for politics, Byron externalizes in himself the aspect of the Revolution he most admires—and we might argue that therefore when he turns on Napoleon (for cowardice in abdicating) he turns on himself as well and can begin to produce the self-ironic poems in which the Revolution becomes a way of seeing, judging, and writing nonrevolutionary experience. To Byron the Revolution and Napoleon mean actions rather than words, though his own are on a sexual level that leaves him half-amused and half-exasperated—and so with the failure of both Revolution and Napoleon he gives up actions in favor of words. In the largest sense these are words for analysis of the phenomenon, although they also carry Lady Byron's sense of "for conquest," which he did eventually attempt at Missolonghi to put into actions more exalted than those of the boudoir.

The two phases of Byron's reaction to tyranny correspond to the fall of Napoleon and the royalist reaction that followed it. For if he leaned temperamentally toward the Napoleonic figure and claimed to find his own literary form emergent in the ironic course of the Revolution, he also imposed on these events the normative, Christian pattern of the Fall. In *Childe Harold*, book IV (1815), he called the Revolution "Man's worst—his second fall" (xcvii), that is, the act in which man finds freedom only to discover it corrupted by ambition. His meditation on the ruins of Rome elicits thoughts on the difference between Napoleon and a Caesar let alone a Brutus. The stanza that leads into the line about "Man's worst—his second fall" opens with lines that might have inspired Goya: "But France got drunk with blood to vomit crime, / And fatal have her Saturnalia been / To Freedom's cause. . . ." The Freedom–Ambition dichotomy explains Adam's and the French Revolutionaries' act of rebellion, as well as the phenomenon of Napoleon. Byron's hero at this point, as John P. Farrell has argued, is the rebel not the revolutionary: The first lives for liberty, the second carries the process (explored by Burke, Blake, and others) through to tyranny. The rebel Byron fears the revolution's "comprehensiveness"—"its power to affect everything, its refusal to be stayed by artillery or legislation or geographical boundaries." [30] Once the rebel allows himself to be seduced into the abso-

30. Farrell, *Revolution as Tragedy: The Dilemma of the Moderate from Scott to Arnold* (Ithaca, 1980), p. 21. For Farrell's interesting discussion of Byron's plays, see ch. 3. For a comment on the revolutionary implications of *Childe Harold*, IV, xcvii–viii, cf. Jerome McGann, *Fiery Dust: Byron's Poetic Development* (Chicago, 1968), pp. 133–34, and Farrell, pp. 143–45.

lutism of revolution, he rejects, in Albert Camus's words, "every aspect of servitude and attempts to annex all creation. . . . In principle, the rebel wanted only to conquer his own existence and to maintain it in the face of God. But he forgets his origins, and, by the law of spiritual imperialism, he sets out in search of world conquest by way of an infinitely multiplied series of murders."[31]

The rebel–revolutionary dichotomy corresponds to the freedom–ambition dichotomy. The stanza following the one on "Man's worst—his second fall" begins: "Yet Freedom! yet thy banner, torn but flying, / Streams like the thunder-storm against the wind." And adopting once more Paine's metaphor at the end of *Rights of Man*, he concludes:

> Thy tree hath lost its blossoms, and the rind,
> Chopp'd by the axe, looks rough and little worth,
> But the sap lasts,—and still the seed we find
> Sown deep, even in the bosom of the North;
> So shall a better spring less bitter fruit bring forth. [XCVIII]

Even Napoleon was good, if for nothing else, for shaking "the earth's rulers . . . from their slumbers on the throne" (XCIX). For besides the Napoleon figure—the triumphant "revolutionary" (in a very special sense shared by Napoleon and Byron) and then the exile on St. Helena musing over the whole course of the Revolution—the important political memories for Byron's poetry were Waterloo and (in England) Peterloo, the Congress of Vienna and the rule at home of a mad, blind old Urizen and his "eunuch" minister Castlereagh.

In the context of Waterloo, Peterloo, and the Congress of Vienna, Byron's stance was of the exile and his theme not a revolution of equality and fraternity but of liberty asserted against tyranny—in Italy, Greece, and his own England. His political plays, *Marino Faliero* and *The Two Foscari* (1821), are about the Napoleonic leader who would revolutionize his society but *from the top*; the doge who both is and is not the head of state, who desires to reform his society but is blocked by his reactionary fellow aristocrats and by his own inner conflicts. Faliero is another hero scandalized by sexual innuendoes being circulated about himself, and this seems to be largely why he undertakes his revolution. The revolution fails. In Byron's own case he then goes into exile and begins to make revolutionary poetry that merges the private and public subjects.

In *Don Juan* the sexual revolt of Juan and Donna Julia is against both the elderly husband Alfonso and Juan's priggish mother (based on Lady Byron), who has had her own affair with Alfonso, who is thus rendered a father as well as a rival in love. The Juan–Julia affair exposed, she is im-

31. Camus, *The Rebel: An Essay on Man in Revolt*, trans. Anthony Bower (1954; rept. New York, 1956), p. 102.

mured in a convent, he sent out into the world to wander an exile. This nucleus of sexual revolt is buried in a context of chatter about Castlereagh and the reaction after 1815—the victory of the Don Alfonsos in the poetic world of Juan/Julia, of the Castlereaghs in the political world of Europe, the polite society of London in the social world from which Byron was driven, and finally the Wordsworths and Lake Poets in the world of English poetry—against whom Byron is rebelling with his flippant style and anti-form.

The improvisatory, the libertine act of writing we saw in Sheridan finds its ultimate expression in his young friend Byron, who quips: "note or text, / I never know the word which will come next" (IX, xli), and after he had finished the first two cantos he wrote his publisher: "Why Man the Soul of such writing is its license?—at least the *liberty* of that *licence* if one likes—*not* that one should abuse it"—in short, just the tentative liberty gesture of Sheridan and Rowlandson that also covers itself.[32] Through his conversational style he also reacts against the Lake Poets (the immediate motive for canto I), and he associates it as much with Pope and the Horatian tradition as with *Tristram Shandy* and Sheridan's conversation. As a corollary, *Don Juan* continues to use love as the revolutionary gesture appropriate to the age of Peterloo and the Congress of Vienna: "Love is for the free!" (V, 127) could be his refrain, and the confining structure of the state is equated with marriage: "And as for 'Heaven being Love,' why not say honey / Is wax? Heaven is not Love, 'tis Matrimony" (XII, xiv). The only difference is that for Sheridan's Liza Linley and her stubborn parents Byron substitutes not only Teresa Guiccioli (or one of his other Italian loves) and her elderly husband but also his own termagant wife in England.

And so the present world in which youth and its sexual potency are placed—the post-Revolutionary one of the eunuch Castlereagh, the old cuckold Alfonso, and the childlike Wordsworth—is a Popean world more closely derived from "The Epistle to Dr. Arbuthnot" and *The Dunciad* than from Byron's own *Corsair* or *Cain*. His Juan is almost the Pope of "Arbuthnot." If Pope was not the nasty satirist he was reputed to be, neither is Juan/Byron the figure of the Don Juan legend; quite the reverse. Juan himself is seduced, or naturally falls in love (as naturally as Adam with Eve). Beginning passive, with time he finds himself forced to take a bold stand, as when he guards the rum supply during the storm at sea. If the cantos had continued to roll out, he was eventually to have joined the French Revolution itself as "an Anacharsis Cloots," and presumably, like Cloots, die on the scaffold.[33]

32. To John Murray, 12 August 1819, in *Byron's Letters & Journals*, ed. Leslie A. Marchand, 6 (Cambridge, Mass., 1976), 208.
33. To Murray, 16 February 1821, in *Byron's Letters & Journals*, 8 (1978), 78.

Byron has also retained the active Don Juan, though years older, in his narrator. The center of the poem is the double perspective of the protagonist and the narrator, of the actor then and the poet now ("he" and "I," not the encompassing "I" of *The Prelude*), of the experience and the view back on it from disillusionment, one microcosm of which is the passage in which Juan alternates expressions of undying love for Julia with seasickness. Juan is the innocent before-the-Fall side of Byron, or the rebel who does not become revolutionary; the poet is his knowledgeable, guilty, world-weary Napoleonic side, who has already been through society with the eyes of a revolutionary, and indeed through the Revolution itself, has given up as a lost cause revolutionary actions, and turned to words. Love as the act of revolution is now seen as a young hero who is described and observed by an older, more experienced, even jaded, certainly ironic (in fact thirty year old) poet, man-of-the-world, and henpecked husband—a literary Napoleon who has lived through the experience of revolution, been defeated, driven into exile, and now comments on the whole process, writing an equivalent of Napoleon's memoirs on St. Helena.

Shelley is a different case: one who is still trying to understand the French Revolution in particular and what went wrong and what might be corrected next time. In *Julian and Maddalo* (1818) he argues out his position of hope in future revolution with Byron's weltschmerz of failed revolutionary activity. For Shelley revolution is something that fails and is suppressed not by some inherent flaw within the revolution itself (or within humankind) but by the other surviving tyrants. It is as if the French Revolution had not evolved of its own momentum (or organic growth) into the Directory and the Empire but had been suppressed, and France conquered, by the Austrian armies.

Shelley comes at precisely the moment in history when this stage is reached. Wordsworth's story began with the intense reaction of the 1790s and was over by 1800; Shelley's only begins with 1815, and if Byron's is defined by the experience of Napoleon and Waterloo, Shelley's is defined by the Peterloo Massacre of 1819. Or rather, because Shelley's doctrine was already at hand long before in the works of William Godwin (his father-in-law), the events of August 1819 gave him his historical paradigm, which he read back into what he called (when he urged Byron to write an epic on the Revolution) "the master theme" of the age.[34]

The family structure of the Shelleyan revolution is also therefore differ-

34. *Letters of Percy Bysshe Shelley*, ed. Frederick L. Jones 1, 504. On the Manchester Massacre at the time, see Shelley's letter to Ollier, 6 September 1819, and to Hunt, 3 and 14–18 November 1819, in *Letters*, 2, 117, 148, 153. See the passage in P. A. Brown's *The French Revolution in English History* (London, 1918), pp. 212–13, which sums up Shelley's position; also Gerald McNiece, *Shelley and the Revolutionary Idea* (Cambridge, Mass., 1969), and Woodring, ch. 6.

ent. The patriarchal figure ravishes the daughter *and* the mother—indeed all the women—and is then killed by the brothers and sisters of the primal horde, who themselves are then punished by the other remaining fathers. In *The Revolt of Islam* (1818) the revolution begins with the attempted violation of Cythna, and according to the ideal Shelleyan scenario proceeds to the overthrow by passive resistance of the tyrant-rapist, a short golden age, followed by the return of the tyrant's forces and the destruction of the revolutionaries. In *Laon and Cythna*, the earlier version of *The Revolt*, what causes the subjects to be persecuted by the tyrants is the incest of brother and sister. Incest *and* revolution are punished by society (though the theme was suppressed in the revision): no longer the seduction of a wife/mother but a more refined violation of decorum in brother/sister. (Toward the end of *La Philosophie dans le boudoir*, Sade went even further, advocating fraternal incest as the most decisive way to overthrow the corrupt patriarchy of the ancien régime and to symbolize that overthrow. The interest and appeal of his proposal can be sensed in both Byron and Shelley, perhaps in Wordsworth's solution of the Dorothy–William, sister–brother relationship at the end of *The Prelude*.)

If *The Revolt of Islam* projects the ideal revolution, but within a realistic appreciation of its probable end, *The Cenci* (1819) shows the way the actual revolution in France evolved—that is, the wrong way. Old Cenci sees himself ultimately as the scourge of God, and so the Cenci children's patricide, the worst of crimes, is justified but remains an error prudentially and morally. To begin, Shelley has constructed his play on the model of Otway's *Venice Preserved*, and both rebels and tyrants are corrupt. The exception is Beatrice, the catalyst of the murder, but she is the key to the failure of the patricide-revolution. For she takes on the strength of her father in the killing of him; then (when she betrays Marzio) she takes on his hypocrisy and deceit as well, as if in his death the tyrant were reborn in her; and finally she takes on his courage. Thus the model of Ambrosio is still at work in Shelley's fiction, and with it the Burkean–Blakean assumption about the inevitable corruption of the revolution. Also still at work is the leveling to undifferentiation of the revolutionaries and the tyrants. Not only Count Cenci but Beatrice, Giacomo, and Orsino all claim as authority for their actions that they are the Scourge of God.

Beatrice's response, as Earl Wasserman has said, is "to the tyrannical violation she has suffered, rather than tyranny itself"; the rebels have killed only a symptom of tyranny and so are crushed by the real tyrant, the Pope.[35] By accepting the doctrine of paternal authority while killing the father, she

35. Wasserman, *Shelley: A Critical Reading* (Baltimore, 1971), p. 94. I rely on Wasserman for my remarks on *The Cenci* and *Prometheus Unbound*.

merely becomes her father, assuming his own standards, laws, and religious superstition.

Her other error is impatience. If on the one hand impatience leads to bloodshed and this to repression by the surviving tyrants, on the other it will lead to the Terror (itself a consequence of external intervention in the Revolution) and Napoleonic imperialism. Finally, it will lead to the "gloom and misanthropy" of the succeeding age, to the mistaken retreat by the Wordsworths and Southeys from hopes of radical reform into conservative reaction, and to the "infectious gloom" of Byron (Maddalo).[36]

Beatrice should have endured like the vast assembly of "the fearless and the free" Shelley projects in *The Masque of Anarchy* (written in 1819 immediately after the Peterloo Massacre) who stand up to the tyrants' forces until the very slaughter overwhelms the tyrants and reduces them to shame and defeat.[37] Or she should have forgiven her father's wrongs while defying his power, on the model of Prometheus, replacing vengeance with pity and patience, endurance and love.

The relationship of Prometheus to Jupiter in *Prometheus Unbound* (1818) is very similar to the servant–master relationship of Caleb and Falkland: The two are utterly dependent on each other for existence. Prometheus says he actually *created* Jupiter, as man creates his god, and "O'er all things but thyself I gave thee power," he tells Jupiter, "And my own will" (I.273–74). Prometheus/Jupiter are man as creator and the projection of his own tyranny into the tyrant, who is, as Wasserman has noted, "a cruel parody of Prometheus" (p. 260). Thus when Prometheus delivers his curse on Jupiter he *becomes* Jupiter or at least that aspect of himself he projects into his god: the act of revenge he has to repudiate in order to break the vengeful cycle and be redeemed.

At the moment of the curse the monster Prometheus/Jupiter is like the interchangeable Orc/Urizen of plates 8 and 10 of *America*. Both monsters are part of a historical process of tyranny, revolution, and intensification of tyranny, but in both cases an attempt is made to rise above the vicious cycle. Prometheus takes the next step by retracting his curse and transcending this (the Jupiter) aspect of himself: the answer is the passive disobedience of refusing to reveal the "secret" of Jupiter's mortality.[38]

36. See *Revolt of Islam*, preface, and *Julian and Maddalo*; see also Wasserman, p. 96.

37. As Shelley put it in the preface to *The Cenci*: "Undoubtedly, no person can be truly dishonoured by the act of another; and the fit return to make to the most enormous injuries is kindness and forbearance, and a resolution to convert the injurer from his dark passions by peace and love. Revenge, retaliation, atonement, are pernicious mistakes" (*Complete Poetical Works of Shelley*, ed. Thomas Hutchinson [Oxford, 1904], p. 298).

38. Byron too proposed a similar solution to the endless "cycle of vengence" in his "forgiveness curse" in *Childe Harold*, IV, ll. 135 ff. The *Caritas Romana*, the daughter who saves her imprisoned father by feeding him her own milk, reverses the cyclic movement toward destruction (see stanzas 78–79) as the pious daughter replenishes her "Sire's heart" with new "life."

It should come as no surprise that this new Promethean order is inaugu-
rated on the first day of spring. Prometheus's restoration coincides with the
renewal of the Spirit of Earth in eternal spring, when through her "with-
ered, old, and icy frame / The warmth of an immortal youth shoots down /
Circling" (III.iii.88–90). This Shelleyan version of the opening of *America*
includes Asia, the generating or sustaining spirit of love. The Spirit of Earth
plays the role of Eros or Cupid, son of Venus: winged, carrying a torch,
called "Child of Light," Earth's "torch-bearer,"

> Who let his lamp out in old time with gazing
> On eyes from which he kindled it anew
> With love, which is as fire. . . . [III.iii.148–51]

The Spirit of Earth, as part of the familiar complex of love–life–sunlight,
serves as guide to the Promethean company, guiding lovers to their union,
"the earth thro' heaven" (III.iv.7).

The choices Shelley offers are the slavish depth of becoming a "willing
slave," as Count Cenci demands of Beatrice; the impatient way of the French
Revolution and bloody revenge; and the patient, stoic endurance and pity—
Prometheus's refusal to consent to reveal to Jupiter his "secret"—which will
defeat the tyrant. He is careful, however, to establish a correspondence be-
tween the alternatives and different poetic modes. In his optimistic experi-
ment in decorum (which should be constrasted with Wordsworth's dem-
onstration of the utter incompatability of the Revolution and any conventional
literary form), Shelley uses tragedy for the story of the failed revolutionary
Beatrice Cenci and epic for the full story of the revolution in *The Revolt of
Islam*; lyric drama for the successful or ideal projection of revolution carried
out in *Prometheus Unbound*; and emblematic satire, on the model of Gillray's
caricatures, in *The Masque of Anarchy* and the mock-oedipal tragedy of
Swellfoot the Tyrant (1819), in which Burke's "swinish multitude" becomes
the chorus of swine in a kingdom ruled by boars.

Even Keats, when he attempts his Miltonic epic *Hyperion* (1818), adopts
the plot of a revolution and associates the process of revolution with the
movement from sublime to beautiful. The act of revolution has become the
model for his own projected "revolution" in writing poetry. But as Words-
worth began his *Prelude* where *Paradise Lost* ended, Keats (closer to Blake
in this respect) reverses the opening: the rebels have won the war and Saturn
has been overthrown by "the rebel" Jove. He gives us the description of the
fallen Titans and the speeches of their council of war as if the first two books

This is a reversal of the Saturn story and of the Second Fall (as Byron calls what he does in fact
see taking place on his travels). Being a Horatian rhetorician rather than a Blakean or Shelleyan
prophet, he *urges* his readers to break the cycle. See McGann, *Fiery Dust, Byron's Poetic Devel-
opment*, p. 53.

of *Paradise Lost* were being repeated from the Satanic point of view but with different names.

Keats uses Hyperion, the sun, as the protagonist of his mature epic in order to tell the story of the new style beauty replacing the old through the experience of the sublime, in this case a revolution. Hyperion is replaced by Apollo, one sun by a second. Hyperion is the sun of the old, comfortable, "beautiful" world associated with adjectives such as "bright," "blowing gold," and "bronzed." The description of the fallen Titans is, however, of a sublime landscape, with "covert drear."

> Scarce images of life, one here, one there,
> Lay vast and edgeways; like a dismal cirque
> Of Druid stones, upon a forlorn moor,
> When the chill rain begins at shut of eve. . . . [II, ll. 32–36]

The effect on Enceladus is precisely a transformation from beauty to sublimity: "once tame and mild / As grazing ox unworried in the meads," he is "Now tiger-passion'd, lion-thoughted, wroth" (ll. 66–67). Saturn too has been transformed by the revolution and now shows "all the frailty of grief, / Of rage, of fear, anxiety, revenge, / Remorse, spleen, hope, but most of all despair" (II, ll. 93–95). What the Titans, like the French aristocrats of Burke's *Reflections*, lose is the state traditionally described as the beautiful, with its maternal, infantile, and regressive associations.[39] *Fall* is the central sublime term in these passages but surrounded by *darkness* and *death*, as well as *insult* and words of conflict and revenge.

Only Oceanus, overthrown by Neptune, sees that the innocence of their existence required the revolution that transforms beauty into sublimity, and that this will in turn lead to a higher form of beauty-through-knowledge:

> So on our heels a fresh perfection treads,
> A power more strong in beauty, born of us
> And fated to excel us, as we pass
> In glory that old Darkness: nor are we
> Thereby more conquer'd, than by us the rule
> Of shapeless Chaos. Say, doth the dull soil
> Quarrel with the proud forests it hath fed,
> And feedeth still, more comely than itself? [II, ll. 212–19]

But the one Titan who has not yet fallen and been replaced is Hyperion (although he is in the process of being replaced by Apollo) and so the sun

39. See Harold McGee, "Keats and the Progress of Taste" (Diss., Yale University 1978), p. 216. See also Stuart Sperry, according to whom *Hyperion* is already "concerned with poetry and the various degrees of its power" and with Keats's "sense of the failure of the generation of poets before his own"—i.e., Hyperion equals Wordsworth (*Keats the Poet* [Princeton, 1973], p. 182); and Stuart Ende, who sees Milton present in Saturn (*Keats and the Sublime* [New Haven, 1976], p. 102).

and its aspect of poetic inspiration are the action and theme of *Hyperion*. Keats follows Wordsworth, who saw the sublime experience as one to be passed through on the way to a higher form of beauty (and of course his progression is parallel to Blake's from Innocence to Experience to a higher Innocence). Apollo, however, who has to represent or bring about this transition, raises the question of how he can do it without being ruined as Hyperion and the other Titans are by the experience. Wordsworth would say that one has to have experienced the Revolution. Keats says that one cannot have. This is not only the difference between two generations but between the egotistical sublime and negative capability, which allows an Apollo or Keats to project himself, as Apollo speaks:

> Knowledge enormous makes a God of me.
> Names, deeds, gray legends, dire events, rebellions,
> Majesties, sovran voices, agonies,
> Creations and destroyings, all at once
> Pour into the wide hollows of my brain,
> And deify me, as if some blithe wine
> Or bright elixir peerless I had drunk,
> And so become immortal. . . . [III, ll. 113–20]

The fragment of *Hyperion* ends, "Apollo shriek'd," and in the new attempt *The Fall of Hyperion* (1819) (Keats's own poetic attempt at the transition of beauty through the sublime to a higher beauty, aware of agony and fall) the verb is transferred to the poet himself. The plot is buried, like the story of Juan in the conversation of *Don Juan*, in a frame of dream vision concerning the inspiration of the poet. The whole becomes more clearly a poem about the development of the poet's identity or unfolding awareness, a small, fragmentary version of *The Prelude*, but fragmentary in the same sense, a "prelude" to the story of Hyperion, in which Keats, it is clear, is trying to decide whether he is Apollo to Milton's Hyperion.

CHAPTER 9 🙌
GOYA AND THE SPANISH REVOLUTION

On the French invasion of Spain in 1808, Wordsworth's landlord Mr. Crump had this to say:

> Well, Mr. W., is there no good to come of this? What do you say to rooting out the Friars, abolishing the Inquisition, sweeping away the feudal tenures?

Certainly Bonaparte "would be a great benefactor to the Spaniards: they were such vile slaves."[1] But then as the Spaniards rose against the French and fought for their freedom, Elizabeth Inchbald wrote of Napoleon:

> No doubt his reign would have been a blessing to them [the Spaniards], would they at first have submitted. But now the avenger is the character he must take, and we shall have to lament another nation, added to the number of those, on whom we have forced him to draw the sword.[2]

Inchbald is saying that it would have been a blessing if Napoleon had simply ruled Spain. But the Spaniards' rebellion put him in the role of the oppressor and tyrant he would otherwise have rid them of. And, she concludes, he was forced into this role because the English supported the Spaniards against him. The Spanish situation, which began as a country freed by the French of ancien régime tyranny, had become a populace rising en masse against a foreign conqueror.

This Spanish revolution allowed an ex-

1. Letter to Thomas de Quincey, 29 March [1809], in *The Letters of William and Dorothy Wordsworth. The Middle Years*, ed. Ernest de Selincourt (Oxford, 1937), p. 275.
2. Quoted without citation in W. L. Renwick, *English Literature 1789–1815* (Oxford, 1963), p. 28.

cuse for English sympathizers with the French affair who had become disillusioned to regain their confidence. As Coleridge wrote in the *Courier*:

> It was the noble efforts of Spanish patriotism that first restored us, without distinction of party, to our characteristic enthusiasm for *liberty*.[3]

The notorious "Don Cevallos" article by Jeffrey and Brougham in the *Edinburgh Review* made the appropriate distinction between the virtue of romantic nationalism and the fruit of the perverted French Revolution, which was international liberalism—against both of which were pitted the reactionaries. The importance of the Spanish revolution was that it was a rising of "the people" and "above all the lower orders." Abandoned by king and aristocracy, the people were left to rise alone against the "enemy of both national independence and civil liberty," the French. Turning to the English audience, "Don Cevallos" calls this "a lesson to all governments—a warning to all oligarchies."

> . . . we can once more utter the words *liberty* and *people*, without starting at the echo of our own voices, or looking round the chamber for some spy or officer of the government.

Because now "salutary, just and necessary revolution" has been rehabilitated and "those feelings of liberty and patriotism which many had supposed were extinguished since the *French* revolution" have been reawakened.[4] The fact that the uprising was in reality reactionary, for king and Church against the liberal forces within Spain, was only part of the complex of ironies the English glossed over.

The political developments in revolutionary Spain coincided with the maturation of Francisco Goya's art. The first phase, that of the *Caprichos*, was the 1790s, when the Spanish reacted to the French Revolution itself; Goya shows Spain in the shadow of the great revolution in their neighboring country. The second phase began in 1808, when Napoleon placed his brother Joseph on the throne of Spain, and the uprising that followed was of the Spanish people against the foreign invaders, who were incidentally the transmitters of revolution, liberal government, and enlightened ideas.

3. *Courier*, 7 December 1809, in *The Collected Works of Samuel Taylor Coleridge. Essays on His Times in The Morning Post and The Courier*, ed. David V. Erdman (Princeton, 1978), 2, 38.

4. "Don Pedro Cevallos on the French Usurpation of Spain," in *The Edinburgh Review, or Critical Journal*, 13 (1808–09), 215–34; the quotations are pp. 220–22. The passage that attracted most attention was one looking toward a similar revolution in England which would raise "the power of real talent and worth, the true nobility of a country" and raise up the masses "to direct the councils of England." See Ben-Israel, *English Historians and the French Revolution*, pp. 40–42. The term *nationalism* was introduced by Barruel, as Billington says, "to denigrate the new form of parochial, secular selfishness that he felt was replacing universal Christian love as the human ideal" (*Mémoires pour servir à l'histoire du jacobinisme*, 3, 184; the words are Billington's, *Fire in the Minds of Men*, p. 58).

This ambiguous phase was represented in Goya's *Desastres de la guerra*; the final *Desastres* heralded the third phase, the counterrevolutionary restoration which replaced the French with the far more burdensome tyranny (for liberal Spaniards at least) of the rightful Spanish king.

Spain was even more primitive and feudal than France, but the Bourbon Carlos III had ruled as an enlightened despot, employing ministers whose aim was to modernize Spain. Those who favored enlightenment were the royal officials, and enlightenment was a matter of opening up trade to laissez-faire principles and recovering from the stagnation of commerce built on privilege and inheritance. Those who were opposed to enlightenment reform were the nobles and clergymen, who feared the breakup of their large landholdings. In Spain then, enlightenment and reform were in progress in the 1770s and 1780s, reaching down from the top of the social structure. To Goya's circle at least, the king was the hero and the villains of the enlightenment drama were the hereditary nobility and the Church, the repressive symbol for which was still the Inquisition.

The Inquisition had had to trim its sails somewhat during the reign of Carlos III, but it was Blanco White's opinion that its hold was as firm as ever. He attributed the apparent softening of its grip less to its own compromises than to the submission of the people, arguing that, for example, the end of the burnings of heretics was less due to the leniency of the Santo Oficio than to the failing will of the heretics to maintain their defiance until the end.[5] The Church remained the tyrant for the enlightened middle class; for the lower orders it held all its old power (although they may have shared the mirth of their betters at the sight of satiric prints on the greedy clergy as well as the idle nobility).

At first the Spanish received no news whatever about the revolution in France. The chief minister Aranda feared it might lead to demands for reform from the bottom rather than (as he believed should be the case) from the top. Only after the death of Louis XVI and the declaration of war on Spain in March 1793 did the news reach the Spanish nation as a whole. Not the reform but the regicide was made known, and so the basic image of France was of a royal beheading; and the people—still in the tight control of their clergy—directed their violent reaction, which erupted in riots, against the French residents and the French forces on the border.

The volatility of the situation was increased by the accession of a less effective king, Carlos IV, and his queen Maria Luisa in 1788, and shortly after by the rise of Manuel Godoy as favorite and then chief minister. Godoy was young, handsome, the queen's favorite, and also apparently the king's; he rose overnight from a guardsman to commanding general and prime minister. The lower classes of Madrid and the great cities were scan-

5. Richard Herr, *The Eighteenth-Century Revolution in Spain* (Princeton, 1958), p. 212.

dalized. They had never approved of *cortejos*, the young men who served as intimate companions of married women of fashion, and the intimacy of this parvenu (soon created Duque de la Alcudia) with the queen contrasted strongly with the austere chastity of Carlos III's life following the death of his queen. From the nobility's point of view Godoy was an upstart and, moreover, a reformer who continued the programs of Aranda. At the peace with France in 1795 the king gave Godoy the title Príncipe de la Paz (Prince of the Peace), making him virtually equal with the Príncipe de Asturias, the heir to the throne. From then on opposition formed around the future Fernando VII. Godoy continued to push reforms, but the attacks on him increased from the major cities and universities. The scandal contributed to make even the reformers and liberals themselves turn more attention to the principles of the French Revolution as an alternative to reform-from-the-top. Godoy, caught between the forces of reaction and reform, was forced in 1798 to resign. By this time he had supposedly fathered the youngest Infanta.

Goya's *Caprichos* may have been ready as early as 1797, but they seem to reflect more accurately the events between then and the actual date of publication, 6 February 1799. By then Godoy had resigned and was replaced by Goya's friend Jovellanos and *ilustrados* ministers; the queen had taken a new lover; the *ilustrados* ministers were replaced and exiled (Aug. 1798); and Godoy was once again exercising influence and power at court. The *Caprichos* were on sale only two days and then withdrawn.[6]

Goya's own situation at this time was ambiguous. He was painter to the king, and Godoy was a personal patron. He was about to paint his *Capricho*-like portrait of the royal family (Prado), who apparently accepted it complacently as a mirror image.[7] He also painted a strikingly original, and in its way equally monumental, portrait of Godoy on the battlefield (fig. 57). Godoy is shown reclining, appearing (unlike the ramrod officer next to him) neither vigorous nor upright, as if in bed or on a chaise longue, with a

6. See Eleanor A. Sayre, *The Changing Image: Prints by Francisco Goya* (Boston, Museum of Fine Arts catalogue, 1974), p. 55, and Gwyn A. Williams, *Goya and the Impossible Revolution* (London, 1976), pp. 34–38. Williams gives the most plausible picture of Goya's political entanglements in their context. Raymond Carr's explanation for the failure of the liberal revolution in Spain is "that political change was unaccompanied by those social and economic changes that give to political revolution its substance." The work of the *ilustrados* altered "the traditional attitudes" of society but not "the traditional structure of society," and this was a discrepancy that was never overcome, whether the revolutionary was a chief minister, a Godoy, or a Napoleon. Spain was the classic example of the failed revolution from above. See Carr, *Spain 1808–1939* (Oxford, 1966), pp. 1, 38.

7. See Fred Licht, *Goya: The Origins of the Modern Temper in Art* (New York, 1979), pp. 67–82, for a brilliant and largely persuasive account of the painting; but cf. Nigel Glendinning, "Signs of the Zeitgeist," *TLS*, 21 March 1980, for another view.

suspiciously phallic cane between his legs.[8] Both of these details might be taken to indicate the source of his power, as the horse's rump next to him might hint at another aspect of the painter's attitude toward him or only a formal parallel to his own plump shape. Godoy himself apparently saw nothing to complain of.

Goya was also a friend of Jovellanos and his circle, as well as of the younger Moratín and other enlightened (in Moratín's case *afrancesado*) writers. In some ways he was illustrating their writings in his works of the late 1790s. Whatever his attitude toward Godoy, he would have seen in the years leading up to Jovellanos's dismissal—and the division of his allegiances that was entailed—a bewildering series of alternations between enlightenment and repression in the policies of Maria Luisa and Godoy, of good intentions and stupidity, while the egregious power of the Church remained largely undisturbed.

I begin by asking whether in the *Caprichos* of 1799 Goya represented only the oppression of the old order or, in some sense, also the explosion that might (and would shortly) dissipate and replace it with a new order. Of course, in the *Caprichos* Goya was doing a number of things. He was producing a visual equivalent of the gothic novels and poems so relished by his circle, and he was satirizing popular superstitions from the point of view of his enlightened friends. (Jovellanos's favorite English novelist was Radcliffe—Lord Holland supplied him with her novels—but he regarded the superstitions of the Spanish vulgar with horror and even opposed their bullfights.) At the same time, Goya was using this "literary" exercise as a vehicle for a condemnation of certain aspects of contemporary society.

One of his referents in the *Caprichos* was undoubtedly the French Revolution with its mixture of release, hope, bloodshed, and further repression (as it appeared from across the Pyrenees), and another was the uprising in Spain in 1793 of the people (*la plebe, la multitud, el vulgo*) against the enlightened aspects of both the French phenomenon and the reforms of the ilustrados, the forces of enlightenment within Spain. This was paradoxically, as R. R. Palmer has noted, "the one part of Europe where a general rising took place successfully for strictly conservative purposes," the issue being the Church versus French "atheists and fiends."[9] But every aspect of "revolution" in Spain was paradoxical. Among other things it showed that pop-

8. The Duchess of Abrantes, writing in 1805, noted that she found Godoy leaning against a console, playing with a drapery tassel; she comments on his informal bearing (Geoffroy de Grandmaison, *L'Espagne et Napoleon* [Paris, 1908], 5, 263). The diagonal slant also characterizes Goya's self-portraits and his portrait of Jovellanos; when his portrait subjects support themselves on a table they often lean in that direction. The table is not supporting an upright posture but allowing them to lean at an angle and create a diagonal. The aim may have been variety, but the effect is very different in the cases of Goya, Jovellanos, and Godoy.

9. Palmer, *The Age of the Democratic Revolution* (Princeton, 1959, 1964), 2, 178.

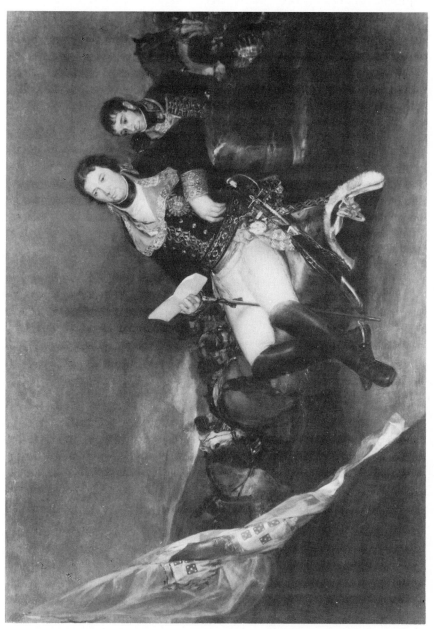

57. Francisco Goya, *Portrait of Godoy*. Painting, 1801.

ular uprisings are usually conservative in that they try to recover something from the past that is being taken away by the innovating, forward-looking liberals. In this case the people were led by clergy and nobility, whose objective was the preservation of their own ancient rights and privileges.

A series of conservative revolts (reaching to the "revolution" of 1820) muddled together with the repression of Church and nobility, the enlightened reforms of some Spaniards, and the ambivalence of the royal family— this *was* the Spanish revolution. There were no clear sides, only repression and revolt cutting across both enlightenment and "black" Spain, high culture and low, foreign influence and nationalism. Goya represented this process in an endless series of prints, drawings, and paintings from the mid-1790s until his death in 1828. The totality of these series can be interpreted as an attempt to come to terms with or master certain images, repeated and expanded into the dimensions of myth.

However, although the *Caprichos*, *Desastres*, *Tauromaquia*, *Disparates*, and the paintings in the *Quinta del Sordo* (the Deaf Man's [i.e., Goya's] House) represent phases or stages in the history of the Spanish revolution, it is also undeniable that these external, historical events had their internal equivalents, and that Goya may have been using contemporary history as a way of coming to terms with his own breakdown, his deafness, and his relationship with the Duchess of Alba, all of which corresponded temporally to the Terror in France, the first French invasion of Spain, and the fall of the ilustrados from power. It is of course equally possible that he may have used images that arose out of these personal crises to represent the historical events that impinged upon him and Spain.

Before looking at these images, a few words are called for concerning the formal characteristics of Goya's art. The art historian Theodor Hetzer has shown, in a brilliant formal analysis, that Goya consciously cuts himself off from the baroque and neoclassical traditions, from the subordination of a traditionally unified picture space, by the isolation of details, in particular human figures.[10] Taking the example of *Caprichos*, no. 25 (fig. 69), he argues that because Goya uses the conventional system of baroque diagonals only "to attract our attention to the figures themselves[,] . . . the particular has usurped the place of the general." This intensification of "the single, isolated motif until it becomes significant in itself" can lead either to isolation of a figure or to the magnification of a detail into nightmare. In this image focusing on the child's bare bottom, Goya uses the forms of baroque art ("with which we associate elevated themes") to the end of isolating one detail, thus transforming a commonplace scene "into something gigantic,

10. "Francisco Goya und die Krise der Kunst um 1800," *Weiner Jahrbuch für Kunstgeschichte*, 14 (1950), 7–22; translated in *Goya in Perspective*, ed. Fred Licht (Englewood Cliffs, N.J., 1973), pp. 92–113. The passage that follows is on p. 109.

uncanny, incalculable." Such scenes "are *in fact* incalculable, because they no longer form part of a self-contained order. . . ." If on the one hand they are isolated and magnified details, on the other they "know no bounds," are no longer limited by the conventional picture space (see no. 51). They know no bounds, not in the baroque sense of suggesting a continuum with the cosmos but in a new sense: this is not part of something greater but simply cut off from other, equally incoherent scenes.

Hetzer uses his perceptive analysis of form to make the point that Goya is laying claim to "the self-sufficiency of the artistic imagination":

> With Goya the artist's genius becomes absolute and responsible to no one. The inspired artist no longer carries out the will of God. He creates a world without God. The baroque artist finds dignity and beauty in things in themselves because they bear testimony to God. For Goya the human figure, the washing, and the basket [of *Capricho* 25] are all trivial in themselves and become significant only in so far as he concerns himself with them.[11]

I do not mean to deny the partial truth of Hetzer's thesis: Goya's letter to the Spanish Royal Academy and his announcement of the *Caprichos* in the *Diario de Madrid*, as well as the contemporary stories of Bermúdez and others about his independent attitude toward patrons, confirm his romantic sense of the free artist. But to claim that the "subject is henceforth to be chosen by the artist himself and what he chooses is his concern alone", simplifies what Goya meant by "the artistic imagination." To say that his choices were only those of the "first modern artist" is, among other things, to ignore the similarity in theme and imagery in the works of Jovellanos, Moratín, and other ilustrados of his circle.[12]

The baroque forms and the heroic rendering of low-life figures (however ambivalent his feelings about the multitud, el vulgo, from which he himself derived) reveal that Goya understood one part of the message of the French and Spanish revolutions: that "direct interference of the masses in historic events" which Trotsky considered the essential aspect of modern revolution. For whatever confused and self-defeating end, the uprising of the people was the defining feature of Goya's revolution.

The isolation of the figures and the breakdown of the overall macrocosmic system of the composition also have to be read on a social as well as

11. Ibid., p. 110. Licht follows Hetzer's thesis (in *Goya: The Origins of the Modern Temper*) to argue that Goya is the "first modern" artist. These words are too vague and easy. I hope to pin down the quality and meaning of Goya's innovations, and then we can call them "modern" or whatever. For a useful account of contemporary (and later) documentary accounts and responses concerning Goya, see Nigel Glendinning, *Goya and his Critics* (New Haven, 1977).

12. See John Dowling, "Moratín's Circle of Friends: Intellectual Ferment in Spain, 1780–1800," *Studies in Eighteenth Century Culture*, 5 (1976), 165–84; Edith F. Helman, *The Younger Moratín and Goya: on Duendes and Brujas,"* Hispanic Review, 27 (1959), 103–22; and Nigel Glendinning, *A Literary History of Spain: The Eighteenth Century* (London, 1972), pp. 112–14.

an aesthetic level. Alienation is Goya's subject, perhaps from the beginning, but certainly with a marked increase of intensity in the 1790s: the alienation of the ilustrados, of himself, and of the artist. He is using his art, in which isolation becomes ultimately swallowing, engulfment, or burial, as a means to the end of expressing this subject. In the same way, I cannot agree when Hetzer, pointing to the breakdown of conventional pictorial boundaries, argues that "Goya frees himself from the old convention that a picture should not extend beyond the limits set by the frame. . . . Its only function is an artistic one; it is there to create a painting out of something that is, in fact, only a segment of a wider view" (p. 110). But between these sentences Hetzer has a revelatory aside: "It becomes obvious that a frame can no longer enclose a world": for Goya adds to the artist's revolution—which is clearly present, one referent of the art work—the external referent of history, of the political and personal experience which can no longer be enclosed, as it can no longer be seen in terms of subordination or a coherent world order. For example, in the *Desastres* the frame that cuts off the executioners, exposing only their rifle barrels, is hardly an artistic statement only; it is a statement about the impersonality of the executioners.

The same must be said of the essential Goya trait from the mid-1790s onward of creating in series (though of course conditioned by the series of cartoons commissioned in the 1780s for the royal tapestry works), and moreover in particular kinds of series. Again this is an artistic statement, but it primarily acknowledges that experience can be represented only in a series of fragmentary, even contradictory images; truth can no longer be expressed in an emblem or in a single comprehensive image. Goya must show a number of reportorial *Desastres* in which the monks are heroic and then, without canceling these, add more—now once again "caprichos"—in which they are aggressive and cruel, and in *that* order. There is no longer a possibility of a unified subordinated structure in which these different facts can be related and comprehended. There is no real, firm conclusion but only various possible endings, including the death of Truth and a conjectural rebirth and then appended etchings of prisoners in chains (attached to the endpapers of the copy Goya gave to Cean Bermúdez). Experience can no longer be grasped in the usual narrative or emblematic series such as (in the Spanish royal collection) the Jan Brueghel *Five Senses* or *Four Seasons* any more than it can in the baroque machine of a single history painting.

In all this Goya uses a style to make a point about society as well as about art. And the evidence can be drawn equally from his use of the art of earlier masters, which answers one aspect of the question of what he (as opposed, say, to David and the French apologists for their revolution) had to build upon. His storehouse of representations was the Spanish royal collection. Walking through the Prado today one experiences the world as Goya did and as he represented it in his art. One thing Goya's series do is to make a

sequence with, or take a start from, the art in the Spanish royal collection. The paintings on the walls of the Deaf Man's House are the open-ended finale of a sequence that begins with Titian and proceeds to Rubens and Velasquez, with a strong infusion of Philip II's favorite northern painter Hieronymus Bosch. Goya's schemata are those of Rubens modified by Bosch, of Massys modified by Murillo, and above all of Velasquez modified by the Enlightenment and the literature of the eighteenth century.

If, as Hetzer shows, Goya reduced the internal coherence of the Velasquez paintings he copied in etchings of the 1780s, emphasizing the isolation of the figures,[13] the point is that he chose a particular kind of Velasquez, the isolated figure of a fool, buffoon, or madman, and used this as the model for all his Velasquez copies. At the same time, he turned back in important ways from the baroque picture structure to pre-Renaissance, pre-perspective box images of the lone figure of Christ or a saint. (Also available in the royal collection were Ribera's martyrs, Christian and mythological, isolated in Carravagesque darkness.) From the dwarves with their proud looks and gorgeous attire, as isolated as figures in his *Caprichos*, Goya took the conventions of an unsparing exactness that is not satire but a Spanish sense of man sub specie aeternitatis, whether king or madman. From Velasquez's portraits of lone euhemerist mythological figures he took the idea of contemporary Spaniards in everyday situations who are *called* gods or come to think of themselves as gods. From *Las Meninas* he took not only the mingling of the grotesque and royal figures but the presence of the artist in his own painting and the problem of the artist consciously seeing himself in relation to his subject matter, his external referents of kings *and* dwarves. He was simply building on the attitude toward the portrait in the Spanish royal collection, found nowhere else in Europe, in which the dwarves were painted with as much art and sympathy as the king. It proved to be a political as well as an artistic education to live and mature among these paintings at this time.

THE *CAPRICHOS*

As published, the *Caprichos* are divided into two parts, with the series of waking scenes followed by nightmare scenes, scenes of contemporary society followed by the witches' coven, *duendes*-monks, and other monsters. The question is whether this version of the kings and dwarves of the royal collection shows a temporal progression or only two versions of the same reality, one seen in a waking state (society masked) and the other in sleep (unmasked). The answer depends on what it is that Goya unmasks in the *Caprichos*.

13. Hetzer, p. 102.

We can begin with *Capricho* 2 (we shall return to 1, the frontispiece self-portrait [fig. 58]). Number 2 (fig. 59) shows a wedding and is inscribed: "El si pronuncian y la mano alargan al primero que llega" (They say yes and give their hands to the first comer) (though *sí* means yes, *si* means *if*). This is the young woman who allows her family to sell her in marriage in order (as one of the commentaries on the *Caprichos* explains) to "live in greater liberty." In this sense such women "say *if* and give their hands" in marriage.[14] Goya is illustrating the Spanish assumption that it is better to circumvent repressive social customs than seek to liberalize them, and that only by giving oneself to a loveless contract can a woman gain the license to have the man she *loves*.

The scene is presented as a wedding procession, but the beautiful bride and ugly groom are proceeding toward an altar on what appears to be a stage. An audience is visible beyond, and at least one mouth gapes in applause or mockery. The bride wears masks facing in two directions, one for her husband and the other for her family behind her; the second face turns her into a version (a memory) of the two-faced woman in Goya's trial print "Sueño de la mentira y la ynconstancia" showing himself and the Duchess of Alba (fig. 76). With the grotesque faces surrounding a beautiful one, as well as the stage setting, the scene seems to evoke an Ecce Homo or even an execution scene enjambed with the ostensible scene of marriage. In a form so extreme as to be grotesque this is the same enjambment used when David brought together the oaths of the Horatii, Lucius Junius Brutus, and Marcus Brutus in *The Oath of the Horatii*—or Blake brought together Orc and Urizen, the lamb and the tiger.

If *Capricho* 2 shows the young woman's contractual imprisonment as a stage performance, 3 shows the consequence (fig. 60). Here is a married woman with her children. Inscribed "Que viene el Coco" (Here comes the Bogeyman), another isolated detail against a totally dark and indeterminate background, it shows a gothic shape, a ghost, and more particularly in the Spanish context a cowled monk. The comment is on the superstition encouraged by the Church (cf. no. 52, from the second half of the *Caprichos*). The mother is saying to her children: If you are bad, God will punish you. She uses the church to keep her children in line, precisely (we may assume) as she herself was treated up to the point where she found her own way out of a similar exploitation in number 2. Her own rapt expression as she looks at el Coco is in powerful contrast to the terror on the faces of her children. Her expression, however, is more physical than spiritual, for the inscription "el Coco," to any literate Spaniard, would have recalled the mother's lover in *Lazarillo de Tormes*. The mother has taken a Morisco as her lover, a con-

14. On the *Caprichos* commentaries, see Sayre, *Changing Image*, pp. 56–58.

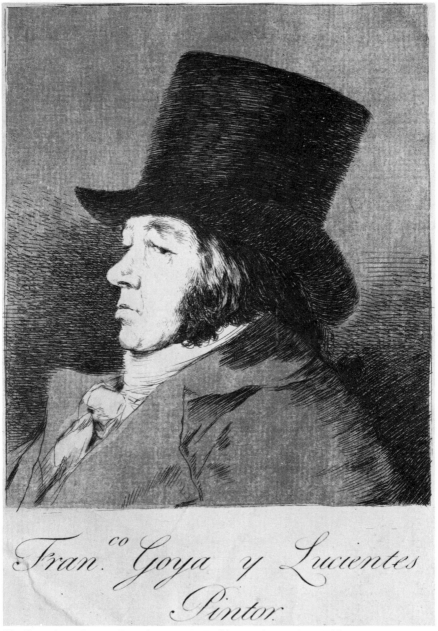

Fran.ᶜᵒ Goya y Lucientes
Pintor

58. Francisco Goya, *Caprichos*, no. 1. Etching and aquatint, 1799.

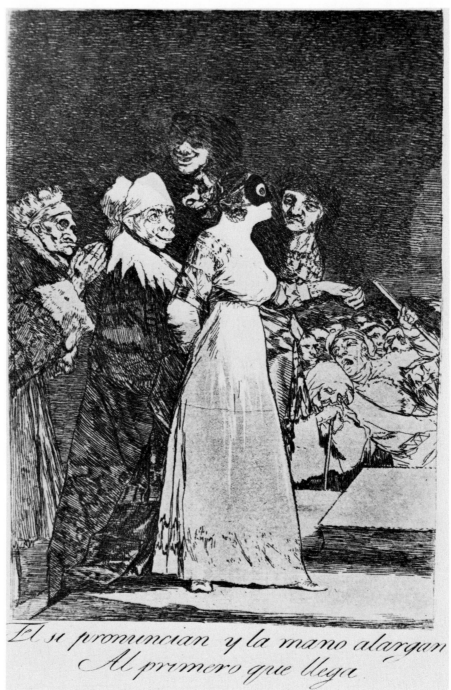

El se pronuncian y la mano alargan
Al primero que llega.

59. Goya, *Caprichos*, no. 2.

clusion the young Lazarillo finds it hard to resist when he is presented with
a little black brother. He remembers

> one occasion when my stepfather was playing with the baby, the child saw that
> my mother and I were white and his father was not; frightened, he ran from him
> to my mother and pointed to him, crying, "Mama! Bogieman [el Coco]!"[15]

Thus from the viewpoint of Lazarillo's younger brother, the father appears
as a figure alien and to be feared (but also ironically as the same as himself).
Lazarillo's own viewpoint is double, like Goya's; he knows him as step-
father, his own mother's lover, but he can depict with apparent detachment
his little black brother's horror at the alien-looking threat, for it is, of course,
his mother's lover. If to the brother el Coco is father and self, to Lazarillo
he is father and his mother's lover. For Goya the Other is the fear of the
Church and the mother's lover—who may be different from the father.

It is no accident that the unit of composition in the *Caprichos* is the family,
which, as it grows out of the superstition of those who worship or recoil
from el Coco, becomes in the second half of the *Caprichos* the witches'
coven. All the reformers agreed on the excessive size and might of the false
parent, the "unproductive classes," the Church and the nobility, who be-
tween them controlled two-thirds of the land in entail and mortmain. The
"slavery" of *mayorazgo* (or entail) was regarded as "the greatest single ob-
stacle in the way of progress" by the ilustrados. "Its declared aim was to
preserve a family name by attaching it perpetually to an estate that passed
undivided to a single heir," and this was a custom that had been criticized
for centuries "for encouraging laziness as well as being an injustice to younger
children."[16] Entail and primogeniture, the oppressive structures of the closed
society, were at the bottom of the imagery of the French Revolution. They
were also available to Goya in the English gothic novel, where the repres-
sive family had become the prison-like monastery from which the single
deeply repressed monk explodes into the monster who does all the terrible
things he had only dreamed of doing, still (in society's wrappings) disguised
as a monk. Now in the el Coco *Capricho* Goya represents the ancien régime

15. *Lazarillo de Tormes* (New York, 1960), p. 6. Cf. the many bogieman jokes involving the
pretenses of the adulterer, going back to the *Cent Nouvelles Nouvelles* (1461), no. 23, "La Pro-
cureuse passe la raye," and also perhaps no. 72, "La Necessité est ingenieuse" (see G. Legman,
Rationale of the Dirty Joke [New York, 1968], pp. 129–30; also Nigel Glendinning, "Goya on
Women in the *Caprichos*," *Apollo*, 106 [1978], 130 ff.).

16. Carr, *Spain 1808–1939*, p. 39; Herr, *Eighteenth-Century Revolution*, pp. 91–96. Lorenzo
Hervas y Panduro's *Historia de la vida del hombre* (1789) argues that political society is like a
family, but in the particular sense that there are only parents and children, as in society only
the prince and his subjects. There should be no distinctions between nobles and commoners
(and implicitly clergy) as all children of the monarch. The work, a condemnation of the hered-
itary nobility/clergy, saw the problem to lie in this third party that separates, or intervenes
between, parents and children. See Herr, p. 260.

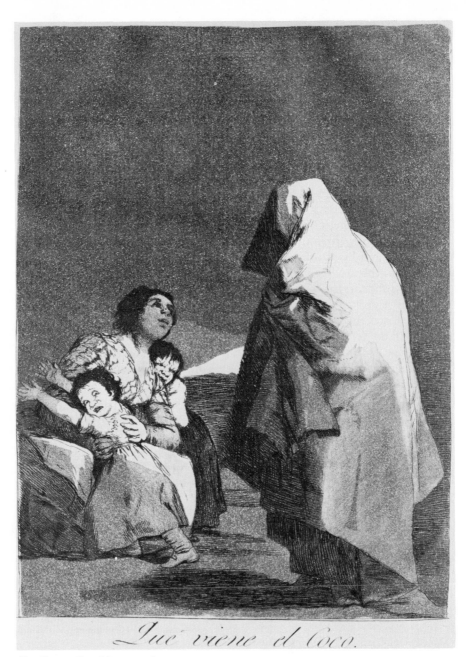

Qué viene el Coco.

60. Goya, *Caprichos*, no. 3.

as the Church and shows its control of repressed material (the struggle of the child with the father for the mother); yet at the same time this uncanny shape suggests a return of the repressed. The *Capricho* in an interesting way represents the modes of both repression and release for the mother, for the monk, and for the artist.

Number 4, "El de la rollona" (fig. 61), shows the aristocratic man-child: the child who does *not* rebel, never grows up, and remains at the oral–anal stage, fingering his mouth (nearby a pair of utensils to contain his food and his excrement), with amulets hanging from his sash to remind us of the Church and its superstitions which (as in no. 3) keep the child in line. The first three plates—which could almost have fitted into Blake's *Songs of Experience*—begin with the ways youth can escape society's toils, but they return from the successful outcome of the courtship ritual to the fundamental relationship of parent and child out of which the scene in number 2 is emerging (the old people waiting hungrily behind the bride). This return implies a cyclic progression. It *is* not only from binding to freedom but to the further binding of the next generation. This woman's liberty, inside the repressive structure of Spanish society, has not led to genuine freedom, in fact has left her children necessarily in the same position as she.

By *Capricho* 5 "Tal para qual" (fig. 62), if we are to believe the manuscript commentaries, we are in the presence of the great national paradigm behind numbers 1–3, Queen Maria Luisa herself, who called the king (Carlos IV), herself, and her *cortejo* Manuel Godoy a "Trinity." Godoy, the young guardsman interloper, was the man of no class who ruled the queen, on the one hand creating something unholy like Milton's Satan, Sin, and Death in relation to the true Trinity, and on the other fitting into Burke's paradigm of the young Rousseauian lover who breaks into the family and seduces (Burke would not have considered this *freeing*) the wife, becoming part and indeed the dominant part of the family and looming like the bogieman in the background of Burke's images of the French Revolution. There was the further inevitable analogy between Maria Luisa in Spain and Marie Antoinette in France, with the awareness that these were all Bourbons. The people of liberal as well as conservative traditions looked back to the reign of that ideal Spanish couple Ferdinand and Isabella and regretted the usurping house of Bourbon. As we have seen, one sine qua non of revolutionary imagery seems to have been a domineering queen and the subsequent suspicions of cuckoldry against the weak father-figure of the king. In a more general way this figure introduces the rendezvous (implied in the earlier plates) of wife and lover, with representatives of the older generation (mothers-duennas-bawds) still hovering in the background.

Numbers 6 and 7 introduce a new theme, that of perception. Masking or playacting was introduced in the marriage scene (2), where the delusion extended to everyone—not only to the husband (pictorially "in the dark")

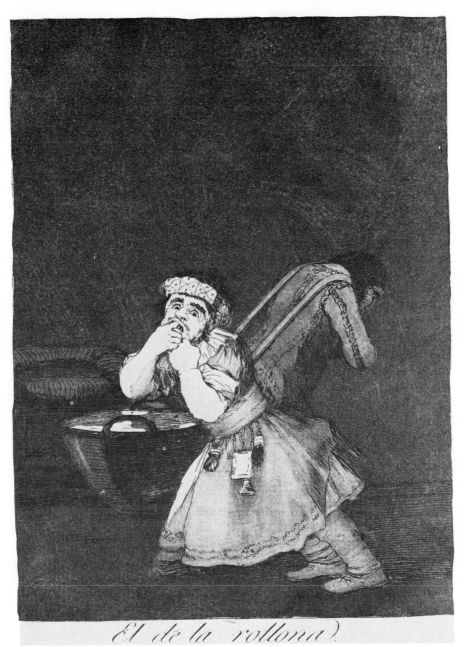

El de la rollona.

61. Goya, *Caprichos*, no. 4.

Tal para qual

62. Goya, *Caprichos*, no. 5.

but to the young woman herself, who assumed that she would "live in greater liberty" through matrimony. In these two plates one of the partners tries to see or fathom the other. In 6 everyone is in masquerade and the peering is mutual, but in 7 it has settled into the pattern that society knows (sanctions) best, with the woman self-contained and mysterious, the central figure, and the man failing even with the help of an eyeglass to make her out.

Numbers 8, 9, and 10 make a trio. The woman in 8 is the sequel to the woman in 2: once safely married, she is swept up by "the first who seizes her"—by figures who (echoing no. 3) resemble el Coco, suggesting again ecclesiastics. They seem to be abducting her but her response is as ambivalent as in 3: her expression is a mixture of fear and ecstasy. Number 9 presents a second view of the marriage: the husband (his face resembles the husband's in 2) is a Tantalus ("Tantalo").[17] The closer he approaches his wife, the farther she recoils. The scene takes place in front of the most famous of tombs, a pyramid; and the metaphor of marriage as tomb adds another context to number 2. In 10 then the woman is holding the body of her dead lover: the husband in 9 has "slain" his wife with boredom, and now the wife has gotten her lover slain, presumably by the husband, in a duel (Goya may have recalled Hogarth's *Marriage à la Mode*, pl. 5).

Such reversal, such reciprocal give-and-take becomes a structure of these early *Caprichos*: Husband is to wife as wife to lover—or bride to husband as mother to child, replacing her in the situation in which she started. Numbers 11 and 12 operate in this way as reciprocal killing and being killed, using and being used. In 11, "Muchachos al avío" (Lads making ready), bandits prepare for a robbery, while in 12 (fig. 63) a woman robs a tooth from the mouth of a hanged man, someone like one of the bandits but now caught. She steals the tooth for a charm to obtain her lover: The image again brings together (as in el Coco) the theme of the married woman's passion with the uses of sorcery and superstition, now completely the woman's, and suggesting that in no. 3 religion may have been a woman's self-delusion as much as a control over her children while carrying on her affair. The teeth, the mouth, and her hand in the hanged man's mouth all reinforce the theme of appetite at the bottom of her revolt: This is a homeopathic treatment, trying to cure a disease with one of its symptoms.

Number 13 (fig. 64) reverses the situation again. The monks, using *their* mouths to devour food, are labeled "Estan calientes" (They are hot)—the food they are eating is hot, their mouths are hot, or "They are *in heat*." The connection of eating with sexual appetite is identified at the level of an ambiguous verbal tag. If we go back to Goya's drawings for the print, we find

17. A Rowlandson print of 1786, *The Sorrows of Werter—the Last Interview* (Lewis Coll.), shows Lotte bare-breasted and lascivious, a picture of her husband on the wall, and Werther tearing his hair; between the lovers is a picture of Tantalus.

A caza de dientes.

63. Goya, *Caprichos*, no. 12.

that while one emphasizes the sexual aspect by the huge phallic nose of a monk, another emphasizes the other metaphoric sense of the drawing (which is also censored in the final print) by showing a human head on the platter being brought in, and adding as caption: "A Dream of some Men who were eating us up." The finished print reduces but retains implicitly the source in sexual desire and the consequence in human devourment, both of which come down to the gaping mouth—in a process of censorship in which Goya forgoes the nose and the head and renders the caption less explicit. One wonders if through Jovellanos he knew Milton's priests with "blind mouths," which summarize the relationship of perception to eating in this print. In each *Capricho* the predatory aspect of passion grows more explicit, from the rape to the robbery and the reciprocal theft of a robber's tooth, to the hungry monks; in each plate the predatory aspect is shifted from one sex to the other. This man preys on that woman, and then vice versa.

Number 14 literalizes the predatory aspect of the male that was only emblematic in 13 and reduces the sexual to a generational relationship. We are back in the situation of number 2, with the different reactions of the family ("a hungry family" according to the commentary), the ugly but rich husband, and the title, "Qué sacrificio," that verbalizes one aspect of the earlier scene. Appetite carries over from the two preceding plates in the family's hunger for money and the husband's for a pretty young wife. The daughter finds herself in "A Dream of some Men who were eating us up." Numbers 15 and 16 continue but simplify the generational relationship: the mother/duenna/bawd ("Bellos consejos") advises the girl on her course of action attracting men, and then the girl, having benefited by her motherly advice (presumably what *she* had learned from her own mother) cuts her in public. The mother corrupts the daughter, and the daughter thus repays the mother.

These reversals continue in 17 and 18 (figs. 65 and 66), where the girl's leg is compared with the old lecher's: Both expose a leg (a traditional image of lustful woman), but she seduces, he grotesquely repels. Relating to the metaphor of "heat" in 13, his "house is on fire," or as the Ayala commentary says, "an old man burning with lust can't manage to get his breeches on or off"; one commentary for good measure makes him a priest.

The wife-mistress has gradually been translated by the theme of her passion outside wedlock into a prostitute. Or perhaps the analogy has only become clearer and clearer: the girl is transformed by her need for liberty into a whore, with in the background something like Wollstonecraft's assumption that "marriage is licensed prostitution." Numbers 19–24 are about prostitution and fall into pairs. In the first two the women are preying on men, in the second two they are being preyed on by men (as in the commentary to 21, "You'll get as good as you give").

In 19 and 20, "Todos Caerán" (All will fall) and "Ya van desplumados" (There they go plucked), the women are plucking the men-birds (*desplumar*

64. Goya, *Caprichos*, no. 13.

Bien tirada está.

65. Goya, *Caprichos*, no. 17.

Ysele quema la Casa.

66. Goya, *Caprichos*, no. 18.

also means to fleece), presumably preparatory to eating them. In 19 (fig. 67) the mother-bawd teaches the arts of seduction, materialized in the emblem above them. The creature luring the men-birds is either harpy or siren: the one associated, as in the story of Phineas, with uncontrollable appetite and the other with creatures who lured men to destruction by their song. She stands on a sphere, actually a bird-catching device resembling, or rather parodying, the wheel in the emblem of Fortune (as in Dürer's famous engraving).[18] This emblem draws us back to the first scene of the *Caprichos*: marriage is a way to control Fortune, a way to balance on that wheel. At a superficial level Goya seems to be saying that any kind of passion—appetite, pleasure—will ruin men and women if they allow that passion to rule them, uncontrolled by reason. Passion and Fortune are the two subjects: Passion prompts people to devise plots to outwit the turning whims of Fortune.

Thus in 21 (fig. 68) the wheel has made a half-turn and the harpy/siren herself is being devoured by the feline magistrate. The male sex counters the female's art with arts of its own; these "arts," however, are the laws of the parent, primogeniture, and male courts of law—reflecting male authority in a male-dominated society. The third cat in 21, for example, is also a form of "Blind Justice," the chief magistrate staring blankly into space while his two colleagues devour the female defendant. In 23 and 24 the judicial system is combined with the ecclesiastical court of the Inquisition, a situation in which "the court authorities who initiated and conducted the prosecutions were men; they were sanctioned by laws created by men, defended in tracts written by men, and their court convictions led to executions conducted by men."[19] Women's arts have their locus in the boudoir, men's laws in the institutions that govern society and in which women have no say. Women's actions are, therefore, automatically subversive and criminal.

Number 25, "Sí, quebró el Cántaro" (Yes, he broke the pot, fig. 69), which seems to interrupt the sequence, in fact epitomizes it: the mother is retaliating by beating her son. She cannot master the male institutions of law and religion but she can use her authority as parent to beat her young and powerless son at home. He remains powerless, however, only for the

18. Dürer's *Fortune* or *Nemesis* "synthesizes the classical goddess of retribution with fickle Fortune," following a Latin poem by Politian. Goya uses the wings and the sphere of Fortune but omits the bridle and chalice. (See Erwin Panofsky, *The Life and Art of Albrecht Dürer* [Princeton, 1955], pp. 81–82). For the wheel as "a pitfall device" (i.e., a bird-catcher), see George Levitine, "Some Emblematic Sources of Goya," *Journal of the Warburg and Courtauld Institutes*, 22 (1959), 109. See also Victor Chan, "Goya, the Duchess of Alba, and Fortuna," *Arts*, 56 (1981), 132–39.

19. Ann Kibbey, "Mutations of the Supernatural: Witchcraft, Remarkable Providences, and the Power of Puritan Men," *American Quarterly* (forthcoming). Kibbey shows that in England witches were accused of killing or injuring people, on the Continent of holding Sabbaths, covens, and pacts with the devil.

Todos Caerán.

67. Goya, *Caprichos*, no. 19.

¡Qual la descanonan!

68. Goya, *Caprichos*, no. 21.

moment, for the sequence shows that he will "give as good as he gets": His own resentment at his punishment will lead to his continuing the male tradition of female castigation (moral and legal) when he grows up into a position of male power in this male-structured society, and this will force the women to deceive and cheat him in the same way, and, when they are mothers, to beat him.

The reference to the boy's bottom in no. 25 leads ahead into 26, "Ya tienen asiento" (Now they have a seat: *asiento* meaning good judgment; *tener asiento* meaning to have a position in society). Women with chairs on their heads are putting their heads where their bottoms should be, replacing reason with passion. This plate refers back to the chair in 18 and ahead to 36, in which "Things are going badly when it's the wind and not money that's lifting the skirt of good young girls" (Ayala MS). The topsy-turvy animal satires (nos. 37–42) follow as commentaries on the promulgation of authority through the institutions (parallel with law) of education, patronage, genealogy, medicine, and even portrait painting.

The basic role of the mother-bawd is, of course, that of instructress (e.g., no. 17). As the mother's raptures in 3 were both spiritual and sexual, so the Celestina (as she was called) always carries a rosary, and the old saying "If you want a girl find an old woman with a rosary" links bawds with mother superiors, nuns, and the Church. In 44 (fig. 73), which opens the second half of the *Caprichos*, the Celestina with her mission to be a metaphorical thread binding lovers is related to the Three Fates and the witches who use their thread in more sinister, though parallel ways. The theme of the oppressed children is now embodied in the babies who are hung from the ceiling or piled (45) in a basket waiting to be "sucked" dry by the old women, or alternatively given instruction in the way to become witches themselves. In 68 the witch and her apprentice riding a very phallic broomstick (on which the witch trains her novice) are metaphorically equivalent to the bawd and the young prostitute.

Flight seems to be the primary physical end to which the witches aspire, the same escape in passion and erotic fulfillment Goya showed in the wedding in *Capricho* 2. It is another stratagem for transcending the rise and fall of fortune. With the powers of flight witches feel less subject to the caprices of fortune that otherwise buffet them unmercifully. But as 19 and 20 showed (and, indeed, no. 43), it is also a property of birds of prey, in 56 of fickle fortune and in 61 of inconstancy (figs. 74 and 75). The Fates also fly. In terms of the French Revolution (or enlightenment and reform) we should recall the hot-air balloons and other flying devices used and discussed at the time of the French fighting in Belgium in 1793. The problem that was discussed then and thereafter was how to steer or propel, how to control

69. Goya, *Caprichos*, no. 25. Before letters.

Ni más ni menos.

70. Goya, *Caprichos*, no. 41.

71. Goya, *The Taking of Christ*. Painting, 1798.

71a. Detail of 71.

El sueño de la razon produce monstruos.

72. Goya, *Caprichos*, no. 43.

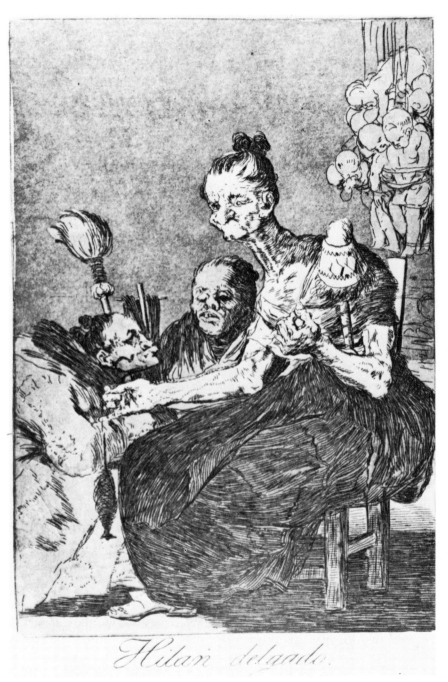

73. Goya, *Caprichos*, no. 44.

these floating bags of air.[20] Goya painted at least one hot-air balloon (Agen, Musée) and included various flying devices in the *Disparates*.

The focus of flying, sexuality, and fortune is 56, "Subir y bajar" (To rise and to fall; fig. 74), showing a man being spun in the air in a wheel of fortune by a huge satyr. The man is generally accepted as a portrait of Godoy, who had fallen in 1798 and risen again in 1799. Unlike say, Jovellanos, a man of principle, he is Time's Fool rising and falling at Fortune's whim. But Fortune is in this case a satyr (related to the cane and chaise longue in Goya's portrait of Godoy) to indicate the sexual source of his power as well as his dependence on the love of a great woman. At the root of witchcraft, as of its social equivalents (as of el Coco), is the sexual stimulus. Goya follows the traditional interpretation: "All witchcraft comes from carnal lust, which in women is insatiable," as the great anatomy of witchcraft, the *Malleus Maleficarum*, insisted.[21]

In the *Caprichos*, however, the sexual instinct is the concomitant of repression, not a release from it. Goya's invention no longer carries the Orc-like quality of sexuality Blake saw in the American and French revolutions: it underlies everything, but as sheer regressive appetite, the opposite of positive energy. *Cojones* and money bags are equated (as in 30, the old man with "little to spend"), and the gothic fiction of the sensibility-prone young female, with a restless curiosity exploited for economic purposes by her elders, seems to be shared by Goya. As in the broomstick of 68, this appears equally in the girls who deck themselves out at nightfall for assignations with men (or reverse bottoms and brains) and those who prepare for a witches' sabbath.

Nevertheless, it is significant that a man is the central symbol of Fortune's cartwheels. I suspect that Godoy was a man with whom Goya in various ways associated himself because he himself was a provincial who had risen in the royal service by ability alone—or, if we accept the metaphor of the *Caprichos*, by a kind of witchcraft which was based on, respectively, sexual attraction and the ability to transmute reality into art. Certainly insofar as there is a contrast to the useless nobleman it is the useful bourgeois or the perceptive artist. In a sense Godoy, the outsider, the male version of the preying and preyed-upon woman, is Goya's protagonist. From nowhere, having no connections, through passion alone he rises to the very top but can at any moment be cast down again.

In 27, "Quién más rendido?" (Which of them is the more overcome?), some of the commentaries see a guarded reference to Goya himself and the Duchess of Alba (perhaps also in one of the bird-men in 19). The profile

20. See Palmer, *Twelve who Ruled* (Princeton, 1941), pp. 354–57, who also cites the encyclopedias of the time on aerostation.

21. *Malleus Maleficarum*, trans. Montague Summers (London, 1928), pt. I, q. 6, p. 47.

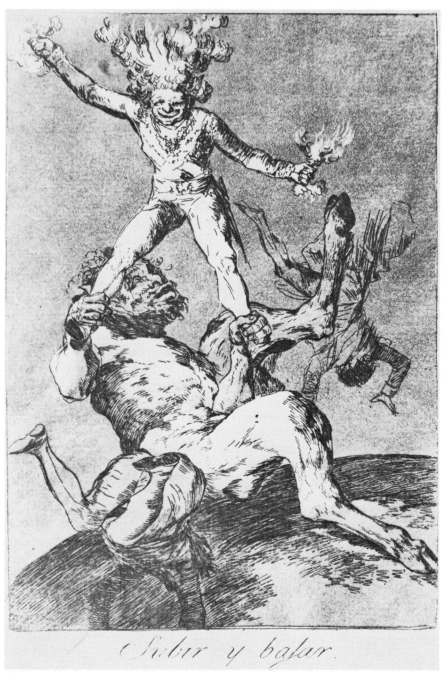

Subir y bajar.

74. Goya, *Caprichos*, no. 56.

does resemble a younger version of the frontispiece. The duchess certainly appears as the symbol of Fortune in 61 ("Volaverunt," They have flown, fig. 75) atop a sphere made of the three Fates (who had also appeared beneath Alba-Fortune in no. 19). As Victor Chan has shown, she is portrayed here as *Fortuna amoris*, with the attributes of the butterfly wings and her mantilla-sail.[22] "Volaverunt" was a good-humored expression for the total loss of something. In a contemporary play it is attached to the parting of the lovers: "What of her passion? It's finished. And your affection? Volaverunt."[23] As the facts of his love affair with the duchess in the mid-1790s show, sex was on a personal level Goya's own stimulus to creativity. The *Caprichos* originated in the Sanlúcar sketchbook, filled when Goya was the Duchess of Alba's cortejo. The drawings of girls in this sketchbook coincide with the 1793 watershed of his career. Goya's independent drawings (with all that "drawings" may suggest of spontaneity and liberty from official commissions and academic rules) begin at just this time, for the only earlier ones are preparatory sketches for paintings and for the etchings after Velasquez. At this moment he plunged into what Gassier, linking artistic and political revolutions, calls "the deeper, more revolutionary side of his work."[24] Gassier means, of course, "revolutionary" as an artist who breaks through conventional barriers—most immediately in the new medium, a "revolutionary technique" as he calls it, of brush and wash, and in the mode of the series of drawings, to be followed in the *Caprichos* by the equally innovative effects of aquatint and etching. But it was also in relation to the actual Revolution in France and Enlightenment in Spain, with their turns for the worse in 1793–94. Beginning with the Sanlúcar album, which contains nothing but drawings of women, we might say that Goya himself, after his "death" by illness and deafness, has a "rebirth" at the Duchess of Alba's Sanlúcar estate, a rebirth which is clearly sexual, of an aging man with a young woman, and associates this with the larger political revolutions of his time as well as with the freeing in various ways of his art (from onerous patronage as well as academic rules). When I read Carderera's remark on the Sanlúcar album, that in "the women's grace and their voluptuous curves . . . all is light, gaiety and candour, like the springtime of the artist's life,"[25] I think of Paine's imagery of the outbreak and spread of the French Revolution: the traditional connection between revolt and springtime and breaking down barriers.

But then Goya's mood changes. The duchess's love—a new, ideal relationship where for a short while men and women met as equals-in-love, no

22. Chan, "Goya," p. 34.

23. The line is taken from Agustin de Salazar's play, *Thetis y Peleo*; cited in J. Lopez-Rey, *Goya's Caprichos* (Princeton, 1953), 1, 151, and n. 11.

24. Pierre Gassier, *The Drawings of Goya: The Complete Albums* (London, 1973), p. 9.

25. Quoted in ibid., p. 19.

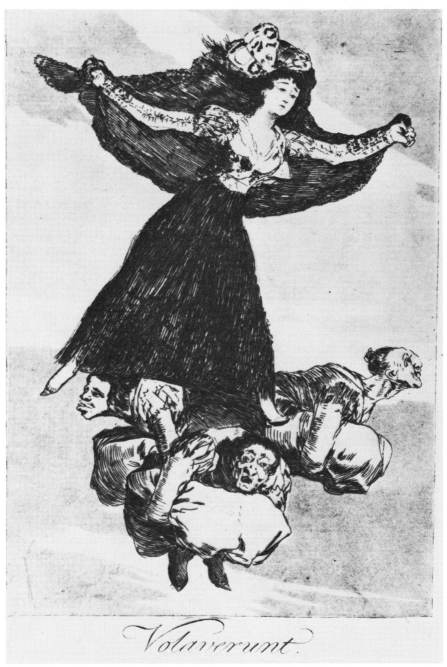

Volaverunt.

75. Goya, *Caprichos*, no. 61.

longer as master and servant or noble and commoner—proves an illusion, presumably in some sense like the illusions of political reform and of the French Revolution itself. The course of the relationship is suggested in the discarded print, called "Dream of Lies and Inconstancy," of which Goya kept a few impressions (fig. 76). Goya initiated his *Sueños* with this image of the two-faced duchess, but he did not use it—probably because it was unassimilated, too intimate, and too purely emblematic. He had not yet found the way to sublimate or transform his experience. But throughout the series runs the undercurrent of inconstancy (he transferred the double face to the bride in no. 2) associated not only with young prostitutes and with Godoy's wheel of fortune but with the duchess herself (61). What is happening on the level of Goya's personal involvement can be seen by tracing a single page from the Sanlúcar sketchbook in which the duchess pulls on a stocking to *Capricho* no. 12, in which a whore does the same, and thence to no. 18, in which the girl's shapely leg is related to the exposed leg of the old "burning" lecher.

If Godoy-Goya is the male protagonist, Alba is the female, in the constant play back and forth of exploiter and exploited. Like her analogues, Alba betrays and threatens Goya, and she is perhaps as much as anything else the reason that the *Caprichos* take the particular form they do, with the wife-queen-mother as the central villain-victim vis-à-vis the cortejo, the Godoy who rides high momentarily but falls as easily as Goya from feminine-maternal favor.

The divisions of the *Caprichos* are marked by Goya's self-portraits. Number 1 (fig. 58) shows him in outdoor dress, wide awake, a cool observer of reason through narrowed, ironic eyes (the Lazarillo de Tormes point of view on *el Coco*). After forty-two plates depicting the waking world of masquerade, observed by his waking consciousness, he shows himself asleep and his sleeping form surrounded by the world of nightmare, inscribed "El sueño de la razón produce monstruos" (The Dream of Reason produces monsters, fig. 72).[26] In the first half the ego is in clear control; in the second the id is in control, surrounding the sleeping artist with a world of demons, the reduction of social institutions (including the Church) to their most primitive and savage form of witchcraft and animism.

The image of Goya asleep must be seen in relation to his painting *The*

26. The most interesting sequence in the second album of Goya's drawings is the twenty-six *Sueños* (Dreams) in pen and sepia. This was the initial series of preparatory drawings for the *Caprichos* (based on the Sanlúcar and Madrid albums), most of which were transferred to copper plates before Goya decided to modify the whole conception. These are basically the witch scenes, beginning with the frontispiece "The Dream of Reason produces Monsters," which then became no. 43, preceded by a self-portrait as wide-awake (1), and forty-one additional drawings in red chalk and sanguine wash which were made for the plates of life-in-society which now lead up to the "Sleep of Reason."

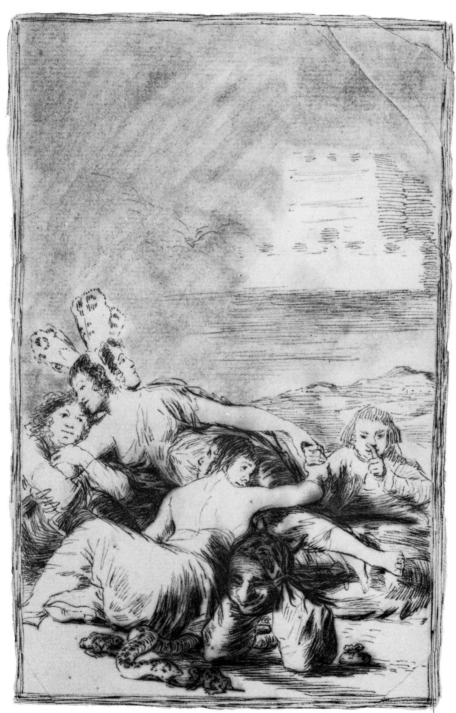

76. Goya, unused *Capricho* ("Dream of Lies and Inconstancy").

Taking of Christ, which he produced at about this time for the Cathedral of
Toledo (fig. 71; detail, 71a). Although it shows the taking of Christ, it uses
the configuration of a *Christ Mocked* based on the many versions by Neth-
erlandish painters, most strikingly available in the Quentin Massys version
in the Spanish royal collection. Goya's painting shows the ugly shapes,
openmouthed to shout, mock, and threaten the beautiful, rational shape of
Christ.[27] The artist is similarly surrounded and threatened by openmouthed
owls and bats of the sort Goya shows in the *Desastres* sucking the life out of
Spaniards (no. 72). But *Capricho* 43 can also be interpreted (as Hetzer does)
as Goya himself taking advantage of the world of fantasy and undifferentia-
tion in the name of his art—or, I would add, in the name of vision or true
perception. It is the only way of seeing truly what is happening in Spain.
The crowded darkness asks, in either case, to be regarded with fascination
as well as horror.

 If we return to number 2 (fig. 59), directly following the first self-portrait,
we see another version of the *Christ Mocked* image. The girl, just the reverse
of the artist's profile, is surrounded by the grotesque crowd—with the open,
gaping mouth like those in the Toledo painting. For she is using her mar-
riage as the only way to free herself (as the woman in no. 3 uses her religion)
from the built-in restrictions and hypocrisies of Spanish life. In this con-
text—which like so much of the *Caprichos* involves antithetical uses of a
single image—the idiot mocking face, hovering over her shoulder, is a re-
sponse to her situation but quite a different one from the sidelong glance of
Goya in number 1. Lawrence Gowing thinks this head is a quotation from
an early Rembrandt self-portrait and may be yet another self-image of Goya.[28]

 Between the two self-portraits, just before "The Dream of Reason," an
artist is shown as monkey-imitator painting his donkey patron (no. 41, fig.
70). A flattering tamperer with nature, he crops the ass's long ears, adorning
his head with a wig, to make him look judicial—a practical step in the
transition from reason to madness carried out by "art." This plate is the last
of the transitional group of man-animal satires (37–41), in which the asses
become teachers, genealogists, physicians, and art-music patrons. The next
plate, 42, shows men carrying horses on their backs, and says in effect;
Which are the horses and which are the men? And from the equation of
horse and man (following that of ass and man) we move into the sequence
of witch–human analogies. But the ape-painter in no. 41, who prepares us
for this transition, is particularized with the profile of the frontispiece; he
must be taken as another mocking self-portrait of Goya (related also to the

 27. The grotesque faces come, of course, from the tradition of Bosch, but they appear also
in Titian's *Ecce Homo* as well as many Flemish paintings of the subjects, including Rubens's
(e.g., the innkeeper in his *Supper at Emmaus*).
 28. *TLS,* 17 February 1978, p. 190.

slightly simian jaw of the girl in 2). From being ironic observer, the artist is acknowledged as mere flattering ape—as portrait painter to the king. This ape-like imitation is (like the girl's marriage) presented to be rejected. Where the monkey uses art as a means of modifying truth in the service of vanity (and as his own means of escape parallel to the marriage of the young woman), the true artist, two plates later, transforms reality as a way of attaining freedom and truth.[29]

"The Dream [*Sueño*] of Reason produces Monsters" can be read: Reason asleep, relaxing its vigilance, releases these monsters; or when reason (as opposed to unreason or something else) dreams, the result is monsters. We have to see the image partly as a reflection of passages like the one in which Marchena (in his *In-Promptu*) says that "superstition may put a people to sleep for an instant in the chains of slavery; but if reason awakens it, beware you hypocrites and oppressors."[30] But Goya's contrast of sleeping and waking also discloses a progression from perception to vision, from daylight to darkness, from sharp ironic sight to dreams—and back again, as in the last plates of the series daylight returns and the witches and duendes disappear (or at least until they return the next night). Although the man sleeps and is surrounded (threatened) by the dark forms of fantasy, he is guarded by an alert cat, taken from the lynx who is one attribute of Fantasia (in Ripa's *Iconologia*). The lynx is not merely clear sight, contrasted with the owl who is blind in daylight and wears spectacles, but "the supernatural penetration of the moral eye of *fantasía*."[31]

In the first half, what is needed to reveal deceit is (according, for example, to the commentary on no. 7) the "judgment and experience of the world." Especially ironic is the man with the monocle who attempts to "read" the young lady as if she were the text accompanying the plate. In the end he cannot know the text because he cannot learn to unmask either himself or

29. The inscription on no. 41 is "Ni más ni menos" (Neither more nor less)—words inscribed on the pans of a balance at the center of vanitas paintings like that of Valdés Leal, in which "Ni más" holds animals representing the Seven Deadly Sins, including an owl lurking in the shadows, while "ni menos" contains instruments of penitence and mortification. In no. 41 the animals from the "ni más" side have taken over and "vanitas" has the added dimension of self-glorification—the ass seeks immortality in a portrait, a memento for posterity, an important element of the vanitas tradition. The *Caprichos* up to this point are "ni mas" than the artist's record of society's pretensions, the pendant no. 43 "ni menos" than an apocalyptic vision of the consequent abandonment of rational principles. The question is echoed in the next plate (42) of who is ape or horse or animal and who is man?—and so a new start is called for. (The Valdés Leal painting is in Seville, Hospital de la Santa Caridad; reproduced, Elizabeth du Que Trapier, *Valdés Leal* [New York, 1960], pls. 123, 24).

30. The passage begins, recalling Paine's *Age of Reason*: "Who can stop the progress of an immense bonfire surrounded by combustible matter?" (quoted in Herr, *Eighteenth-Century Revolution*, pp. 275–76).

31. See George Levitine, "Some Emblematic Sources of Goya," 121.

others. (He is related to Rowlandson's old men peering at their young women through spectacles, telescopes, and lorgnettes.) But inexplicably glimpsed between the figures of the man and woman hovers the floating, disembodied, knowing face we saw in the background of no. 2 (who also appears in 14 and 30, and modified in 5, 26, and others). *Another* degree of observation, this contrasts with the unavailing eyeglasses, with Goya's own ironic glance, and with the direct statements of the captions—which point us toward the irrational perception of the second half of the *Caprichos*. These floating disembodied heads, culminating in the grinning head on the giant banner of *The Burial of the Sardine* (Madrid, Academy of San Fernando) where the head as a kind of round sun in the sky becomes a dark moon, offer a more disturbing dimension of perception, closer to the "Dream of Reason." For they seem to be Goya's *Sueños* of those heads carried on poles by the Parisian mob, reflecting the most powerful of the images offered the world by the French Revolution.

Goya's captions serve as another level of interpretation, another sign that the *Caprichos* are concerned with the problem of interpreting, understanding, and coping with an enigmatic external reality. Goya has adapted the form of the traditional emblem: The image is accompanied by a motto or caption, and this is augmented by the artist's written although still riddling commentary. The mottoes become an integral part of the design, the words of a speaker who (like the disembodied heads) points the irony, expresses surprise, ventures a statement addressed sometimes directly to the figures represented, poses a question, offers advice, or threatens disaster. The captions assist the visual images in making the connections between the worlds of the witches and of masked polite society by the play on words such as *asiento* (see above)—or *untar* (both to anoint and to bribe), *soplar* (to blow and to inform on), and *chupar* (to suck and to "milk" or drain economically).[32]

Often they point to the discrepancy between what appears to be happening and what is. When we are told that the old woman being shunned by the young girl in number 16 is her "mother," we see Goya's characteristic relationship between image and word: the picture gives the word its reference. We know that the word *mother* (or table or chair) bears only an arbitrary relation to the object, but if Goya says mother and points to a particular woman, his viewer will know what the word designates. At the same time, he does not know whether *mother* means blood relative or bawd, and as Gwyn Williams notes, "Far from clarifying the picture, many of [the captions] serve to deepen ambiguity and sharpen paradox."[33] This applies equally to the longer commentaries in manuscript, which appear to be a

32. Helman, "Moratín and Goya," p. 120; see also Gassier, p. 14.
33. Williams, *Goya and the Impossible Revolution*, p. 39.

series of gradual suppressions or exposures of particulars; the least (apparently) censored of them readily identify contemporary public references. Goya's captions tell us how to take the image, but the relationship is as indirect as his glance in the frontispiece, and as ambivalent. The captions are true to the emblematic tradition, which calls for a complex interplay. But for Goya the image always takes precedence over the word, and the verbal element is a response, a partial explanation, of something seen, shown, or merely given.

Beyond the emblematic structure of the *Caprichos* is Goya's written announcement of their publication in the *Diario de Madrid*. Here he (or his spokesman) lays the aesthetic dimension before his public, justifying the use of the *capricho* form, which, as defined by the Royal Spanish Academy, was "done by the power of invention (*ingenio*) rather than by adherence to rules of art"[34] and accordingly was only marginally acceptable to contemporary aesthetic doctrine. Goya's announcement portrays the artist as the dreamer of number 43; it explains that in these designs he "has neither followed the example of others, nor [like the ape of no. 41] been able to copy from nature." For he has held himself "aloof" from nature and "has had to put before the eyes forms and attitudes that till now have existed only in the human mind, obscured and confused by lack of precedent [*ilustración*] or exaggerated by the unruliness of passions."

He is, of course, defending himself from the accusation that he has portrayed particular contemporaries. But he is also projecting an art that makes no pretense to a conventional mimetic standard but instead redefines mimesis. To justify his method of representation he joins two antithetical myths of the artist as creative force in an ironic amalgamation that yokes incompatible things—as in the case of the Italian architectural caprices that locate St. Peters and the Leaning Tower of Pisa in the same cityscape. He takes the story of Apelles' representing an ideal woman by choosing the best features of many beautiful women and he conflates this with Horace's monster in the *Ars poetica*—the woman who, a "dark, grotesque fish below" ("turpiter atrum / desinat in piscem"), is one of "the dreams of a sick man" ("aegris somnia"). (He uses the 1789 translation of his friend, Tomás de Yriarte, whose lines also suggest the phrasing for "El sueño de la razon produce monstruos.") He lets us know that he is aware that the passage in

34. *Diccionario of the Royal Spanish Academy*, quoted in Sayre, *Changing Image*, p. 60. The capricho was a form Goya would have associated most immediately with G. B. Tiepolo, who worked at the Spanish court in Goya's youth, and whose scherzi and capricci of families of magicians and witches in scenes of instruction and ritual are evoked by his, including even the way the isolated figures rise out of a barren landscape. For a general account of the capricho, see John Dowling, "*Capricho* as Style in Life, Literature, and Art from Zamora to Goya," *ECS*, 10 (1977), 413–33.

Horace is about a painting and that it includes a well-known reference to the "Sister Arts":

> Painting (like Poetry) chooses from the universal what it considers suitable to its own ends: it reunites in a single fantastic personage circumstances and characteristics that nature has divided among many. From such a combination, ingeniously arranged, results the kind of successful imitation for which a good artificer deserves the title of inventor, and not that of servile copyist.[35]

By taking traditional critical vocabulary out of its classical context, Goya subverts our notion of what art should represent. When he claims that "the majority of the objects represented in this work are ideal," he is parodying the platonic "ideal" as perfection and a striving toward the "Idea." *His* prints are "ideal" in the sense that they have "so far existed only in the human mind, obscured and confused by lack of precedent." The traditional association of the "ideal" with the beautiful is no longer valid, whether politically, historically, or aesthetically.

Thus the *Caprichos*, as "invention" and not as the work of an "artist copier," are unbounded by the traditional provinces of poetry and painting. The grotesque is therefore the appropriate mode into which he launches his art. The old meaning of grotesque, "visual elements compounded artificially but patterned on the natural world," remained.[36] The French sense of the

35. *Diario de Madrid*, 6 February 1799. Edith Helman draws the connection between Goya's *Capricho* no. 43 and the monster of Horace's *Ars poetica*, showing the connection with Cadalso's works, especially his *Eruditos a la violeta* (1772). In the second "lesson" in that book, devoted to poetry and rhetoric, the pupil is advised to memorize the lines in the *Ars poetica*—lines traditionally committed to memory by Spanish secondary-school students. Yriarte's translation, the one most read at the time, includes the line, "A los sueños de enfermos delirantes." See Helman, "'Caprichos' and 'Monstruos' of Cadalso and Goya," *Hispanic Review*, 26 (1958), 205–07; on the references to the Horatian passage by critics, see pp. 207–08; see also Paul Ilie, "Concepts of the Grotesque before Goya," in *Studies in Eighteenth-Century Culture*, ed. Ronald C. Rosbottom, 5 (Madison, 1976), 185–201.

Goya is referring to the gathering of parts of different beautiful bodies to make one ideal Venus, as in Agucchi's words: "These, not content to imitate what they see in a single subject, go around collecting the beauties scattered in many, and unite them together with exquisite judgement, and reproduce things not as they are, but as they should be, to become their complete selves" (quoted in Denis Mahon, *Studies in Seicento Art* [London, 1947], p. 242). Cf. Annibale Carracci's version (reported by Massani in the preface to *Le Arti*): "They go collecting it [beauty] from more objects, or from the most perfect statues, to make a work which is absolutely perfect in every part"—vs. the caricaturist "who knows how to offer aid to nature, represents this aberration even more definitely, and places before the eyes of the beholder the little portrait charged to the extent most conformable to the perfection of deformity" (Mahon, pp. 260–62). Both theories do make, in the Frankenstein sense, a grotesque figure, and the caricature can use the same modus operandi as the idealizing portrait of a Venus.

36. Ilie, "Concepts of the Grotesque," p. 190. Ilie discusses the neoclassical background in aesthetic discussions of Goya's period: the search for ideal form, which indicated examples of deformity (the ugly, incongruous, and so hybrid) as admonitory cases along the way.

word, however, with the synonyms *ridicule, bizarre,* and *extravagant,* was also current, and by the mid-century Spanish writers were joining the idea of a strange hybrid with the aim to ridicule.[37] The emphasis of the Spanish ilustrados was on *utility*: Jovellanos and his friends believed, for example, that poetry and art should be socially useful; the grotesque could function as satire. Earlier in his *Diario de Madrid* piece, Goya says pointedly, alluding to Aristotle's *Rhetoric* 1.ix, that though satire is thought "the province of Eloquence and Poetry," it "may also be the object of Painting."

Nevertheless, Anton Raphael Mengs was the spokesman for the normative view of art in Goya's Spain: a neoclassicism that contributed to the articulation of David's *Oath of the Horatii*. The *capricho* was an extreme off-shoot of the baroque extravagance of the Tiepolos (whom Mengs had replaced in the 1770s) and a form practiced by both Giambattista and Domenico. Even Jovellanos wrote both for and against the *capricho* in architecture, and Gregorio Mayans could praise Bosch's "exquisitos y extravagantes sueños" only because they were excused by the religious content of his art. But these were exceptions from good taste and "not examples to be followed."[38] Only strong provocation could justify the turn from good taste to *fantasía, imaginacíon, capricho, sueño,* and *grotesco.*

By implication Goya finds in the strong provocation of the times his justification for discarding conventional strictures of subject matter, decorum, and expression. He is describing a social and political monster, an amalgam of repression and revolution; of government, enlightenment, and Francophilia confronting another of church, nobility, the beggarly mob, and nationalism. In this context, with ridicule as one aspect, a grotesque mode is justified.

In the same way that he undermines our expectations of the way art functions and poetry and painting interact, Goya subverts our carefully structured dichotomies between waking and sleeping, reason and madness, and language and disorder. In the end we have to realize that these dichotomies are invalid, or no longer valid in the late 1790s because they are no longer distinguishable. What is a language of reason? Where is the division between our waking (conscious) and sleeping (unconscious) worlds? What is madness, Goya's *Caprichos* or our own dissipated reality? The first half of the *Caprichos* or the second? Goya's satiric point—that these seeming "con-

37. In 1705 Francisco Sobrino, in his *Diccionario neuvo de las lenguas española y francesa*; in 1753, Miravel's trans. of Moreri's *Gran diccionario histórico* joins the decorative hybrid idea with ridicule and fantasy with ordinary mimesis (see Ilie, p. 192.)

38. For Jovellanos, see Ilie, p. 194; for Mayans, see his *Arte de pintar* (1774; Valencia, 1854), chapter "De la invencíon" on Bosch (pp. 71–73), where he praises his "exquisitos y extravagantes sueños" (Ilie, p. 198).

For Domenico Tiepolo's response to the age of revolution following his return from Spain to Venice, see Paulson, "Punchinello in Venice," *Bennington Review*, no. 11 (Sept. 1981), pp. 58–69.

traries" are interchangeable—extends even to the juxtaposition of himself, the artist, with the woman of *Capricho* 2 and the Godoy of 56.

The dreamer of monsters in 43 is an artist, asleep at his drawing board. The lynx represents clear sight in darkness but, seen in the context of the other animals, he is also a bestial, predatory force that stalks with creatures of the night. As a lynx, Goya participates in as he observes the nocturnal visions of the second half. Are these monsters then his creation or creatures that create his dreams? Is he the creator or the victim of his imagination? Do the words, mottoes, and commentaries attached to his drawings act as the artist's attempt to enclose his fantastic imaginings in a rational, comprehensible form?

What we also notice is that witchcraft applies as well to his "combination" of diverse elements into "a single fantastic personage" as to the witches' brew itself. Take the woman in 12 who is pulling the tooth of the hanged man in order to obtain a love charm (fig. 63). "What a pity the common people should believe such nonsense," says Goya's commentary. "What won't a woman in love do!" These words, if not ironic, are clearly inadequate: She is a case of the compulsion to exert some control, some mastery over nature (human nature) by magic if all else fails, and as such—in the context of the self-portraits and the *Diario* announcement—she is another analogue of the artist, expressing the painful, even ghoulish nature of the artistic process. We can therefore see Goya associating his sympathy with the woman-victim of Fortune, the business of witchcraft, the revolutionary process, and his own artistic creation. The tooth-pulling carries on the alternation of those who prey on others and become prey themselves, as the robber becomes the robbed. But implicitly all these are children oppressed by parents and seeking any way out: The girl getting married or becoming a prostitute may be closer to the monkey-artist who is a "servile copyist," and the boy who breaks a pot and the girl who steals a tooth may be closer to the artist who reproduces his *Sueños*.

In *Capricho* 25 Goya represented one of the basic wish-fulfillment fantasies in which, to use Freud's words, "A small child is being beaten on its naked bottom," which says: "My mother is beating the child whom I hate" (my rival for her love).[39] It is the mother spanking the child, another version of the figure whose attention is directed to el Coco, and whose attention in the other *Caprichos* is directed to her "daughters." These are primal

39. Freud, "A Child is being Beaten," *Standard Edition*, 17, 179–204. Goya reminds one of George Crabbes's "Peter Grimes" (in *The Borough*, 1810). Young Peter feels oppressed by his father, strikes him, and spends the rest of his life punishing surrogate sons for his disobedience to his father: He becomes his own image of his father, takes on parish boys, mistreats, and kills them. He reasserts the Father as superego in guilt, justice, and madness, but also in the old lesson that to revolt and escape from society is only to succumb to the greater tyranny of the self. Cf. the beginning of "Ellen Orford" and, for that matter, Yeats's *Purgatory*.

images that take us back to early stages of development, and they are as much about the fantasist as about the political situation he represents in these terms. While the artist is observing these "children" coldly from the outside, his own effort is in various ways parallel to theirs.

Number 13 then, as we have seen, follows 12 as another reversal: In one the mouth is being taken from by the woman, a tooth removed, while the other is concerned with oversexed monks putting things in their mouths—metaphorically swallowing "us" as do the owls and bats of "The Dream of Reason." All these configurations make a single image-type of the exploiter and the threatened/terrified party collapsed into one in the artist who both holds at arm's length and immerses himself in the destructive element, both excoriates revolutionary Spain and uses it to create a new and original, self-liberating art.

As a revolutionary artist Goya, like the Spanish mob, reaches back to the vulgar Spanish folk superstitions (which happened to have also been taken up as camp by some of the nobility). For example, he derives the incongruous, grotesque shapes from such popular sources as the street parades with their *gigantones* and *máscaras*.[40] It is significant that he does this in the second part of the *Caprichos*. Although these *Sueños* were drawn first, he represents them as second, as if he has exhausted the sophisticated modes (such as irony) and, in order to see the world truly, has to sink into this primitive state of sleep in which witches and superstitions convey the truth, as well as *being* the truth. He is now deep within the mind of the woman pulling the tooth.

Goya deplores the snuffing out of enlightenment reason but draws his own strength from the undifferentiated darkness below. The grotesque "combinations" of society ladies and witches are also the popular images of the subculture, to which he was drawn because they were in fact his own, and because he also shared the ilustrados's fascinated horror of them. To understand the monstrous (in the Horatian sense) relationship between the common people and the second half of the *Caprichos*, one need only look back at the attacks on popular Spanish culture by the "paternalistic modernizers and enlightened patriots" who were isolated in their enlightenment "from what even Jovellanos could term 'the vulgar and idiotic people' who preferred the Spanish drama to the precepts of Boileau."[41] Goya shows his anxiety and ambivalence toward this body of culture in the image of "The

40. Ilie, "Concepts of the Grotesque," p. 187.

41. Carr, *Spain 1808–1939*, p. 71. The attacks on popular Spanish culture enumerated the errors of diviners, prophets, folkhealers who claimed miracles and forms of magic, as irrational, credulous, and extravagant (for example, Benito Feijoo, *The Universal Critical Theatre—Teatro Crítico Universal*, 8 vols. [Madrid, 1733], especially I, essay 1; 2, essays 3–5; 3, essays 1, 6; 5, essay 16). Meléndez Valdés in a speech of 1798 attacked broadside ballads which presented as heroes bandits who murder and rape, thus arousing emulation in the lower orders (*Discursos*

Dream of Reason": the representation of witches is not just, as Gudiol has said, "a counter-weight to courtiers' perfidies and cloyingly sweet scenes," [42] or to the ape's portraits of the royal family and Godoy, although it is both of these. It is also a response to the ilustrados themselves and to Spanish society, which draws us back to those ambiguous young women in the first half of the *Caprichos*.

The "Dream of Reason" releases both the locked-up fantasies (others' and his own) of apparently rational men and also all sorts of disorder and energetic intrusion, allowing the artist to express precisely that which has been threatening him or seeking outlet, and his art (his witchcraft) allows him to control it. The revolutionary energy in the background—in those background figures, those faces out of Christ Mocked compositions—therefore becomes foreground in the second half of the *Caprichos*: revolutionary in the sense of primal and hidden forces coming to the surface as in the reports of the taking of the Bastille and the following massacres with heads born aloft on poles. In Spain these dark forces were exploited on the political level by the nobility and the clergy to overthrow the ilustrados and the forces of *luces*. That on the personal or artistic level they were exploited by Goya—perhaps to come to terms with deeply personal anxieties—makes one wonder if he already made the association (as he was later to do) between the *counter*revolution and his art. For the moment, before the stage of the *Desastres*, he was as revolutionary, in the simple sense of joining the *levée en masse*, as the Spanish people were to be in fact in 1808, when they rose against Godoy and the French.

Thus, ostensibly the *Caprichos* express the closed, constricting, mother-dominated, Church-dominated society of Spain in the period, seen in the light of the movement of enlightenment, but with the feverish attempts at "liberty" by married women, witches, and artists as somehow (especially when they refer to Godoy and the queen) reflecting, in the vacillations of freedom and repression, the basic ambivalence of the Spanish Enlightenment. Yet anyone looking at the series is going to think of the return of the repressed, the bubbling over and bursting out of the unmentionable, subculture Spain as not primarily a parallel but a contrast to the soi-disant civilized society of Spain in the first half.

Forenses [Madrid, 1821], pp. 167 ff.). Whether as admonition or as source of strength, Goya certainly makes art of such scenes—and of all the areas that were exorcised by the ilustrados.

42. José Gudiol, *Goya 1746–1828* (New York, n.d.], 1. 279. On the parallel between the artist and the witch, see the commentary for no. 46: "Without punishment and self-discipline one can't get on in any science. In witchcraft one needs unusual talent, perseverance, maturity, and a rigid obedience to the teachings of the Great Witch master who conducts the seminary in Barahomax": for which we can read artists, the academy in Madrid, the academic tradition of art, the Renaissance, Old Master assumptions about art, and so on.

In a sense the two parts are related as not only different kinds of perception but as different phenomena, specifically social: one seen from above, by the aristocratic enlightenment Goya, the other from below, through the eyes of Goya the vulgar Spaniard. On one level these *Sueños* are simply the "visionary" version of the oppression of the old upon the young of the first part; on another they represent the equally appalling alternative of the people—the revolution itself, which held the French at bay in 1793 and then swept out Jovellanos and the ilustrados reformers and left the artist Goya groping between the two worlds.

The second half of the *Caprichos* projects the alternative family that will appear under the new, vulgar regime—the revolution of the people against the ilustrados—and perhaps recalls the grotesque figures of the French Jacobins and sans-culottes of Gillray's prints, in particular *Un petit Souper à la Parisiènne* (fig. 48, which Goya could have seen among the cartoons Moratín brought back with him from England), "A Family of Sans-Culottes refreshing after the fatigues of the day" by devouring aristocrats. In the background the bodies and pieces of bodies hanging and otherwise stored recall the witches' parlors of the later *Caprichos* but also of course the dismembered heads of the monks' repast in the first half.

Thus the oppressed who become the "monsters" are made so, as the women are made adulteresses. Like the monsters, the oppressed are both hated and feared, like our own unconscious, our lower, sexual instincts (like the whores in the first half, where it is the female element that is both magnetic and terrifying). We might say that Goya begins in the first half with men and then brings in "natural" monsters (the asses) as examples and foils to men. Then with *Capricho* 43 he introduces the unnatural monsters, who, first presented as horrifying, gradually grow more familiar, become more likable, more like "men." They are described, and in some cases shown, as friendly looking, but it is equally reasonable to say they are as disgusting looking as "men." It is possible to see these final plates as reflecting numbers 19–21, where the monsters are strictly subservient to the wishes of cruel men; these duendes and witches are as hardworking as the whore in 23, who "served everyone so diligently, so usefully" but is condemned by the same men who used her.

To reformulate the tension of defense and anxiety we observed in Gillray's caricatures, we can say that Goya's grotesque functions as a way of providing (Wolfgang Kayser's words) "a satisfactory conscious equivalent, a concrete depiction of these demons of disorder" by making them legible, formulated for rational minds, in some sense acceptable; but at the same time, it offers "the loudest and most remarkable contradiction to all rationalism and to every kind of systematic thought." It can be "the banisher of dark powers, the liberator of the mind from the uncanny and demonic"

while at the same time it is "the opponent of rigid order and system, the liberator of the mind from the cramping bonds of logic."[43]

THE *DESASTRES* AND SERIAL PROGRESSION

Goya's second series of prints, the *Desastres de la Guerra* (1810–20), represented the phenomenon of revolution itself in Spain—both popular uprising against the French invaders and counterrevolution against the ilustrados, the afrancesados, the Francophile part of the court, and the enlightened middle class of Spain in the name of the heir Fernando VII, Spanish nationalism, and self-determination. In this dilemma Goya simply shows the atrocities balanced, French followed by Spanish, becoming anonymous and undifferentiated; after sixty such "reported" scenes he can only resort again to the allegorical phantasmagoria of the *Caprichos* in order to convey some sense of the return of royal, clerical, and noble oppression, and the ironic success of the "revolution."

The matter of perception is once again emphatic. If the *Caprichos* opened with the ironic face of Goya and halfway through exchanged it for the sleeping artist, the *Desastres* begins with a visionary figure, eyes open and arms outstretched, related to Goya's painting of *Christ on the Mount of Olives*, whose arms are outstretched to anticipate the agony on the cross (Esquelas Pias de San Anton, Madrid). The Christ-in-the-Garden figure leads into the reporting of events that are beyond ordinary belief. The terse comments on the images—"nor they," "neither," or "this too," "the same" (*lo mismo*)—emphasize the repetition of the visual images, and after so long the sameness, the undifferentiation of sides and causes.

The sequence that follows runs from the actual battle, the fighting and murdering, to the panorama of dying, dead, and mutilated. The conflict is presented as a sort of duel in which the figures of Spanish guerrilla and French soldier are balanced, with Spanish stake, dagger, and hatchet opposed to French rifle, musket, and bayonet (no English soldier ever appears).[44] Women are involved almost from the start (no. 5) sometimes re-

43. Kayser, *The Grotesque in Art and Literature*, trans. Ulrich Weisstein (New York, 1966), p. 203; cf. Arthur Clayborough, *The Grotesque in English Literature* (Oxford, rev. ed., 1967), p. 68.

44. On Goya's ambivalence toward the Civil War, indeed his "collaboration" with the French, see Gabriel H. Lovett, *Napoleon and the Birth of Modern Spain* (New York, 1965), 1, 586–88 (e.g., on Goya's painting *Allegory of the City of Madrid*); on the distinctions between afrancesados and liberals in these same years (the former believing in reform through enlightened despotism, the latter through the democratic process and a constitutional monarchy), pp. 608–09; and on the position of the rival *tertulias* in Madrid—of Goya's friend the younger Moratín, and Manuel José Quintana—see pp. 611–12. Moratín and his friends, "though also in favor of reforms, were moderates and abhorred revolutionary convulsions. Consequently, they were

sisting rape and sometimes actively participating as guerrilla fighters. Rape is followed by the most brutal retaliation on the soldiers, including castration and dismemberment, and at length there is no longer any strong sense of cause-and-effect, only one crime after another. Numbers 48–64 chronicle the results of the famine of 1810–12, reducing the slaughter to the level of a natural phenomenon with no distinction between French and Spanish, men or women. Only 61, with its smiling profiteer, breaks the utter depersonalization of the slaughter in these plates.

At 65 the apocalyptic realism of the burial scenes turns to satire, to emblematic scenes of clerical and aristocratic follies employing animal symbolism. These begin with the excessive worship of the dead, relics, and holy images, referring ironically back to numbers 46–47, where a priest is killed and the relics he protects are taken as loot by the French, and to the whole sequence in which the massed dead are not granted the value of relics. In 68 (which also recalls *Capricho* no. 4) the Church is an institution plied with devotional offerings and gives in return only feces; or, perhaps Goya is saying, it equally hoards treasure and its own feces (fig. 79). The image of a half-buried corpse, with the familiar shadowy figures of mockers in the background, holds a paper inscribed "Nada" (69), and a line of nobles and monks recalls Brueghel's *The Blind leading the Blind* (70). An inquisitor writes in a book of condemnations with his bat-wing ears picking up every incriminating rumor or betrayal (71), and a vampire bat sucks the life out of a man's body (72). An owl attacks (or whispers to) a cat, an image on an altar that the bystanders are worshiping. Witchcraft returns with priestcraft, but the same reciprocal killing and devouring continues. In 74 a wolf writes the laws while a priest holds the ink for him, and in 75 a parrot is the prelate to whom kings, asses, dogs, wolves, and two-faced men listen attentively. In 76 a sad plucked bird with only stumps of wings is all that remains of the Napoleonic eagle, who is being ignominiously driven away by a Spaniard with a pitchfork. He is the last echo of the plucked-bird fantasy of the *Caprichos*, and Napoleon is now no more than a memory of those fortune's-fools, the whores and Godoy. But in the pendant, 77, the eagle has been replaced by a prelate, his arms extended to resemble the eagle (or, looking further back, the Duchess of Alba in flight in *Capricho* no. 61)—not in flight but only balancing on a slack rope. In all these *Desastres* an indistinguishable mass of people fills up the horizon line; it is not clear whether they are cowed worshipers, threatening avengers, or both.

In 78 while a white horse is attacked by a pack of wolves (from 74), the

admirers of Napoleon and supporters of Godoy and did not hide their adulation of the Prince of Peace" (p. 611). See also Herr, *Eighteenth-Century Revolution*, pp. 272–77, and Carr, *Spain 1808–1939*, pp. 73–45, 89. For French propaganda efforts, see B. F. Hyslop, "French Jacobin Nationalism and Spain," in *Essays inscribed to C. J. H. Hayes*, ed. E. M. Earle (New York, 1950), pp. 190–240.

dogs trained to protect against wolves sit, ignoring the danger. In 79 the symbol of the white horse, killed by the pack, has become a woman (the return of those heroic women from earlier in the series) emanating light, being buried by a barely distinguishable mass, the people mingled with bishop, monks, and king. In the final plates—it is not clear where the series ends since it was never published by Goya—we are left with the question "Will she rise again?" (80), followed by a monstrous creature something like a swine (the same one being grappled with in 40) feasting on its own farrow (81, fig. 80), and "This is truth," a bearded farmer with his mattock and a basket containing produce and a lamb standing beside a woman from whom light radiates. An additional (eighty-third) plate shows soldiers ravishing women once again, and two further plates attached to one set of the prints Goya himself arranged show chained prisoners. But whatever the ending—or nonending—we are left with the question of which was worse, war and killing and raping by the French or the return of priestcraft and oppression by the Spaniards. The same priests who were heroes against the French become oppressors against the Spanish. Contrast has become undifferentiation. The final plates asking whether truth is dead or will rise again are as hopeful and as hopeless as the last plate of the *Caprichos* ("Is it time?"—to awake? to change? or merely to continue the same, endless repetition?).

The ambivalence toward the lower classes implied in the *Caprichos* is central to the *Desastres*. Goya sees them at one moment as pathetic victims, the next as ignorant or rapacious animals; now as heroes, now as barbaric brutes. The crude faces and clumsy bodies derive graphically from the low-life art of the Netherlands, to be seen in the royal collection, but also from those of the duendes and witches of the *Caprichos*. In those final caprichos of the *Desastres* they are blurred into vague shadowy shapes that merge with the figures of priests, prelates, and kings. Their hero was the egregious Fernando VII, who returned and ruled by a coalition of the mob, the Church, and the most reactionary aristocrats.

This coalition brought down Godoy and the court by mob action at Aranjuez in March 1808 and revolted against the French in Madrid in May, to rise again on 10 May 1814. The return of Fernando (*El Deseado*), the mob action, and the imprisonment of liberals coincided. The crowds marched on the Palace of the Congress, dragging the nameplate of the Plaza de la Constitución through the streets and shouting, "Long live Fernando VII," "Long live Religion," "Down with the Cortes," and "Long live the Inquisition."[45] This "people" combined with the privileged orders against the lib-

45. See Lovett, 1, 832–35. As Godoy himself claimed, the "tumult of Aranjuez" was carried out by the mob controlled by his enemies the nobles to unseat him—as the next day it went to work on his followers and his house in Madrid. Then on 2 May, rising against the French troops, they saw the French as an extension of Godoy: "an outburst of fanatical xenophobia led by monks and friars," as the French believed, "who wished to prevent the 'national' revo-

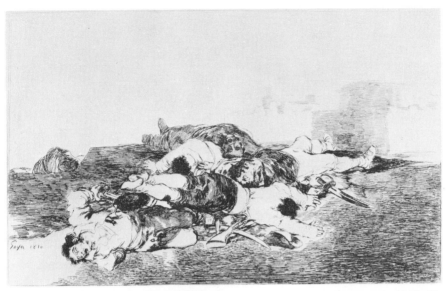

77. Francisco Goya, *Desastres de la guerra*, no. 22. Etching and aquatint, 1810–20. Before letters.

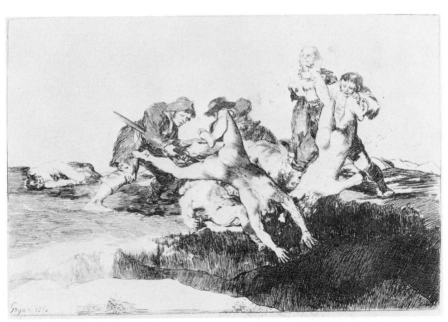

78. Goya, *Desastres de la guerra*, no. 27. Before letters.

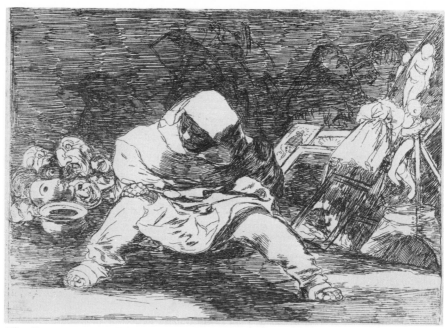

79. Goya, *Desastres de la guerra*, no. 68.

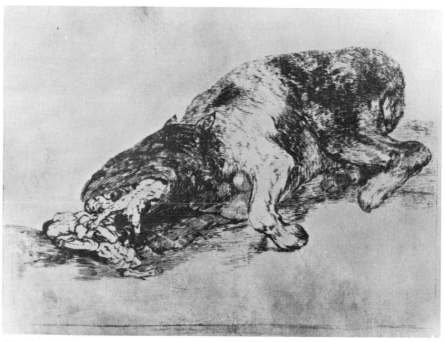

80. Goya, *Desastres de la guerra*, no. 81.

eral minority that desired reform in order to produce, from 1814 to 1820, counterrevolutionary terror and the darkest reaction. Goya's response was the later *Desastres*, the paintings in the Deaf Man's House, and eventually trans-Pyrenean exile. The *Desastres* only make explicit the implicit connections in the *Caprichos* between witches-duendes, superstition, the Church, the Inquisition, the nobility, the lower orders, and the ignorant *multitud* as source of energy and fantasía but also of threat, chaos, and terror.

The situation was unprecedented, as was the expressive power of the drawings with which Goya represented the situation and in particular his use of serial progression. It is important to appreciate the revolutionary nature of the series of independent drawings he began to make in the late 1790s, which culminated in the series of etchings but also continued independently. Even when they did not appear on the pages of a bound "album," these drawings were carefully numbered by Goya (sometimes renumbered to accommodate later additions) and a sequence was established.

All the albums have a vertical format. "The album drawings, concerned only with Man," says Pierre Gassier, "adopt the verticality of their subject." [46] The *Caprichos* continued the vertical format but the *Desastres*, followed by the *Tauromaquia* and the *Disparates*, are about *groups* of people, people reduced to little more than natural forces, and therefore take the horizontal format. The albums, however, allow us to make some generalizations about the nature of Goya's serial compositions—for example, as they resemble or differ from the series not only of Hogarth but of Blake, Rowlandson, and Domenico Tiepolo, who were his immediate contemporaries. What is apparent in all these series is their independence of the Hogarthian diachrony (the so-called progress) in favor of what Gassier calls "the many-sided expression of an idea or theme" (1, 10). Although the strict progression was retained by a series such as Cruikshank's *The Bottle*, in general the post-Hogarthian artists determinedly react against the possibility of both progress (in the Condorcet sense) and causality, replacing these characteristic eighteenth-century structures with other kinds of movement ranging from lateral to circling, based on repetition and difference. The

lution as the resistance of blind fanaticism to enlightened reform" (Carr, pp. 120, 84, 88, and n.). The urban mob, which emerges as the heroes of 2–3 May, was controlled by the aristocracy and the Church, for example, as objects of charity: The semibeggar mob was held in thrawl equally by ecclesiastical charity (30,000 soup bowls daily in Madrid) and by "the conspicuous waste of the aristocracy," and was therefore a mob dependent on "these great spenders" (Carr, p. 55). In the years that followed, guerrilla warfare was, as Caffarelli wrote to Berthier, "à proprement parler, la guerre des pauvres contre les riches"—as it was also a rural phenomenon in which the peasant showed his natural hatred for urban civilization, the centers that the French held with relatively little difficulty (31 Oct. 1811, quoted in Carr, p. 109). Also useful on this subject is Williams, *Goya and the Impossible Revolution*, and Nigel Glendinning's review, "The Artist in his Time," *TLS*, 19 November 1976, p. 1450.

46. Gassier, *Drawings*, 2, 21.

most general description of this "modern" principle of progression is ex-
pressed by our contemporary, Francis Bacon. David Sylvester, in one of his
interviews with Bacon, says: "You paint a lot in series, of course." "I do.
Partly because I see every image all the time in a shifting way and almost in
shifting sequences. . . . I do them one after the other. One suggests the
other."[47] When asked whether a series remains a series after he has finished
the paintings, Bacon answers:

> Of course, what in a curious way one's always hoping to do is to paint the one
> picture which will annihilate all the other ones, to concentrate everything into
> one painting. But actually in the series one picture reflects on the other continu-
> ously and sometimes they're better in series than they are separately because,
> unfortunately, I've never yet been able to make the one image that sums up all
> the others. So one image against the other seems to be able to say the thing more.

Bacon sums up the effect of the post-Hogarthian series and the way Goya
carried out his long series of drawings.

Goya's typical sequence is most clearly seen in the drawings of album C:
First there is "What I saw" (as he often puts it in the *Desastres*), which is the
real world seen through the ironic eye of the Goya of the *Caprichos* frontis-
piece. These scenes then gradually become caprichos or sueños. Notice the
progression in the Sanlúcar album, almost exclusively about women, to the
Madrid album, showing women surrounded by males and other figures,
until at f. 55/6 masks and witches appear, and youth gives way to age and
ugliness, direct representation to caricature and grotesque figures. In album
B the elements of caricature initiate the transition, while in the *Caprichos* it
is a series of animal satires. In album C caricature types and "visions of a
single night" serve as the transition, followed by the blatant horror of scenes
of the Inquisition, prisons, and torture. But then there are a couple of scenes
showing liberation from prison and finally a parallel series showing monks
divesting themselves of their robes. They resemble in their gestures the
goblin-monks of the *Caprichos* stretching as the night comes to an end,
signaling the return of the Goya of the first frontispiece.

The strategy is to set up a contrast—day and night, reason and unrea-
son—and show that they are two ways of seeing the same thing. For this is
basically a progression from one mode of perception to another, from re-
porting to visionary transmutation, which becomes a progression from the
perception of one form of tyranny to another.

It is difficult not to think of Blake's piper and his bard, who are estab-
lished before each phase, first of *Innocence* and then of *Experience*, is under-
taken. The practice goes back to the artist's placing his head on the frontis-
piece of his folio of prints. But to divide into two phases of perception is a

47. *Francis Bacon interviewed by David Sylvester* (New York, 1975), pp. 20–21.

strategy that may have been called for by the extraordinary circumstances under which both artists worked. If in Goya the progression is from light to darkness, with perhaps a hint of the return to light at the end, in Blake the progression is from simple to complex, with a possibility that some people may pass beyond experience to a higher innocence, whereas others will be stuck in a kind of endless repetition. The movement of Goya's perception, however, reflects a movement from one state to a worse; the world of the murderous unconscious may even follow causally from the masking and social posturing of polite society. This has become the case in the *Desastres*, where the aftermath of the terrible heroism of the "war of liberation" proves so much worse, so disillusioning that it can only be expressed as caprichos. But in terms of the ideas of war/peace and enslavement/liberation these are two contrasting worlds that amount finally to the same, at least in Spain between 1814 and 1820.

Goya knows that neither rhetorical nor narrative mode is any longer relevant—that neither persuasion nor ending exists. But not yet willing to go all the way in acknowledging this insight, he ends his numbered series with a sign of hope (still officially a happy ending) and yet continues to add other unnumbered scenes that leave the sequence open—as in the extra plates of the *Desastres* (or, in the *Tauromaquia*, the continued versions of the death of Pepe Hillo followed by more bullfight scenes of increasing disorder and openness).

THE *TAUROMAQUIA*

> The annals of the French Revolution prove that the knowledge of the few cannot counteract the ignorance of the many . . . the light of philosophy, when it is confined to a small minority, points out the possessors as the victims rather than the illuminators of the multitude.[48]

The dichotomies of alert wakefulness and sleep, observation and vision, day and night, ego and id, reason and instinct, which began with Enlightenment, *lumière*, and *Aufklärung*, defined the world of the *Caprichos*. In the whole series, as Gassier has said, Goya expressed "by means of a perfectly bitten etched line and superbly controlled shades of rich, dark aquatint, the whole conflict between light and dark, between right and wrong, between 'enlightenment' and ignorance, which was the fundamental meaning of the rationalist cause" in Spain.[49] Edith Helman develops the metaphor when she writes of "the intense light of reason" which Goya "trained [like] a spotlight" on the *Capricho* scenes, "making them stand out in striking relief,

48. Coleridge, *Essay on his Times* (London, 1850), 1, 7–8.
49. Gassier, with Juliet Wilson, *The Life and Complete Works of Francisco Goya* (New York, 1971), p. 130.

more sinister and mysterious than ever." [50] These plates, and the works that followed, were largely *about* the contrast of light and darkness. *Lumière* (or *éclarer*) conveyed the sense of light trying to penetrate darkness (*ténèbre*) and bring truth to light.

A contemporary poem, Shelley's "Lines written among the Euganean Hills" (publ. 1819), is structured on the rising and setting of the sun, both poetic and political. As there are islands of brightness in the dark, aimless sea of life, so there were islands of civil and intellectual liberty in the past, now small spots of illumination amid darkness. The "lamp of learning" which was Padua's university, while hardly a sun (more a scholastic "meteor" that "gleams betrayed and to betray"), nevertheless is a "sacred flame" which will cast out—or serve as source for—"new fires" or a "spark" that will set off a conflagration analogous to the spring Paine described in *Rights of Man* as spreading from bud to bud, and disperse the counterrevolution.

In *The Triumph of Life* (1822), however, while "the [natural] Sun sprang forth" in a world of spring and sunlight, and all things responding "Rise as the Sun their Father rose," the world of the poet's dream is sunless, plantless, and dead, with only "a cold glare, intenser than the noon, / But icy cold [which] obscured with blinding light / The Sun," i.e., the true sun of liberty. This false sun is the chariot leading the triumph of life, its light inadequate to direct its way, and dragging behind it the Enlightenment heroes—in particular Rousseau, their spokesman—who have outlived their ideals.

The figure of light is applied by Shelley in an equally ambiguous way to Byron–Maddalo in *Julian and Maddalo* (1818):

> The sense that he was greater than his kind
> Had struck, methinks, his eagle spirit blind
> By gazing on its own exceeding light. [ll. 50–52]

The two "suns" and the combination of "light" and "blind" operate in the same way in J. M. W. Turner's sun-oriented landscapes, for example in his *Regulus* (1842). The painter looking at himself is blinded by his own excessive light—an ideal light turned blindingly inward upon itself, contrasted with the ideal light that sheds itself on the world, thereby transfiguring it. [51] In art, Turner's sun is one final statement of the Enlightenment faith in illumination; Goya's *Tauromaquia* is the other.

As we saw in the *Caprichos*, darkness and sleep bring forth both ignorance and liberation of the imagination, which on the level of the artist means a breakthrough in his art. The imagery of light and dark as day versus night,

50. Helman, "Moratín and Goya," p. 116.

51. For a discussion of Turner in these terms, see Paulson, "Turner's Graffiti: The Sun and its Glosses," in *Images of Romanticism*, ed. Karl Kroeber and William Walling (New Haven, 1978), pp. 167–88, and *Literary Landscape: Turner and Constable* (New Haven, 1982).

figure versus ground, "civilized" society versus an atavistic regression to witchcraft and demonology, is finally summed up by Goya in the bullfight. A matador, in his "suit of light," standing in a blaze of sunlight, confronts the dark bull emerging from the black hole of a pen into the sunlight of the ring. The ring, however, sharply demarcates the light and the dark halves, the man's half and the bull's. The bull represents animal instinct, the uncontrolled, repressed forces of nature of the sort encountered in the second half of the *Caprichos*. Both man and bull are grounded in the shadow and silhouetted against the sunlight. And the bull is killed by the matador in what is called "the moment of truth" (*hora de verdad*).[52]

For Goya, I am proposing, the bullfight served as a paradigm and summation of the Spanish history of enlightenment that culminated in the slaughter of the Peninsular War and the return of Fernando. The *Desastres* were only a more literalizing version, showing two forces, the French soldiers and the Spanish mob, mutually destructive, in ambiguous combat. The bullfight prints were made in 1815–16, at the midpoint of the *Desastres*, the turning point from observation to capricho, from the struggle among Spaniard, Frenchman, and fellow Spaniard to the return of Fernando and counterrevolution.

In the *Tauromaquia* Goya looks back to the eighteenth century, in which rules were formalized for the bullfight, the procedures and methods for killing the bull were detailed, and the bullfight was raised from a popular and brutal sport into what was considered an art. The bull itself would have recalled to the Jovellanos circle Burke's reference to it as a sublime animal.[53] But Goya's other representations of bullfights make it clear that he saw this as a popular ritual (turned aristocratic) of deep-seated ambiguity. The best way to determine what Goya felt about the bullfight (complementing the reports that he loved to attend them) is to look at *The Bullfight* he painted

52. Cf. Hetzer on the *Tauromaquia*: "There is no criticism of the social order, no troubling topical reference. He has shed all this. What interests is nothing but its pictorial effect" ("Francisco Goya," p. 112). On Goya and his attitude toward the Enlightenment, see Hubert Damisch, "L'Art de Goya et les contradictions de l'esprit des Lumières," *Utopie et Institutions au XVIIIe siècle*, ed. Pierre Francastel (Paris, The Hague, 1963), pp. 247–57.

53. Burke, *Philosophical Enquiry*, p. 65. The bull can also be documented in Goya's drawings as a male principle (e.g., album B, 23). In any case it is another example of the transvaluation of a symbol—in this case with complex double meanings that ask to be interpreted. As Fraser wrote, "To a pastoral people a bull is the most natural type of vigorous reproductive energy" (*Golden Bough* [London, 1932], 5.4, 71). The bull was both emblem of fertility and sacrificial victim to fertilize the soil, as in the case of Dionysus as bull and his ceremonial dismembering by his followers. There were cults in which the actual or symbolic eating or drinking of the bull's flesh or blood conferred his power and fertility (cf. the stories of Zeus as bull, as when he carried off Europa). It is interesting to note that in the iconography of Crete "the bull was at once the king's crest and an emblem of the sun" (*Golden Bough*, 5.4, 111). See also Alan Fraser, *The Bull* (Reading, 1972), esp. pp. 26–44. For its connection with the return of crops and the rejuvenation of the natural cycle, see pp. 48–66.

in a series of scenes (ca. 1810), which also included a madhouse, an Inquisition trial, and a religious procession of flagellants (figs. 81–84). Taken by itself, *The Bullfight* could be read as a popular pastime, exemplary of the Spanish spirit, but in the context of the other three paintings, we have to read it under the categories of madness, playacting (the insane miming kings and queens), bloody religious fanaticism, and cruelty in the guise of trial and punishment. We then have to read the other paintings under the bullfight categories of national sport, interchangeability of men and animals, and bloody sacrifice. These paintings add up to a four-part interlocking metaphor for Spanish society, and when Goya isolates the bullfight in the *Tauromaquia* he carries along associations of the other three Spanish paradigms as well.

The images of the *Tauromaquia* have received their share of historical interpretation. Eleanor Sayre, for example, points out that "one cannot help but observe that the low turbans and clothing [of the Moors in some of the plates] have a very strong resemblance to the dress worn by Napoleon's Moorish Mameluke troops in Goya's *El 2 de Mayo*," and she goes on to note that according to Moratín the Elder and Pepe Hillo's *Art of Bullfighting* (or *Tauromaquia*), bullfighting became a true art form in the eighteenth century *only* "when the nobility began to withdraw from their privileged pastime and common men took it over as a profession."[54] With the Moors and after, bullfighters had belonged to the nobility. There might, therefore, have been a parallel between the commoners and either the bullfighters or the bulls. It is difficult to agree that the bull simply represents the revolutionary energy of the people, thwarted by the abstract illumination of the aristocratic reformers from above, since the crowd itself appears as an antagonist of the bull, assisting the bullfighters. The crowd swarms out into the arena from time to time, like the dogs loosed on the bull; its figures resemble the grotesques of the *Disparates*, which Goya was making at about the same time (e.g., no. 12). This does not rule out the possibility of an irony in the figure of the bull, strength and beauty attacked by gross, ugly plebeian force. The ultimate tragedy of those years was embodied in the courage, strength, brutality, stupidity, and suffering of the people pitted against the ideals of enlightenment in their own liberal politicians and in the French invaders.

Nigel Glendinning has argued, from a manuscript page which includes the descriptive subtitle "Bárbara Diversión!" (Ashmolean Museum, Oxford), that Goya's series must be an attack on the Spanish admiration for

54. Sayre, *Changing Image*, pp. 202, 203. She refers to the parallel between the commoners and the bulls and "the stunning achievement of ordinary men during the war for the liberation of Spain," which Goya could not publish in his *Desastres*. Here he shows "commoners taking a pastime from the nobility and transforming it into a great art" (p. 203).

81. Francisco Goya, *Bullfight in a Village*. Painting, ca. 1812–19.

82. Francisco Goya, *Inquisition Scene*. Painting, ca. 1812–19.

83. Francisco Goya, *Procession of Flagellants*. Painting, ca. 1812–19.

84. Francisco Goya, *The Madhouse*. Painting, ca. 1812–19.

bullfighting.[55] It is true that Jovellanos and the ilustrados (or at least some of them) regarded the bullfights, along with street ballads and the mystery plays of Calderón, as popular follies. Their attack was in terms of utility: the bullfight wasted working time. In 1804 Carlos IV abolished the *corrida de toros*, for which Godoy (who was attacking bullfights as well as mendicant orders) received the blame. The corrida was reinstated by Fernando VII after the abdication of his father and was carried on by the Bonapartists. On 18 March 1811, around the time Goya was painting his four Spanish pastimes, a special corrida celebrated Joseph Bonaparte's saint's day.[56] We would also, in order to come up with anything like a satisfactory conclusion, have to take into consideration what we know of Goya's feeling about the proscriptive "rules" that had been formulated by the Royal Academy for the artist—and ask how he might have related the contemporary formulated bullfight to the old popular bullfights of yesteryear.

It is at any rate tempting to suppose that Goya in his last years looked back on the successful bullfight, the artistic killing of the bull, as an enactment of the victory of enlightenment and reason over the forces of darkness and irrationality. For the same period that raised the bullfight from a brutal sport into a rational art had raised man—in Spain and in the rest of Europe—as an enlightened, rational animal to a position where he could see through the dark clouds of centuries of what Burke called ancient wisdom to discern what Paine regarded as the gleaming truth.

There are strange aspects to the *Tauromaquia*. For one, the artistic ingenuity of the bullfighter is carried to the point of the absurd in a matador who manacles his legs and sits in a chair to meet the bull (18) or stands

55. "A New View of Goya's *Tauromaquia*," *Journal of the Warburg and Courtauld Institutes*, 24 (1961), 120–27. Cf. the *Oracion apologetica*, probably by Ramón de Salas, with its ironic reference to Spain's reliance on bullfights, from which its martial spirit and its political wisdom stem: "If the circus of Rome produced such delicacy in the people that they noted if a wounded gladiator fell with decorum and breathed out his life with pleasant gestures, the circus of Madrid teaches how to observe if he flies gracefully over the horns and spills forth his guts with decorum. If Rome lived happy with *bread and arms*, Madrid lives happy with *bread and bulls*" (quoted in Herr, p. 334). Goya also made a "Folly of young Bulls," in which the symbolic bulls victoriously take to the air. At some point he intended to end the *Tauromaquia* with the *Disparate* of the flying man: presumably as a reference to the "art" of man in controlling nature. Bermúdez's set of the *Tauromaquia* had this attached print, with the title ending, "and one of the ways in which men can fly with wings."

56. In 1805 Carlos IV abolished the corrida de toros "on humanitarian and economic grounds, claiming that the excessive emphasis on this spectacle hampered the development of agriculture" (Lovett, *Napoleon and the Birth of Modern Spain*, 1, 80; 2, 523–24). For Jovellanos's attacks on bullfights, see Carr, p. 70; for Godoy's attacks on bullfights as well as mendicant orders, see Carr, p. 82. The bullfight situation portrayed by Goya may be qualified by the phenomenon of the great popular hero, the matador Pedro Romero, or Pepe Hillo, or Romero's rival Costillares. By the 1780s Madrid was divided not into supporters of the bull and supporters of the matador so much as into *Romeristas* and *Costillaristas*.

manacled atop a table whose cloth the bull is charging (19)—or the picadors who (in one of the unused plates) approach the bull in a stagecoach.

Second, the logical scenario for a bullfight series was that of Carnicero's popular series (1790), which showed the bull freed into the bullring (1), contesting with the picador (2–5), and with the occasional unworthy bull who has to be killed by dogs (6), followed by the torero contesting the bull (7, 8) and the matador instantly killing the bull with a single accurate thrust (9–11), and finally the bull's body dragged from the arena by mules (12). Unlike Carnicero, Goya portrays the historical progression of the bullfight: the civilizing, modernizing, and enlightening of the sport in Spain. In this he follows the text of the matador Pepe Hillo, whose *Tauromaquia* described the history of bullfighting as it developed into an art: from the bullbaiting of primitive artless Spaniards to bullfighting made an art by the Moors (who added the enclosed area from which an audience can watch the spectacle) and by the enlightened Spaniards of the eighteenth century.[57]

In the third place, Goya shows what can go wrong in a bullfight. The bull gets out of the ring and kills a spectator (21, fig. 86), authenticated by the familiar "I saw" in Goya's own hand-written caption: "The bull jumped into the bleachers and killed two. I saw it" (Boston Museum). Moreover, the series ends not with the death of the bull or his body being dragged from the arena but with the bull killing a famous matador (33, fig. 87). And indeed that matador, Pepe Hillo, authored the book on bullfighting as an art, from which Goya took the title for his own sequence. Goya shows the sanctity of the enclosed theatrical area broken and the art of the matador subverted by the dark natural force of the bull. Something close to an allegory emerges in which the Moors (and their conquest and dispersal from Spain) equal the French, with the ultimate confrontation pitting two aspects of the Spanish character in a tauromaquia which is also a psychomachia.

Unlike Carnicero's wooden, stylized popular prints, Goya's series comprises a sophisticated drama of sun and shadow. He recognizes that the sun itself is, if not protagonist, closely equated with the protagonist, the torero or matador. As Hemingway wrote of the bullfight:

> The sun is very important. The theory, practice and spectacle of bullfighting have all been built on the assumption of the presence of the sun and when it does not shine over a third of the bullfight is missing. The Spanish say, 'El sol es el mejor torero.' The sun is the best bullfighter, and without the sun the best bullfighter is not there. He is like a man without a shadow.[58]

57. Pepe Hillo, *Tauromaquia, o arte de torear a caballo y a pie* (Madrid, 1804, the expanded second edition of a work originally published in 1796 in Cadiz, probably in fact by Don Jose de la Tixera).

58. *Death in the Afternoon* (New York, 1932), p. 15.

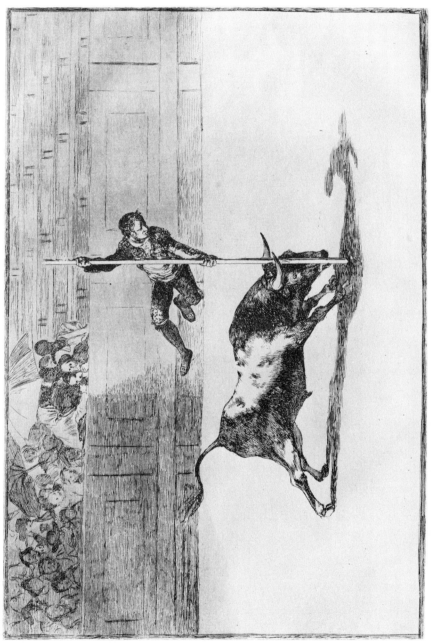

85. Francisco Goya, *Tauromaquia*, no. 20. Etching and aquatint, 1816.

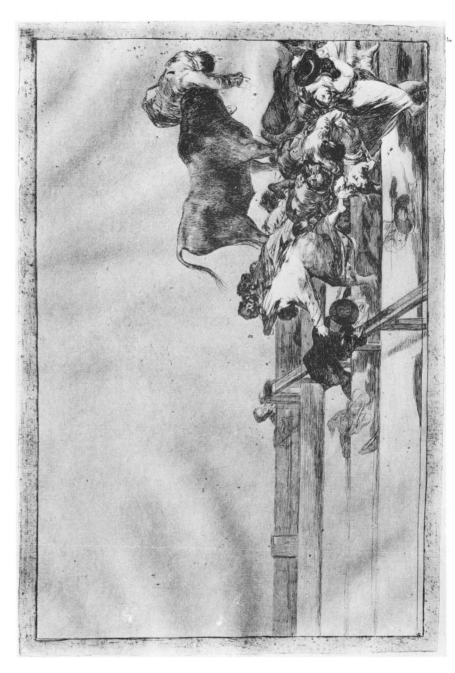

86. Goya, *Tauromaquia*, no. 21.

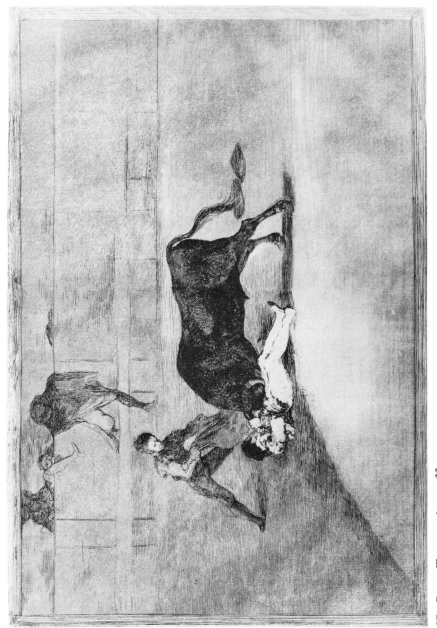

87. Goya, *Tauromaquia*, no. 33.

But the sun-matador as center of energy is contested by the bull, who blots out the sun with his pure animal energy. He is played off against humans who become increasingly animal as he becomes increasingly beautiful and beleaguered, a reprise of Christ in the *Taking of Christ* in Toledo, the artist in "The Dream of Reason," and dead Truth in the *Desastres*.

The progression begins with modern bullfighting in 12, where the bull, dark and standing against the sunlight, faces the grotesque humans (he has already killed two) who are getting ready to spear him. Then in 13 the bull leaps out from the shadow at the man—the matador dressed in elaborately courtly dress (from an earlier age) on horseback in the sunlight. In the upper left corner are the faces of the audience and the long strong rectangle of the wall separating them from the pure animal vigor of the bull.

Then in 14, which begins the representations of famous bullfighters, both matador and bull are in the shadow. The matador, on foot now like the bull, is wrapped into an undifferentiated figure that is hardly distinguished from another bull (again with the vague indications of the spectators along the thin rectangle of the wall at the top). In 15 too the shadow has encompassed both matador and bull, and here and in 16 they are in hand-to-hand combat.

Goya's procedure can be summed up with a single plate, 20 (fig. 85). The shadow is cast on the ground by both bull and matador in such a way as to combine the two, making a schema with reason above and animal instinct below, as structured as a miracle play. The relationship is emphasized by the audience to the spectacle (above as usual), in which two people have open umbrellas (the only umbrellas in the series) protecting them from the sun, formally parallel to the torero. Is the suggestion that rational man is to the violent bull as protecting umbrellas are to the umbrella-holder? Or that there is a bit of the bull within every man? In this sense the bullfight is a kind of exorcism: Man in killing the bull performs a ritual murder of the unreason within himself, purging himself of the forces of darkness. It takes the form of a balancing act.[59]

Number 20 then is followed by the plate (fig. 86) in which the bull has invaded the stands, broken the theatrical or rational barrier, and killed a spectator. Unreason proves victorious at the same time that the hysteria of the crowd and the destructive, as opposed to the aesthetic, elements of the bullfight emerge. Number 22, a contrasting image of total order in which "the celebrated Pajuelera" plants his pike gracefully in the hump of the bull, is followed by 23, all confusion in shadows, with the populace swarming out into the ring; in 24 the matador is on another bull, which seems barely

59. The contrast is most striking in one of the unused plates, no. 34A, where the bull is total darkness silhouetted in the foreground against the bullfighters. Other unused plates show the horse thrown by a bull, animal vs. animal, with the bullfighters, small masses of heads and shoulders behind the bull, and two other versions of the death of Pepe Hillo.

under control: one bull light, the other dark, and the man on the dark one. The disorder increases in 25, the man having turned his back and allowed his dogs to attack the bull; in 26 the bull, beginning to win, unhorses a picador; and in 28 the brave Rudon wounds the bull—and so meets his death. In 32 "Two teams of picadors [are] thrown one after the other by a single bull," and 33 shows the death of Pepe Hillo, of which Goya made various alternative versions.

The conclusion in the death of the matador should be compared with the conclusions of Goya's other series. In the *Caprichos* the daylight of rationalism ultimately disperses the witches and goblins of night. In album C it brings the disrobing of the monks and nuns and the return of Truth. In the *Desastres* a white horse is contrasted with white-draped Truth (78, 79), and both *Desastres* and album C end with the female sun-figure, symbol of reason, Truth, and Peace *dead* but still *radiant in white* surrounded by *dark* forces of stupidity and oppression, with at least the possibility of her rebirth.

In the *Tauromaquia* Goya takes the simple opposition of light and dark or man and animal inherited from the Enlightenment, which saw light as illumination of darkness, superstition, and royal tyranny, and pushes it toward confrontation, reversal, and then undifferentiation. In the earlier scenes the heroic aspect of man is emphasized, the loneness of the two antagonists; in the later, as the sport becomes more theatrical and sophisticated, the bull begins to rampage, destroying spectators and at times the bullfighter. Now ordained outcomes are in doubt, all control is about to be lost, and one day the matador is victorious, while the next it is the bull. The kill becomes messy and, as Goya continues his scenes of bullfights (the series remains as open-ended as the others) in the lithographs of *The Bulls of Bordeaux*, often many people are required to do in the bull. Two and even five bulls are sometimes in the ring at the same time. The ritual is debased as the bull dominates the action. Hysteria grips the crowd as masses of absurdly grinning Spaniards swarm into the ring, and it is no longer clear who is killing whom. In the last (fourth) plate, "The Divided Arena," the entire process has doubled, and there are two rings, two bulls, two matadors, and two crowds.

In both *Desastres* and *Tauromaquia* there is a progression from reason and reporting (events recorded as seen by Goya himself) to license and fantasy, as unreason takes over with darkness, sleep, and undifferentiation, the burial of faceless dead and merging of man and bull in a common shadow. The final versions of the repertoire of these images (on the walls of the Deaf Man's House) are extremes of detachment and involvement which belie a temporal progression of any sort. They coexist as different responses to an insoluble problem, as acts of defiance and ways of inuring oneself to the unbearable, an expression of both the failure of political revolution and the success of the artist's own revolution.

THE *QUINTA DEL SORDO*

To fathom the importance of Goya's paintings in the Deaf Man's House one need only walk in Madrid from the Prado (where the black paintings now hang) to the Royal Palace with its ceilings by G. B. Tiepolo. Goya's paintings are the absolute end of the great European tradition of decorative wall painting as beauty, glory, and art. Instead of consolidating the tradition as it was developed from Titian to Veronese to Tiepolo, or instead of retaining its forms and playing them ironically against contemporary subject matter, as Hogarth and Gillray did, Goya dismantles the tradition and reduces its components to the barest minimum. This puts him in the company, for example, of the Franz Hals whose portraits of the Governors of the Almshouse (Hals Museum, Haarlem) reduced the group portrait tradition to the sheer expressiveness of faces and hands, lowering both style and iconography to a level hitherto unthinkable. Goya goes even further, recreating (by the simplifications of "lowering") a fusion of low and high modes of representation, of the sublime and the sublimated, which replaces the tradition of history painting with one in which the conflict of a Saturn and Jupiter, scratched on the wall like graffiti beneath the elevated frescoes above, is no longer (or not only) in the graphic image but is played out by the artist himself with Titian and Tiepolo.

Goya asks us to see the long lateral walls of the Deaf Man's House as his windows with views out across the valley of San Isidro to the outside world. The ground floor room shows pilgrims on their way to the hermitage of San Isidro—a scene which requires as context Goya's own happy picnickers in his *Pradera of San Isidro*, a design for one of the tapestry cartoons he made in the 1780s (figs. 88, 89). From the "window" he has a view of the hermitage of San Isidro, to which every year, on 15 May, the people of Madrid made pilgrimage to honor their patron saint. Now, around 1820, looking out on contemporary Spain, Goya sees no happy middle-class picnickers but the threatening mob of the "black" Spaniards, painted in his "black" saturnine manner—black because of the reference to the superstitious, benighted people and because it is the color of melancholy and so refers both outward to the object or cause and inward to the subject, Goya himself and his state of mind. He looks out through this "window" onto the valley of people coming straight at him. He has in effect to be imagined as the object of their attention, of their idiotic gape-mouthed aggression, in the same position as Christ in relation to his mockers.

This is a composition he has executed many times. Not only the artist among the monsters of "The Dream of Reason" fits the pattern but also the bird in the well-known portrait, *The Boy in Red* (*Don Manuel Osorio Manrique de Zúñiga*, Metropolitan Museum, New York, fig. 90), who holds in its beak Goya's own calling card, with palette, brushes, and books. The cats

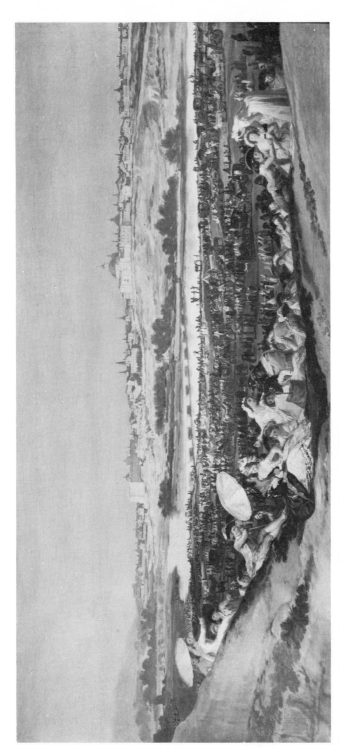

88. Francisco Goya, *The Meadow of San Isidro*. Painting, 1788.

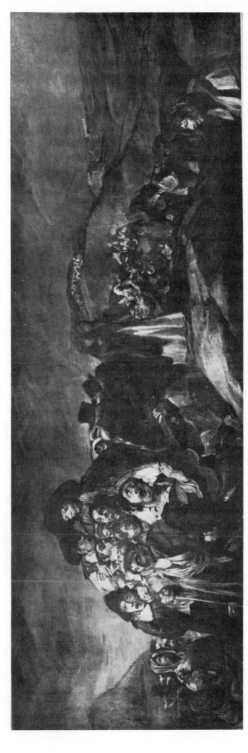

89. Francisco Goya, *Quinta del Sordo* [Deaf Man's House]: *The Pilgrimage of San Isidro.* Painting, 1820–23. Prado Museum, Madrid.

in the background are eying the bird in precisely the way the monsters are threatening Goya in "The Dream of Reason" and the mob is threatening Christ in the Toledo painting. Although the cats' mouths are closed, the context tells us that the devouring of the bird is what they intend.

If we go back to the *Taking of Christ* (fig. 71), we might object that the open mouths indicate a cry of suffering rather than mockery. In fact the tradition in which Goya is painting is the Christ Mocked, not the Crucifixion, where the figures do mourn. Nevertheless, the effect may derive from his joining both. The common element is the hideously gaping mouth. As in the celebration of the Eucharist to which the pilgrims are headed, the mouth is open to devour the body and blood of Christ, and the devourer is atoning for his ultimate father's (his own original) sin, therefore retaining the traces of the evil mocker while also suffering vicariously with his Redeemer.

But what holds us in *The Boy in Red* is not the birds' mouths (though eating is intended) but their eyes: round and incredibly large. I wonder if it is possible that for Goya eyes are related to mouths, sharing the common factor of devourment. We have come very close to such an equation in our discussion of the *Caprichos* (and the lynx's eyes in no. 43) and the conclusion that on some level perception (the artist's) and eating are the same.

On the wall opposite the pilgrimage is a witches' Sabbath, a saturnalia which relates through juxtaposition the Christian superstitions of the vulgar Spaniards to witchcraft in an even more explicit way than in the *Caprichos*, where witches and monks mingled and became interchangeable.

The most striking juxtaposition, however, flanking the doorway, is the pair of paintings of Saturn devouring one of his sons and Judith beheading Holofernes (figs. 91 and 92). These images are echoed in the two figures opposite at their dinner and by a demon with open mouth prompting or tempting an old man: all of which has led some commentators to assume that the depth of Goya's black humor lay in the fact that this was his dining room.[60] The imagery is further echoed in the room directly above by a dog's head sinking out of sight on one wall and by two men being engulfed as they fight one another (fig. 94). The two peasants furiously swing at each other with cudgels while they sink into a mire—their mad obsession making them quite oblivious to their actual plight.[61] Their struggle is that of the

60. Charles Yriarte, who visited the Deaf Man's House in 1867, is the source for this fact (*Goya: sa biographie, les fresques, les toiles, les tapisseries, les eaux-fortes, et la catalogue de l'oeuvre* [Paris, 1867]; Gassier and Wilson, *Life and Complete Works*, p. 321).

61. The figures are taken from Hogarth's *Election* 4 (1758) but the difference is the most striking thing: Goya's cudgels are straight out behind either man giving a powerfully centrifugal effect to their struggle, which fits with the utter desolation of the scene, the emptiness around them, as they sink into the mire (which might have been suggested by the surroundings in *Election* 4, or even by the slough in plate 11 of *Industry and Idleness*). For a larger context, see

90. Francisco Goya, *Manuel Osorio de Zuniga* (The Boy in Red). Painting, ca. 1788.

divided Spain of the *Desastres* or the matador and bull of the *Tauromaquia* (or the entangled figures of the album drawings). The combatants—or the occupants of the room—are being coldly observed on the opposite wall by the Holy Office of the Inquisition.[62]

It has been suggested that in this context the *Saturn* is either Goya's "interpretation of the civil war" or of "a young generation . . . sacrificed and consumed by its elders."[63] But the double beheading that is taking place in the "dining room" forces us to narrow the reference. The *Saturn* (which supports the colors and theme of melancholy) derives pictorially from Rubens's full-length Saturn in the Spanish royal collection (fig. 93), where Goya would have seen it. But Rubens's Saturn is only biting, sinking his teeth into the child's breast, indenting the Rubensian baby flesh. Goya's Saturn is holding the long mature body of an adolescent or a man, and he has bitten off the head.[64] He has specifically bitten off the son's head (a head is also referred to in the pendant *Judith and Holofernes*). It is the beheading of the French king (and of the nobles and of the revolutionaries themselves) that leads ultimately to Goya's *Saturn* and *Judith*. The cutting off of the king's head, traditionally the head of the body politic, the superego that controls the unruly instincts of the populace, was the most disturbing symbol of all those emanating from Paris to be absorbed in the consciousness of contemporary artists (reflected even perhaps in the severed heads painted by Gericault).

Another source for Goya's colossus might have been the Jacobin image of Hercules and in particular a cartoon, "Le Peuple Mangeur de Rois," which showed the giant sans-culotte Hercules roasting the king over a fire and preparing to eat him. This print was published in *Révolutions de Paris*, fol-

René Girard, *Violence and the Sacred* (Baltimore, 1972), p. 48, where he describes the oedipal confrontation at the crossroads in these terms: "It is Laius who, at the crossroads first raised his hand against his son. The patricide thus takes part in a reciprocal exchange of murderous gestures." He sees "reciprocal violence" as the basis for all masculine relationships: They are fighting for the common desired object, whatever it may be.

62. On the large walls of the upper chamber the viewer is higher off the ground and so sees the floating figures of the Fates (from *Capricho* no. 44) and the flying figures or demons at which a firing squad out of the *Desastres* (or *Dos Mayos*) is firing. If the name Asmodea, which has usually been attached to the panel, is authoritative, the allusion has to be to Le Sage's *Diable Boiteux* and to Asmodeo the minor devil of sensual pleasure who flies about Madrid showing his human charge the vice and folly that is concealed by the rooftops—another version of the *Caprichos* with its theatrical metaphor of unmasking. (Identified by Brugada in 1828, the figure has always thereafter been called feminine: Asmodea rather than Le Sage's Asmodeo or Asmode—perhaps going back to Yriarte's source in Javier or Mariano Goya.)

63. See, e.g., Heer, *Europe, Mother of Revolutions* (New York, 1964), pp. 78–79.

64. Glendinning, studying photographic reproductions of the paintings before restoration, states that Saturn originally "showed an erect or partially erect penis" ("The Strange Translation of Goya's 'Black Paintings,'" *Burlington Magazine*, 117 (1975), 473. For one of the many contemporary Saturns, see Byron's *Don Juan*, XIV, 1 and 2.

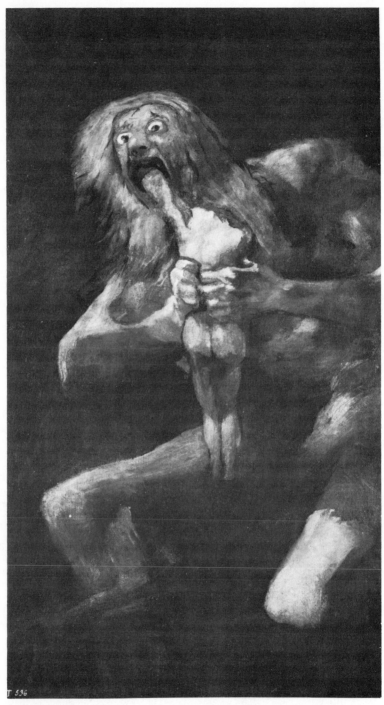

91. Francisco Goya, *Quinta del Sordo: Saturn*. Painting, 1820–23.

92. Francisco Goya, *Quinta del Sordo: Judith and Holofernes*. Painting, 1820–23.

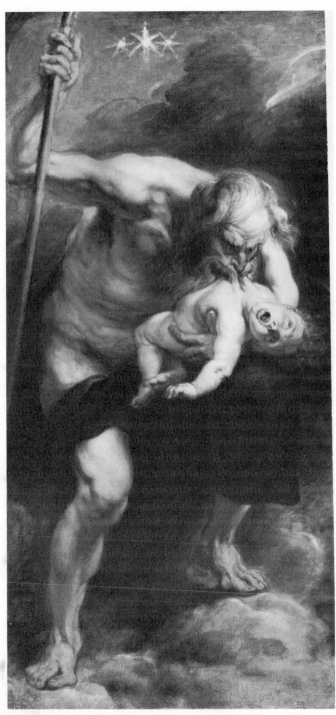

93. Peter Paul Rubens, *Saturn*. Painting, 1636–37.

lowing the editor's suggestion that monumental statues of Hercules as the people (replacing images of the feminine Liberty of the Girondins) be raised in every French city. Homer, he says, had called kings "mangeurs de peuple," and therefore these statues of the French sans-culotte giant should be labeled "Le Peuple Mangeur de Rois." This image makes explicit the deep sense that by eating the king the people become the national incarnation of his sovereignty.[65]

But behind the Saturn is more specifically Vergniaud's words describing the real process of the French Revolution, "the revolution like Saturn devours all its children" (see above, p. 24). This was an image that was picked up and applied to the Revolution's progress toward a return to repression. The apostate General Dumouriez in 1798 had called upon all European monarchies to reenter the war against France: If they did not, he said, "Democracy would devour Europe, and end by devouring itself." To complete the context of Saturn we should add, first, Gillray's most powerful image of Jacobinism, which connected beheading, dismemberment, and cannibalism, and was probably known to Goya (fig. 48); second, Goya's own paintings of cannibalism (American Indians eating Catholic priests) of around 1808–14; and, finally, P. Esteban Arteaga's argument in *La bellezza ideal* (1789) that Polyphemus devouring Ulysses' companions was a subject appropriate to poetry, but in a painting or sculpture it would be unbearable.[66] In short the political and aesthetic dimensions join in the image of Saturn as they have in Goya's other revolutionary images.

The complementary imagery of eating and being eaten, which in this room links the "hungry" pilgrims, saturnalia, witches' Sabbath, the Eucharist, and the murder of the Son by the Father, is centered in Saturn. But what of the Judith next to him? The painting of Judith extends the scene from the father beheading the son to the woman beheading her lover. She takes us back to the women in the *Caprichos* and *Desastres*, who are sold and raped and respond desperately and violently, in prostitution, maternal tyranny and adultery, and the fleecing and destroying of men. Other versions of her appear in the same room: the one fashionably dressed lady attending (at a little distance) the witches' black mass and the woman on the wall opposite Judith attending a grave—somebody's, perhaps Goya's (he had recently been near death), in which the body is literally swallowed and out of

65. See *Révolutions de Paris*, 17, no. 217 (10–18 frimaire, an II), in the Bibliothèque Nationale, Paris. I am indebted to Lynn Hunt in her forthcoming "Hercules and the Radical Image in the French Revolution" for this information.

66. Dumouriez, *Tableau speculatif de l'Europe* (Feb. 1798), p. 131; reissued as the *Nouveau tableau* (Sept. 1798), p. 279. Arteaga writes: "Ni dejaría de horrorizarse viendo la hedionda y descomunal boca de aquel gigante con un hombre atravesado en medio de ella, a y la sanguaza que le ensuciaba" (*La belleza ideal*, ed. M. Batllori [Madrid, 1955], p. 43; cited in Ilie, "Concepts of the Grotesque," p. 191).

94. Francisco Goya, *Quinta del Sordo: Duel with Cudgels.* Painting, 1820–23.

sight. The young woman standing next to the tomb in mourning attire, leaning against the mound with its iron railings, has been identified as Leocadia Weis, Goya's companion of his last years, and the one normative element, beautiful and untouched, amid this chaos (though she too is in black and may be repeated in the young woman observing the black mass).[67]

Judith had her own revolutionary history. During the French Revolution, when the old names were abolished on decks of cards, one French cardmaker made Judith Queen of Spades holding Holofernes' head and his falchion, and beneath was the motto: "Ma force est dans mons bras" (My strength is in my arm).[68] But there had also been Goya's serpent-like woman reflected in the canvas-mirror as a snake entwined about a scythe, who is both seducing and castrating.[69] One wonders how this figure relates to the replicas of the life-size Virgin (in some cases with an acutely phallic shape) which Goya likes to show borne in procession following flagellants and other fanatics (fig. 83). In number 67 of the *Desastres* she becomes one of the spoils of war to be protected by the natives or ravaged by the insurgents. She is apparently being saved from destruction, unlike the many actual virgins of the preceding plates. This "virgin" is related to the young lady in *Capricho* 57, who not only disguises her own face with that of an animal but also holds a mask or a head between her thighs, revealing her hidden rewards as yet another disguise, as a mouth—an organ of devouring. Perhaps that duplicity of the female is linked (as the serpent-woman would suggest) for Goya with melancholy through the object-loss of her necessary castration: What is *not* there is a further mask, the orifice of pleasure having in actuality teeth quite sharp and ravenous.[70] The fear of castration is closely related to the fear of being eaten. There is the *vagina dentata*, on one hand, in which the fear is of castration, and on the other there is the well-known Hispanic *Devoradora*, or devourer-of-men.[71] The *penis captivus* and love-board

67. See Gassier and Wilson, *Life and Complete Works*, p. 317, where it is argued that these are "scenes from beyond the grave, visions of the afterworld such as he [Goya] may have glimpsed when he lay on the brink of death."

68. See W. Gurney Benham, *Playing Cards: History of the Pack and Explanations of its many Secrets* (London, 1931), figs. 211, 212.

69. See Gassier and Wilson, nos. 648 and 649, dated ca. 1797–98. One perhaps gets a better sense of the *Judith* if we recall the Sala delle Donne Forti (Room of Heroic Women) in La Rocca de Soragna (near Parma); here are frescoes of Jael nailing Sisera, Judith beheading Holofernes, and so on, by Giovanni and Leonardo Clerici (1702). Goya's decoration is in one sense a parody of such decorations, turning them into images of "heroic women" for *this* time.

70. See Marcel Brion, *Bosch, Goya et la Fantastique*, ed. Gilberte Martin-Mery (Bordeaux, 1957), p. xxii.

71. Cf. the old joke, "When I got married thirty years ago, it looked good enougn to eat—now it looks like it's going to eat me" (Gershon Legman, *World's Dirtiest Jokes* [New York, 1969], p. 71; also, Legman, *No Laughing Matter: Rationale of the Dirty Joke*, 2d ser. [New York, 1975], p. 450). For the *Devoradora*, see Legman, p. 450.

jokes of popular subculture have to do with substitutions and doublings, in effect joining Saturn and Judith.[72]

The person who stands in the middle of the room must see himself either as the victim of Saturn—or as Saturn himself, whose sons are coming at him across the valley of San Isidro to devour him. In one sense Saturn is only Time-Death, related to the Fates weaving their thread (on the wall of the room upstairs) and to Goya's old age and his recent brush with death. But in the context of the juxtaposition of Saturn and Judith we find projected once again a curious family trio of the father–giant–lover with the son and the wife-mother. The father kills the son but succumbs to the wife or perhaps both kill the son; the Revolution devours its children and the father his son in the old oedipal combat of victorious counterrevolution. The Spanish situation, beginning as a family triangle in the *Caprichos*, had narrowed down to a father–son conflict (like the two men sinking out of sight) when in the first Spanish revolution, in Aranjuez in March 1808, the son overthrew the father's favorite (Godoy, the pseudoson and lover of the queen) and had himself declared king in place of the father. Napoleon's response when he brought father and son together was that "he would be entirely justified in not recognizing a son who had gained power through the misfortune of his father."[73]

Saturn is also presumably related to those gigantic, Polyphemus-like figures Goya shows looming over the Spanish countryside, juxtaposed with armies of Lilliputian soldiers. (There is a drawing of Gulliver in Lilliput in one of the last albums.) The giant is linked in size and sublimity to Burke's associations of it in his *Philosophical Enquiry* with "tyranny, cruelty, injustice, and every thing horrid and abominable. We paint the giant ravaging the country, plundering the innocent traveller, and afterwards gorged with his half-living flesh: such are Polyphemus, Cacus, and others. . . ."[74] But whether the figure is supposed to be the heroic Spanish spirit, the Herculean

72. For relevant jokes, going back to Antonio Viguali's *La Cazzaria* (1530), see Legman, *Rationale*, 2d ser. pp. 450–53.

73. Lovett, *Napoleon and the Birth of Modern Spain*, 1, 104; see also pp. 115–18, 121. There is also Carlos IV's remark to Fernando when the son knelt before his parents and tried to follow them after the ceremony: "Have you not caused enough insults to my white hair?"—turning his back on his son (ibid., p. 116). As to the queen, Napoleon is supposed to have exclaimed: "What a woman! What a mother. . . . She filled me with horror!" (p. 118). Of course, Napoleon's own aim, in terms of France, was to rid Spain of another branch of the House of Bourbon and to perpetuate *his own* dynasty instead.

74. *Philosophical Enquiry*, pp. 157–58. See the poet Arriaza's *Profecía del Pirineo, en Julio de 1808*, in *Poetas líricos del siglo XVIII*, 3, in *BAE*, 67 (1953 ed.), 69–70. The colossus of the Pyrenees rises and asks Napoleon, standing on the Pyrenees and regarding Spain, to survey the country where his soldiers are killing innocent Spaniards and be warned that he will suffer defeat and ultimate ruin. Cf. also Byron's "giant on the mountain," *Childe Harold*, canto I, stanza 39 (1812).

sans-culotte, Napoleon's ravaging army, the spirit of revolution, or the ravaging excesses of the Spanish mob is absolutely unclear. Most likely it is all of these.

With the absence of the son's head (that observing, detached head of the *Caprichos*) the most important reversal has taken place. Now the gaping mouth becomes primary, the opening into which the head has disappeared; the mouth of the father or, it seems in the *Desastres*, the all-engulfing fatherland. In the *Desastres* this has become all those pits receiving the corpses from firing squads, famine, and disease (fig. 78). In the second phase of the "war of independence" the swallowing up by the old monarch and the Church is emblematized by the additional plate called "Proud Monster" (fig. 80), an animal something like a sow swallowing (or vomiting, discarding) her own farrow; or, to use Freud's characteristic emendation, "Kronos devoured his children, just as the old boar devours the sow's litter."[75]

Thus all these scenes connect with the two strangers in the room upstairs, who flail away wildly at each other with crude clubs as the soil itself swallows them, with the dog, who, only its head visible, seems to be sinking from sight, and even with the *Tauromaquia* bull and matador, who are drawn ever closer by the engrossing, devouring shadow of the bullring. What is apparent is the tremendous isolation and the typical sense of engulfment within a cavity, a vacancy, a *creux*. The head, absent, unseen, literally swallowed is the context that must be understood for the *Judith* as well as the *Saturn*. Whether by the sword or by the ravenous mouth, the head is the object of dismemberment.

We can connect the image also with the series of open mouths, going back to *Capricho* 2 and the *Taking of Christ* of Toledo Cathedral, and with the caves and archways in the backgrounds of scenes of Inquisition, madness, imprisonment, banditry, rape, and murder, where prison and mouth are one as consuming agents (figs. 82, 84).[76] In Goya above all other artists the association of cave-grotto-grotesque is embodied in a dominating formal structure.[77] The grotto was also, as Goya would have known, regarded as the home for melancholy, the proper residence of the melancholy man as

75. *Interpretation of Dreams*, in *Standard Edition*, 4, 256.

76. For example, Gassier and Wilson, nos. 916–18, but also 919, 920, 922–27, and 929. The stage effect makes the openings in the background recall the Hell's Mouth of the mystery plays, and of the Last Judgment on the walls of cathedrals.

77. A pivotal work is a series of copies Goya made after Flaxman's very neoclassical bas-relief drawings of hooded figures, but how different the result: Goya's are hardly neoclassical but all shadows and empty holes, anything but flat (see Gassier and Wilson, nos. 760–65, p. 166). There is the point of connection, which could have been with David as well as with Flaxman except that while the French are trying to tool a style which expresses certainty, basically a continuation of the Enlightenment, Goya produces images that are full of holes and empty spaces—chasms, abysms, and darkness (or their negative, complete blank light outlining a fighting knot of two or more people).

the grotesque was his proper style.[78] The locales of melancholy enumerated by Robert Burton in *The Anatomy of Melancholy* correspond to the caves and deserts of Goya's *Caprichos*: "The night and darkness makes men sad, the like do all subterraneous vaults, dark houses in caves and rocks, desert places cause melancholy in an instant." Melancholy, according to Burton, is the mood for grotesque creation, and his associations of the artist with darkness, sleep, dream, witches, and goblins are precisely Goya's:

> How many chimeras, antics, golden mountains, and castles in the air do they build unto themselves! I appeal to painters, mechanicians, mathematicians. . . . What will not a fearful imagination conceive in the dark? what strange forms of bugbears, devils, witches, goblins.

But it is also important to recall that for Burton, and most later writers on melancholy, the source of the disease was love, or rather a lost or unrequited love.[79]

These themes are one with the melancholy of the "black" paintings and

78. The grotto in the gothic-grotesque is a prison and an escape, or both at once. Ambrosio approaches his grotto in the abbey garden with waterfall and walls of roots, and it is here that he meets Matilda reclining "in a melancholy posture" (*Monk*, p. 50). The grotto is the scene of his emancipation as well as his enslavement. Later he stands before "the long passage" at the end of which is "the private vault," listening to the "melancholy shriek of the screech-owl" before he descends to rape Antonia, who proves to be his sister (p. 378)—and in that grotto the private plot of his passion for Antonia and the public one of the prioress's tyranny join in the scene of mob violence which brings down both convent and Ambrosio's fortunes. The Revolution is summed up here in the grotto that in various senses "liberates" him, leading ultimately to his fatal liberation into space, sunlight, and death, but also to the subsequent stage in which lover, brother, son, and murderer merge in images of total unstructured violence.

When Caleb concludes that Falkland himself is the murderer, he "hastened to the garden, and plunged into the deepest of its thickets," "the most secret paths of the garden," where his thoughts "forced their way spontaneously" to his tongue (pp. 129–30). As yet another equivalent sought by the writers of the 1790s the grotto is an expression of potential, of a ritual burying that leads to new life, a visit to the underworld (as in the ancient epic) that impels outward and upward to a new world—but one in which masters and servants, persecutors and persecuted victims become one.

79. *The Anatomy of Melancholy* (London, 1932), 1, 241; 1, 254. A poem by Daniel Kenrick, "The Melancholy" (ca. 1715), sums up the themes associated with the malady, emphasizing unrequited love:

> I Spend my sad Life in Sighing and Cries,
> And in dark silent Shades mourn the Frown of her Eyes;
> Rude Satyrs and Fawns a Sympathy show,
> And Wolves howl in Consort the Voice of my Woe.
> Ev'n Mountains and Groves are kinder than She,
> Groans rebound from each Rock, Tears drop down from each Tree,
> And all things but Sylvia can pity poor Me.

the imagery of Saturn.[80] Melancholy, Freud argues in "Mourning and Melancholia," is caused by "an object-loss which is withdrawn from consciousness." The ego identifies with "the abandoned object," and the result is that

> the ego wants to incorporate this object into itself, and, in accordance with the oral or cannibalistic phase of libidinal development in which it is, it wants to do so by devouring it.[81]

In *Totem and Taboo* Freud tells how by means of murder and cannibalism the sons overcome the dominion and threat of the father, and in the act of devouring identify with him.[82] The implication of the object-loss being withdrawn from consciousness is that the *object*, which is generally attributed to love of the "human being," is linked to that first object-loss of castration fear which is exorcised in the totem meal, and further that at its extremity of reference the lost penis-object is also bound analogously, as a detachable part of the body functioning in a system of exchange, to excrement and babies, items essential to the saturnalian rituals of the witches' Sabbath.[83]

At the same time that he was executing the paintings in the Deaf Man's House, Goya painted the really gaping mouth of St. Joseph of Calasanz (fig. 96), which is swallowing the host, the symbolic body of Christ, in his last communion—within the larger cavelike mouth of the Roman arch which frames the action. As in the Saturn myth, the swallower is in some sense destined to be swallowed. Communion, of course, like the feast of the primal horde (indeed like the revolution), is a ritual that promises a way to immortality or paradise—related to the sucking perversions of the witches in the *Caprichos* as a way to increase one's own power by eating/sucking someone more powerful, whether king or potential king. The assumption is, as in witch lore, that power is conveyed by giving and taking the contents of the body. Interestingly, the fact is emphasized by Goya's friend Moratín in his edition of the *Auto da fe* that witches dug up their own relatives and fathers ate their children and children ate their fathers, accompanied indeed with bread and wine.[84]

In the Eucharist (in which the Son is devoured) these infantile, disruptive,

80. See Folke Nordstrom, *Goya, Saturn and Melancholy: Studies in the Art of Goya* (Stockholm, 1962).

81. *Standard Edition*, 14, 245, 249–50. See also Panofsky, *Studies in Iconology: Humanistic Themes in the Art of the Renaissance* (Harper & Row, 1972), pp. 69–83.

82. 13, 142, 145. *Identification* is another, related Freudian term, which also draws our attention to the relationship between the desire to *be like* and the desire *to have*, "the most brutal expression of which is the act of devouring" (as Freud saw in "Mourning and Melancholia"). Identification was "conceived as a reaction to the loss of an object," Ricoeur writes, identification with an external ideal and the introjection of the lost object into the ego—the same process seen in the murder and ingestion of the father by the primal horde. (See Paul Ricoeur, *Freud & Philosophy: An Essay in Interpretation*, trans. Denis Savage [New Haven, 1970], p. 216.)

83. *Standard Edition*, 23, 100–01.

84. Helman, "Moratín and Goya," p. 116.

95. Francisco Goya, *St. Francis Borja attending a dying Man*. Painting, 1788.

96. Francisco Goya, *The Last Communion of St. Joseph Calasanz*. Painting, 1819.

dangerous actions are transformed, for the communicant, into a way of reconciliation with God and with society. The Eucharist is a way of using such infantile and potentially dangerous energy, not as degradation but by ritual in order to control it. Moreover, the distinctive feature of Christ's eucharistic sacrifice is that He wills, gives, feeds, and saves of His own will and choice. One is therefore left wondering whether a painting such as *The Last Communion of St. Joseph Calasanz* is a reconciliatory way out of the Spanish revolutionary dilemma or only a continuation in which St. Joseph's gaping mouth, which is a strange, predatory sucking shape that recalls the *Caprichos*, represents the Father's greedy devouring of the sacrificial Son, a Christian version of Saturn. Is this his "last communion" in that it is his definitive devouring of Christ-the-Son to give himself (the aged dying father rather than the fraternal group of fallen man) eternal life?[85]

It is necessary to relate *The Last Communion of St. Joseph Calasanz* to the accompanying panel of *Christ on the Mount of Olives*, in which Christ is in much the same pose but with arms outstretched, sacrificial and prepared for crucifixion (which also relates to the frontispiece of the *Desastres*), and also all the way back to the early *St. Francis Borja attending a Dying Man* of 1788 (fig. 95). Here Goya's demonic fantasy figures, of the sort grouped around the artist in "The Dream of Reason," make their first appearance as they wait to capture the soul of the dying man. The man's open mouth is the place from which the spirit issues at death, but here it is also the mouth waiting to devour the blood of Christ that spurts from the crucifix held by Saint Francis Borja. The large orifice formed by the moon-shaped window is the first of those gaping, hungry cave-mouths, anticipating the mouths in the background of later Goya paintings. The miracle has just occurred; the cleansing blood sprays toward the dying man. The demons are waiting to seize the soul that emerges from the mouth while the mouth is reaching out to receive the life-giving blood of Christ in another version of "The Dream of Reason."

85. These eucharistic ceremonials take place, as both sacrifice and performance, in settings of artificial lighting and posing on a combined scaffold, altar, and stage that is essential to the Christ Mocked structure (as well as to the bullfight). One of the struggles in process was between the primitive festival or the mystery plays condemned by the ilustrados and contemporary, enlightenment theater. The time when the bullfight was being formulated and regulated was also the time when the Spanish stage was being reinvigorated, and one notices how Goya flattens the circle (one of his favorite forms) of the bullright into a theatrical stage. One common element in the Academy of San Fernando series of madhouse, Inquisition, religious procession with flagellants, and bullfight was the stage and a theatrical performance in which audience and performers mingled, which seems to interlock as a metaphor for Spanish society with the gaping archways that resemble mouths. All the other common denominators of cruelty and the conjunction of man-animal come down to the make-believe in which madmen play kings and queens, judges and matadors, only to be swallowed by that larger mouth absorbing them as part of a self-perpetuating ritual.

In short, the *St. Joseph* and the *St. Francis* may confirm our sense that the *Saturn* does not represent the primal horde but the saturnine Father devouring his sons—as protection against those threatening shapes approaching from outside the house with *their* open mouths, as a turning of the tables on the cannibalistic sacrifice of the horde. But what we have come back to is the unmistakable analogy between the artist's own figure and the threatened figures of Christ and now the dying St. Joseph and the man being ministered to by St. Francis Borja. The fact that the demons have not been exorcised (or appear not to be) questions the efficacy of the Christian ritual and gives the miracle itself a ghastly dimension by allowing for the possibility that the creatures have in fact been called up by its performance as Goya the artist called up those creatures in the second half of the *Caprichos.*

Among other things the juxtaposition of witches' Sabbath and pilgrimage merges the acceptable communion of Christian festivals with the horror of Saturn and the witches who feed not only upon men but even children. These festivals come very close to the ambiguity of exorcism and veneration in the primal horde's feast: The consumption of the totem should serve at once as a charm against dismemberment of one's father and one's own sons. In the act, however, such a communion can equally evoke the dismemberment of its desire and so lead to melancholy. It is this carnivorous ambivalence and/or duplicity which is posed in Saturn, who has castrated his own father, Uranus, and yet preserves himself from the same fate by consuming his own offspring (biting off the head, the intellectual center of the body).

If the fear of being eaten (or, in the witch *Caprichos*, of being sucked into nothingness) is a major source of anxiety in the oral period, in the anal it is the fear of being robbed of the body's contents.[86] If the *Caprichos* made most evident the equivalence of excrement with penises and babies, the *Desastres* added battle slaughter to the rhetoric of defecation, which already included festive masks and religious relics. In *Desastres* 68 the monk is shown defecating among relics and other Church treasures he is hording (fig. 79). As the "Proud Monster" (fig. 80) makes clear, both swallowing and vomiting (excreting) are equally present in the sequence. War, which is essentially revolutionary war, becomes a brutal beast or giant which first consumes a populace and then disgorges it as waste. Recall the scenes, especially *Desastres* 22 (fig. 77), in which the human bodies form an almost casual heap, as scenes of a sort of defecation by some vicious colossus (which might even be related to the giant brooding on the horizon in a defecatory posture in the mezzotint *The Colossus*).

The extreme regression of these primal images seems altogether appropriate in Goya's final works—and indeed is the only explanation for them.

86. See Otto Fénichel, *The Psychoanalytic Theory of Neurosis* (New York, 1949), p. 77.

The whole revolutionary process in Spain we have seen to be—at least in its popular manifestation (vs. the reform of the liberal, enlightened, and intellectual ilustrados)—the desire for a return to some earlier, more primitive state of security. We cannot avoid Freud's idea that the primitive force of "instinct" (*Trieb*, drive), unchecked by reason, is "an urge in organic life [at a lower level of consciousness] to restore an earlier state of things," to regress to an earlier, safer organic situation on the way to the quietus of death. Freud's point is that instincts, which we tend to associate with a drive toward change, are also an expression of "the conservative nature of living things" and move back toward the origin, which is nothingness.[87]

The scenario Goya outlines is unmistakable: The oedipal situation of the family in the *Caprichos*, which is interchangeable with the witches' coven, is only a stage on the way back to even more primitive stages into which the Spaniards and he (as their artist) regress in the years following. This is the transitive state signified by the undifferentiation of subject and object, as in the image of Saturn and his son: "The child who hits says he has been hit, the child who sees another child fall begins to cry" (cf. *Capricho* no. 25).[88]

Since the oedipal is a phase later in time than the oral and anal, we may wonder whether Goya himself is not either reliving backward the sequence or seeing this happening in his fellow Spaniards, who began by repudiating the "organic development" of change advocated by the ilustrados, which, in Freud's terms, "must be attributed to external disturbing and diverting influences" such as the French.[89] Revolting against this reform, they regress to forms of revolt which he associates with the oedipal phase—which are precisely those that have been built into the whole repressive nature of Spanish life. But the repressed instinct, released, follows its own regressive trajectory further back into archaic and infantile practices. Thence the Spaniards regress to anal sadism and to oral satisfaction and aggression, to those images of mouth, anus, teeth, biting, and devouring. This is the Spanish ver-

87. As Freud puts it, "All the organic instincts are conservative, are acquired historically and tend towards the restoration of an earlier state. It follows that the phenomena of organic development [i.e., change] must be attributed to external disturbing and diverting influences" (*Standard Edition*, 18, 37–38). This means literally the return to earlier phases of libidinal development—in Goya's case to oral and anal phases, as I have said. But paradoxically (as it seems) this suggests that a fixation on the oedipal phase is also a repetition or a regression, and that revolution itself—as opposed to what Freud refers to as "organic development"—is a sudden change of the organism which is *not* organic, and therefore is a regression (or even a perversion) (see, e.g., 23, 154–55).

88. See above, n. 39; also Fredric Jameson, "Imaginary and Symbolic in Lacan: Marxism, Psychoanalytic Criticism, and the Problem of the Subject," in *Literature and Psychoanalysis: The Question of Reading: Otherwise, Yale Studies in English*, nos. 55/56 (New Haven, 1977), p. 354.

89. Indeed, Freud invokes the sun as a primary impetus to organic development (18, 38).

sion of revolution Goya represented, and the greatest irony is the correspondence of the national psychomachia to the personal.

For we can apply that desire of instinct to restore an earlier stage to Goya the artist as well as to the subculture Spaniards (of which Goya was, at heart, one). As an artist he moves from words back to the visual, to touch, and to the all-embracing oral impulse out of which the others grow, and finally to the Deaf Man's House, where he abandons words altogether and moves from color and form to sheer tactility and monochrome, to excremental blackness, thick pigment, outraging his walls with obscene images as a kind of graffiti, joined with the subjects of orality and anality, of swallowing and disgorging. The paintings stand for the stark violation of all the stylistic conventions of beauty in Western art.

But in Goya the opposite forces of the revolution are also manifest. While the instinctual forces draw him back to earlier stages of political and personal as well as psychic development, the opposite intellectual forces of the Enlightenment push him toward reform in politics *and* in his art, with their elitist concepts of freedom and self-determination. They may arrive at the same end. The enlightened class also yearned for a gothic, romantic past, which involved aspects of primitivism (witchcraft was the Spanish equivalent of the tales of Ossian and the German märchen). The Enlightenment also delighted in primitive cultures, in broken or crossed blood lines, and so in the regressive plot which mingled virtue and vice. The "black" paintings unfold Goya's Enlightenment discovery of pagan, even diabolic, undergrowth, or underworld (or subculture) imagery, in Christian Spain; his plot, with which he replaces the Tiepolo images of heroic monarchs and artists in triumphant ascension, is anthropological (another analogue is Wordsworth's regressive plots in *Lyrical Ballads*). Goya shows the sad results of the Enlightenment in Spain but at the same time he witnesses the phenomenon through Enlightenment eyes.

At this point it is appropriate to recall the unifying style, or concept, of the grotesque (the *grotte*sque, with its associations of melancholy and its origin in the "grotesque" design that merges human, animal, and plant shapes in a regressive undifferentiation) in which the devourer and the devoured, the ingested and the excreted, are one—and as well the grotesque which is a defective twin of the sublime. Neither depends on form, indeed requiring a kind of un-form, which can mean both formlessness and deformity. For both sublime and grotesque the artist reaches beyond the classical norms, but in the sublime experience the spectator is aware of his failure to find a corresponding form. In this sense the ilustrados's intellectual awareness makes the grotesque experience of his fellow Spaniards for Goya the artist a sublime one.

Running parallel in Goya's work are two senses of *revolution*. One is the interpretation (or exposure) of dreams (*Sueños*)—of a latent content under

a manifest—as a revolutionary action, and the other is the regressive process of dreams as itself revolutionary. From the *Caprichos* onward, we can see (in Paul Ricoeur's terms) that "Since desires hide themselves in dreams, interpretation must substitute the light of meaning for the darkness of desire. Interpretation is lucidity's answer to ruse."[90] For Goya interpretation is simply the reduction of illusion. But interpretation can be seen "not only as a deciphering of hidden meanings, as a struggle against masks, but as a revelation of archaisms of every sort. . . ." This formulation applies to Goya in both aspects of his art: Unmasking is followed by the revelation of regressive archaisms, an intuitive grasp on Goya's part of the function of dreams, in an art which is (in Freud's sense) an "interpretation" of dreams. The archaisms are at first (in the first part of the *Caprichos*) the antiquated social customs of the monarchy, and then (in the second part) the archaic forces and energies released when these (oedipal) customs are removed.

Goya himself does not regress quite so far. He represents voids devouring and regurgitating human life, but his canvases prove to be consciously created voids which devour the phantasms of the imagination, as well as the actions of his fellow Spaniards. Throughout his work runs the ambiguous image of the artist at once threatened and threatening, at once the child who hits and is hit, at once Saturn and his son (or Holofernes).

The same artist who must have felt himself bewitched by a duchess and feeding a monstrous lamp that "sucks up life's oil,"[91] or felt himself somehow devoured by vacillating patronage and allegiances, must also have been aware how his own work throve on the actual horrors which were devouring his country and people. If the giant brooding on the horizon is a Saturn (or a Napoleon or the Spanish people) responsible for the excremental slaughters of revolution, Goya himself is equally on some level of consciousness the Saturn who plucks up and ingests such scenes. The revolutionary as Saturn equals the artist as Saturn.

On the second floor opposite the doorway of the Deaf Man's House was a panel, the same shape and size as the Saturn below, showing an old man

90. *Freud & Philosophy*, pp. 159–60. But if the dream or sueño "can stand as the paradigm for all interpretation it is because dreams are in fact the paradigm for all the stratagems of desire." Regression in the psychical apparatus then can apply either (1) "in the formal sense of a return to images, [2] in the chronological sense of a return to infancy, and [3] in the topographical sense of a return to the fusion between desire and pleasure, according to the type of hallucinatory fulfillment called the primary process."

91. The painting called *The Devil's Lamp* (London, National Gallery) is based on Don Antonio de Zamora's play *El Hechizado por Fuerza*, in which a priest is made to believe himself bewitched by a young lady so that he will live only as long as the lamp in her room remains burning. Goya's painting has the priest adding oil to a lamp held by a goat-devil; the prompter's text in the foreground ("Lámpara descomunal") refers to one of the priest's exhortations: "O monstrous lamp, / whose civil light / from me like a wick / sucks up life's oil. . . ." (reproduced in Gassier and Wilson, no. 663).

masturbating and being mocked behind his back by a young couple (perhaps his children, perhaps women) (fig. 97). This is finally what Goya seems to be saying Saturn and his own art amount to—self-satisfaction, while the world, even his own alienated offspring, look on amused. The image of Saturn devouring his own sons is perhaps only a heroic version of the old man masturbating. Photographs before restoration of the painting (see p. 363, n. 64) show Saturn with a prominent erection; as well as beheading he seems to be sucking the son who is a displacement (or extension) of his own sexual organ: he is both killing the son and self-satisfying himself. This is the final self-portrait, recalling in structure not only *Capricho* 43 and the *Christ Mocked* but above all, as a parody, the self-portrait with Dr. Arrieta (fig. 98), which had just preceded the paintings on the walls, following the illness that may have elicited them, and which could be the daylight version of this nightmare scene of the old man, with the same strange ambiguous forces which we have come to expect lurking in the background.[92] It is revealing that Goya should end the black paintings of the Deaf Man's House (just before fleeing to France) not with an image of the instincts and the pleasure principle which involve other persons, but with an image of auto-eroticism, the discharge of tensions (artistic, personal, public) within a self-enclosed apparatus.

If we regard Goya's art of revolution as a defense mechanism, we can see a dual response of projection and introjection—a casting out, onto something else, of whatever the self cannot bear to acknowledge as its own, and an incorporating of a prohibited object or instinct into the self so as to defend against it, which may mean in order to punish it. Goya expels his experience (say of the Duchess of Alba, his deafness, his aging) onto the situation in Spain, and he incorporates those aspects of the scene that seem most threatening and at the same time strengthening to him as an artist—the irrational, primitive, regressive. What in the *Desastres* he projects onto the external situation of the Spanish War, in the Deaf Man's House he dramatizes as an awareness of how the artist's own process of projection/introjection operates.

It is possible to see now why the artist in Rowlandson's satires, so concerned with violence, yet remained an outsider to the violence, which in

92. In this context the *Majas on a Balcony* (Metropolitan Museum, New York) seems the same sort of picture as *Goya and Dr. Arrieta* or the masturbating man—or even the *Boy in Red*—in which the figures (or *our* world) are guarded over, perhaps preyed upon in some strange way, by the shadowy figures in the background. What if it could be proved that Goya felt abandoned, betrayed, and cheated by his son and daughter-in-law (as Gassier and Wilson suggest may have been the case)? Would this give a different meaning to the Saturn and the Judith, especially with Leocadia on the opposite wall watching? And even to the old man masturbating, being laughed at by the young couple spying on him? But this is only to repeat that with Goya there is always a continuum between the public event and the personal pain.

97. Francisco Goya, *Quinta del Sordo: Two Young People laughing at a Man*. Painting, 1820–23.

Goya agradecido, à su amigo Arrieta: por el acierto y esmero con q. le salvó la vida en su aguda y
peligrosa enfermedad, padecida à fines del año 1819. a los setenta y tres de su edad. Lo pintó en 1820.

98. Francisco Goya, *Self-Portrait with Dr. Arrieta*. Painting, 1820.

other ways he valued. It was in order not to be contaminated by it, to remain "artist" and to keep it in some sort of order (by way of his Lines of Beauty) or retain some use for it (as, for example, a way to sexual enjoyment). But insofar as the artist *is* contaminated—as Goya makes quite explicit that *he* is—he makes himself in his work something of an atonement, a sacrificial victim who brings the reciprocal devourment to a point of rest. Goya is being devoured as a eucharistic sacrifice, but he can be thus devoured because he himself is guilty of the same reciprocal violence: This is the primary experience of the Deaf Man's House, of standing in its rooms surrounded by Goya's images.

The Spanish people is another Frankenstein monster: released, this cyclopean colossus devours his children. And yet, as we see, the differences are diminished, and there is no longer, of necessity, any distinction between the colossus and the people he devours, or above all between him and the artist who depicts him. The artist bridges the gap between the devouring colossus and the people because the artist—their surrogate, their redeemer—can show how the individual is also both devourer and devoured. In him the reciprocal violence can focus on this one human figure. Perhaps this is only a way of saying that the act of revolution, which in Spain (as in France) has become civil war, pulls us back to the very origins of culture and the basic nature–culture dichotomy—the moment when there is no differentiation between devourer and devoured, between parent and child, between artist and object.

I have been using the word *revolution* because we are speaking of the period of the French Revolution. But in the Spain of Goya all we see is a series of revolts and failed revolutions of the people and of Goya himself. Only the artist was revolutionary in the sense of proceeding with a plan for reconstruction—not of society, which he is only mirroring, but of his art. That is where the true Spanish revolution lay, and it only metaphorically fattened or fed upon the confused series of revolts and abortive revolutions in Spain, which cut across classes, interest groups, and even nationalities.

If we compare Goya's revolutionary art with that of David and the French artists, we see that the neoclassical response was to simplify and fashion "a new order and severity" but to retain essentially the same compositional subordination of the baroque—and in some ways intensify it. The result was simple, positive, admonitory, aimed at conveying positive statements about revolutionary virtue: in short, good revolutionary propaganda. While David strove for a new order by simple forms that could be taught and learned by large numbers of artists, Goya emphasized the experience: what it was like, what it felt like (as his self-portraits, his shifting ways of perceiving and knowing, show) to live through the revolution. And so he portrays the isolation, the monstrous shapes, the heroic/monstrous images of

the people, and to do so he develops new formal principles, based on if anything the free imaginings of the grotesque, thereby accompanying the external revolution with an internal and an artistic one.

The artists with whom Goya asks to be compared are the English (or the French of the next generation after David). His configurations of imagery are very close to those of Burke, but there is also the question of the remarkable resemblance to Blake (whose work he could not have known)—to the use of children as epitomes of sexual energy, release, and repression, as images of revolutionary consciousness. For example, from his tapestry cartoons to his final *Disparates* he uses children's games as a metaphor of adult behavior in society, and from this he moves to marriage ceremonies, masking, festivals related to the saturnalia, and on to the witches' Sabbath.[93] These are all examples of the forms and hypocrisies of society, a reduction of social customs to parody. In Blake's *Songs*, of course, the child's energy is closer to being normative, but both artists deal with the world of "experience" in which the child is curbed, instructed, and corrupted by his parents and then carries on the corrupting cycle. The second parallel with Blake is the personal involvement and perception of the artist, presented in phases: first simple observation, second visionary prophecy, seen in Blake's progression from piper to bard, as from *Innocence* to *Experience*.

Blake and the English artists and writers shared with Goya the situation of a group of liberal-thinking people living in a country of confused revolutionary and counterrevolutionary cross currents, and looking abroad to the model of France. They were fortunate enough to be free of the constricting situation of the successful revolution, which requires apologists only. They were free to represent the whole revolutionary phenomenon as it developed in time, and they all came up with the same revolutionary scenario in which the people revolt and break away from tyranny only to destroy each other and set up a worse tyranny. The revolution they represented was a failed revolution—or the failure of (perhaps any) revolution.

At that point Blake goes off into the self-enclosed world of art, as Words-

93. An obvious form taken by regression in Goya's work is the grown man who retains the clothes and habits of the child (as in *Capricho* 4). In the fourth of the *Disparates*, "Big Booby," he shows a very large child dancing, a child big enough to reverse the proportions between himself and his father; and in number 12 infancy seems to be taking the place filled by witchcraft in the *Caprichos*. The family is still the unit of the *Disparates* (as in no. 3), but the huge child has now replaced el Coco, the people replaced the Church, as the object of irrational fear (and source of artistic inspiration). We have to see this imagery in the context of Burke's, Wordsworth's, and Blake's (and Rousseau's) children as repressed energy that given freedom will change the face of the earth; then in later stages, as Wordsworth's children who cannot, should not, or (more sinisterly and dangerously) will not grow up. It is these children who continue to regress in Goya's works beyond the oedipal to earlier stages of development. So the oedipal situation, adumbrated by Burke and picked up and emphasized by Blake, denotes for Goya the childish and regressive character of the revolutionary protagonist.

worth goes into the internalization of revolution in spiritual autobiography, and Goya into endless self-analysis in which the artist first associates himself with the forces of revolution and ultimately with the forces of counterrevolution, the Saturn who devours his own young and the old man masturbating. All these artists see the phenomenon of revolution (explosion, success, and failure) as a personal psychomachia, as an expression of both the failure of political revolution and the success of the artist's own self-sufficient revolution.

But the close parallel between Goya and Blake extends only to the phase of the *Songs* and the *Caprichos*. Blake's final phase is an introjection and creation of a city of art along revolutionary lines; Goya's is a resolute facing of the ugly truth outside and inside himself. Blake's solution, after (and even perhaps before) the *Songs*, is to go off into allegory and hieroglyph. Goya's is to keep the incriminating images to himself and a close circle of friends while passing for a safe Spaniard in the daytime. (In fact, his life in those last years must have been a matter of conforming actions in the light of day followed by subversive actions in the darkness.)

The revolutionary scenarios in England and Spain were finally very different. As seen by the English, the oedipal conflict (the revolution of 1789–94) was followed not by further regression down the scale of development but by what in this context must be regarded either as a coming to terms with the situation, as the revolutionary ego employs these urges "in another way, forming character-traits or undergoing sublimation with a displacement of their aims," i.e., in terms of human sexual development;[94] or as a playing out of the fiction of the primal horde in which the brothers establish a more effective tyranny than the father, based on the taboos they have produced to represent their feelings of guilt.

These Freudian categories correspond very closely to the insights of Burke, Blake, and others in England. Goya, however, sees the process as a continuing regression into undifferentiation, which corresponds to the orthodox Freudian rather than the revisionist Reichian and Marcusan view, which sees "the claims of Eros" as what save man from regression toward the conservative end, Thanatos. Freud ascribes this pull to *both* Eros and Thanatos—recalling that Eros in the platonic myth directs the search for a lost primal unity which was split asunder.[95] I am not arguing for one position

94. Freud, *Standard Edition*, 28, 155.

95. Marcuse argues: "The death instinct is destructiveness not for its own sake, but for the relief of tension. The descent toward death is an unconscious flight from pain and want. It is an expression of the eternal struggle against suffering and repression" (*Eros and Civilization*, p. 29). He is describing the passive response of the masses, the conservative subculture phenomenon of softening and coming to terms with their hard lot; to which he opposes the active response of Eros, which it is the aim of every government to stifle or bemuse. Marcuse is expressing Blake's view, not Goya's. Blake depicts the repression which Marcuse describes as the forces of society directing Eros into the channels of Thanatos.

or the other but only showing that in the Spanish situation Goya represented the phenomena he observed and lived through, which were largely revolutionary, as regressive. In England Blake, for example, represented the phenomena as ego-instinctual, a paradoxical progress/regress. We can also contrast their views of the progress of artistic perception. Blake's from *Innocence* to *Experience*, from piper to bard (or prophet), is ambiguous enough but it is part of a cycle out of which he wishes to break into a third, higher state of perception. Goya's perception is simply two phases, and the second, or visionary, state is revealed as in fact a regression—or at least a perception into states or regression. Goya's "vision" is literally what Blake's innocence was, a return to the eyes of a child at an ever earlier stage of its development. What now seems to make Goya's art "modern" or the "first modern art" is his absolutely unflinching conversion of the national and personal phenomena into representation at its extreme limits.

INDEX 🐜